JAZZ ALBUM COVERS

The Rare And The Beautiful

by Manek Daver

JAZZ ALBUM COVERS

ジャズ・アルバム・カバーズ

マネック・デーバー著

The rare AND THE beautiful

by Manek Daver

CONTENTS

目次

FOREWORD

In 1991, Manek Daver sent me his book *Jazz Graphics - David Stone Martin.* What he had accomplished was a magnificent project. I was delighted to see David Stone Martin's jackets - the large majority of which had been done for my own labels Clef, Norgran, Down Home and Verve. I wrote Manek Daver to commend him on what I felt was an awesome achievement. This was the beginning of a relationship born of appreciation of designs of jazz LP covers. Historically these jackets will ultimately be priceless.

I have encountered in my lifetime very few creative sponsors, sponsors who have unselfishly and unstintedly given the world artistic works of art; and not only without profit to themselves, but in many cases at a loss. Manek Daver is one of a dwindling group of people who throughout history has kept art alive.

It is interesting to note that of the covers that he has managed to gather together, practically none is from a major label. The answer, obviously, is that, with very little exception, the major labels did not record jazz, except in the early years. Thus, without the challenge the music might have given them, they were equally non-inventive when it came to record cover art. The big company commercial attitudes inhibited whatever their art directors might have done that was original.

In the sixties and seventies there were big companies acquiring small jazz labels, a kind of "no-pain" acquisition, and in almost every instance the cover art reflected this non-creative mood. They even went so far, in the case of Verve (which I created and owned) to reissue the music with new art work, which had little reference to the music, nor were they individually distinctively even, to save money, going so far as to run the same liner notes on different albums.

In addition to working with the great jazz artists in the studio and on concerts, I equally had great joy in working with artists such as David Stone Martin, Sheldon Marks, and Merle Shore on layout and art work as well as with photographers such as Phil Stern and Herman Leonard.

With the advent of the compact disc, it virtually means the end of creative art work as demonstrated on LP covers. Even if the LP cover were reduced to compact disc size, it rarely, if ever works, and it is simpler for the record company to run a photograph of the principal artist than to design new art work. This means that the tremendous work that Manek Daver has done is historically astounding; thank goodness there is someone like him who has preserved for posterity these priceless works of record cover art.

NORMAN GRANZ

序　ノーマン・グランツ

　1991年，マネック・デーバーから『ジャズグラフィックス─デヴィッド・ストーンマーチンの世界』を受けとった。彼はなんとすばらしい企画を実現してくれたのであろうか。デヴィッド・ストーン・マーチンの描いたジャケットの数々を見て，私は嬉しくてならなかった。なにしろ，その大半は私が自ら作ったクレフ，ノーグラン，ダウン・ホーム，ヴァーヴのレーベルの作品だったからだ。さっそく私はマネック・デーバーに手紙を書き，これは敬服すべき偉業であると心からの賛辞を贈った。こうして，ジャズのLP盤のジャケット・デザインの真価を認めるところから，われわれのつきあいが始まった。これらのジャケットはいずれ，歴史上，値段のつけようのないほど貴重なものとなるにちがいない。

　これまでの人生を振り返ってみても，創造的な芸術の後援者に出会ったのはほんの数えるほどしかない。彼らは私利私欲にとらわれず，世界の芸術作品に惜しみない援助をしてきた。それはなんら自分の儲けにならないどころか，多くの場合は赤字だ。長い歴史の中で，芸術の輝きを守り伝える人々は次第に少なくなってきたが，まさにマネック・デーバーはそんなひとりなのである。

　おもしろいことに，彼が尽力して集めたジャケットにはほとんどメジャー・レーベルのものがない。言うまでもなくそれは，わずかな例外を除いて，メジャー・レーベルが初期の数年だけでジャズの録音から手を引いたからである。したがって，ジャズへのこだわりや熱意に欠け，レコードのジャケットも創意に欠ける平凡なデザインだった。大手レコード会社の営利主義が，アート・ディレクターに独創的なデザインをすることを許さなかったのである。

　1960，70年代に入ると，大手レコード会社は次々と小規模なジャズ専門レーベルを，いわば「痛手なき」吸収という形で傘下におさめ，たいていの場合，ジャケットのデザインもその非創造的な姿勢を反映したものと変わった。そうした吸収の波は私が設立し所有していたヴァーヴにも及び，レコードの再発にあたってジャケットも一新されたが，それは中身のジャズとはほとんど関係のないデザインであった。もっともさすがに，経費節約のために異なるアルバムに同じライナーノーツを用いるという会社はなかったけれど。

　私は偉大なジャズ・アーチストたちとともに録音やコンサートに取り組んだだけでなく，デヴィッド・ストーン・マーチンやシェルダン・マークス，マール・ショーといった芸術家や，フィル・スターンやハーマン・レナードといった写真家とも，ジャケットのレイアウトやデザインにあたることができたことを，たいへん幸せに思っている。

　コンパクトディスクの登場によって，事実上，LP盤のジャケットに見られるような創造性に富んだ芸術作品は姿を消すと言っていいだろう。LP盤のデザインがそのままCDの大きさに縮小されて使われたとしても，同じ効果のあることはまずないし，だいいちレコード会社にしてみれば，主要アーチストの写真を載せるほうが，新しい芸術作品をデザインするより手間が省けるというものだ。つまり，マネック・デーバーは歴史上，画期的な偉業を成し遂げたのである。極めて貴重なレコード・ジャケットを後世に伝えてくれる彼のような人物がいてくれることに，つくづく感謝せずにはいられない。

ACKNOWLEDGEMENTS

I started listening to jazz 40 years ago. Many of my first records were Norman Granz labels. Among non-musicians, no one has done more for live and recorded jazz than he has. Of the countless records and concerts which he has produced, there has never been a bad one. I am extremely grateful to him for writing the Foreword for this book.

I remain indebted to Ernest Carmichael, Associate Professor of English, Kanagawa University, Japan who with his infinite knowledge of jazz, inspired me to start writing again and even suggested the title for this book. Three others have helped immensely. Shinjiro Furusho and Cynthia Sesso read and improved my text with the depth of their own considerable knowledge of jazz records. Joanna Williams guided the editing of my business executive's English into a more readable form.

The David Stone Martin section includes printer's proofs of Disc/Asch jackets given to me by Cheri Martin. Sadly, during the course of the writing of this book Cheri Martin died. My consolation is that she did read the draft pages and did know of the additional DSM jackets I am able to present. My thanks also to Cynthia Sesso, Russ Chase, William Carraro, Jehangir Dalal and Dwight Deason for the loan of jackets.

I first met Herman Leonard when he visited Tokyo in 1991. He came to my home and we talked of some of his jackets. Innumerable good humored faxes followed, establishing more jackets and background stories, culminating in a visit to his San Francisco studio. My thanks to him for the use of some alternate shots to those used on the jackets. Gil Mellé has been most generous with memories of his music and his jacket designs. This friendship, too, started with phones and faxes and finally a wonderful day with Gil and his wife Denise at their home just outside Los Angeles. My special thanks to Gil Mellé for his painting which became the cover for this book.

The Frank Gauna section might never have been as no one seemed to know where he was. For his address, I am indebted to our mutual friend Dan Cirlin. Frank Gauna's exuberance made me smile each time we talked on the phone and when we met at his Los Angeles studio. Frank and his wife Audrey are a wonderful couple whom I phone whenever I need a boost for the day. I have known 'Pencil' Abe ever since I came to Japan. A wonderfully good natured friend not just to me but also to my children. My thanks to him for his wonderful stories and alternate photographs.

The initiative and credit for the Pierre Merlin section belongs to Dr. Francis Hofstein of Paris. Dr. Hofstein has had a long interest in jazz as a researcher, a writer and as a collector of records and

感謝の言葉にかえて

私がジャズを聴きはじめたのはもう40年も昔のことだ。初めのころ手に入れたレコードの多くは、ノーマン・グランツのレーベルのものだった。ミュージシャンを除いて、ノーマン・グランツほど実演、録音ともにジャズに貢献した人物はいない。彼のプロデュースした数知れないレコードとコンサートは、どれもみな精彩を放っていた。本書の前書きを書いてくださった氏の厚意に、心から感謝の意を表したい。

神奈川大学で英語を教えるアーネスト・カーマイケル助教授には、なにかとお世話になった。ジャズの生き字引たる彼の適切な助言のおかげで、私はつまずきながらもワープロを打ちつづけることができた。本書の題名を考えてくださったのも彼である。さらに、3人の方々にも並々ならぬお世話になった。古庄紳二郎とシンシア・セッソーのおふたりには、その豊富なジャズ・レコードの知識をもって、私の書いた原稿に手を加えていただいたし、ジョアンナ・ウイリアムズ氏には、経営者である私の拙い文章を読みやすい形に推敲していただいた。

「デヴィッド・ストーン・マーチン」の章に収めたディスクとアッシュの両レーベルのジャケットの校正刷りは、シェリー・マーチンからお借りしたものである。悲しいことに、本書の完成を見ずして、シェリー・マーチンはこの世を去った。下書きの原稿を読んで、新しく紹介されるデヴィッド・ストーン・マーチンのジャケット作品を知っていただけたのが、せめてもの慰めだ。ほかにジャケットをお貸しくださったシンシア・セッソー、ラス・チェイス、レッド・カーレイロ、ドゥワイト・ディーソンの各氏にもお礼を申し上げたい。

1991年、ハーマン・レナードが東京に来日したとき、私は初めて彼と会った。ハーマンが私の自宅を訪れ、ふたりでいくつかの彼のジャケット作品について話をしたのである。これをきっかけに、その後ファックスで幾度となく楽しいやりとりをして、次々とジャケットや背景事情が明らかになり、とうとう私がサンフランシスコのスタジオに彼を訪ねるまでになった。ジャケットに使われた写真の別ショットを何枚か使わせてくれたハーマンにお礼を言いたい。また、ギル・メレも実に快く、数多くの演奏やジャケットのデザインにまつわる話をしてくれた。彼とのつきあいも電話に始まって、ファックスでのやりとりが続き、ついにはある日、ロサンゼルス近郊の自宅でギルと夫人のデニスに会う夢がかなった。本書の表紙を描いてくれたギル・メレに、心からお礼を言いたい。

「フランク・ガウナ」の章については、設けることができないのではないかと思われた。彼の所在を知る者がなかなか見つからなかったからだが、それでも住所を突きとめられたのは、共通の友人であったダン・サーリンのおかげである。電話で話すたびに、私はフランク・ガウナのあふれる活気につい顔をほころばせたものだが、それはロサンゼルスのスタジオで実際に会ってみても変わらなかった。フランクとオードリーはすばらしい夫婦で、私は気分がめいったときは必ずふたりに電話することにしている。また、「ペンシル」アベとは日本に来て以来のつきあいだ。私はもちろん、私の子供たちにとっても、陽気で優しい大切な友人である。興味深い話やジャケットの別ショットの写真を提供してくれたアベにも、お礼を言いたい。

「ピエール・メルラン」の章は、パリ在住のフランシス・ホフスタイン博士の手ほどきと信頼によるところが大きい。長い間、ジャズ・レコードとジャズに関するコレクションの研究家、著述家、コレクタ

artifacts. He has long been an admirer, a friend and a collector of Pierre Merlin's work. Dr. Hofstein interviewed Pierre Merlin for issue No. 19/91 of the 'Revue d'Esthetique' from which I have quoted. Fortunately, Pierre Merlin himself kept a printer's proof of many of his jackets. My gratitude to Pierre Merlin for making these proof prints available and to Dr. Francis Hofstein for his enthusiasm and support.

The Debut section is an expansion of an article I wrote some years ago for the 'Record Collectors Magazine' of Japan. Additional jackets came from Uwe Weiler. Uwe Weiler is a specialist on the Debut label and will soon publish his own book Debut Records Discography——The American Debut Label. For the Southland chapter, my thanks to Dr. Bruce Boyd Raeburn of the Hogan Jazz Archive, Tulane University and Mr. George Buck of Jazzology Records for background information and the gift of some jackets. The rest of the chapters come from my own memories of many happy years of collecting and listening to records as well as general reading on jazz. Recording dates are from the jackets or from the discographical publications of Walter Bruyninckx or Michel Ruppli.

Tony Nishijima is one of the world's authorities on jazz records being both a great record collector and a pioneer dealer in rare jazz records. I am grateful for his kindness in checking the Japanese translation. My thanks to Graphic-Sha Publishing (Nobu Yamada, Rico Komanoya) and book designer Yusuke Tamura for their attention to each detail and their own affection for the project.

The records used for illustrations are the original first issues. I felt this was essential to capture the exact colors and lettering of the original design. It also accounts for why some of the jackets are not pristine. The Disc/Asch covers used in the David Stone Martin chapter are standard play albums (78 rpm). All others are microgroove long play. Diameters, if other than 12", are so stated. The time pressures of my own daily work did not allow me time to research other books on album design. All errors and omissions are my own failure.

Often, the jacket design, the album title and the musicians are closely interwoven. I leave to each viewer the personal thrill of such discoveries. The years of the record issues are included where relevant though not the full titles of the music or names of musicians. There are excellent discographies for such data. My hope for this book is that it will be considered worthy of the album cover art which it celebrates.

ーとしてジャズと取り組んできたホフスタイン博士は，長年にわたって，ピエール・メルランの作品を賞賛し，支持し，収集してきた。本書では，『ルヴュ・デステティック』誌，1991年第19号に掲載された博士によるピエール・メルランのインタビュー記事を引用させていただいた。さいわい，ピエール・メルランの手元に多くのジャケットの校正刷りがあり，これをお借りすることもできた。ピエール・メルランの厚意と，ホフスタイン博士の熱意と励ましに；深い感謝の意を述べたい。

「デビュー」の章は，数年前に私が日本の『レコード・コレクター』誌に書いた記事を発展させたものである。本書で新たに加えたジャケットは，ウエ・ワイラー氏からお借りした。ウエ・ワイラー氏はデビュー・レーベルに関する専門家で，まもなく『デビュー・レコーズ・ディスコグラフィー――ザ・アメリカン・デビュー・レーベル』を出版される予定である。「サウスランド」の章については，チューレイン大学，ホーガン・ジャズ記録保管所のブルース・ボイド・レイバーンと，ジャゾロジー・レコードのジョージ・バックのおふたりに背景事情の提供やジャケットの寄贈をしていただき感謝に絶えない。なお，その他の章については，ジャズ・レコードを集め，聴き，ジャズに関する著述にもひととおり目を通してきた，幸せな私自身の40年間の記憶に基づいている。

TONY 西島氏は世界的なジャズ・レコードの権威であると同時に，屈指のジャズ・レコードのコレクターであり，希少盤ディーラーの草分けでもある。快く日本語への翻訳のチェックを引き受けてくださった氏に，お礼を申し上げたい。

最後に，この企画を暖かく受け入れ，出版にあたっていろいろとご尽力をいただいたグラフィック社の山田信彦，駒野谷理子，ブック・デザイナーの田村祐介の各氏にも，お礼を申し上げたい。

本書で紹介するジャケットには，オリジナルの初回プレスのレコードを使った。オリジナルのデザインの色と文字を正確に伝えるにはそれしかなかったからだ。なかには多少汚れているジャケットがあるのはそのためである。ちなみに，デヴィッド・ストーン・マーチンの章で使ったディスク，アッシュの両レーベルのジャケットは78回転のSP盤で，それ以外はすべて音溝の狭いLP盤。12インチ盤以外も同様である。

今回，日々の仕事に追われて，他のアルバム・デザインに関する書物にあたる時間がないままに終わってしまった。誤りや不備があるとすれば，ひとえに私の責任である。なぜなら本書は，私がレコードを聴き集めるなかで得た情報に，ライナーノーツや雑誌や書物をひととおり読んで得た情報を加えた記憶に基づいているのだから。

しばしばジャケットのデザインとアルバムのタイトルとミュージシャンとが，密接に結びついていることがある。が，それを発見するえもいわれぬ快感は，どうか皆さんそれぞれに味わっていただきたい。レコードの発行年月日は妥当な範囲で付記したが，全部の曲名やミュージシャン名までは記さなかった。それらについては，他の優秀なレコード音楽史を参考にされたい。本書では，すばらしいジャズ・アルバムのジャケット・アートを少しでも楽しんでいただければ幸いである。

INTRODUCTION

One hour up the Rhine river from Cologne is the town of Linz. Linz houses the 'Musik Museum Burg Linz am Rhein'. Walk into it, and you will find yourself surrounded by an amazing archive of rare instruments which commemorate the history of recorded music and, our own special interest, the Gramophone. But this is not a book on the history or future of musical sound. There are just three events in the history of recorded sound which are of importance to our consideration of jazz album design.

The first is the Flat Disc which emerged at the turn of the 20th century as the winner over tin foil, wax and other cylinders as the standard format for sound recording. The Flat Disc was to evolve with different speeds, diameters, and base raw materials. We are concerned with two classic formats. The 'standard play' started in the 1920s. It is a double sided recorded disc, 10" or 12" diameter, 78 revolutions per minute. This 'standard play' offered between just under 3 or just under 5 minutes of uninterrupted music (depending on the diameter of the disc). It was followed in 1947 by the 'long play' microgroove disc of 10" or 12" diameter, 33.1/3 revolutions per minute offering from 18 to 25 minutes of continuous music.

The second notable event was that by the middle 1920s the marvel of the gramophone had become the central piece of home entertainment. Designed originally as a play back instrument, it now became a piece of furniture around which the living room was often built. As gramophones could now cost a lot of money, with them came the need both to maintain and show off one's collection of records. It was a natural consequence for record companies to put several standard play records together in an album. So the record album was born——from the need to package and keep together records which had a common theme. If jazz was well represented on standard play records, it was not only attributable to the jazz factor itself but also because these were the great years of social dancing and of dance music. Records, which we would know as jazz, were issued in plenty but described on the label as a fox trot or a quick step or even as Novelty music.

The third factor was Columbia's successful introduction of the Long Play record in 1947. Within the same disc size, it offered 4 times the music of the standard play. Through the process of 'microgroove' cutting——many more grooves could be put into the

はじめに

ケルンからライン川をさかのぼること1時間, リンツという町に「リンツ音楽博物館」がある。その中に足を踏み入れると, 所狭しと展示された, レコード音楽の歴史を刻む珍しい機器や, 注目すべきグラモフォン (円盤蓄音機) の数々に目を見張る。これらの所蔵品は, 録音の歴史を物語っているだけでなく, 将来新しい録音と再生の方法が開発されていくことも示唆している。しかし, 音響の歴史と未来について述べるのが本書の目的ではない。ここではレコード音楽史上, ジャズ・アルバムのデザインに関わる重大な3つの出来事だけを追ってみる。

第一の出来事は, 19世紀の終わりに, すず箔を巻きつけたりワックスを塗ったりした円筒形のレコードに代わって平円盤が登場し, ディスク録音方式が一般化したことである。平円盤は回転数, 直径, 原料に改良を重ねて発展したが, 本書に関係するのは2つの代表的な種類だ。まず, 1920年代に実用化された「標準レコード (SP盤)」は, 両面録音の直径10インチまたは20インチ, 回転数毎分78回転のディスクで, 連続演奏時間は片面わずか3分足らず5分足らず (ディスクの直径による) だった。その後1947年に, 直径10インチまたは12インチの毎分33.1/3回転という音溝の狭い「長時間レコード (LP盤)」が登場, 演奏時間は片面18分から25分と大幅に延びた。

2つ目は, 1920年代半ばまでに, 画期的発明品である円盤蓄音機が家庭の娯楽の中心として普及したことである。本来, 再生装置として作られた蓄音機は, 家具のひとつとしてリビングルームの主役に据えられることも多くなり, 家具の例に漏れず, 高価な品が売り出されるようになった。そのうえ人はレコードを収集するだけでなく, そのコレクションを披露せずにはいられなくなった。当然の結果, レコード会社は数枚のSP盤を1枚のLP盤にまとめることを考え, こうして共通のテーマでレコードをひとまとめにする必要から, レコード・アルバムが生まれたのである。レコード音楽史上アルバムの先駆をなしたのは, アレックス・スタインウェスと米コロムビア社だった。ジャズが多くSP盤に収録されているのは, ジャズそのものの要素にもよるが, 当時は社交ダンスやダンス音楽の全盛期だったことにもよる。その証拠に, 私たちがジャズとみなすレコードが数多く発売されながら, ラベルにはフォックストロットとかクイックステップ, あるいはノベルティ・ミュージックなどと表示されていた。

3つ目は, コロムビアが1947年に売り出したLPレコードの成功だ。LP盤は同じディスクの大きさで, SP盤の4倍の長さの演奏時間があった。「マイクログルーブ」と呼ばれるカッティング法によって, 同じ直径のディスクにずっと多くの音溝を刻めるようになったのである。

same overall diameter. Careless handling or storage would immediately damage the microgrooves. The LP had to be kept in a protective jacket. It was also no longer feasible for the store to play a record long enough for the customer to listen to and decide to buy or not. The jacket would now have the function of describing the nature of the music on the record. And both sides of the jacket were essential to defining the content of a particular record including advertisements for other offerings under the same label. The designer suddenly became a crucial factor in the production and presentation of recorded music.

The major record companies usually had their own art departments. Their jackets were often a combined effort and as a general rule, carried no individual credits. This was because the major record companies were issuing records of all kinds of music and an art department capable of designing jackets for all types of music under strict deadlines was indispensable.

Jazz benefited greatly from the Long Play record. Live jazz was not the three minute performance to which the standard play record had so far restricted it to. The 10" LP allowed individual recordings for up to 12 minutes. Suddenly the number of labels issuing only jazz records exploded in number. And here is where the skills of the great individual jacket photographer and designer came in.

Jazz record design challenged the graphic designer in ways that other music forms did not. Many of the jazz musicians recording were 'new' faces, who were not immediately recognizable and often lacked a photogenic personality. For the jazz listener accustomed to an under three minute recording, each track could now be longer with more improvisations and more solo work. It required a different listening 'ear'. As well as explaining the recording, the jacket would need to convey the special ambiance of the record and of course influence the decision to buy. Hence, there was a contradiction between the two mediums of recorded jazz and of live jazz. A great designer could span that gap by resolving the difference between the sound document being marketed and the quick lived drama of the musicians 'cooking' (Ernest Carmichael feels it is no accident that jazz is associated with food lovingly cooked and enjoyed!). How would the designer transport the music

LP盤は取り扱いや保管に注意を怠たると，たちまち細かい音溝に傷がついてしまうため，それを保護するようなジャケットに入れられた。また，店がレコードをかけて客に聴かせ，買うか買わないかを決めてもらう手間も省けた。ジャケットが中身の音楽の性格を表す役目を果たすようになったからだ。ジャケットの両面はレコードの内容を伝えるのはもちろん，同じレーベルの他の作品の宣伝をするためにも欠かせないものとなり，レコード・ビジネスにおける重要な存在として，にわかにジャケットのデザイナーが注目されはじめた。

大手のレコード会社にはたいてい美術担当部があり，ジャケットは共同で製作されるのが普通で，デザインに携わった個人の名前を表示することはまずなかった。音楽全般にわたるレコードを発表していた大手レコード会社にすれば，それもやむをえなかった。締切厳守であらゆるジャンルの音楽のジャケットのデザインをこなせる美術担当部は，絶対に不可欠だったのである。

LP盤の登場はジャズに大きく貢献した。それまでSP盤は3分の演奏に限定されていたためライブは収録できなかった。それがLP盤によって，一挙に片面12分まで録音可能になったのである。ジャズ・レコードを専門に発表するレーベルが急増し，ここに個人の優れたジャケットの写真家やデザイナーが腕をふるう場が生まれた。

ジャズ・レコードのジャケットには，他の音楽ジャンルにない斬新なデザインが求められた。レコードに吹込むジャズ・ミュージシャンの多くは「新人」で，顔が名刺代わりになることはなかったし，写真映えのする人物でもなかったからだ。3分に満たない演奏に慣れていたジャズの聴き手にとっては，LP盤はどのトラックも即興演奏やソロ演奏が増えて前より長くなり，これまでとは違う「聴き方」が要求された。ジャケットもレコードの内容の説明だけでなく，演奏の独特の雰囲気を伝えながら，しかも客の購買意欲を促すデザインにする必要があった。このようにレコードとライブは相反する表現手段だった。だが，一流のデザイナーは市販の音の記録物とミュージシャンの生の熱演（クッキング）の間の違いをジャケットで埋め，この2つのジャズを見事に結びつけてみせたのである。（ちなみにアーネスト・カーマイケルによれば，ジャズが愛情のこもったおいしい料理を連想させるのは偶然ではないそうだ！）　では，どうやってデザイナーは音楽をジャケットという自分の媒体に移して表現し，再び現実の世界に送りだしたのだろうか？

デザイナーはたいてい自らもジャズファンで，録音スタジオに同席してミュージシャンたちに感情移入することが多かった。よくジャケットにデザイナーとプロデューサーにしかわからない「秘話」が隠さ

into his medium, possess it, clothe it, and then send it back to the real world?

The designer was usually a jazz lover, often present at the recording studio and certainly in empathy with the musicians. It was typical of jazz that the jacket often had an 'inside story' whose meaning did not carry beyond the immediate designer and the producer. The musician is of course the ultimate designer and alone knows why he played as he did. But right there marching in lock step with him is his jacket designer. The designers of the classic jazz recordings of the 1950s and 1960s are walking archives of jazz history. Sadly, we may never understand the full significance of the 'how' and 'why' of a particular record cover nor be able to honour its designer.

There are great jacket designs in other forms of recorded music too. But I think the designer may have had a somewhat easier job. For classical and popular music it was often enough to feature the face of a well known musician. Or the names of the compositions were familiar enough to speak for themselves. But look at the work of the jazz album designers and how consistently they avoided the mediocre. Take a moment to admire how well they succeeded in presenting compositions by unknown musicians playing unknown new titles in styles far from familiar!

I fear the designers of half (my own estimate) of the jazz albums issued from 1948 to say 1960 will never be identified. The major recording companies rarely gave individual credit. Many jazz labels were too small or too indifferent to care about crediting jacket designs. All too many jackets carry cryptic signatures impossible to read with both the record company and the producer long since faded away. At times, credits were incorrectly made.

Recorded jazz owes much to the independent producer and record company owner. Were it left only to the major companies, we would not have jazz as we have it today. Few people today realize that the issue of jazz LPs in the 1950s and 1960s was hardly a commercial proposition. That producers like Norman Granz, Alfred Lion, Richard Bock, Bill Grauer, Bob Weinstock could record great talents and package these with the equally great talents of David Stone Martin, Herman Leonard, Burt Goldblatt, Paul Bacon, John Hermensader, Esmond Edwards, Reid Miles,

れているのも，ジャズならではの特徴だ。もちろんミュージシャン本人こそ究極のデザイナーであり，演奏のわけを知る唯一の人物である。だが，そのミュージシャンと一心同体なのがジャケット・デザイナーなのだ。1950，60年代のジャズの名盤のデザイナーたちは，いわば生きたジャズ史である。このままレコード・ジャケットが「なぜ」「どうやって」デザインされたか十分に理解することなく，デザイナーに敬意を表することもできないのでは悲しい。

ほかのジャンルのレコードにも，むろん傑作と呼べるジャケットはある。しかし，私にはジャズに比べてデザイナーがいささか手を抜いている気がしてならない。クラシック音楽やポピュラー音楽の場合，有名なミュージシャンの顔写真を載せることが多かったし，曲名自体が有名で余分な説明や凝ったデザインは必要なかったからだ。ところがジャズ・アルバムのデザイナーの作品はどうだろう。どれをとっても平凡なデザインにならぬよう意匠を凝らしていて，そのすばらしさにしばし目を奪われる。無名のミュージシャンが斬新なスタイルで演奏する無名のタイトルの曲を，彼らはなんと鮮やかに表現していることだろうか！

私のみたところ，1948年から60年頃に発表されたジャズ・アルバムの半分は，ジャケットのデザイナーが確認できそうもない。大手のレコード会社はめったに名前を表示しなかった。ジャズのレーベルのほとんどはごく小規模だったり，無関心だったりして，ジャケットのデザインを手がけた人物のクレジットまで気がまわらなかったのだろう。実に多くのジャケットは暗号めいた判読不可能なサインがあるだけで，頼みの綱のレコード会社もプロデューサーもとうに存在しないし，表示はあってもときどき間違っている。

ジャズ・レコードの発展は，フリーのプロデューサーや小規模レコード会社のオーナーの力に負うところが大きい。もし大手のレコード会社だけに委ねられていたなら，今日のようなジャズはありえなかっただろう。今日からはとても想像がつかないが，1950，60年代はジャズLPを発売してもほとんど商業ベースに乗らなかったのだ。ノーマン・グランツやアルフレッド・ライオン，リチャード・ボック，ビル・グロー，ボブ・ワインストックといったプロデューサーたちが，優れたミュージシャンの演奏を録音し，それをデヴィッド・ストーン・マーチン，ハーマン・レナード，バート・ゴールドブラット，ポール・ベーコン，ジョン・ハーマンセイダー，エズモンド・エドワーズ，リード・マイルス，フランク・ガウナ，トム・ハナンなどやはり傑出したデザイナーがパッケージデザインしたアルバムの数々は，私たちにとってまさに聴覚と視覚で楽しめるかけがえのない遺産である。

William Claxton, Don Schlitten, Frank Gauna, Tom Hannan, Paul Weller and Ken Deardoff guaranteed us a staggering legacy to enjoy aurally and visually.

The development of new formats for recordings continues. The Standard Play gave way to Long Play which in turn gave way to the Compact Disc. En route, we have had diversions into various forms of magnetic tape. Partly it is a commercial matter, for the success of a new format means the need to purchase new kinds of reproduction equipment. The sales of the Compact Disc (CD) have dwarfed those of LPs. Yet the LP is still being produced and refuses to die. There are a great many collectors of rare and original issue LPs. It's true that for the new young listener starting on music there is only one format today — the CD. That two major audio equipment companies have recently announced recordings in two new mediums is also understandable. New technologies always evolve; it is a pure and simple fact of commercial life.

The war over the comparative warmth and sound-feel of an LP and a CD has been waged endlessly in sound and audio magazines. Whatever the merits of such and such technical 'improvement' it does seem to me that the naturalness of an original issue analog recording sounds antiseptic in its digital version. In any case, for its hand-feel, and the convenience of the jacket design and the liner notes, the CD cannot compete with the LP. In the hands of a capable designer, the LP jacket was, is and will continue to be, a work of art. An LP is an acquisition and like all acquisitions it is meant to be handled and kept with love and care.

Let us rejoice that music has become more available to more people — for a musical world is a happier one. Each new format is welcome and hopefully has its place. But there is no doubt that album cover art is a vulnerable form. The postage-stamp approach of the CD and the trend to still smaller formats leaves less space for design. Curiously, the only niche left for jacket design is the Laser Video Disc. But this is insignificant as the Laser Disc is usually a movie or a sing-along 'karaoke' format.

As an art form, the jazz album design reached its pinnacle in the 1950s and 1960s. Its golden days are clearly over, but the store of art to enjoy is still with us. As time goes on, some designers have passed away and others dropped out of sight. We need to find those

録音方式は次々と新たな展開をみせる。SP盤に代わってLP盤が，続いてコンパクトディスクが主流となり，その途上では様々な形の磁気テープも登場した。もっとも，こうした開発にはいくぶん商業的な意図もからんでいる。新しい方式が成功すれば，新種の再生装置が売れるというわけだ。コンパクトディスク（CD）の発売以後，LPレコードの売り上げは頭打ちとなったが，それでもLP盤は生産され，姿を消そうとはしない。希少なオリジナル盤のLPを求めるコレクターたちが，驚くほどたくさんいるからである。しかし，音楽を聴きはじめたばかりの若い世代にとっては，今日ならCDが唯一絶対であることは確かだし，2大オーディオ機器メーカーが新たに2つの録音方式を発表したのもうなずける。とどまることのない科学技術の開発，それが商業社会のまぎれもない現実なのである。

LPとCDの温かみと音質をめぐって，音楽雑誌やオーディオ雑誌で果てしない論争が繰り広げられている。技術的な「改良」とやらでどこがどう良くなったにせよ，私にはオリジナル盤のアナログ録音の自然な音が，デジタル盤では妙に整いすぎて味気ない気がする。ともかく，手触りといい，ジャケットのデザインとライナーノーツの便利さといい，CDはLPにはかなわない。しかも有能なデザイナーの手がけたLP盤のジャケットは，過去，現在，未来と永遠に変わることのない芸術作品である。LPは貴重な蒐集品であり，ほかの蒐集品と同じように，愛情をこめて大切に取り扱い，保管しなければならないのである。

より多くの人々がより簡単に音楽を楽しめるようになったのは，喜ばしいことだ。音楽の世界がまたひとつ充実した証拠である。新しい方式を喜んで受け入れ，それぞれの目的に応じて併用できればすばらしい。とはいえ，アルバムのジャケット・アートの前途が決して明るくないことは疑いの余地がない。一挙に縮小したCDに始まり，さらに小型化しようとする傾向は，デザインのスペースをますます狭めていく。おかしなもので，ただひとつレーザー・ビデオ・ディスクだけがジャケット・デザインに適した大きさを保っているが，これはふつう映画や「カラオケ」用なので問題外である。

ひとつの芸術として，ジャズ・アルバムのデザインは1950，60年代に絶頂期を迎えた。黄金時代は明らかに過ぎ去ったが，そのすばらしい芸術の数々は今に残っている。歳月が流れ，デザイナーの中には当然この世を去った者もいれば，消息のわからない者もいる。私たちは幸い今も存命中のデザイナーを見つけだし，どのジャケットを，なぜ，どんな方法でデザインしたかを記録しなければならない。

私がジャケットのデザインに興味を持つようになったのは，そもそ

designers we are fortunate to have still in our midst and to be able to explain the history of the jackets they designed.

My own interest stemmed from my interest in David Stone Martin's jacket designs and my friendship with him. David influenced many designers, knowingly or unknowingly. I was glad to present over 230 of his jackets in my earlier book *Jazz Graphics —David Stone Martin*. That this book was completed in David's own lifetime was my greatest satisfaction.

The world has been kind to my DSM book and this has encouraged me to collate the work of other designers. Which meant finding and contacting them to document their recollections. This was far simpler said than done. I am not a professional writer - I am a business executive and could never make time either to travel or to research background matter. What I could use was my own collection of jazz albums plus the memories of 40 years of continuous listening and irregular reading about jazz. In 1991, Herman Leonard visited my home in Tokyo to look at jackets he had forgotten about or which he did not know existed. From Herman Leonard, plus the discovery of 70 more David Stone

Martin jackets came the thought of this present book.

It seemed pointless to include a smattering of jackets by many designers. It was of course impossible to group together every jacket by a designer. But the collection should be reasonably complete and the reproductions still be of a visible size. This meant constraints about the number of designers I could include. Even an elementary survey of jazz album design would require several volumes.

I regret there were just not enough pages to include in adequate depth the work of two designers both of whom I have met and intended to include here. One is William Claxton who along with Herman Leonard is one of the greatest photographers of jazz. Bill Claxton's photographic jackets for the West Coast labels such as Pacific Jazz, Contemporary, and World Pacific are superb. The other is Don Schlitten who designed the 'ear' logo for Signal records, several hundred jackets for the Prestige labels (Prestige, New Jazz, Swingville, Moodsville, Bluesville) as also for his own label Xanadu. To include Bill Claxton and Don Schlitten would have meant an additional 60 pages which the present book could

もデヴィド・ストーン・マーチンのジャケットに惹かれ，彼と親しくなったのがきっかけだった。デヴィッドは知る知らずにかかわらず，多くのデザイナーたちに影響を与えた。幸せなことに，先に出版した『ジャズ・グラフィックス』で230枚を越える彼の作品を紹介できた。しかもデヴィッドが生きているうちに完成し，これほど嬉しいことはなかった。

デヴィッド・ストーン・マーチンのジャケット作品集に対する世間の反応は温かく，これに勇気づけられて，私は他のデザイナーの作品もまとめてみようと考えた。それはつまり，彼らの所在を突きとめ，連絡をとり，回想を書き記すということであった。だが，言うは易く，行うは難しだった。私はプロの物書きではない。企業の経営者であって，遠方に出向いたり，背景事情を調べたりする時間は作れなかった。利用できるものといえば，自分のジャズ・アルバムのコレクションと，ひたすらジャズを聴き，ときにジャズに関する著述を読んで蓄積された40年間の記憶だけだった。1991年，ハーマン・レナードが東京の私の自宅を訪れてジャケットを調べ，本人が忘れていたり，存在することすら知らなかった作品を見つけた。これに加えて，新たにデヴィッド・ストーン・マーチンの70枚のジャケットが発見され，私は本書の出版を思い立った。

多くのデザイナーのジャケットを中途半端に寄せ集めるのは，意味がないように思われた。デザイナーの全作品を紹介するのはむろん無理とはいえ，それなりの数がそろったコレクションを，見やすい大きさで載せるべきである。そうなると紹介するデザイナーの人数をしぼらなければならなかったが，それも仕方なかった。なにしろジャズ・アルバムのデザインをざっと眺めるだけでも，数冊は必要なのだ。

残念ながら，本人と会い，本書で紹介するつもりだったにもかかわらず，十分に作品を載せる余裕がなくて断念せざるをえなかったデザイナーが2人いる。1人はハーマン・レナードと並ぶジャズ写真の巨匠，ウイリアム・クラクストンである。ビル・クラクストンの撮ったパシフィック・ジャズやコンテンポラリー，ワールド・パシフィックといったウエスト・コーストのレーベルのジャケットはまさに傑作だ。そしてもう1人はドン・シュリッテンで，シグナル・レコードの「耳」のロゴマークを初め，プレスティッジの各レーベル（プレスティッジ，ニュー・ジャズ，スイングヴィル，ムーズヴィル，ブルースヴィル）と自主レーベルのザナドゥの数百枚にのぼるジャケットをデザインしている。ビル・クラクストンとドン・シュリッテンの作品をその価値に見合った形で収めるには，さらに60ページが必要であり，本書ではそれだけのページ数を追加するのは無理だった。私としては，彼らの

not accommodate in the way that their work deserves. I have no option but to keep it on overflow and ready, hopefully, for a future volume.

There are other great designers whose work I hope to have the privilege to present. Foremost are Burt Goldblatt and Paul Bacon. Goldblatt is a designer at perfect ease with his camera, his drawing pen and in combinations of both. Goldblatt is prolific — I have myself over 300 of his jackets and this is far from being complete. Paul Bacon is a close parallel. Bacon's work on the 'X' and Riverside labels is too beautiful to try and compress. The Paul Bacon designs included here in the Blue Note 10" section speak eloquently of his talent. Like David Stone Martin, Goldblatt and Bacon have the unique quality that their designs have fully stood the test of time and richly deserve presentation. A representative selection of their work would involve an impressive number of jackets. The French photographer and designer Jean-Pierre Leloir is outstanding both in his work and for the fact that many of his jackets have gone on to become, for collectors, among the rarest of the rare. Reid Miles's designs on Blue Note are well known through their many reissues. But Reid Miles also designed wonderful jackets for the Prestige label which are less known but even more striking.

Whether books can be published or not, I think we jazz record collectors do need to try and identify as many jacket designers as possible. I am anxious to contact or have any information about Tom Hannan, Eva Diana, Charles White, Marte Roling, Lee Friedlander, Bob Parent, Herb Snitzer, Marvin Israel, Murray Stein, Ken Deardoff with a view to record for posterity details of their wonderful jackets. There are also specialist jazz labels (Savoy, Emarcy, Aladdin, Dial, Tempo,——another endless list!) who issued great records in superb jackets but hardly ever credited designers. I can always be reached through my publishers or at CPO Box 457 Central, Tokyo 100 - 91.

作品を紹介できる次の機会を信じて待つしかない。

作品を紹介したい偉大なデザイナーはほかにもいる。その筆頭がバート・ゴールドブラットとポール・ベーコンだ。ゴールドブラットは写真に素描，さらにはその両方を自在に組み合わせるというなんとも器用で柔軟なデザイナーである。ゴールドブラットの手がけたジャケットは相当数にのぼり，私も300枚ほどのジャケットを持っているが，彼の作品のごく一部にすぎない。ポール・ベーコンの場合もよく似ている。「X」やリヴァーサイド・レーベルのジャケットの美しさたるや，とても凝縮して紹介しきれるものではない。本書のブルーノートの10インチ盤の項に収めたポール・ベーコンのデザインを見ただけでも，その比類ない才能がはっきりとおわかりいただけると思う。デヴィッド・ストーン・マーチンと同様，ゴールドブラットとベーコンも特異な存在だ。時が経っても人を魅了してやまない彼らのデザインは存分に紹介すべきであるが，代表的なジャケットを抜粋するだけでもかなりの数になりそうである。また，フランスの写真家兼デザイナーであるジャン・ピエール・ルロアールは，写真，デザインともに傑出した作品を生んだ。実際，彼のジャケットの多くが，希少盤中の希少盤としてコレクターたちの垂涎の的となっている。日本でも一流のデザイナーたちが優れたジャケットを生んだが，極めて希少で手に入りにくい。その日本のジャズ・アルバムのデザインの第一人者，K. アベを，本書で紹介できて嬉しく思う。しかし，紹介したいデザイナーはまだまだいる。

出版が実現するかどうかに関わらず，私たちジャズ・レコードのコレクターはできるかぎり多くのジャケット・デザイナーを確認しなければならないのではないだろうか。かくいう私は今，トム・ハナン（プレスティッジ盤やジュビリー盤の作品は絶賛に値する）とエヴァ・ダイアナ（モード盤）となんとか連絡をとろう，なんらかの情報を得ようと必死になっている。

出版社を通して，あるいは，〒100-91 東京中央局私書箱457号宛てに，情報をお寄せいただければ幸いである。

For my own Rare and Beautiful
ROXANA and TANNAZ

Manek Daver

ブック・デザイン＝田村祐介
Book Design＝Yusuke Tamura
和文翻訳＝名倉幸江
Japanese Translation＝Yukie Nagura
翻訳監修＝トニー・西島(トニーレコード)
Supervising Translation＝Tony Nishijima(Tony Records)

JAZZ ALBUM COVERS
The Rare And The Beautiful
by Manek Daver
Copyright © 1994 by Graphic-sha Publishing Co,. Ltd.
1-9-12 Kudan-kita Chiyoda-ku, Tokyo 102 Japan

Printed in Japan
First printing, March 1994

Albums / Artists

DAVID STONE MARTIN

デヴィッド・ストーン・マーチン

My earlier book *Jazz Graphics——David Stone Martin* was my attempt at a personal tribute to a man whose work I had admired for many years and who I later had the privilege to consider a close friend. I had hoped my fellow record collectors and graphic artists would be satisfied with this. Still I was delighted that reviewers and critics could put into much better words than I the true contribution of David Stone Martin. To quote some of them :

"DSM's achievements stand as permanent complements to performances which are achievements in the medium of recorded jazz. DSM proves one could improvise jazz through the very act of illustrating it. When DSM illustrated, jazz became art." (Swing Journal, June 1991, Japan)

"As you see DSM's art you will recognize at once that other unmistakable sound which accompanies these illustrations——the sound of jazz." (Record Collectors Magazine, May 1991, Japan)

"David Stone Martin's sureness of line and his unerring sense of proportion give the cover a previously unforeseen potential. He set the copyists a very intuitive and therefore difficult act to copy." (Straight No Chaser, England July 1991)

"The superb use of color and unique line with brush and pen captures the stance and mannerisms of these jazz giants. As Kenny Davern once told me 'the likeness doesn't matter; being drawn by David Stone Martin is like being drawn by Picasso.'" (Jazz Journal England July 1991)

"The world of David Stone Martin art is filled with men and women of great dignity and quiet

power. You have the rediscovery of an artist who did so much to graphically construct the social identity of jazz in the 1950's." (The WIRE, England, October 1991)

"DSM is the most solid point of contact between the visual arts and the spirit of this music - a real founder of a movement. The imagination of DSM was flying at 360 degrees in order to fulfil this task." (Musica Jazz, Italy, December 1991)

Happily, DSM was able to read these and other tributes to his work in his lifetime and it is to my own satisfaction that I am now able to present new material by him in addition to that used in *Jazz Graphics——David Stone Martin.*

David Stone Martin died on March 6th 1992 at the age of 78. He had been in hospital still very weak with complications following a fall at his home. I had been with him the day before he died and witnessed his life ebbing away. The American national newspapers had handsome tributes to him.

In *Jazz Graphics* I put together more than 230 DSM jackets. I knew I had missed more, the *Disc* and *Asch* covers in particular. In my last visit to David's home, I found a forgotten treasure trove of printer's proofs of *Disc* and Asch covers. To these I have also added covers loaned by other collectors as also from my own collection. With these are presented another batch of covers for the Norman Granz labels, some interesting 'new' covers (of the 1980s) for the *Interplay* and *Sea Breeze* labels etc. A total of **76** more DSM jackets. While everything DSM drew is Beautiful and now Rare, not all the jackets fall into the category of jazz. But I consider it an important and necessary task to put together as many of DSM's jackets as possible.

As I studied more and more jazz album cover designs, I found it impossible to put aside the influence of the DSM 'line' and of the individual way he would

　先に出版した『ジャズ・グラフィックスーデヴィッド・ストーン・マーチンの世界』は，私が長年その作品にあこがれ，やがて光栄にも親友と呼べるに至ったひとりの人物に捧げたものであった。自分と同じレコード・コレクターやグラフィック・アーチストの仲間に満足いただければと思っていた。ところが嬉しいことに，論評家や批評家の方々が，デヴィッド・ストーン・マーチンの真価をより多くの言葉で鋭く表してくださったのである。そのいくつかを各国の雑誌から引用してみよう。

　デビッド・ストーン・マーチンは多くのジャズメンのジャケットを描き，彼ら偉大なジャズメンの歴史的な名演奏とともに，そのジャケットもジャズの歴史へ永遠に残ることになった。……JAZZ をイラストでインプロバイズすることができるということを証明してみせたデビッド・ストーン・マーチンの〝コンプリート・レコーディング〟がここにある。『スイング・ジャーナル』1991 年 6 月　日本

　イラストを見ただけで音が聞こえそうなほどジャズ感覚にあふれたマーティンの作品の数々は，ジャズ・ファンにとってはこの上ない目の保養だろう。『レコード・コレクターズ』1991 年 5 月　日本

　デヴィッド・ストーン・マーチンの確かな線と絶妙なバランス感覚は，ジャケットに予想もつかなかった新しい可能性を与えている。彼の作品は直感によるところが大きく，それゆえ真似しようにもなかなか真似はできない。『ストレイト・ノー・チェイサー』1991 年 7 月　イギリス

　絶妙な色づかいと筆とペンによる独特の線が，ジャズの巨人達の姿勢や癖を見事にとらえている。かつてケニー・ダヴァーンは私にこう語った。『似ているいないはどうでもいいんだ。デヴィッド・ストーン・マーチンに描いてもらうのは，ピカソに描いてもらうようなもんだよ』『ジャズ・ジャーナル』1991 年 7 月　イギリス

　デヴィッド・ストーン・マーチンの作品の世界は，威厳と静かなる力に満ちた人々であふれている。ここに私達は，1950 年代，イラストによってジャズを社会に位置づけたアーティストの姿を改めて見る。『ザ・ワイアー』1991 年 10 月　イギリス

　デヴィッド・ストーン・マーチンほど視覚芸術とジャズの精神を固く結びつけている者はいない。いわばこの流れの真の創始者である。この職務を果たすため，

彼は想像力を 360 度はたらかせていた。『ミュージカ・ジャズ』1991 年 12 月　イタリア

　さいわい，デヴィッド・ストーン・マーチンは存命中にこれらを初めとする数々の賛辞を読むことができたし，私自身こうして『ジャズ・グラフィックスーデヴィッド・ストーン・マーチンの世界』に加え新しい作品を紹介できて，満足感でいっぱいだ。ではさっそく，『ジャズ・グラフィックスー』にはなかった彼に関する新しい資料を補いながら話を進めよう。

　デヴィッド・ストーン・マーチンは 1991 年 3 月 6 日，78 才で他界した。彼は自宅で倒れてから入院生活を送っていたが，合併症を起こしひどく衰弱していた。息をひきとる前日から私はずっと彼につきそっていて，最期を見とった。アメリカの全国の新聞は彼の訃報と手厚い追悼記事を載せた。

　『ジャズ・グラフィックス』では 230 枚を越えるデヴィッド・ストーン・マーチンのジャケットを紹介したが，特にディスクやアッシュのレーベルのジャケットを初めとして，まだまだ見落としているものがあるのはわかっていた。最後にデヴィッドの自宅を訪ねたとき，私はディスク盤とアッシュ盤のジャケットの試験刷りという貴重な掘り出し物を見つけることができた。これに，他のコレクターからお借りしたジャケットと私のコレクションを加え，ノーマン・グランツ・レーベルのジャケットや，インタープレイ，シーブリーズなどのレーベルのなかなか興味深い 1980 年代の「新しい」ジャケットもご紹介できることになった。計 76 枚のデヴィッド・ストーン・マーチンのジャケットを新たに収録した。

　デヴィッド・ストーン・マーチンの描いたジャケットはどれも美しく，今ではめったに手に入らないが，すべてがジャズ・レコードのものとは限らない。しかし，できるだけ多くの彼のジャケットを紹介することは意義があるし，必要だとも思う。

　ジャズ・アルバムのジャケットのデザインを研究すればするほど，私はデヴィッド・ストーン・マーチンの「線」と，人物を 10 あるいは 12 インチの正方形の「枠にはめる」その独特なやり方が，いかに大きな影響を及ぼしているか思い知らされてきた。彼の影響は至る所に見られる。ピエール・メルランもそのひとりだ。彼の非凡な作品は後でご紹介しよう。「フランスのデヴィッド・ストーン・マーチン」の異名をとるメルランは，「いやでもデヴィッド・ストーン・マーチンに

'frame' his figures into the 10" or 12" square. The DSM influence is everywhere. Pierre Merlin whose remarkable art I am delighted to also present enjoys the reputation of a French DSM and says **"I could not help admiring DSM and being inspired by him, even involuntarily."** The young Andy Warhol jackets, also shown here, are as close as any record jackets could be to DSM's work. I see the DSM influence in literally hundreds of record jackets issued throughout the 1950s. It is as if each record company asked their designers to mimic the DSM style. The DSM influence also extended to photo covers too in which faces, and instruments were cropped out of the frame in DSM style. The DSM covers remain an initiation into the art not just of jazz, but of all record album covers. So it delights me to include this DSM update with covers not included in my earlier *Jazz Graphics —— David Stone Martin*. I do not repeat any of the details or the over 200 jackets which were in this earlier work. I hope these will be seen together.

Many of the jackets shown now relate to the albums of 78 rpm discs produced by Moses Asch. These were done during the late 1940s and are stunning in effect. For these are the young, the brilliant, the totally fresh DSM complete with the strong yet audaciously simple DSM 'line'. They also show the incredible ability to capture not just the spirit of jazz but of all kinds of music. Also included are jackets for Norman Granz's labels; for Enoch Light's *Grand Award* and other labels which were not included earlier.

I was fortunate in making the friendship of Dan E. Cirlin who through the 1950s worked for the Jeffries Banknote Company which printed most of the Granz label jackets. Dan Cirlin worked closely with DSM. His note on how jackets were printed and his working relationship with DSM takes us a step closer to an understanding of the designer's craft.

A final note. The jacket of *Jazz Graphics —— David Stone Martin* which was obviously drawn and designed by DSM, by an oversight was not credited in the book.

WORKING WITH DAVID STONE MARTIN
By Dan. E. Cirlin

When asked to recall what it was like to print record album covers through the 1950's, a flood of emotions comes over me.

In December 1951, I started a new job negotiating printing orders for Jeffries Banknote Company of Los Angeles. Only a week prior to that my wife presented us with our second son. So here I was —— new job, new son, and what did I know about selling bank notes. After all until recently I was an Agronomy major at the University of California.

Less than a week after joining the firm, through two graphic designer friends (Milt Zolotow and Felix Landau) I was told David Stone Martin was coming to town to work on some record album covers for a new label called Jazz at the Philharmonic. Remember, this is December 1951 and long playing records were new, especially in California. And yes, they were the ten inch variety.

I knocked at the door of room 108 of the Beverly Hills Hotel that Monday morning. Before me, sitting upright was a reddish blond curly haired gentleman with a sheet wrapped around him. My first visual impression was this combination of Mahatma Gandhi and Harpo Marx is quite a character. David proceeded to make me feel at home while he took out his quill, a bottle of ink, some drawing paper and on a little footstool, whipped out the most moving rendition of Lady Day (Billie Holiday). The immediate response to that quick sketch was what an incredible talent ! His spelling was questionable, as he asked me whether she spelled her first name with a 'y'. As he crossed out the 'y' and inserted the 'ie' I knew I had a friend.

In our print shop, our two color presses were Miehle's. The sheet size was 25"×38". This enabled us to print a front cover and a liner on the same 60 # coated one side label paper. The under side was uncoated to enable the album convertor to glue the paper to the chip board. The length of the run, or print quantity, was limited to 3,000. This relatively short 'run' was only efficient

は惹かれたし，影響された」と言っている。若き日のアンディ・ウォーホルが手がけたジャケットも例外ではなく，彼の作品によく似ている。1950年代に発売された文字どおり何百というレコードジャケットに，私はデヴィッド・ストーン・マーチンの影響を見る。まるでレコード会社がしめし合わせて，デヴィッド・ストーン・マーチン風に描いてくれと頼んだかのようだ。また，その影響は写真のジャケットにも及び，顔や楽器がデヴィット・ストーン・マーチン式で枠で切り取られているものが多い。

デヴィッド・ストーン・マーチンのジャケットは，ジャズだけでなくあらゆるアルバムジャケットの芸術を研究する上でのいわば入門書である。それだけに，先の『ジャズ・グラフィックスーデヴィッド・ストーン・マーチンの世界』で紹介できなかった作品を含め，彼に関する最新の情報を提供できることを嬉しく思う。既に紹介した内容や200枚以上のジャケットは今回省かせていただくので，ぜひ前書と合わせてご覧いただきたい。

ここでとりあげるジャケットの多くは，モーゼス・アッシュが製作した78回転盤のアルバムのものである。1940年代後期に描かれたこれらのジャケットのすばらしさには，ただただ驚嘆するばかりだ。力強く，しかし無謀なほど簡略化された独自の「線」が息づく，新鮮で鮮やかで実に生き生きとしたデヴィッド・ストーン・マーチンの世界がそこにある。また，ジャズだけでなくあらゆる種類の音楽の精神をとらえる彼の驚くべき才能もうかがえる。他に，ノーマン・グランツの主宰するレーベルや，イーノック・ライトのグランドアワードなど前書に収められていないレーベルのジャケットも載せた。

幸運なことに私は，1950年代初め，グランツ・レーベルのジャケットの大半を印刷したジェフリーズ・バンクノート・カンパニーに勤めていたダン・E・サーリンと親しくなることができた。彼とデヴィッド・ストーン・マーチンは親しい仕事仲間であった。ジャケットの印刷方法やデヴィッド・ストーン・マーチンとの仕事上の関係をつづってくれたサーリンの手記を読むと，このデザイナーの技巧がまた少しはっきり見えてくる。

最後に，『ジャズ・グラフィックスーデヴィッド・ストーン・マーチンの世界』のジャケットはもちろん彼本人が描きデザインしたものだが，うっかり記載し忘れてしまったので一言申し上げておきたい。

デヴィッド・ストーン・マーチンと働いた日々
ダン・E・サーリン

1950年代，どんなふうにレコードアルバムのジャケットを印刷していたか思い出してほしいと言われたとき，さまざまな思いが私の胸に去来した。

1951年12月，私は新しくロサンゼルスのジェフリー・バンクノート・カンパニーで印刷営業の仕事を始めた。1週間前に次男が生まれたばかりだった。そんなわけで，このときの私は新しい仕事に就き，新しい息子を得，まして小切手を商うということがどういうことか何も知らなかった。なにしろ，ちょっと前まではカルフォルニアの大学で農業専攻の学生だったのだから。

入社して1週間もしないうちに，私はふたりのグラフィック・デザイナーの友人，ミルト・ゾロトゥとフェリックス・ランドーから，デヴィッド・ストーン・マーチンがジャズ・アット・ザ・フィルハーモニックという新しいレーベルのレコードアルバムのジャケットを作成するためにロスにやって来ると教えられた。忘れないでもらいたい，これは1951年12月の話で，特にカルフォルニアでは当時まだLP盤は目新しかった。そして，もちろん10インチ盤LPのことである。

その週の月曜の朝，さっそく私はビヴァリーヒルズ・ホテルの108号室を訪ねた。私の前に現われたのは，赤みがかった金髪の巻き毛の紳士が，シーツを体に巻きつけ背筋をぴんと伸ばして座っている姿だった。マハトマ・ガンジーとハルポ・マークスを合わせたみたいなひどい変わり者だ，という第一印象を受けたのを覚えている。デヴィッドは私の気持ちをほぐしにかかった。羽ペンとインク瓶と数枚の画用紙を小さな足載せ台の上に取り出したかと思うと，あっという間に，今まで見たこともないほど生き生きとしたレディ・デイ（ビリー・ホリデー）の絵を描いてみせたのだ。そのすばやいスケッチに，思わず私は心の中で叫んだ。すごい天才だ！ だが，デヴィッドはつづりに自信がないらしく，ビリーの最後は「y」かどうかと訊いた。彼が「y」を線で消して「ie」と直したとき，私は彼と友達になったような気がした。

私たちの印刷所では，ミール製の2色刷り印刷機を使っていた。シートのサイズは25×38インチだったので，表カバーとライナーノーツを，同じ60＃の片面糊付きのコート紙に印刷することができた。アルバムの加工業者がボール紙に接着できるよう，裏はコートしなかったのである。生産量，つまり印刷部数は3000

and cost effective if we made one set of zinc plates. Our company being new to the record album cover business, we decided to do a top notch job and elected to print letter press. We used copper engravings, better quality than zinc but not cost effective, made from negatives, which came from directly photographing the art work. The cuts (engravings) were then mounted on wood, to the prescribed thickness, Then we pulled press proofs for the customer (DSM) to approve. It would take two or three days to get approval and deliver the flat sheets to the convertor. As a bank note company we also printed financial statements for corporations. So we were accustomed to speed and three days turnaround time was a luxury we did not always get. Most often, the liner notes were ready when the cover art was picked up. But sometimes these were delayed as when Norman Granz was busy or out of town. Then we had to wait for the copy. The liners were done on a battery of linotype machines on our own premises. DSM would suggest the type font to be used both for the lettering on the cover and the style to be used on the back liner. On occasion, DSM would visit our shop and inquire as to new type faces, and so we used 'Wide Latin' for a Charlie Parker front cover and back liner. We had a new font called 'Egyptian' which DSM selected for a Buddy de Franco cover. Sometimes DSM did the original art in black ink and after getting the proof added color on an onion skin overlay. Remember, each color used a separate zinc plate.

The early printed covers tended to be in two colors. To protect the surface we varnished both the cover and the liner. At that time, the album was either a single piece of cardboard or two pieces held together with a strip of reinforcement tape at the closed back. Later, we tried heavier paper to eliminate the reinforcement tape. To economize for the relatively short print runs (usually between 3,000 and 5,000) we used zinc engravings and then magnesium cuts. To further cut costs, we would send the cover art to an outside specialist who would later supply us with progressive proofs for the multi-color lithograph form of printing still using a two color press with the same printing area. The paper went up to 70 # coated one side label and for special issues of large selling LP's (such as the Ella Fitzgerald albums), the print order increased to 35,000. We also tried to protect and enhance the surface of the super calendared paper called 'Kromemote' with a sheet lamination. The additional cost caused us to use a liquid laminate called 'Marcoting'.

From the end of 1951 till 1958, we did a couple of hundred album covers for Norman Granz and his able controller Mo Ostin (later to become Chairman of the Board for Warner Bros. Records). After a while the 10" sleeve grew to 12". And the 33.1/3 rpm acquired a 45 rpm relative. The 45 rpm was only 7" but since the art work used was merely a reproduction, we printed both on the same paper.

DSM's special way with craftsmen, typesetters, plate makers and press men even extended to our 'in-house' ink makers. Since they made high quality ink for bank notes, they gave DSM a special insight into their work. So our shelves were filled with ink cans bearing labels like 'Charlie Parker-Red', 'Oscar Peterson-Blue', 'Count Basie-Tan', 'Johnny Hodges-Blue'. Turn the Johnny Hodges album (Clef 128-Johnny Hodges Collates No.2) to the right and you can read DSM's own hand writing in the 'rain' falling down. In a Lester Young cover (Clef 108-Lester Young Collates) and again a Gene Krupa cover (Clef 121-The Gene Krupa Trio) DSM incorporated some of our security scroll prints into the design. DSM illustrated his genius in adapting other mediums into his innovative illustrative tools.

For me, the 1950's were special; new decade, new father, new job in a new industry. As also the start of a friendship and learning with David Stone Martin.

部にすぎなかった。この比較的短い「生産量」だと，亜鉛版印刷でなければコストに対し効率が悪かった。しかし，レコードアルバムのジャケット業界では駆け出しのわが社は，超一流の仕事をしようと決意し，凸版印刷を選んだ。亜鉛よりコスト効率は悪いが質のいい銅を使い，直接作品を写真に撮って作った原版から彫版を作る。その銅版（彫版）を木の台に載せて規定の厚さに整え，顧客（デヴィッド・ストーン・マーチン）の確認のため，手刷りで試験刷りをした。合格点をもらって，刷り上がったシートを加工業者に届けるまでに，2，3日かかった。銀行券会社として企業の財務諸表の印刷も手がけていた私たちは，急ぎの仕事に慣れていたから，3日もかけられるというのはめったにない贅沢なことであった。

たいていの場合はカバー・アートと同時にライナーノーツも手に入ったが，ノーマン・グランツが多忙であったり，町を留守にしていたりして，ときどきこれが遅れることもあった。そんなときはただ待つよりほかなかった。ライナーノーツは社の印刷所で，ライノタイプ印刷機を用いて印刷した。デヴィッド・ストーン・マーチンは表のカバーの文字に使う活字の大きさと書体と，裏のライナーノーツに使う書体をよく提案したものだ。ときおり印刷所を訪れては新しい書体について尋ねたりもした。チャーリー・パーカーのカバーとライナーノーツに「ワイドラテン」体を使ったのも彼の意見であった。「エジプシャン体」という新しい書体を，バディ・デフランコのジャケットに選んでいる。また，彼は黒のインクで原画を描き，試し刷りができてから半透明紙を重ねて色を加えることもあった。ちなみに，印刷には1色につき1枚ずつ亜鉛版が必要だった。

初期に印刷したジャケットは2色刷りが多い。印刷の表面を保護するために，私たちはカバーとライナーノーツの両方にニスを塗った。当時，アルバムは厚紙1枚か，2枚を重ねたもので裏に補強テープが施されていたが，後に，この補強テープをなくそうと，もっと重い紙を使ってみたりもした。比較的少ない印刷部数（通常は3000から5000部）のコストを下げるために，亜鉛版を使い，それからマグネシウム版に変えた。さらにコストを削減するため，ジャケットのカバー・アートの印刷を専門業者に外注。後に，まだ一方で2色刷り印刷機を使うなか，いち早く多色刷りの石版印刷による試験刷りをみせてくれることになる。印紙も70＃の片面糊付けのコート紙となり，人気の高い特別なLPの盤（エラ・フィッツジェラルドのアルバムなど）ともなると，注文部数は35000部まで増えた。ま

た「クロームモート」と呼ばれるスーパー仕上紙（強光沢紙）の表面を保護，強化するのに，薄い透明シートを張り合わせてもみたが，コストがかさみ，「マーコティング」という液体ラミネートを使うことになった。

1951年末から1958年まで，私たちはノーマン・グランツとその有能な管理人モー・オスティン（後に，ワーナーブラザーズ・レコードの取締役会長となる）のために，200枚余りのアルバムジャケットを印刷した。それからまもなく，10インチのジャケットが12インチと大きくなり，33.1/3回転盤の45回転盤バージョンも生まれた。45回転盤は7インチしかなかったが，ジャケットに使われる作品はLP盤といっしょだったため，どちらも同じ紙に印刷した。

デヴィッド・ストーン・マーチン独特の植字工や製版工，印刷工といった職人との関わり方は，「社内」のインク製造者たちにまで及んだ。銀行券用の高品質のインクを作っていた彼らに，デヴィッドは特別な関心を抱いたのである。そんなわけで，会社の棚には「チャーリー・パーカー・レッド」とか「オスカー・ピーターソン・ブルー」「カウント・ベーシー・タン（黄褐色）」「ジョニー・ホッジス・ブルー」といったラベルのインク缶がずらりと並んでいた。ジョニー・ホッジスのアルバム（Clef 128-Johnny Hodges Collates No.2）を右に回すと，降る「雨」の中にデヴィッド・ストーン・マーチンの筆跡が読める。レスター・ヤングのジャケット（Clef 108-Lester Young Collates）とジーン・クルーパのジャケット（Clef 121-The Gene Krupa Trio）では，彼はわが社の印刷した証券の渦巻き模様をデザインに組み，他の媒材を独自の革新的な道具としてしまうという天才ぶりを見せたのであった。

私にとって1950年代は特別な時期であった。新たな10年を迎え，新たな子供が生まれ，新たな業界で新たな仕事を始めたとき，そしてまた，デヴィッド・ストーン・マーチンとつきあい，ともにいろいろなことを学びはじめたときであった。

THE MOSES ASCH LABELS

Moses Asch was considered a true and fearless pioneer among record producers. Throughout the mid 1940s he did not hesitate to record and attractively package a wide range of music which appealed to him. To simplify, I have grouped the Asch issues of his various labels into Folk and Blues, Jazz, Jewish and other Ethnic music. The jackets were by the young David Stone Martin. DSM brought a young, firm and free-flowing style to the covers, displaying a sureness of understanding far beyond the realms of just jazz. These were the years immediately following his work as Art Director of the Tennesse Valley Authority and his World War II effort art work for the Office of Strategic Services and the Office of War Information. DSM brought to these, his first jackets, the influence of his strong social committments. These covers probably show DSM at his finest.
Jazz Graphics——David Stone Martin included 40 of the DSM jackets on the *Asch* labels. Here are more. All of the same period——the middle and late 1940s.

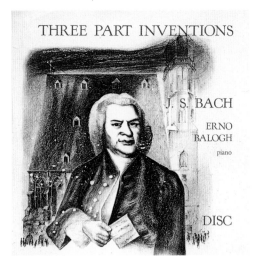

DISC 770

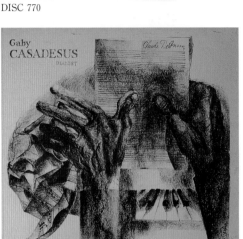

Asch 103

モーゼス・アッシュ・レーベル

　モーゼス・アッシュはレコードプロデューサーの大胆不敵な真の先駆者とされている。1940年代半ばを通して，彼はためらうことなく自分を惹きつける音楽を広く録音し，魅力的なジャケットに包んだ。わかりやすくするために，ここでは様々なレーベルのアッシュのレコードを，フォーク，ブルース，ジャズ，ユダヤなどのエスニック音楽に分類した。そして，これらのジャケットを手がけたのが，若き日のデヴィッド・ストーン・マーチンであった。彼は新鮮で力強くいかにも自由な技法でジャケットを飾り，ジャズの範囲を大きく越えた様々な音楽の精神を見事に表現した。このわずか前，彼はテネシー川流域開発公社の芸術監督を務め，第二次世界大戦中は戦略事務局と戦時情報部の戦争遂行のための芸術活動に協力している。最初のジャケットには，この強烈な社会的責任意識の影響が見られる。おそらく最も精巧なデヴィッド・ストーン・マーチンの作品といえよう。
　『ジャズ・グラフィックスーデヴィッド・ストーン・マーチンの世界』では，彼の手がけた40枚のアッシュ・レーベルのジャケットをおさめた。本書ではさらに多く収録した。いずれも1940年代半ばから末にかけての同時期の作品である。

Three albums of **CLASSICAL** music

DISC 770
Erno Balogh‐Three Part Inventions

DISC 801
Santa Monica Symphony Orchestra
Winter Reveries

Asch 103
Gaby Casadesus‐Pianist

Three albums of **SPOKEN WORD** for the *Caedmon* label which I believe was also a *Moses Asch* label:

CAEDMON TC 1428
The Light in the Forest‐by Conrad Richter

CAEDMON TC 2049
Johnny Tremain‐by Esther Forbes

CAEDMON TRS 348
The Playboy of the Western World
by John Millington Synge

クラシック音楽のアルバム３枚

DISC 770
Erno Balogh-Three Part Inventions

DISC 801
Santa Monica Symphony Orchestra-Winter Reveries

Asch 103
Gaby Casadesus-Pianist

「語り」のアルバム

　最後に，カエドモン・レーベルの「朗読」のアルバムを３枚紹介しよう。私はこれもモーゼス・アッシュに属するレーベルだと考えている。

CAEDMON TC 1428
The Light in the Forest-by Conrad Richter

CAEDMON TC 2049
Johnny Tremain-by Esther Forbes

CAEDMON TRS 348
The Playboy of the Western World-by John Millington Synge

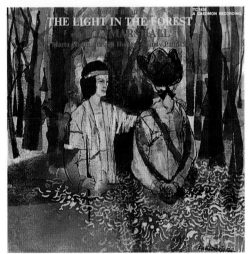

CAEDMON TC 1428

DISC 801

CAEDMON TC 2049

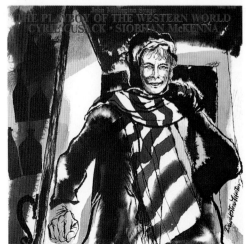

CAEDMON TRS 348

The FOLK AND BLUES albums :

DISC
Roll the Union On

ASCH 364
Richard Dyer-Bennet - Ballads

DISC 737
Texas Gladden - Sings Blue Ridge Ballads

DISC 733
John Jacob Niles - The Seven Joys of Mary

DISC 611
Hudson Valley Songs

DISC 631
Square Dances Without Calls

DISC 601
Young Folksay Series - Lullabies and Rounds

DISC
Cisco Huston - Cowboy Songs

DISC
John Jacob Niles

DISC 726
Leadbelly - Woody Guthrie - Cisco Huston
Midnight Special

DISC 661
Josh White - Women Blues

DISC 740
The City Sings for Michael

ASCH 432
American Folksay - Ballads and Dances

DISC 657
Spirituals Vol. 2

フォークとブルースのアルバム

DISC
Roll the Union On

ASCH 364
Richard Dyer-Bennet-Ballads

DISC 737
Texas Gladden-Sings Blue Ridge Ballads

DISC 733
John Jacob Niles-The Seven Joys of Mary

DISC

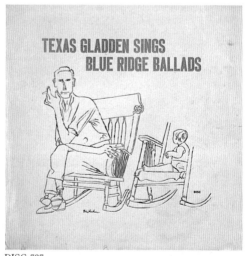

DISC 737

ASCH 364

DISC 733

DISC 611

DISC 631

22

DISC 611
Hudson Valley Songs

DISC 631
Square Dances Without Calls

DISC 601
Young Folksay Series-Lullabies and Rounds

DISC
Cisco Huston-Cowboy Songs

DISC
John Jacob Niles

DISC 726
Leadbelly-Woody Guthrie-Cisco Huston-Midnight Special

DISC 661
Josh White-Women Blues

DISC 740
The City Sings for Michael

ASCH 432
American Folksay-Ballads and Dan[ces]

DISC 657
Spirituals Vol. 2

DISC 601

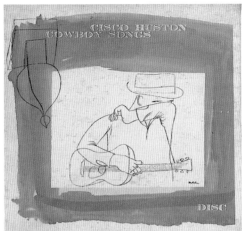

DISC

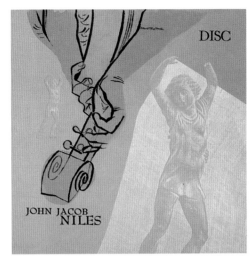

DISC

DISC 726

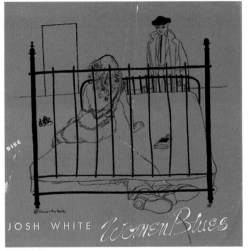

DISC 661

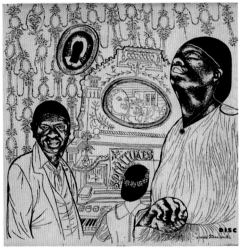

DISC 657

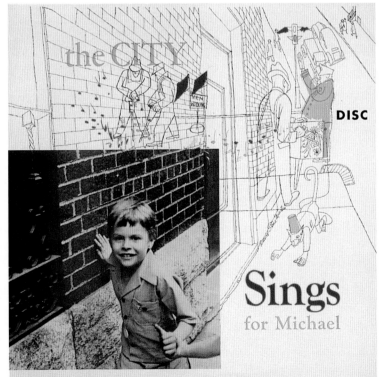

DISC 740

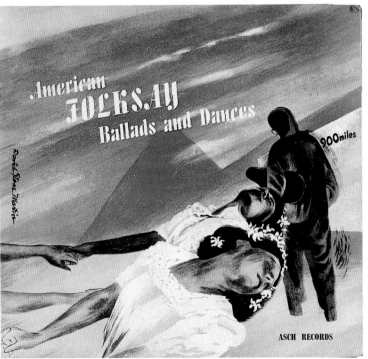

ASCH 432

JAZZ recordings produced by Moses Asch featuring traditional and for the time (mid 1940s) modern musicians.

DISC 701
Joe Sullivan - Quartet with Sidney Bechet, George Wettling, Pops Foster

DISC 620
Stella Brooks - Blues for Stella Brooks

DISC 706
Cliff Jackson - Midnight Piano

DISC 709
Baby Dodds - Drum Solos

DISC 600
Rhythm Band Music

ASCH 101
Greta Keller - Moods by Greta Keller

DISC 622
Erroll Garner - Billy Kyle

DISC 711
Muggsy Spanier - And his Orchestra

ASCH 357
John Kirby and Orchestra

ジャズ・アルバム

　モーゼス・アッシュが製作したジャズのレコードには，トラディショナルと当時（1940 年代半ば）のモダン・ミュージシャン達の両方の作品がある。

DISC 701
Joe Sullivan-Quartet with Sidney Bechet, George Wettling, Pops Foster

DISC 620
Stella Brooks-Blues for Stella Brooks

DISC 706
Cliff Jackson-Midnight Piano

DISC 709
Baby Dodds-Drum Solos

DISC 600
Rhythm Band Music

ASCH 101
Greta Keller-Moods by Greta Keller

DISC 622
Erroll Garner-Billy Kyle

DISC 711
Muggsy Spanier-And his Orchestra

ASCH 357
John Kirby and Orchestra

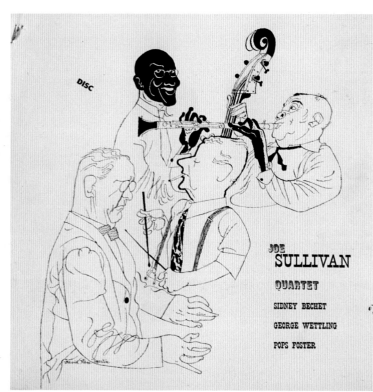

DISC 701

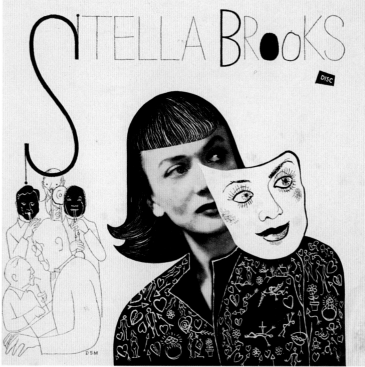

DISC 620

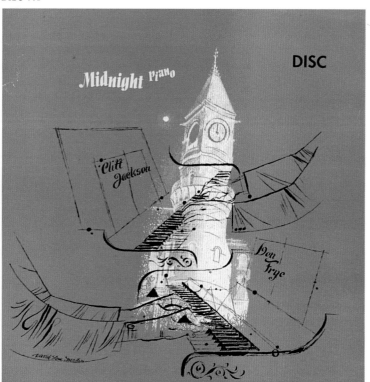

DISC 706

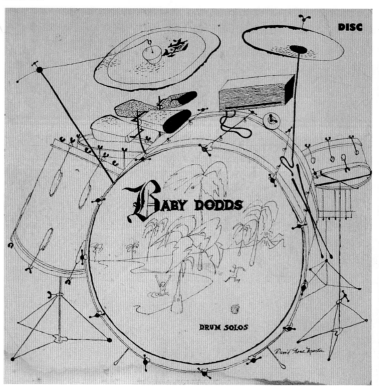

DISC 709

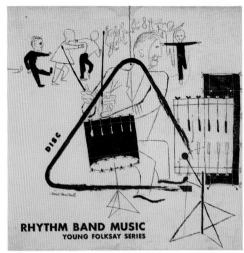

DISC 600

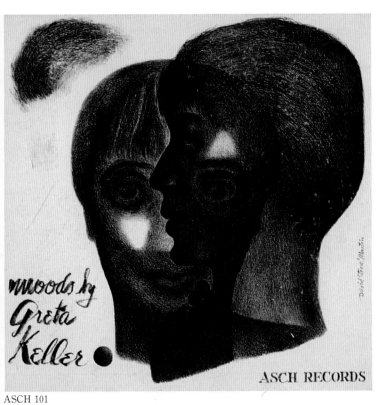

ASCH 101

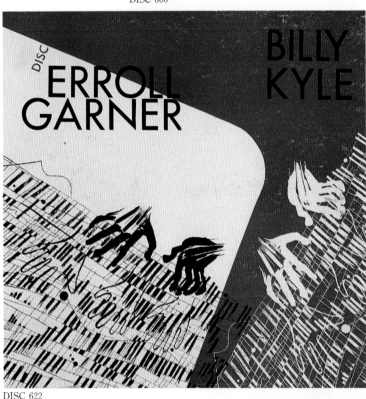

DISC 622

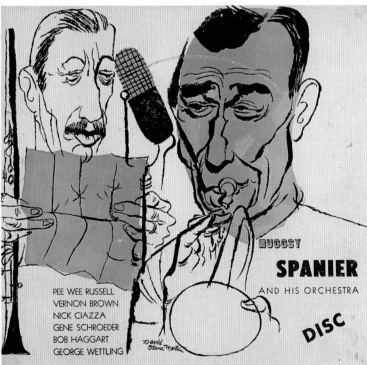

DISC 711

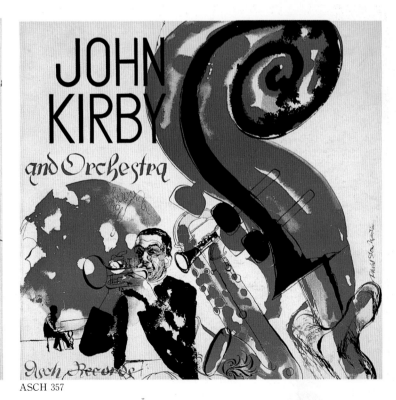

ASCH 357

Moses Asch's **ETHNIC** music revealed his strong feelings for Russian causes, the Jewish faith and also for Calypso and African music.

DISC 930
Cantor Diamond - Cantorials

DISC 9012
Cantor Jonah Binder - Sabbath Prayers

DISC 937
Hazamir Singers of Palestine - My Father's House

DISC 402
Serge Prokofieff - Overture on Hebrew Themes

ASCH 346
New Songs from the U.S.S.R.

DISC 731
Adia Kuzenetzoff - Gypsy Songs of Russia

DISC 753
Kurenikov First Symphony
Modern Russian Composers

DISC 721
Carlos Montoya - Flamenco

DISC
Byzantine Singers

DISC 629
Creole Songs

DISC 614
Felix and his Internationals - Calypso Vol. 1

FOLKWAYS
Nadi Qamar - The Nuru Taa African Musical Idiom

エスニック・アルバム

　モーゼス・アッシュのエスニック音楽からは，いかに彼がロシア物やユダヤ信仰，カリプソやアフリカの音楽に共感していたかがわかる。

DISC
Cantor Diamond- Cantorials

DISC 9012
Cantor jonah Binder-Sabbath Prayers

DISC 937
Hazamir Singers of Palestine-My Father's House

DISC 402
Serge Prokofieff-Overture on Hebrew Themes

ASCH 346
New Songs from the U.S.S.R.

DISC 731
Adia Kuzenetzoff-Gypsy Songs of Russia

DISC 753
Kurenikov First Symphony
Modern Russian Composers

DISC 721
Carlos Montoya-Flamenco

DISC
Byzantine Singers

DISC 629
Creole Songs

DISC 614
Felix and his Internationals-Calypso Vol. 1

FOLKWAYS
Nadi Qamar-The Nuru Taa African Musical Idiom

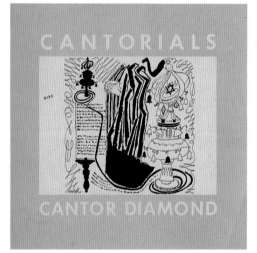
DISC 930

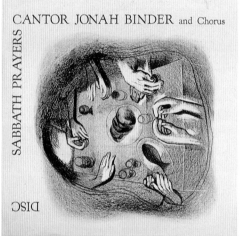
DISC 9012

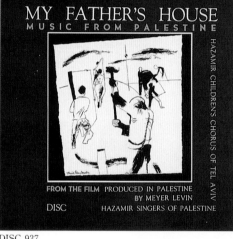
DISC 937

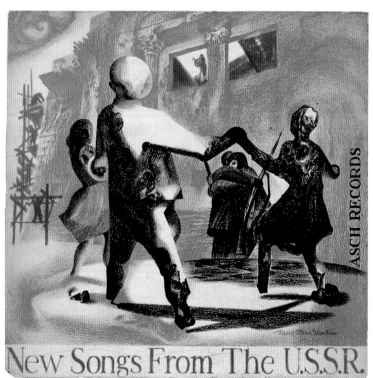
ASCH 346

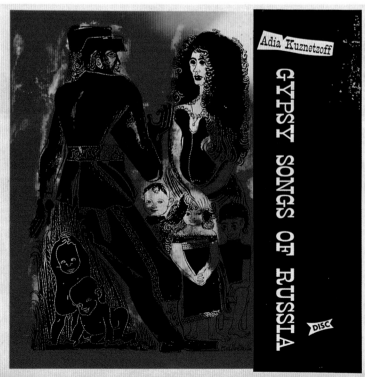
DISC 731

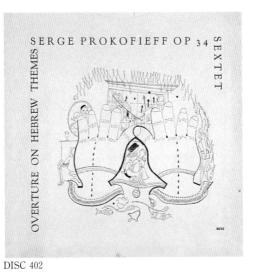

DISC 402

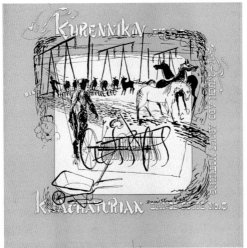

DISC 753

DISC 614

DISC 721

DISC

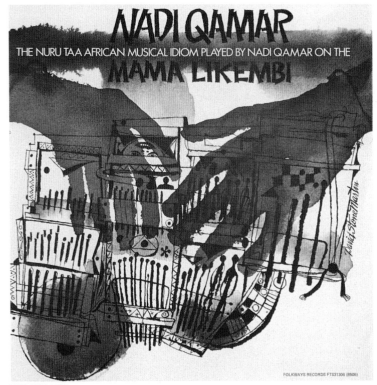

DISC 629

FOLKWAYS

THE NORMAN GRANZ LABELS

Norman Granz's first recording of JATP Vol.1 was issued on the **Stinson** label (illustrated in *Jazz Graphics*). **Stinson** was not really a Moses Asch label-it belonged to the distributor of his recordings. A few issues of the Jazz at the Philharmonic, produced and recorded by Norman Granz, were issued on **Disc** which was a Moses Asch owned label. This arrangement included sessions produced and recorded by Granz of Nat King Cole, Meade Lux Lewis, and Slim Gaillard. Granz outgrew this arrangement and started his own labels, initially **Clef**.

DSM drew the jackets for the Granz productions issued on the Moses Asch DISC label:

DISC
Jazz at the Philharmonic Vol. 2

DISC 503
Jazz at the Philharmonic Vol. 3

DISC 504
Jazz at the Philharmonic Vol. 4

DISC 505
Jazz at the Philharmonic Vol. 5

DISC 506
Nat King Cole Quintet

Differing explanations have prevailed as to how Granz chose the name Jazz at the Philharmonic. And also how recordings exist of his early Jazz at the Philharmonic concerts, at a time when 'live' recordings seemed technically impossible. Mr. Granz was kind enough to write me as to how this happened :

"The name Jazz at the Philharmonic (J.A. T.P.) had nothing to do with the fact of a 'Philharmonic or Metropolitan music origin in the major cities...' The name was for a much more prosaic reason: When I advertised the concert at the Philharmonic Auditorium in 1944 I gave the printer instructions to put on the posters 'Jazz Concert at the Philharmonic Auditorium' He could not get all that on a small poster. So he condensed it to 'Jazz at the Philharmonic' and that is how the name began and I saw no reason to change it. The Philharmonic Auditorium, by the way, was then considered the best concert hall in Los Angeles and before that had never had anything except classical concerts. Mine was the first jazz concert.

Actually I did not plan the recording of the first Jazz at the Philharmonic concert in 1944. It was the American Forces Network (AFN) that asked permission to record the concert to be sent to the American forces in Europe and Asia as World War II was still on. They gave me a copy of the recordings and it was from these recordings that I got the idea of releasing them as a documentary of a Jazz concert."

My grateful thanks to Norman Granz for these and also other clarifications graciously made by him. Also for his permission to reprint some of the David Stone Martin illustrations from the Jazz at the Philharmonic Concert programs.

ノーマン・グランツ・レーベル

　ノーマン・グランツが最初に録音した『ジャズ・アット・ザ・フィルハーモニック (JATP) Vol. 1』は，スティンソン・レーベルから発売された(『ジャズ・グラフィックス』にジャケット収録)。もっとも，厳密に言うと，スティンソンはモーゼス・アッシュのレーベルの一つというわけではなく，そのディストリビューターに属していた。ノーマン・グランツがプロデュースし録音した数枚の『ジャズ・アット・ザ・フィルハーモニック』は，モーゼス・アッシュが所有するディスク・レーベルから発売された。このシリーズにはグランツが録音，製作したナット・キング・コールやミード・ラックス・ルイス，スリム・ゲイラードによるセッションも含まれている。だが，グランツはこの企画に飽き足らず，自己レーベルとしてまずクレフを創設した。

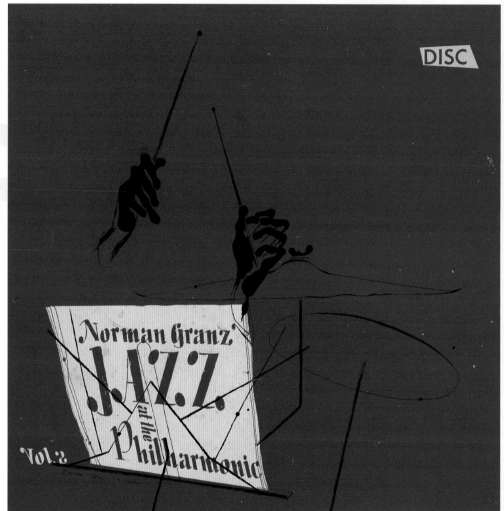

DISC

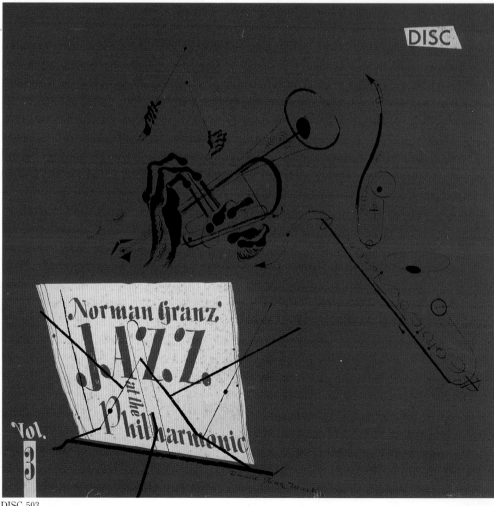

DISC 503

ディスク・レーベル

モーゼス・アッシュのディスク・レーベルから発売されたグランツのプロデュース作品のジャケットは，デヴィッド・ストーン・マーチンが描いている。

DISC
Jazz at the Philharmonic Vol. 2

DISC 503
Jazz at the Philharmonic Vol. 3

DISC 504
Jazz at the Philharmonic Vol. 4

DISC 505
Jazz at the Philharmonic Vol. 5

DISC 506
Nat King Cole Quintet

なぜグランツがジャズ・アット・ザ・フィルハーモニックという名前を選んだのか，なぜライブ録音が技術的に不可能だったと思われる時代の初期のジャズ・アット・ザ・フィルハーモニーのコンサートの録音が存在するのか，これまで様々な説が唱えられてきた。これについて，ミスター・グランツは親切にもどうだったのか一筆したためてくださった。

―――ジャズ・アット・ザ・フィルハーモニック（J.A.T.P.）という名前は，『フィルハーモニックやメトロポリタンの音楽は大都市から生まれ，云々…』という事実とはまったく関係がない。もっとずっと単純な理由からついた名前だ。1944 年にフィルハーモニック・オーディトリアムで行なわれたコンサートの広告を出すとき，私は印刷業者にポスターに「ジャズ・コンサート・アット・ザ・フィルハーモニック・オーディトリアム」と載せるよう指示した。ところが業者は，小さなポスターに全部おさめきれなくて，縮めて「ジャズ・アット・ザ・フィルハーモニック」と印刷したんだ。それがこの名前の最初で，私もあえてそれを変えなかった。ところで，当時フィルハーモニック・オーディトリアムはロザンゼルスで最高のコンサートホールとされていて，それまではクラシックのコンサートしか開かれていなかった。初めて私がジャズのコンサートに使ったんだ。

実をいうと，1944 年の最初のジャズ・アット・ザ・フィルハーモニックのコンサートは録音する予定ではなかった。コンサートの録音の許可を願い出たのは，アメリカ軍放送（AFN）だった。まだ第二次世界大戦

中のことで，ヨーロッパやアジアの米軍に慰問のために送るのが目的だった。彼らはそれらのコピーを私にくれた。これがきっかけで，私はジャズコンサートの記録盤を発売しようと考えついた。―――

これらを初め他にも丁寧な説明をしてくださったば

かりか，ジャズ・アット・ザ・フィルハーモニックのコンサートのプログラムから，デヴィッド・ストーン・マーチンのイラストをいくつかを掲載することを許可してくださったノーマン・グランツに，私は心からお礼を申し上げたい。

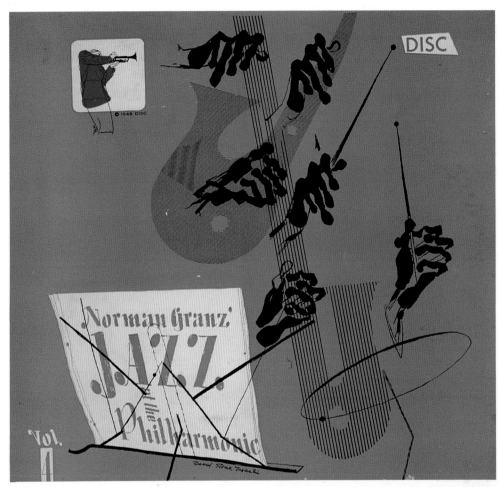

DISC 504

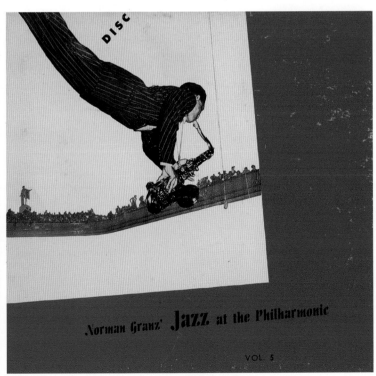

DISC 505

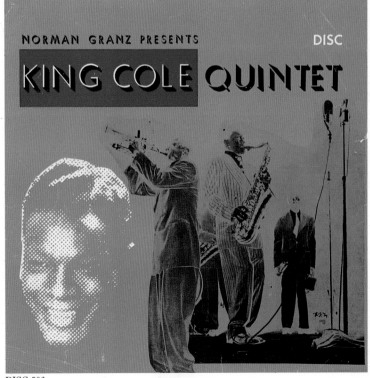

DISC 506

Jazz Graphics pictured around 200 jackets which DSM drew for the Granz labels. And here are 8 more DSM jackets on the Granz *Verve* label. All from the 1950s.

Verve 1012
Al Hirt - Al Hirt's Jazz Band Ball
Verve 3000-5
Bill Broonzy - The Bill Broonzy Story
Verve 15006
Mort Sahl - A Way of Life

Verve 1009
Bob Scobey with Lizzie Miles - Bourbon Street
Verve 4057
Ella Fitzgerald
Sings the Harold Arlen Song Book Vol. 1
Verve 4058
Ella Fitzgerald
Sings the Harold Arlen Song Book Vol. 2
Verve 4062
Ella Fitzgerald - These are the Blues

ヴァーヴ・レーベル

『ジャズ・グラフィックス』では，デヴィッド・ストーン・マーチンがグランツ・レーベルのために描いた約200枚のジャケットを紹介した。本書ではさらにグランツのヴァーヴ・レーベル盤のジャケットをおさめた。いずれも1950年代の作品である。

Verve 1012
Al Hirt-Al Hirt's Jazz Band Ball

Verve 3000-5
Bill Broonzy-The Bill Broonzy Story

Verve 15006
Mort Sahl-A Way of Life

Verve 1009
Bob Scobey with Lizzie Miles-Bourbon Street

Verve 4057
Ella Fitzgerald
Sings the Harold Arlen Song Book Vol. 1

Verve 4058
Ella Fitzgerald
Sings the Harold Arlen Song Book Vol. 2

Verve 4062
Ella Fitzgerald-These are the Blues

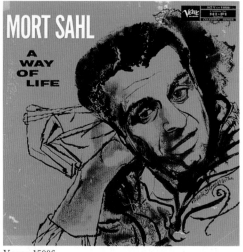

Verve 15006

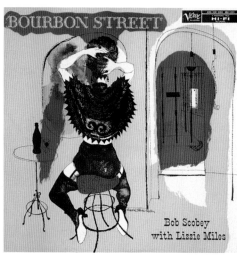

Verve 1009

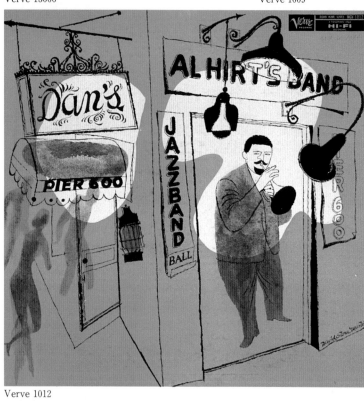

Verve 1012

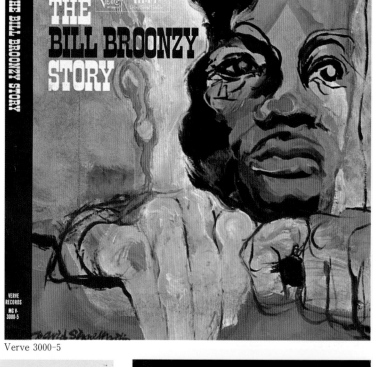

Verve 3000-5

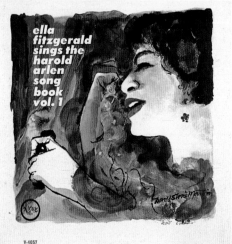

Verve 4057

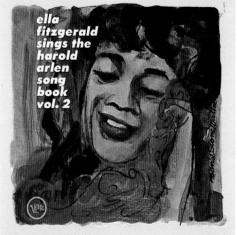

Verve 4058

Verve 4062

OTHER LABELS

Two very early LPs (circa 1950) for the **Waldorf Music Hall** label. I have no details to add nor do the covers include notes.

Waldorf Music Hall 33 103 (10")
Lew White (at the Organ) Moods for Lovers

Waldorf Music Hall 33 124 (10")
Robert Trendler Orchestra and Chorus
Hit Songs from Gershwin Hit Shows

Five more jackets from Enoch Light's **Grand Award** label. The original paintings were commissioned by Enoch Light.

Grand Award 33-322
A Musical History of Jazz

Grand Award 33-328
The Ink Spots' "Greatest"

Grand Award 33-304
Porgy and Bess

Grand Award 33-331
Peanuts Hucko - A Tribute to Benny Goodman

Grand Award 33-340
The Roaring 20's

その他のレーベル

ワルドルフ・ミュージック・ホール・レーベルのごく初期の2枚のLP (1950年頃)。ジャケットについては改めて説明を加えるまでもない。

Waldorf Music Hall 33 103 (10インチ盤)
Lew White (オルガン) -Moods for Lovers

Waldorf Music Hall 33 124 (10インチ盤)
Robert Trendler Orchestra and Chorus
Hit Songs from Gershwin Hit Shows

さらに，イノック・ライトが主宰するグランド・アワード・レーベルから発売された5枚のジャケット。原画はイノック・ライトが依頼した。

Grand Award 33-322
A Musical History of Jazz

Grand Award 33-328
The Ink Spots' "Greatest"

Grand Award 33-304
Porgy and Bess

Grand Award 33-331
Peanuts Hucko-A Tribute to Benny Goodman

Grand Award 33-340
The Roaring 20's

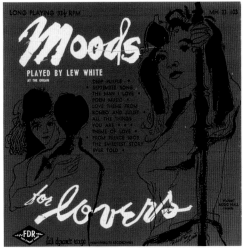

Waldorf Music Hall 33 103 (10")

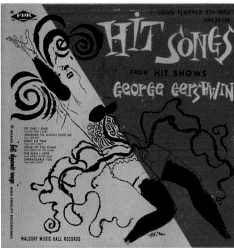

Waldorf Music Hall 33 124 (10")

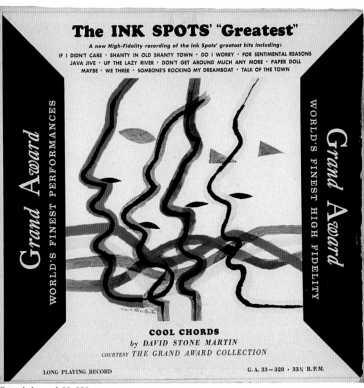

Grand Award 33-328

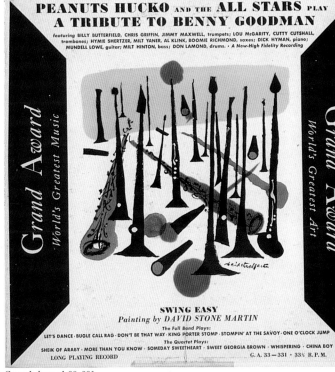

Grand Award 33-331

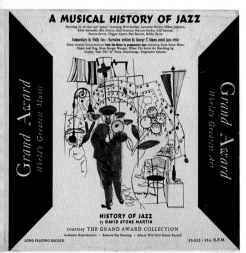

Grand Award 33-322

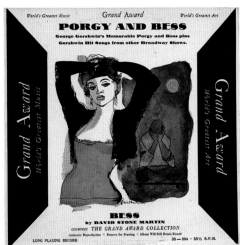

Grand Award 33-304

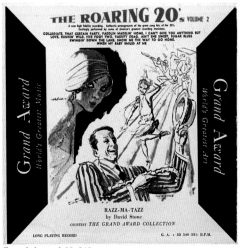

Grand Award 33-340

And seven jackets from other labels.

Decca 8665
Josh White - Josh White

Atlantic 1668
John Coltrane - Alternate Takes

Capitol 881
Music from 'The James Dean Story'

RCA 1158
Ustad Vilayat Khan - Music from 'The Guru'

Folkways FI 8355
The Art of the Folk - Blues Guitar

Statiras 8077
Kenny Davern - Live Hot Jazz

Archiv DARC-2-1105
Blossom Dearie - Blossoms on Broadway

他のレーベルからの7枚のジャケット

Decca 8665
Josh White-Josh White

Atlantic 1668
John Coltrane-Alternate Takes

Capitol 881
Music from 'The James Dean Story'

RCA 1158
Ustad Vilayat Khan-Music from 'The Guru'

Folkways Fl 8355
The Art of the Folk-Blues Guitar

Statiras 8077
Kenny Davern-Live Hot Jazz

Archiv DARC-2-1105
Blossom Dearie-Blossoms on Broadway

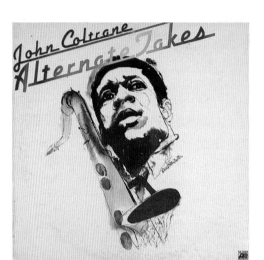

Atlantic 1668

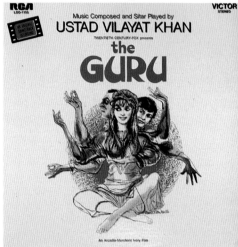

RCA 1158

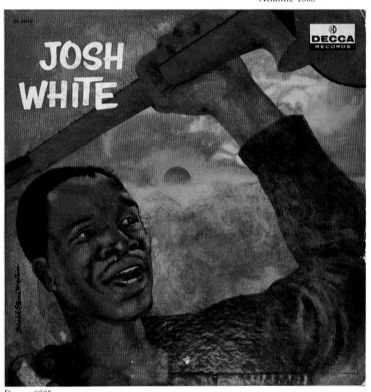

Decca 8665

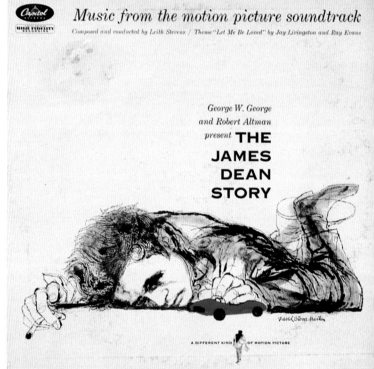

Capitol 881

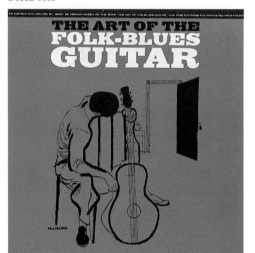

Folkways FI 8355

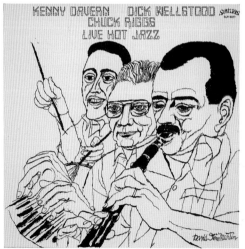

Statiras 8077

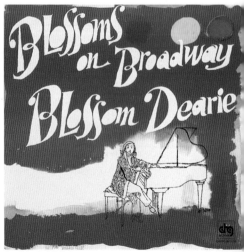

Archiv DARC-2-1105

THE INTERPLAY AND SEA BREEZE COVERS

Between 1979 and 1981, record producers, John Brechler and Toshiya Taenaka, commissioned DSM to design 6 jackets for their Interplay and Sea Breeze labels.

DSM drew these jackets towards the end of his long career when he did not travel from his Connecticut home. The musicians were not men he knew personally. He worked from photographs sent by Brechler and Taenaka. The DSM style and the 'sound of Jazz' pervades with the usual brilliance.

These records were pressed in a very small quantity and are already collector's items. Particularly so, since the records pressed and issued in Japan did not have the DSM covers.

My thanks to John Brechler and Toshiya Taenaka for lending me these archive copies. My hope is they will reissue these records for more DSM collectors to have their own copies.

Interplay 7720
Sam Jones - Sam Jones Trio

Interplay 7725
Warne Marsh/Sal Mosca - How Deep/How High

Interplay 7727
Claude Williamson - La Fiesta

Sea Breeze 1006
Al Haig - Piano Time

Sea Breeze 1007
Frank Strazzeri - Relaxin'

Sea Breeze 2004
Sam Jones - 12 Piece Band

インタープレイとシーブリーズ

　1971 年から 81 年にかけ，レコード・プロデューサー，ジョン・ブレックラーとトシヤ・タエナカは，インタープレイとシーブリーズの両レーベルの 6 枚のジャケットのデザインをデヴィッド・ストーン・マーチンに依頼した。

　これらのジャケットを描いたとき，デヴィッド・ストーン・マーチンはすでに長い現役生活の終わりに近く，コネチカット州の自宅にこもりっきりになっていた。個人的に会ったことのないミュージシャンのジャケットだったため，彼はブレックラーとタエナカから送られた写真をもとに絵を仕上げた。例によって，デヴィッド・ストーン・マーチンらしさと「ジャズのサウンド」が鮮明に息づく秀作である。

　これらのレコードの発売部数はごく少なく，すでにコレクター垂涎のアイテムとなっている。特に日本で生産，発売された国内盤にはデヴィッド・ストーン・マーチンのジャケットがないだけに人気が高い。

　貴重なレコードをお貸しくださったジョン・ブレックラーとトシヤ・タエナカにお礼を申し上げたい。願わくば，もっと多くのデヴィッド・ストーン・マーチンのコレクターが自分のコレクションに加えられるよう復刻していただけたらと思う。

Interplay 7720
Sam Jones-Sam Jones Trio

Interplay 7725
Warne Marsh/Sal Mosca-How Deep/How High

Interplay 7727
Claude Williamson-La Fiesta

See Breeze 1006
Al Haig-Piano Time

See Breeze 1007
Frank Strazzeri-Relaxin'

See Breeze 2004
Sam Jones-12 Piece Band

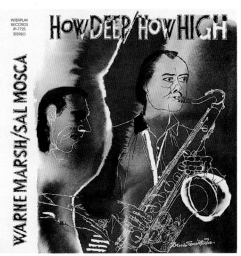

Interplay 7725

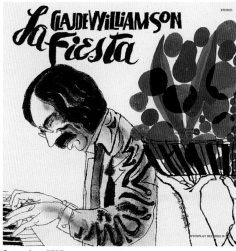

Interplay 7727

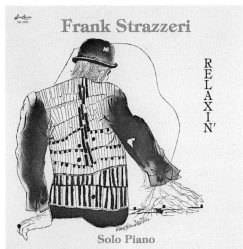

Sea Breeze 1007

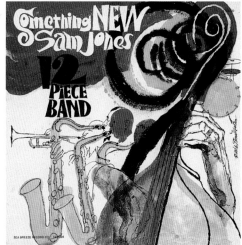

Sea Breeze 2004

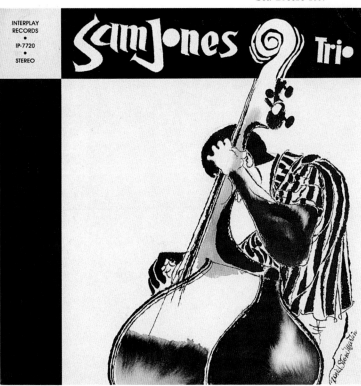

Interplay 7720

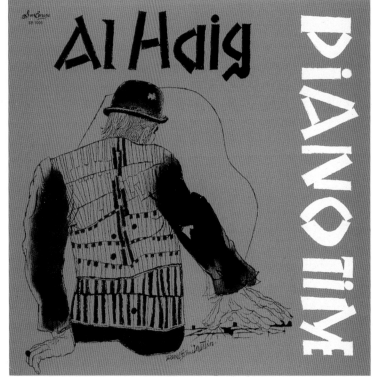

Sea Breeze 1006

David Stone Martin illustrated and designed the attractive program notes which accompanied the concerts of Norman Granz's *Jazz at the Philharmonic* groups. Some of which are shown here. Reproduced with the permission of Mr. Norman Granz.

　デヴィッド・ストーン・マーチンは，ノーマン・グランツの「ジャズ・アット・ザ・フィルハーモニック」コンサートのために，魅力的なプログラムをデザインし，イラストを起こした。ノーマン・グランツの許可を得て，ここでそのうちのいくつかをご紹介しよう。

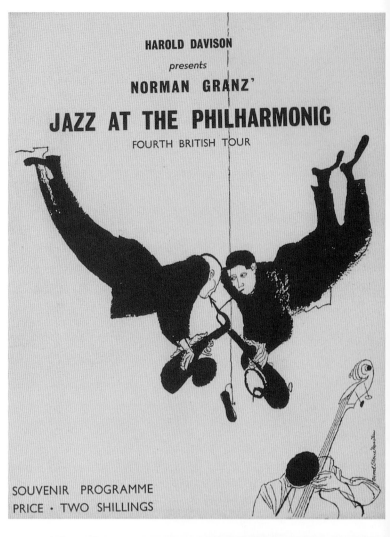

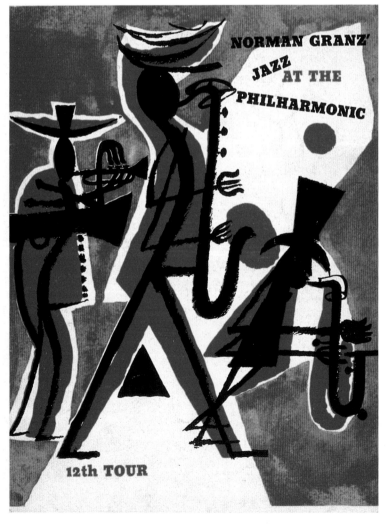

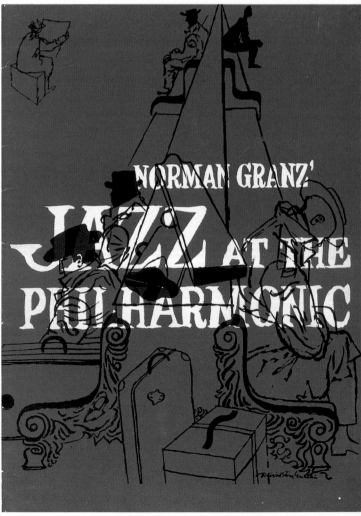

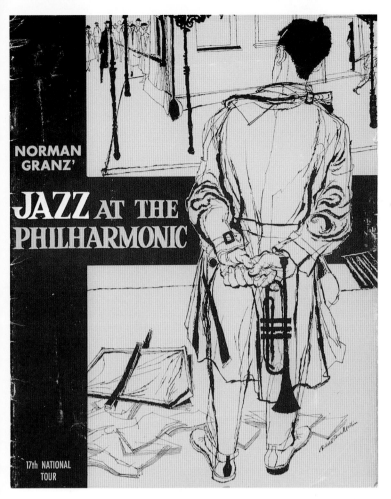

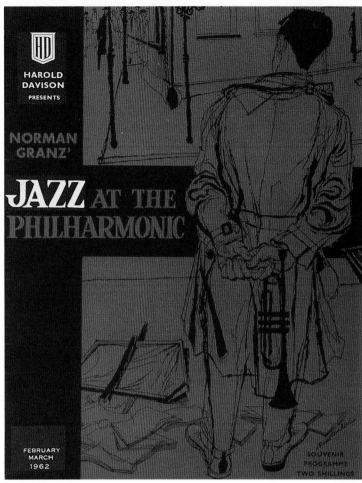

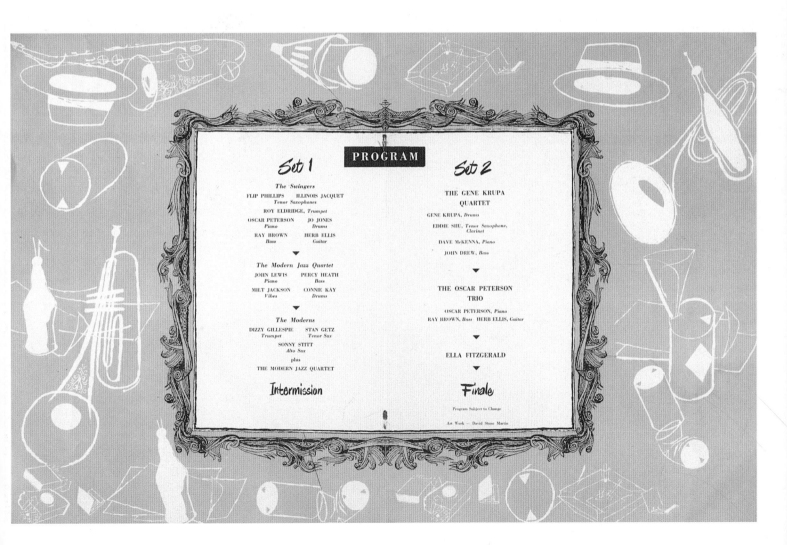

HERMAN LEONARD

ハーマン・レナード

Leonard got his interest in photography from his elder brother, who was a professional photographer. The young Herman accidentally found his elder brother's art studies and became hooked on photography as a career. His first photographs were of school friends.

In 1940 he enrolled at Ohio University. It was the only University which offered a fine arts degree in photography. In 1942 he was drafted and spent just under three years at the Burma front. Demobilized – he returned to Ohio University to graduate (1947) with his Bachelor of Fine Arts in Photography. He immediately aimed for the greatest start a budding photographer could aim for. He applied for a job to work with Yousuf Karsh (Karsh of Ottawa). Karsh was then acknowledged and still is today, as the world's greatest portrait photographer. Instead of a job, Karsh offered and Leonard accepted a one year apprenticeship with no pay. Leonard travelled with Karsh and assisted him in photographing great personalities including, Albert Einstein and President Truman. The year with Karsh ended in the fall of 1948.

Leonard then moved to New York City to start his own studio in Greenwich village. He earned his first income from portraits (the Karsh experience in immediate mind) of his father's business friends and also of artists and writers. He did assignments for too many magazines to list. He very quickly got interested in jazz. And became a regular at the now legendary Birdland club and also the other jazz clubs of 52nd Street, Broadway, Harlem. The camera gained him free entry.

In 1956, Marlon Brando needed a personal photographer to chronicle his three month travels through the Far East. A mutual friend introduced Leonard. Brando (himself both a bongo player and a jazz freak) recognized Leonard's work from the jazz magazines of the time. Brando interviewed many other photographers but there was little doubt he wanted Leonard. So he offered Leonard the job——to start in two days. For Leonard, it meant winding up his by then very busy New York studio work. He was able to do so by leaving things to his aide Chuck Stewart (Stewart was to become a fine jazz photographer in his own right).

Brando returned to America via Paris. Leonard immediately fell in love with Paris. Barclay Records offered him the job as Chief of their art department. Playboy Magazine asked him to be their photographer for Europe. There seemed to be plenty of work in Europe, so he stayed on in Paris to start his own studio. He branched out into fashion and advertising photography.

His studio in Paris was a great success with 9 employees and 4 photographers, but the monotony of the work got to him. In 1979 he gave up his Paris studio to spend a year in a 300 year old farmhouse in Ibiza. Then back to Paris. In 1987 he went to England where there was plenty of work, but he couldn't work legally. In 1989, Leonard returned to America after 25 years in Europe and made San Francisco his new home.

He started 1993 with a transfer of residence to New Orleans. New Orleans welcomed him with an immediate 'Certificate of Merit for Outstanding Service' and the Key to the City of New Orleans. Leonard's plans are "**I am hoping to do a film/book project on 'Jazz——The Only Original American Art-Form'. Not a history of jazz but a study of why it started here and its present day status. I want to photograph and film the old jazz clubs that still exist, those great but obscure musicians who never left the bayous, and the new and exciting young musicians.**" While in London (1987) Leonard had pulled his old jazz negatives from the cardboard box under his bed to set up the first of his "The Images of Jazz" exhibition. An estimated 10,000 people came to the gallery during the exhibition——making it one of the most successful exhibits by a living photographer. Since then, 45 more exhibitions of Leonard's jazz work have been held world wide; including 11 in North America. In 1992, three exhibitions of "Images of Jazz" were held in the Japanese cities of Tokyo, Kichioji and Osaka.

The Smithsonian Institute in Washington requested and Leonard accepted that the entire "Images of Jazz" series will become part of their permanent collection. It will be housed in the Smithsonian's Musical History Department along with the manuscripts of Duke Ellington, the trumpet of Dizzy Gillespie and the saxophone of Stan Getz.

A collection of Leonard's photographs was published both in French (L'Oeil du Jazz) and in English (The Eye of Jazz). It is now in its 5th edition. He plans

レナードはプロの写真家だった兄の影響を受けて，写真に興味を抱くようになった。彼は偶然兄の習作を見つけ，写真で身を立てる決心をしたのである。最初に撮ったのは，学友たちの写真だった。

1940年，オハイオ大学に入学。写真芸術の学位が得られる唯一の大学だった。1942年に徴兵され，戦地ビルマで3年を過ごす。復員後，オハイオ大学に戻り，1947年，写真芸術の学士号を取得して卒業した。

レナードはいきなり，新米写真家としては最高のスタートをきろうとした。ユースフ・カーシュ（カーシュ・オブ・オタワ）と働こうと仕事の口を求めたのである。当時，カーシュは世界的な人物写真の巨匠であり，それは今日も変わらない。しかし，カーシュは仕事ではなく1年間の無給の見習い奉公を申し出，レナードはそれを承知した。彼はカーシュについてあちこちまわり，アルバート・アインシュタインやトルーマン大統領など偉大な人物たちの写真をとる助手をした。1948年の秋，カーシュのもとでの見習期間は終わった。

それから，レナードはニューヨーク市に移り，グレニッチヴィレジに自分のスタジオを構えた。最初に収入を得たのは，父親の仕事仲間やアーチストや作家の人物写真だった（カーシュのもとで得た経験がさっそく生かされたのである）。彼は数えきれない雑誌の仕事をした。また，あっという間にジャズに引き込まれ，今では伝説の『バードランド』をはじめとする52番街，ブロードウェイ，ハーレムのジャズ・クラブの常連となった。カメラのおかげで彼はただで入ることができたのだった。

1956年，マーロン・ブランドが極東を巡る3か月のプライベート旅行の写真を撮る写真家を捜していた。ふたりに共通の友人が，レナードを紹介。自らボンゴを叩くジャズ狂であったブランドは，当時のジャズ雑誌でレナードの作品を知っていた。多くの写真家とも面接してみたが，レナードを選んだのは当然だった。さっそく彼はレナードにこの仕事を申し込み，2日のうちに出発することを告げた。しかし，レナードにとってそれは，目が回るほどの忙しさになっていたニューヨーク・スタジオの仕事を捨てることであった。彼は助手のチャック・スチュアートに後を任せ，旅行に同行した。（後にスチュアートは独立してすばらしいジャズ写真家となる）

ブランドはパリを経由して帰国した。レナードはたちまちパリの魅力にとりつかれた。帰国後，彼はバークレー・レコードに芸術部長として迎えられ，やがて『プレイボーイ』誌の依頼で撮影のため渡欧。ヨーロッパにはたくさんの仕事がありそうだとみたレナードは，そのままパリに留まり，自分のスタジオを構えて，ファッションや広告の写真にも手を広げた。

パリのスタジオは，9人の従業員と4人の写真家を抱え大成功を納めた。しかし，単調な仕事に嫌気がさし，1979年，レナードはパリのスタジオを畳んで，地中海の島イビサの築300年の農家で1年を過ごす。その後パリに戻り，1987年にイギリスに渡る。イギリスにも多くの仕事があったが，法律上認められなかった。1989年，ヨーロッパから25年ぶりにアメリカに帰国し，新たにサンフランシスコを活動の拠点とする。1992年，住居をニューオリンズに移し，ニューオリンズをはじめルイジアナ，ミシシッピ地域のブルース・シンガーやジャズ・ミュージシャンの写真を撮りたいという大望を遂げた。

ロンドンにいる間(1987)に，レナードはベッドの下のダンボール箱から古いジャズ写真のネガを引っぱり出して，最初の『ザ・イミッジズ・オブ・ジャズ』展を開いた。1か月の展示にざっと1万人が訪れ，現代の写真家による個展の中でも最大級の成功をおさめた。以来，世界各国で45回にわたるレナードのジャズ写真展が開かれている。うち11回は北アメリカで開かれ，1992年には日本でも東京，吉祥寺，大阪の3か所で『イミッジズ・オブ・ジャズ』展が開催された。

ワシントンD.C.のスミソニアン協会の要請を受け，レナードの『イメージズ・オブ・ジャズ』シリーズの全作品が永久所蔵品の仲間入りをすることになった。スミソニアン協会の音楽博物館に，デューク・エリントンの楽譜やディジー・ガレスピーのトランペット，スタン・ゲッツのサックスといっしょに展示される予定だという。

レナードの写真集はフランス（『L'Oeil du Jazz』）とイギリス（『The Eye of Jazz』）で発行され，現在第5版を重ねている。さらに第6版だけでなく，他界したミュージシャンに捧げる限定版も発行する計画である。

ジャズは幾人かの偉大な写真家を生んだ。しかし，その中でレナードは比類のない位置にある。なぜなら，彼の作品は1949年から55年のジャズの本質を見事にとらえているからだ。この時期にレナードが撮ったジャズの写真が，崇拝する大物ミュージシャンや好きな音楽を自分のための記録に残そうとして撮ったものだ

a new edition along with limited editions of prints dedicated to those musicians no longer with us.

Jazz has several great photographers. But Leonard's position is unique. For Leonard's work illustrates and captures the essence of jazz between 1949 and 1955. It is crucial to understand that the jazz photographs he took then were for his own personal record of the great musicians he admired and of the music he loved. He photographed without any commercial considerations in mind. The jazz photography was for his own pleasure; unfettered by editorial or subject-personality constraints. It was only years later that the LP came about and his photographs were bought for album covers.

His lighting techniques evolved from his many hours backstage at clubs, theaters, and concert halls. He watched the performers backlit by the strong spotlights, producing an etched, three dimensional effect. His photography started (1948, 1949, 1950) with the 'newspapersmans Volkswagen'——a Kodak 4X5 Speed Graphic. He went onto a Rolleiflex followed by one of the first Hasselblad's. The studio portraits were on 4X5 and 5X7 view cameras for portraits. Later he switched to 35 mm Contax and Nikons——which he works with today.

In Leonard's own words:

"I always did my own developing and printing. It was the only way I knew to get results. You shoot, process, look at your mistakes and do it again and again until you get it right. Many times, I would come back with nothing. But in the end I got a little better. And the back lighting technique which always emphasizes smoke against a dark background, was an accident when I was shooting a trumpet with Goodman's band, I believe, by the name of Ray Wetzel. I had one light behind him and one other behind me to fill in the shadows. The one behind me failed to go off and I ended up with this wonderful wedge-lighted silhouette. So I started learning how to light that way because it seemed to capture the real club atmosphere. Like Karsh told me 'Always tell the truth in terms of beauty.' So to me, that was the truth."

Leonard visited Tokyo in October 1991 for an exhibition of 'The Images of Jazz'. We met then for him to look at and talk about the jackets. He had lost track of the covers he had done. He estimated he had done maybe 30 jazz covers. We quickly found nearly 100. And we also discovered three amazing things.

First, we found 15 records where the cover was credited to him. But in his personal honesty he said **"This is a great cover. I wish it were mine. I did not do it."** My rejoinder; **"it should be yours; it is credited to you."** But Herman remembers all his photographs and would be firm **"never mind what the cover says - it is a fine cover; it just is not mine."** I have not included these covers here despite their Herman Leonard name. Included are two covers which are credited to others but are beyond doubt, his.

Second, I showed him jackets which were not credited, but which I suspected were his. And indeed, many of these (essentially Emarcy's) which were uncredited, can now be correctly credited.

Third——Herman most graciously went through his files of prints and negatives. He collected and made available to me various alternates. The original prints too are of importance——for the jacket had often 'cropped' these differently or added colour to original black and white shots.

It will be impossible to ever locate all the Leonard jackets. He just took too many wonderful photographs, which, due to his kindness, became too easily available, reprintable without credits. Even what is shown here is only a part, certainly nowhere near all, of Leonard's jackets.

Both in America and France, Leonard was often commissioned to photograph covers for popular singers. Great covers again but not of the jazz genre. Hence out of the scope for this book.

The Leonard jazz jackets are shown in three groups: the Norman Granz labels; the Emarcy work; and the third group are jackets for other labels. The chapters on the Debut Label and on Frank Gauna's work also include some Herman Leonard jacket photographs.

ということを，ぜひとも理解していただきたい。これっぽっちも商売意識なしに撮っていたのだ。あくまでもジャズの写真は趣味であって，編集や被写人物のから制約を受けていないのである。このわずか数年後，ＬＰ盤が登場し，彼の写真はジャケット用に買われるようになった。

レナードのライティング技術は，クラブや劇場やコンサートホールの舞台裏で過ごした多くの時間の中で養われたものだった。彼はそこで，パフォーマーを背面から強烈なスポットライトで照らすと，くっきりとした立体感を生む効果があることを知った。レナードは初め，「新聞記者のフォルクスワーゲン」ことコダック４×５インチ判スピード・グラフィックのカメラを使った(1948, 49, 59年)。それからローライフレックス，ハッセルブラッドの最初の機種へと移行。スタジオの人物撮影には，ポートレート用の４×５インチ判と５×７インチ判のビューカメラを使用した。後に，35ミリ判コンタックスとニコンに変え，今日もこれを使っている。

では，私に宛てた手紙からレナード自身の言葉を引用してみよう。「私は必ず自分で現像し焼き付けた。そうする以外，腕を上げる方法を知らなかったんだ。写真を撮って，現像し，悪いところを調べる。それを何度も繰り返すうちに，どう撮ればいいかわかってくる。最初は何度やっても同じだった。でも，しまいには少しよくなった。それから，暗い背景にスモークを浮かび上がらせるときに使う背面光の技術だが，あれはグッドマンのバンドのトランペット，確かレイ・ウェッツェルが吹いていたと思うが，それを撮っているときたまたま思いついたものだ。私は彼の後ろから１つ，自分の後ろから１つライトを当てて全体を明るくしようとした。ところが私の後ろのライトがつきそこなって，結局このくさび形に浮かび上がったすばらしいシルエットが撮れた。それがちょうどクラブの生の雰囲気をとらえているような気がして，このライティング法を試しはじめたというわけだ。カーシュは『常に美によって真実を表わせ』と言ったが，私にとってはあの姿こそ真実だったんだ」

1991年10月，『ジ・イミッジズ・オブ・ジャズ』展のためにレナードが東京を訪れたとき，私たちは彼に会ってジャケットを見ながら話をした。レナードはどの写真がジャケットに使われたか忘れてしまっていた。30枚ぐらいのものだと思っていたのだ。だが，私たちはすぐに100枚近いジャケットを見つけ，さらに３つの驚く

べき発見をした。

まず１つ。われわれはレナードの名前が表示された15枚のレコードジャケットを見つけた。ところが，正直な彼は「すばらしいジャケットだ。私の写真だといいんだが，私は撮ってない」と言う。私は言い返した。「あなたのですよ。名前があるじゃないですか」だが，レナードは自分の撮った写真は１枚残らず覚えていると譲らなかった。「ジャケットにどうあろうと関係ない。見事なジャケットだ。でも絶対に私の撮った写真じゃない」と。そんなわけで，これらのジャケットはハーマン・レナードの名前はあるものの，本書ではとりあげていない。逆に，別人物の名前になっているが，間違いなく彼の作品とみられるジャケットを２枚載せた。

２つ目。私は名前はないが彼の写真ではないかと思われるジャケットを，レナードに見せてみた。案の定，その多く（エマーシー盤がほとんど）は彼の作品であった。

そして３つ目。何とお礼を言っていいかわからないが，レナードはポジとネガのファイルを細かく調べ，約40枚のジャケットのオリジナル写真や控えの写真を集めて貸してくれた。名前表示がないか，特に興味深く貴重であるかどちらかのジャケットのものだった。こうしたオリジナルの写真も重要だ。というのも，もとの写真を「トリミング」したり，白黒写真に彩色したりしているジャケットが少なくないからである。

レナードの手がけたジャケットをすべて捜しだすことはまず不可能だ。彼は数知れないすばらしい写真を撮り，それらは彼の親切心から，ごく簡単に手に入れて名前も表示せず印刷できたからである。ここで紹介するのは，レナードのジャケットのごくごく一部にすぎない。

アメリカでもフランスでも，レナードはちょくちょくポピュラー歌手のジャケット写真を撮っている。もちろんこれらの写真も秀逸だが，ジャズのものほどではないので本書では省かせていただいた。

ここではレナードの撮ったジャズのジャケットを，ノーマン・グランツ・レーベル，エマーシー・レーベル，そしてその他のレーベルという３つのグループに分類して載せた。

THE NORMAN GRANZ LABELS

(Clef, Norgran, Verve - Records issued 1953-1956)

Herman Leonard was in the audience when the 'Jazz at the Philharmonic' group played near his university (1947). An enthusiastic audience-photographer, he also went backstage——his first meeting with Norman Granz. Later they would meet in New York at concerts and related events. Around 1953 Granz started using Leonard's Birdland photographs for jackets. This was followed by commissions for photography both in Leonard's studio and at the recording sessions. They were close personal friends then——and remained so through their lives.

Leonard recalled to me some happy memories. On a special visit to Hollywood to photograph Frank Sinatra——he stayed at Granz's Hollywood home. By coincidence both men took up residence in Europe. Leonard bought a Maserati car from Granz. The car gave him trouble——Granz insisted on taking it back for a full refund.

In October 1991 Norman Granz remarked to me with a huge amount of good humor "Herman always wanted to do things his way. I would tell him——photograph Oscar listening to Lester. Or Dizzy listening to Roy. Don't just photograph them playing. Their faces; listening to others make great photographs."

Soon after I met Herman and recounted Granz's advice. Herman's equally good humored comment was "Now, Norman tells me that! But we always had great chemistry together. Isn't that the final key to collaboration?" Indeed it is Herman and it is very much evident in the album covers.

Clef 634

ノーマン・グランツ・レーベル

1953〜56年発売のクレフ，ノーグラン，ヴァーヴ盤

1947年，ハーマン・レナードの大学の近くで「ジャズ・アット・ザ・フィルハーモニック」グループが演奏したとき，彼もその聴衆のひとりであった。熱狂的なファンであり写真家であったレナードは，楽屋までおしかけ，そのとき初めてノーマン・グランツと会った。その後，ニューヨークでもコンサートやジャズ関係のイベントで何度か顔を合わせ，1953年頃，グランツはレナードが『バードランド』で撮った写真をジャケットに使いはじめる。こうして，レナードは自分のスタジオとレコーディング・セッションの両方で写真を撮ることになった。当時ふたりは親友であり，その友情は生涯を通じて変わることはなかった。

レナードから楽しい思い出を聞いたことがある。フランク・シナトラの写真撮影という大事な仕事でハリウッドを訪れたとき，グランツの家に泊まったこと。偶然同じころ，ふたりともヨーロッパに住居を構えたこと。そして，グランツからマセラーティの車を買ったが，後になってまた同じ値段で買い戻すと言い張られて困ったこと，などだ。

1991年10月，ノーマン・グランツはご機嫌で私に語った。「ハーマンはいつも自分のやり方を通したがってね，私はよく『レスターを聴いているオスカーを撮れ』とか『ロイを聴いているディジーを撮れ』って言ったもんだよ。『演奏しているところばかりじゃだめだ，人の演奏を聴いている顔は傑作になるんだ』ってね」

それからほどなく，私はハーマンに会ってグランツの助言を伝えた。ハーマンもご機嫌でやり返した。「まったくノーマンのやつときたら！ そのくせ，私たちはいつでもすごく馬が合ってね，それが共同で仕事をする究極の秘訣じゃないのかな？」と。なるほど，その答えはハーマン自身であり，またアルバム・ジャケットにはっきりと表れている。

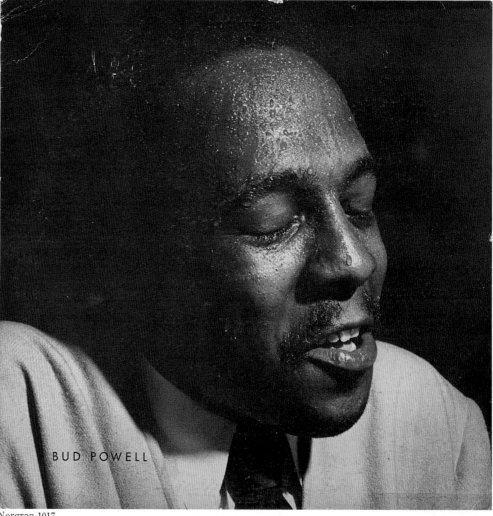

Norgran 1017

LEONARD——'Birdland' and other New York jazz clubs （1949/54）
Clef 634
Flip Phillips/Buddy Rich
Flip Phillips-Buddy Rich Trio

Norgran 1017
Bud Powell - Jazz Original

Norgran 1098
Bud Powell - Bud Powell '57
(This 1949 Birdland shot remains the classic one of Bud Powell. It is also the photograph used for the Debut DLP-3 Bud Powell, Jazz at Massey Hall which is shown in the Debut section.)

Norgran 1046
Louis Bellson - Skin Deep

Norgran 1099
Louis Bellson - The Hawk Talks

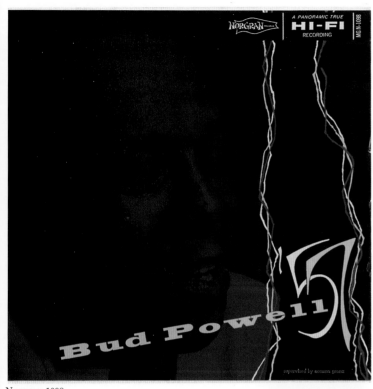

Norgran 1098

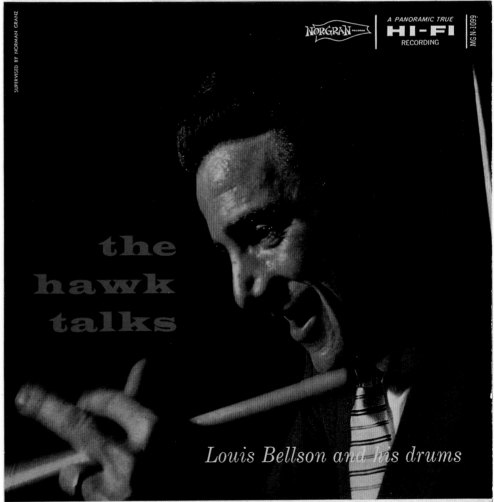

Norgran 1046

ニューヨークのジャズクラブ「バードランド」その他の写真(1948/54)

Clef 634
Flip Phillips/Buddy Rich-Flip Phillips-Buddy Rich Trio

Norgran 1017
Bud Powell - Jazz Original

Norgran 1098
Bud Powell - Bud Powell '57
1949年,「バードランド」で撮影したこの写真は、バド・パウエルを写した傑作のひとつである。デビュー・レーベルのところで紹介した Debut DLP-3 Bud Powell,「Jazz at Massey Hall」のジャケットにも使われている。オリジナル写真ージャケットに印刷した方が色がぼやけている。

Norgran 1046
Louis Bellson - Skin Deep

Norgran 1099
Louis Bellson - The Hawk Talks

Norgran 1099

Norgran 1055
Johnny Hodges - Ellingtonia 56

Norgran 1056
Lester Young - The Jazz Giants '56

Norgran 1060
Johnny Hodges - Used to be Duke
(The title relates to Hodges and his sidemen Shorty
Baker, Harry Carney, Jimmy Hamilton, Lawrence
Brown all being former Ellington alumni. A Birdland
shot——Harry Carney in the background.)

Verve 8205
Lester Young/Teddy Wilson - Pres and Teddy
(A montage of two shots)

Norgran 1055
Johnny Hodges - Ellingtonia 56

Norgran 1056
Lester Young - The Jazz Giants '56

Norgran 1060
Johnny Hodges - Used to be Duke
タイトルはホッジスとサイドマンのショーティ・ベイカー，
ハリー・カーネイ，ジミー・ハミルトン，ローレンス・ブラウ
ンが全員，エリントン楽団の出身であることからついた。
「バードランド」にて撮影。後方はハリー・カーネイ。

Verve 8205
Lester Young/Teddy Wilson - Pres and Teddy
2枚のモンタージュ。オリジナル写真。

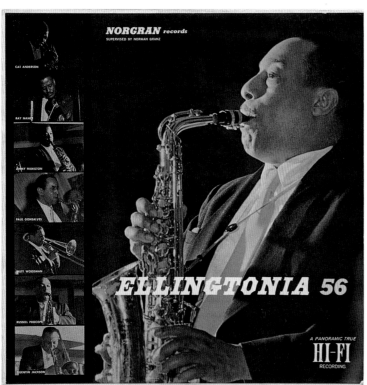

Norgran 1055

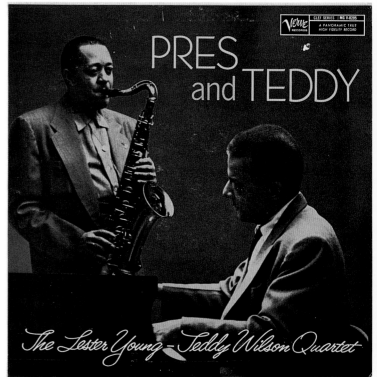

Verve 8205

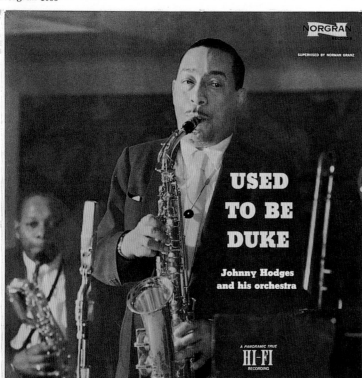

Norgran 1060

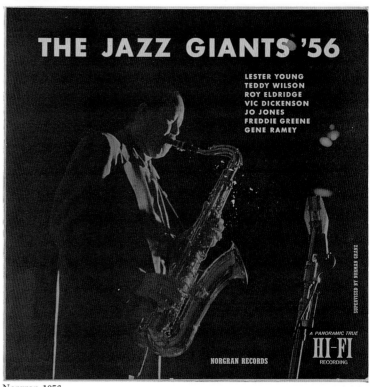

Norgran 1056

HERMAN LEONARD - Count Basie

Four remarkable covers which Leonard made of Count Basie.

Clef 722
Count Basie - The Band of Distinction
Clef 724
Count Basie - King of Swing
(The impeccable Basie at Leonard's New York studio.)

Verve 8012
Count Basie - April in Paris
(Basie and Leonard walked up the Champs Elysees in Paris. They found a flower lady from whom Basie charmed a bouquet of carnations although she had no idea who he was. Arc de Triomphe in the background.)

Verve 8199
Count Basie - Basie in London
(Outside a London pub —— early 1960's. Basie's companions are the 'Pearly King and Queen' of the year. An annual festival where participants put on their home made pearl button embellished outfits. Everyone retired to the pub - where Basie played a bit of piano.)

カウント・ベーシーを撮った４枚の名ジャケット

Clef 722
Count Basie - The Band of Disinction
Clef 724
Count Basie - King of Swing
ニューヨークのレナードのスタジオにて撮影した，非の打ちどころのないベイシー。

Verve 8012
Count Basie - April in Paris
ベイシーとレナードはパリのシャンゼリゼ通りを歩いているとき，花売り娘に会った。ベイシーはカーネーションの花束を買って娘をうっとりさせたが，彼女は相手が誰かまったくわかっていなかった。色は褪せているが，凱旋門をバックにご機嫌なベイシーとパリの様子が生き生きと伝わってくる。２枚の別ショット。

Verve 8199
Count Basie - Basie in London
1960年代初め，ロンドンのパブの前にて撮影。ベイシーと一緒にいるのは，その年の「貝ボタンの王と女王」。人々が手作りの真珠貝のボタンで飾った衣装を着て参加する年に一度の祭りの最中だったが，ベイシーがピアノを一弾きすると，皆パブに押しよせた。

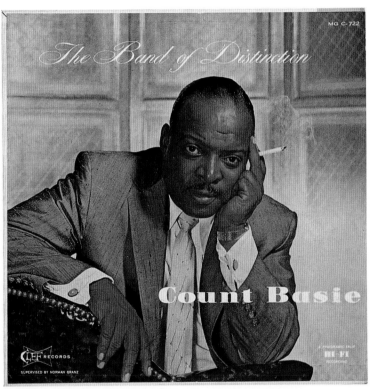

Clef 722

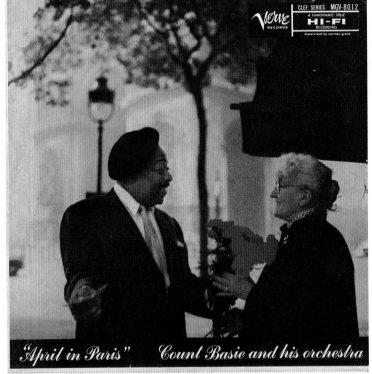

Verve 8012

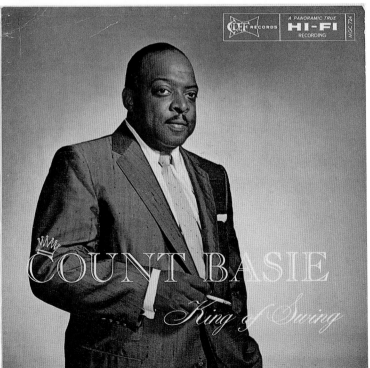

Clef 724

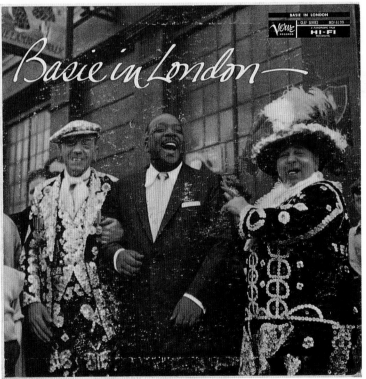

Verve 8199

41

LEONARD - Musician Portraits

The influence of Karsh of Ottawa manifests itself in what could be considered formal——mostly prop-free ——musician portraits by Leonard of Jazz.

Clef 694
Oscar Peterson - Recital By Oscar Peterson

Verve 8290
Ray Brown - This is Ray Brown

Clef 705
Roy Eldridge - Dale's Wail

ミュージシャンの人物写真

レナードの撮ったいわゆる形式的な――たいてい小道具を使わない――ジャズ・ミュージシャンの人物写真には，カーシュ・オブ・オタワの影響がはっきりと表れている。

Clef 694
Oscar Peterson - Recital By Oscer Peterson

Verve 8290
Ray Brown - This is Ray Brown

Clef 705
Roy Eldridge - Dale's Wail

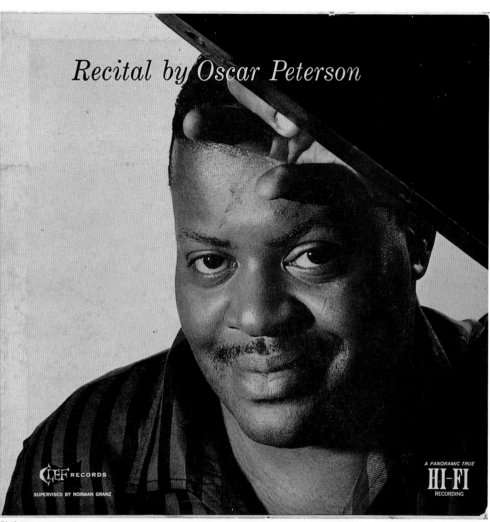

Clef 694

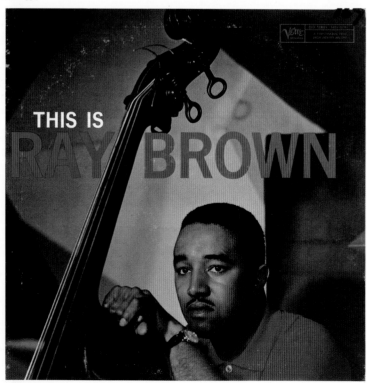

Verve 8290

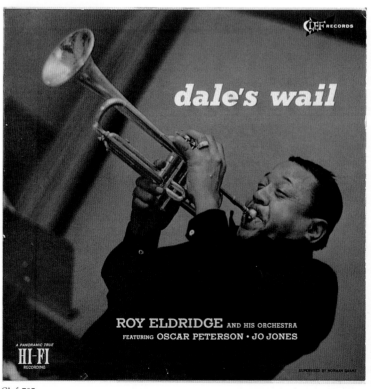

Clef 705

Norgran 1082
Billy Bauer - Plectrist

Clef 721
Billie Holiday - Lady Sings the Blues
(Leonard photographed Billie Holiday many times. For this particular shot Leonard explains **"In 1954, Norman Granz asked me to shoot a cover for her recording session in New York; but when she arrived, I was so appalled at her appearance——so drawn and pathetic——that I said to Norman, 'I can't shoot that for a cover——it's too tragic.' He pushed me into the studio saying 'Get in there and shoot ! It may be your last chance !'.. and it was."**)

Verve 8021
Tal Farlow - Tal

Verve 8289
Tal Farlow - This is Tal Farlow
(New York studio shots　Same shirt but color changed.)

Norgran 1082
Billy Bauer - Plectrist

Clef 721
Billie Holiday - Lady Sings the Blues
レナードはビリー・ホリデーを数多く撮っているが,この写真についてこう説明している。「1954年,ノーマン・グランツから,彼女がニューヨークで録音する間にジャケット写真を撮るよう言われた。ところが,やって来た彼女を見てぎょっとしたね。ひどくやつれて悲しげだったんだ。で,私はノーマンに『あれじゃあジャケットにできない。痛々しすぎるよ』と言った。すると彼は私をスタジオに押しこんで

言った。『いいから撮るんだ！　こんな彼女は二度と撮れないかもしれないぞ！』って……実際そのとおりだったよ」と。同じレコーディング・セッションの別ショット。

Verve 8201
Tal Farlow - Tal

Verve 8289
Tal Farlow - This is Tal Farlow
ニューヨークのスタジオにて撮影。

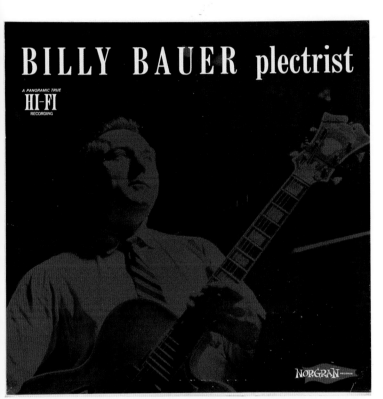

Norgran 1082

Clef 721

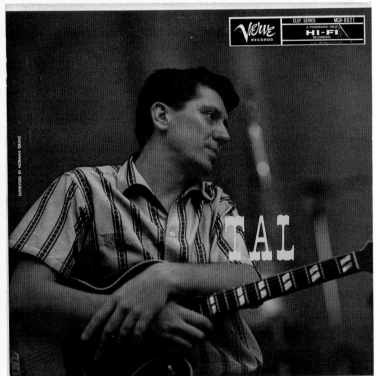

Verve 8201

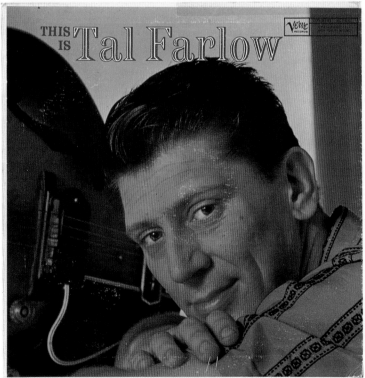

Verve 8289

Verve 8323

Verve 8323
Art Tatum - The Greatest Piano of Them All
(Albert Einstein and Art Tatum were the only two whose photographing made Leonard tremble with fear and excitement. About this Tatum shot: "I remember how nervous I was and how privileged I was to actually be in this genius's private home for the entire afternoon. I especially did not want to show his eyes which were unattractive. Tatum's wife told me later ——at the opening of one of my shows—— that this was the best photograph of her husband, ever." A more detailed print is in 'The Eye of Jazz'.")

Norgran 1071
Lester Young - Lester's Here
(One of the best known still lifes in the photo history of jazz. From a Norman Granz recording session of the 1950's. Lester was called away to another room—— leaving behind his pork-pie hat; his smoldering cigarette balanced on his empty Coke bottle. Next to the opened score of 'All of Me'.)
The original print.

Verve 8323
Art Tatum - The Greatest Piano of Them All
アルバート・アインシュタインとアート・テータムの写真を撮るときだけは，さすがにレナードも畏怖と興奮に震えた。このテータムの写真について彼は語っている。「現実に天才ジャズピアニストの自宅に午後いっぱいいられて，どんなに緊張し，どんなに光栄に思っていたか覚えてるよ。とにかく魅力のない目にだけは撮りたくなかった。後で，テータムの奥さんが私の個展の初日に，『今までで最高の夫の写真ですわ』と言ってくださった。写真集『ザ・アイ・オブ・ジャズ』にもっといいやつが載ってるよ」と。

Norgran 1071
Lester Young - Lester's Here
ジャズの写真史上，最も有名な生物写真のひとつ。1950年代のノーマン・グランツのレコーディング・セッションより。レスターは別室に呼ばれ，その後にはポークパイ・ハットと，空っぽのコーラ瓶の上に載った吸いかけの煙草，そして開いた『オール・オブ・ミー』の楽譜が残った。オリジナル写真。

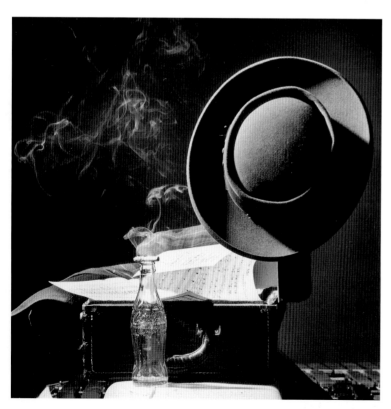

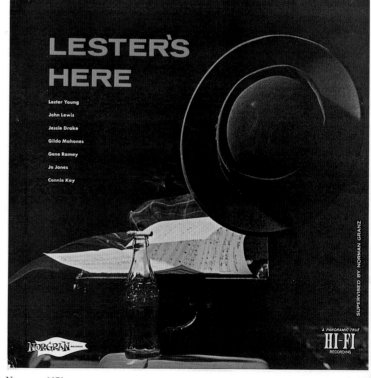

Norgran 1071

HERMAN LEONARD - Dizzy Gillespie

Dizzy Gillespie and Herman Leonard were close personal friends. Dizzy's playing is always witty and his stage presence invariably spiced with good humor. Dizzy and Herman capture it in the covers too.

Norgran MGN 1084
Dizzy Gillespie - World Statesman
Photographed at Leonard's New York studio. The conquistador type helmet was a prop left over from an earlier session for Playboy Magazine. Left in as "it seemed to fit. Part of a joint session with Roy Eldridge, both of them sitting on my studio floor, facing each other and playing to each others horns."

Verve 8015
Dizzy Gillespie - Django Reinhardt (one side each) - Jazz from Paris
(Place Pigalle, Paris——full of girlie shows, cabarets and tourists ! Leonard shot several nights to get the effect he finally liked.)

Verve 8017
Dizzy Gillespie - Dizzy in Greece

(Shot at Grant's Tomb, New York. Gillespie dressed at Leonard's studio. "It was pretty weird in those days to see this funny black man dressed as a Greek Royal Guard hailing a cab in New York City. But Dizzy loved it.")

Verve MGV 8313
Dizzy Gillespie - Have Trumpet, Will Excite !
(Mid 1950's - Leonard's studio.)

ディジー・ガレスピー

ディジー・ガレスピーとハーマン・レナードは気心知れた親友同士だ。ディジーの演奏は常に機知にあふれ、ステージではいつもユーモアをきかせてくれる。ディジーとハーマンはそんな彼の持ち味をジャケットでも表現している。

Norgran MGN 1084
Dizzy Gillespie - World Statesman
ニューヨークのレナードのスタジオにて撮影。征服者風のヘルメットは以前『プレーボーイ』誌の撮影で使わずじまいになった小道具で、「使えそうだ」ととってあった。「これはロイ・エルドリッジと一緒に写したときのもので、ふたりは私のスタジオの床に差し向いで座って、相手に向かってトランペットを吹いたんだ」。

Verve 8015
Dizzy Gillespie, Django Reinhardt - Jazz from Paris
（両面タイトル盤）
パリのピーガル広場にて撮影。ストリップ劇場やキャバレーが立ち並び、観光客であふれている！ レナードは幾晩も撮りつづけ、ようやく気に入る撮影に成功した。

Verve 8017
Dizzy Gillespie - Dizzy in Greece
ニューヨークのグラント将軍の墓にて撮影。ガレスピーはレナードのスタジオで着替えをした。「ギリシア近衛兵の格好をしたへんな黒人がニューヨークでタクシーを呼ぶってのは、当時はとんでもなく奇妙なことだった。でも、ディジーはおもしろがってやったんだ」。

Verve MGV 8313
Dizzy Gillespie - Have Trumpet, Will Excite !
1950年代、レナードのスタジオにて撮影。

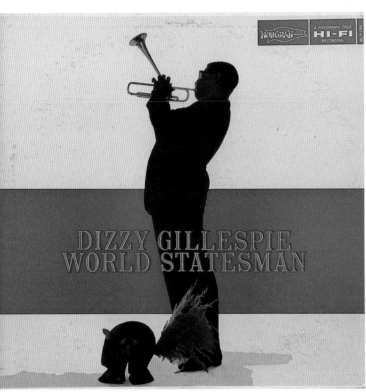

Norgran MGN 1084

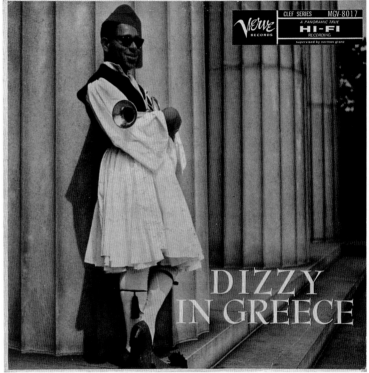

Verve 8017

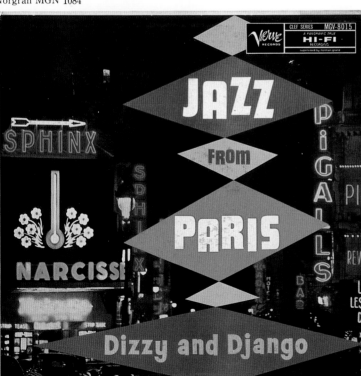

Verve 8015

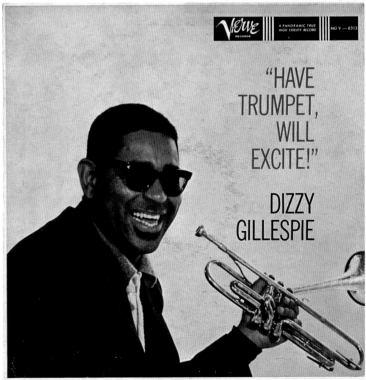

Verve MGV 8313

HERMAN LEONARD - Stan Getz

When Stan Getz passed away in 1991, the second (Lester Young was the first) uniquely individual tenor sax sound I grew up with was stilled. No tenor saxophone will ever sound the same. Leonard's own comment **"I would never have believed that such a baby face could produce such mature music. He looks so innocent."** Which comes out in the photographs.
For the sake of completeness two covers of Getz which Leonard did for the **Roost** label are included here.

Norgran 1088
Stan Getz - More West Coast Jazz

Verve 8294
Stan Getz - The Steamer

Verve 8296
Stan Getz - Award Winner
(The silhouette is from the photo of Verve 8294)

Roost 2207
Stan Getz - At Storyville
(All these covers are from photographs shot in New York in the early 1950's).
Great covers but from greater original photographs - shown here.

Norgran 1088

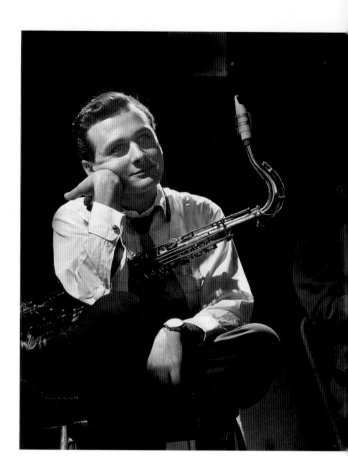

Verve 8296

スタン・ゲッツ

　1991年，スタン・ゲッツがこの世を去ったとき，私がともに育った第二の（レスター・ヤングが最初だった）強烈な個性のテノール・サックスのサウンドが消えた。あんなサウンドを創りだすテノール・サックス奏者はもう二度と現われないだろう。レナードはこう言っている。「あんなベビーフェイスの男があんな円熟した演奏をするなんて，とても信じられなかった。そりゃああどけない顔をしているんだ」なるほど写真からもわかる。

　不足のないよう，レナードが撮ったルースト・レーベル盤のゲッツのジャケットも2枚紹介しておこう。

Norgran 1088
Stan Getz - More West Coast Jazz

Verve 8294
Stan Getz - The Steamer

Verve 8296
Stan Getz - Award Winner
Verve 8294の写真から作ったシルエット。

Roost 2207
Stan Getz - The Sound
これらのジャケットはいずれも，1950年代初めにニューヨークで撮影した写真を使っている。どのジャケットも傑作だが，ここではさらにすばらしいオリジナル写真を載せた。

Verve 8294

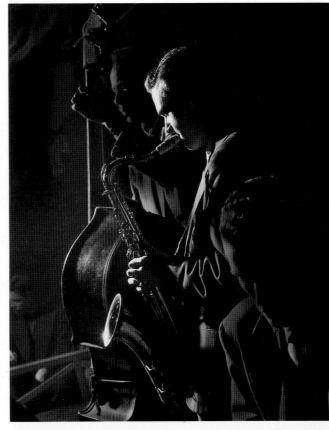

Roost 2207

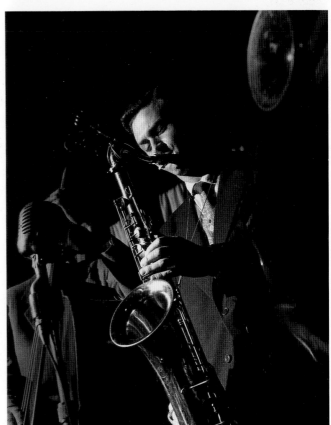

THE EMARCY LABELS
Emarcy - Wing 1953-1956

In 1950 Leonard was both photographer and guest at Ella Fitzgerald's birthday party. Other guests included Duke Ellington, Dizzy Gillespie, Ray Brown, Benny Goodman, Nat King Cole, George Shearing - an endless list. But it was here that Leonard first met Bobby Shad, the Artists and Recordings Manager of *Emarcy*. They met later at the *Emarcy* office, which for Leonard was the beginning of several years of photography in recording sessions.

A few *Emarcy* covers do credit Leonard. But whether through oversight, indifference or policy, *Emarcy* covers rarely credited photographer or designer. This has been a great loss. *Emarcy*'s - such as the Clifford Brown/Max Roach, the Erroll Garners, - have become essentials of any jazz collection. These jackets - repeated on countless reissues - can now be identified and happily credited to Herman Leonard.

Herman and I looked at many *Emarcy* covers so that he could identify which are his work.

Emarcy 36008
Clifford Brown/Max Roach - Brown and Roach Incorporated

Emarcy 36037
Clifford Brown - Study in Brown
(The Clifford Brown/Max Roach sessions are among the most creative small group sessions of the post-war period. Clifford Brown was at the peak of his dramatically short recording career of just 4 years. Like too many Emarcy covers, these did not credit Leonard.)

Emarcy 36008

エマーシー・レーベル
1953～56年のエマーシー，マーキュリー，ウイング盤

　1950年，レナードは写真家を兼ねた客としてエラ・フィッツジェラルドの誕生パーティーに招かれた。招待客はほかに，デューク・エリントン，ディジー・ガレスピー，レイ・ブラウン，ベニー・グッドマン，ナット・キング・コール・ジョージ・シアリングなどなど挙げだしたらきりがなかった。しかし，そんななかでレナードは初めてエマーシーのアーチスト兼レコーディング・マネージャーであるボビー・シャッドに会った。その後ふたりはエマーシの事務所で会い，それから数年にわたって，レナードはレコーデイング・セッションで写真を撮ることになった。

　エマーシー盤にもレナードの名前が表示されたジャケットが数枚あるが，手落ちなのか方針なのか，エマーシーはめったにジャケットを手がけた写真家やデザイナーの名前を載せなかった。この損失は大きい。クリフォード・ブラウンとマックス・ローチの共演盤やエロール・ガーナーの諸作といったエマーシー・レーベル盤は，ジャズ・ファンなら必ず持っている名盤となって，幾度となく再版を重ねてきたからだ。だが，嬉しいことに，今それがハーマン・レナードの写真だとわかったのである。

　レナードと私は多くのエマーシー盤のジャケットを調べて，レナードの作品を見つけだした。

Emarcy 36008
clifford Brown/Max Roach-Brown and Roach Incorporated
Emarcy 36037
Clifford Brown - Study in Brown
クリフォード・ブラウンとマックス・ローチのセッションは，戦後きっての創造力ある小グループ・セッションである。クリフォード・ブラウンはわずか4年という劇的に短い実働録音期間の絶頂にあった。大半のエマーシー盤と同様，これらにもレナードの名前はない。

Emarcy 36037

Emarcy 36007
Clark Terry - Clark Terry

Emarcy 36004
Sarah Vaughan - Sarah Vaughan (with Clifford Brown)

Emarcy 36011
Dinah Washington - For Those in Love
(Dinah Washington impressed Leonard as a very strong woman that no man could boss around.)

Emarcy 36040
Herb Geller - Herb Geller Sextette

Emarcy 36007
Clark Terry -Clark Terry

Emarcy 36004
Sarah Vaughan - Sarah Vaughan(With Clifford Brown)

Emarcy 36011
Dinah Washington - For Those in Love
レナードはダイナ・ワシントンから，どんな男の言いなりにもならない強い女だという印象を受けた。

Emarcy 36040
Herb Geller - Herb Geller Sextette

Emarcy 36007

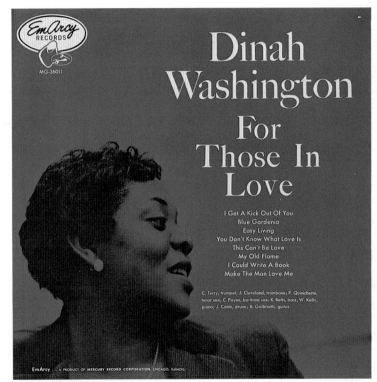

Emarcy 36011

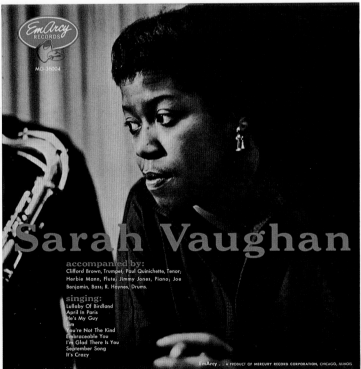

Emarcy 36004

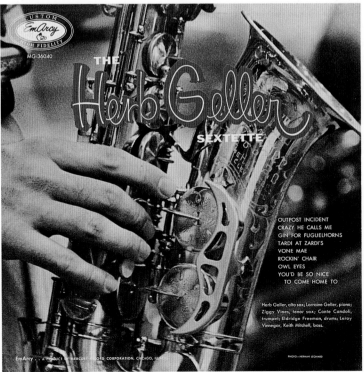

Emarcy 36040

Emarcy 36047
Terry Gibbs - Terry Gibbs

Emarcy 36103
Terry Gibbs - Swingin'

Emarcy 36056
Gerry Mulligan -Presenting The Gerry Mulligan Sextet
(Shot at the 1955 Newport Festival. Mulligan was
walking through the castle-like building of the
Belacourt Estate to the stage. Leonard caught Mulligan
in a ray of light. **Emarcy** removed the ray of light in the
design for the cover.)
Original photograph.

Emarcy 36047
Terry Gibbs - Terry Gibbs
Emarcy 36103
Terry Gibbs - Swingin'

Emarcy 36056
Gerry Mulligan - Presenting The Gerry Mulligan Sextet

1955年のニューポート・ジャズ祭にて撮影。マリガンが城の
ようなベラコート・エステートの建物を抜けてステージに
向かう途中，レナードは一筋のライトに浮かぶマリガンの
姿を写した。エマーシーはその光を除いてジャケットに使
用した。オリジナル写真。

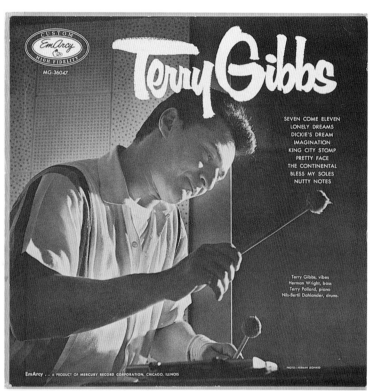

Emarcy 36047

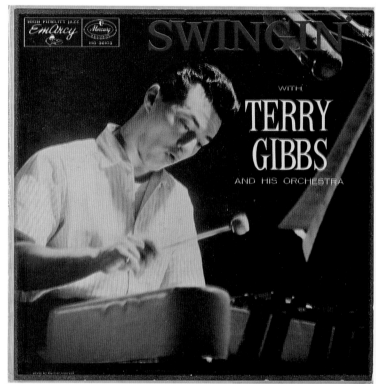

Emarcy 36103

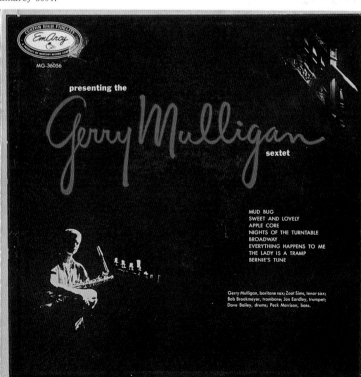

Emarcy 36056

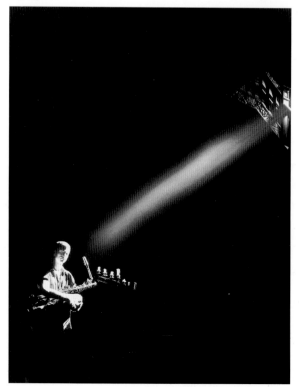

Emarcy 36063
Julian Cannonball Adderley - And Strings

Emarcy 36043
Julian Cannonball Adderley

Emarcy 36129
Billy Eckstine - Imagination

Mercury 20090
Erroll Garner - Afternoon of an Elf
(New York recording sessions. Garner, an impromptu composer recorded an ad lib composition 'Blues for Herman' at this session, which was not released.)

Emarcy 36063
Julian Cannonball Adderley - And Strings
レナードによるセッションの密着印画。

Emarcy 36043
Julian Cannonball Adderley

Emarcy 36129
Billy Eckstine - Imagination

Mercury 20090
Erroll Garner - Afternoon of an Elf
ニューヨークにてレコーディング・セッション。即興の名手ガーナーは，このセッションで『ブルース・フォー・ハーマン』と題するアドリブ曲を録音したが，発表はされなかった。

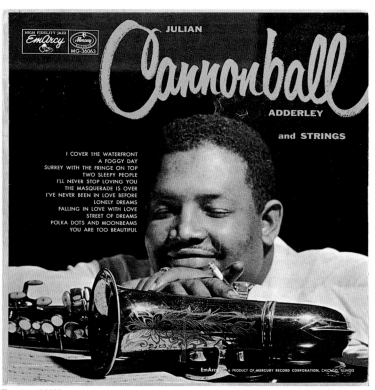

Emarcy 36063

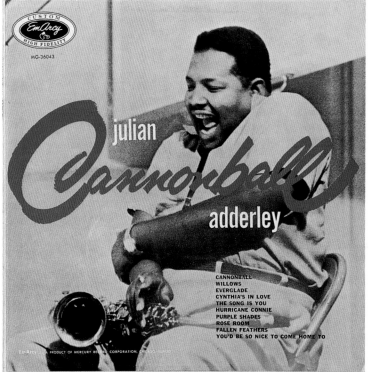

Emarcy 36043

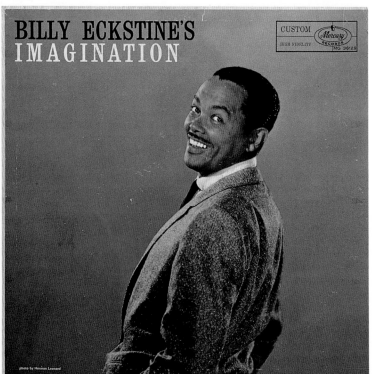

Emarcy 36129

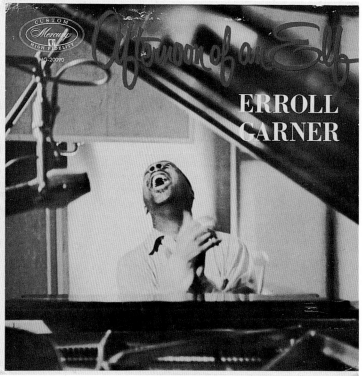

Mercury 20090

Mercury 20329
Blue Stars of France – Pardon my English
(The Blue Stars, were a singing group who worked out
of France. Shot during Leonard's Paris days.)

Wing 6004
Jackie Paris – Songs by Jackie Paris
Jackie Paris – Can't Get Started With You
(The same record but issued nearly simultaneously
with two different covers. Both by Leonard. Collectors
refer to the first as the 'on the beach' cover. It was shot
at Coney Island, New York city as a general composi-
tion; not intended as a record jacket. Wing – a subsidi-
ary of Mercury – for reasons of their own soon swit-
ched to the portrait cover, which is also by Leonard.)

Mercury 20329
Blue Stars of France – Pardon my English
ブルー・スターズはフランス出身のボーカル・グループだっ
た。レナードがパリ在住中に撮影。

Wing 60004
Jackie Paris – Songs by Jackie Paris
Jackie Paris – Can't Get Started With You
ほぼ同時期にジャケット違いで発売された2枚。どちらも
レナードの写真だが，コレクターには最初の「浜辺」のジャ
ケットの方が人気がある。これはニューヨークのコニーア
イランドでごく普通に撮影したもので，ジャケットに使う
予定ではなかった。まもなくマーキュリーの子会社ウイン
グは，社側の事情から同じくレナードの撮った人物写真の
ジャケットに変えた。

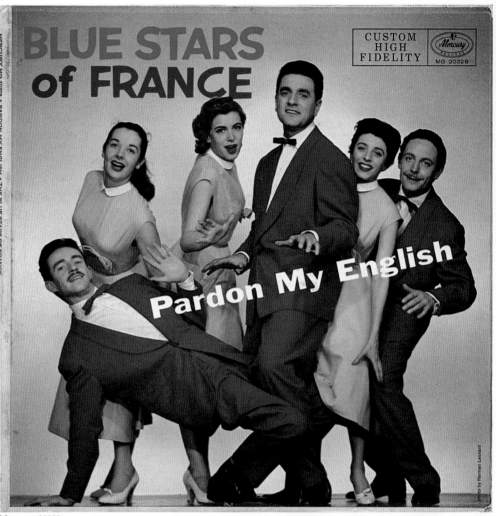

Mercury 20329

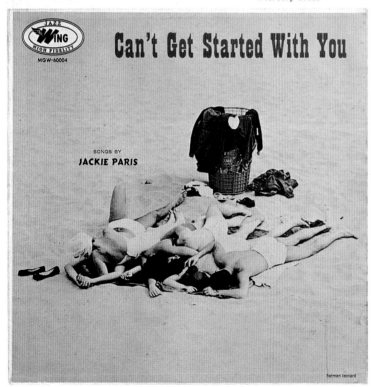

Wing 6004

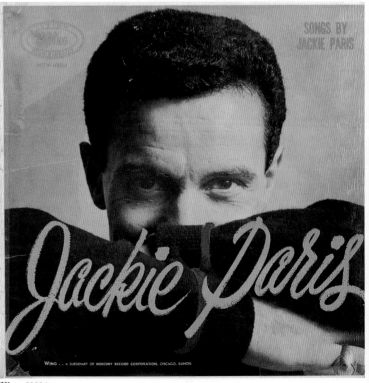

Wing 60004

OTHER LABELS

Jazzland 50
Fats Navarro - Classics of Modern Jazz
(Fats was for so many jazz listeners, the trumpeter. This shot is 1948, New York. Fats died two years later - he was only 27 years old. He left us with limited recordings - and even fewer photographs. Leonard's photo of Navarro - shown here - has been too often 'borrowed'.)
The original photograph.

Savoy 12079
Charlie Parker - The Charlie Parker Story

(Savoy hardly ever credited its cover photographers or designers. No doubt about this one.)
The original photograph.

その他の主なレーベル

Jazzland 50
Fats Navarro - Classics of Modern Jazz
多くのジャズファンにとって，ファッツはまさにトランペッタ中のトランペッターだった。ジャケットの写真は1948年，ニューヨークにて撮影された。この２年後にファッツは他界，27才の若さだった。彼が残した録音は多くない。写真となるとなおさらだ。レナードが撮ったこのナバロの写真は，いろいろなところに使われている。オリジナル写真。

Savoy 12079
Charlie Parker - The Charlie Parker Story
サヴォイはジャケットを手がけた写真家やデザイナーの名前をほとんど載せなかった。これもその１枚である。オリジナル写真。

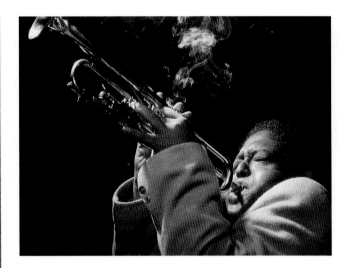

Jazzland 50

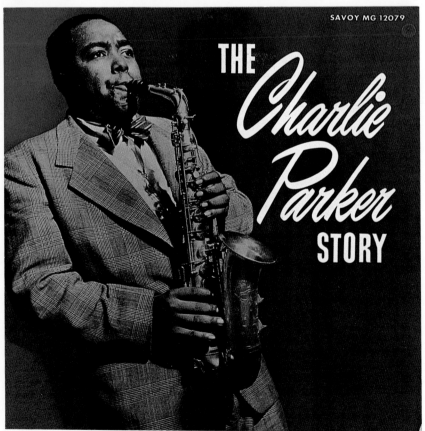

Savoy 12079

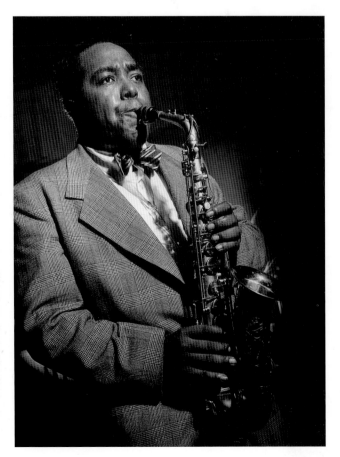

United Artists 14010
Billy Strayhorn - The Peaceful Side
Design: Frank Gauna

Barclay 5
Stephane Grappelly - et son Grand Orchestre a Cordes
(From Leonard's Paris days, 1958/59. Shot in an old
Parisian studio with skylights.)

Barclay 82-161
Eddie Barclay - Confetti
(The Eddie Barclay Grand Orchestre playing Quincy
Jones arrangements. A fun cover with Barclay and
Jones in a shower of confetti.)

Barclay 17
Eddie Barclay - Eddie Barclay et son grand orchestre
(Eddie Barclay liked to mix old and new pop songs
played by big bands.)

United Artists 14010
Billy Strayhorn - The Peaceful Side
Design: Frank Gauna

Barclay 5
Stephane Grappelly - et son Grand Orchestre a Cordes
1958，59年，パリ在住中にレナードが撮った写真から。天
窓のある古いパリのスタジオにて撮影。

Barclay 82-161
Eddie Barclay - Confetti
クインシー・ジョーンズの編曲による，エディ・バークレー・
グランド・オーケストラの演録。紙ふぶきを浴びるバークレ
ーとジョーンズを写した愉快なジャケット。

Barclay 17
Eddie Barclay - Eddie Barclay et son grand orchestre
エディ・バークレーは新旧のポップソングを取り合わせて，
ビッグ・バンドで演奏するのを好んだ。

United Artists UAJ 14010

Barclay 5

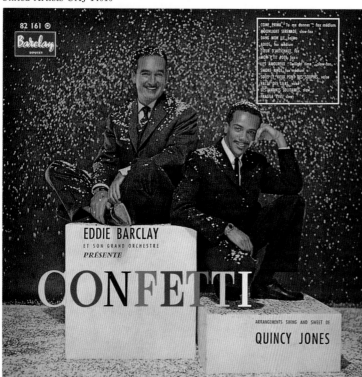

Barclay 82-161

Barclay 17

Barclay 844 006
Dizzy Gillespie - and his Operatic Strings Orchestra
(Recorded 1952 and 1953 in Paris. The cover photograph too is from a Paris concert.)

Barclay 84058
Thelonious Monk - Thelonious Monk Trio
(A Barclay issue of 1952 recordings using a still earlier Herman Leonard photograph.)

Antilles AN 8742
Andy Sheppard - Introductions in the Dark
(To end the Herman Leonard section with a musician portrait in his classic and immediately recognizable portrait style. Recorded and photographed in London, 1988.)

Barclay 844 006
Dizzy Gillespie - and his Operatic Strings Orchestra
1952, 53年，パリにて録音。ジャケット写真もパリのコンサートのもの。

Barclay 84058
Thelonius Monk - Thelonius Monk Trio
1952年録音のバークレー版。初期の写真を使った作品。

Artilles AN 8742
Andy Sheppard - Introductions in the Dark
ハーマン・レナードの章を終わるにあたって，いかにも彼らしいスタイルのポートレートショットを取り上げてみた。録音・撮影ともロンドンで行なう。1982年の作品。

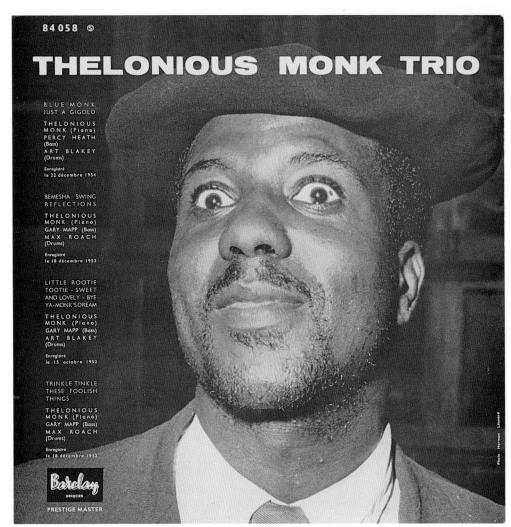

Barclay 84058

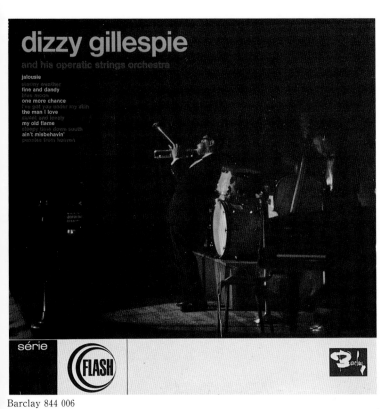

Barclay 844 006

Antilles AN 8742

GIL MELLÉ

ギル・メレ

In any aspect of rare and beautiful Jazz album covers, Gil Mellé's position is totally unique. The recordings he made were without exception, important and way ahead of his time. It took many years for even astute listeners to catch up with them. As a leader, he made 8 records between 1953 and 1958, almost all his own compositions. His sound colors were extremely advanced in that his quartets were not based around a piano. They had instead a tuba or a french horn which were exceptionally difficult instruments to write jazz for. These records are high on the want lists of collectors.

Mellé's uniqueness in that he is the one of the very few, perhaps the only, jazz musician who also designed great record jackets. Not just for his own records, but also for landmark recordings of Thelonious Monk, Miles Davis, Sonny Rollins, Tadd Dameron etc. That these jackets are not immediately associated with Gil Mellé is because he signed his name unobtrusively, only to be found if you scoured the record for it.

It doesn't end with these records. As an artist, numerous of his paintings are in museums and private collections. He is also one of the world's most important private collectors and an international authority on microscopes. Researchers from all over the world study his collection of microscopes; he is now in his 18th year as President of the Los Angeles Microscopic Society. His main work however, lies in composing and recording entire scores for the movie and television industry. His first movie score was 'The Andromeda Strain'——a totally electronic score. Since then, he has written music for countless movie and TV films. He still paints, composes for pleasure and works on his collection of vintage automobiles.

Let me set aside his many achievements and get back to his rare and beautiful records and jackets.

Mellé (the name is a kind of professional change from O'Malley) grew up in New York. The school orchestra needed an oboe player. Mellé wanted to be it, but he needed first to play a single reed instrument to develop his embouchure. A friend loaned him an alto saxophone. Mellé began to study as much as he could both in and out of school. In the 45 years since then, Mellé has remained interested only in jazz. He had no interest in bands or studio work. With neighborhood friends, he formed his first group.

By 1949 he was playing professionally. And a key date was Birdland 1951, when he was the third group playing opposite the groups of Charlie Parker and of Kai Winding. Mellé's original collection of 300 Duke Ellington records had expanded to include everything Parker had done. Mellé was in awe to be playing on the same stage. But Parker encouraged him not just to play but to play to his own writing. For Mellé it was the greatest encouragement any one could give him. Since then virtually everything Mellé has played are his own compositions, unique theme structures, and distinctive line ups of instruments. His music still remains far ahead of its time. His recordings of the 1950's were admired for being 'brave' in many ways. But it is only now that they are better understood.

The art and drawing part just came naturally. "I could always draw whatever I could see. I could look at a fountain, a tree or a person and sketch it. In school I was forever told that my father or someone else had done it and I had just put in my name. But I was just painting or drawing what I was seeing."

It was a chance introduction to Alfred Lion that changed Mellé's life. "Alfred Lion was the greatest man I ever knew. He became like my real father. He just took me over and straightened me out. He got me focused on other things in life which all came back to music. Alfred took me to museums, theaters, concerts, he opened my eyes to modern art. He asked me what do you like to do apart from music. I said I like to draw. He saw my drawings, called Paul Bacon, took me over to Paul's house. Paul was at his table designing a cover, asked me to watch and see what he did. And Alfred asked me to do the Charlie Christian and the Lionel Hampton covers. If not for

希少で美しいジャズ・アルバムのジャケットとなると，ギル・メレの存在は独特のものだ。彼の吹込んだ音楽はみな意義深く，常に時代の先を行っていた。目先の利くジャズ・ファンでさえも，理解するまでには何年もかかった。1953年から58年にかけて，メレは8枚のリーダー作を録音。そのほとんどが自らの作曲であった。彼のサウンドは極めて斬新で，カルテットの中心はピアノではなく，ジャズにするのがとりわけ難しいチューバかフレンチホーンだった。これらのレコードはコレクターの間でかなり高い人気を呼んでいる。

メレの特異さは，彼が優れたレコード・ジャケットもデザインしたまれな，いや，おそらくは唯一のジャズ・ミュージシャンだということにある。自分の作品のジャケットだけではない。セロニアス・モンク，ソニー・ロリンズ，タッド・ダメロンなどの名盤のジャケットも手がけた。ただ，これらのジャケットがすぐにギル・メレと結びつかないのは，署名がひどく控え目で，よくよく探さないと見つからないからなのだ。

ジャケットだけではない。アーチストとして，200枚を越えるメレの絵が博物館や個人のコレクションにおさめられている。また，彼は世界でも指折りの顕微鏡の個人収集家であり，世界的な権威でもある。世界中の研究者がメレの顕微鏡コレクションを訪れ，彼はロサンゼルス顕微鏡協会の会長として今年で18年目を迎えた。しかし，メレの本業は映画やテレビの背景音楽を作曲し録音することだ。最初に担当した映画音楽は『ザ・アンドロメダ・ストレイン』(邦題『アンドロメダ病原体』)で，全編電子音楽であった。以来，数知れない映画やテレビ映画の音楽を作っている。今でも彼は趣味で絵や曲作りをつづけ，ロールスロイスのクラシックカーのコレクションに励んでいる。

こうした多くの功績はさておいて，メレの希少ですばらしいレコードやジャケットに話を戻すとしよう。

メレ（いわば芸名。本名オマレイ）は，ニューヨークで育った。学校のオーケストラがオーボエ奏者を募集していて，彼はそれに名乗りをあげるが，最初はシングル・リードの楽器で鍛える必要があった。友人からアルト・サックスを賃借りし，メレは学校となく家となく時間のある限り練習しはじめた。それから45

年，ジャズ一筋に生きることになる。楽団やスタジオの仕事にはまったく興味がなかった。彼は近所の友人たちと最初のバンドを作った。

1949年には，メレはプロとして演奏。そして，1951年，『バードランド』で運命の日が訪れる。この日，彼はチャーリー・パーカーとカイ・ウインディングのグループの前座として三番目のグループで演奏することになっていた。デューク・エリントンのレコードを300枚集め，さらにパーカーの作品も全部そろえていたメレは，その本人と同じステージで演奏することに畏怖の念を抱いた。だが，パーカーが彼を励ました。セットの合間にパーカーは，「おれは人の曲を自分流に演るだけだけど，君は君自身の曲を演奏するんだ」とメレを褒め，自分もちゃんと作曲できたらなあと羨ましがった。メレにとって，これはだれより大きな励ましとなった。以来，彼が演奏している曲は事実上すべて自らの作曲であり，比類ない主題構成と独特の楽器陣容を特徴としている。メレの音楽は常に時代のはるか先を走りつづけてきた。1950年代の録音は多くの意味で「勇敢」だと賞賛されたが，その価値が本当に理解されだしたのは，今日になってからのことである。

美術的な才能は生来のものだった。「目にしたものはいつでも何でも絵に書けた。噴水や木や人を見たら，それをスケッチできたんだ。学校時代，父親かだれかに描いてもらって自分の名前を加えただけなんじゃないか，っていつも疑われたよ。でも，私はただ自分の見ているものを描いていただけなんだ」

たまたまアルフレッド・ライオンに紹介されたことが，メレの人生を変えた。「アルフレッド・ライオンほどの人物に会ったのは初めてだった。彼は実の父親みたいな存在になった。私を引き受けてくれ，ちゃんとした方向に進ませてくれた。いずれ音楽の栄養素となるような人生の様々な事柄に触れさせてくれた。しょっちゅう博物館や劇場やコンサートに連れていって，現代芸術に目を開かせてくれた。アルフレッドには子供がいなかったから，私を養子にしたい気持ちもあったんだと思う。音楽のほかになにをしたいかと訊かれて，絵が描きたいと答えたことがあった。彼は私の絵を見ると，ポール・ベーコンに電話して，私をポールの家まで連れていった。ポールはジャケットのデザインを机に向かってしているところで，私によく見るように言った。そうして，アルフレッドからチャーリ

Alfred I would never have done an album cover."

Mellé was the first of the **Blue Note** family to hear of Rudy Van Gelder. Van Gelder was an optometrist. But his real love was sound engineering. His home doubled as a recording studio. The home studio was designed around the second Ampex tape recorder ever made. Till then, recordings had been made on disc——tape was a new and unknown sound technology. But Mellé studied what magnetic tape was about and went to meet Van Gelder. Mellé returned convinced enough to request Alfred Lion to use Van Gelder's techniques for **Blue Note**. The experimental guinea pig turned out to be Mellé's own recording. It became the first of countless **Blue Note's** to be recorded under Van Gelder's supervision. Five years later Mellé was recording for **Prestige**. And once again his recording became the first of innumerable **Prestige** sessions recorded with Rudy Van Gelder.

In 1964, Mellé left New York City for Los Angeles. He continued to perform at Festivals, occasionally in clubs. But it became more and more difficult to keep employed a full-time band with top musicians capable of playing his advanced music. Mellé turned to the movies. He wrote music for specialised films produced by the National Geographical Society and Scientific American. His big break came in 1968 when he was contracted for the movie of the best seller 'The Andromeda Strain'——he wrote a highly acclaimed, often copied, trailblazer of an all electronic music score. **"When I work on a film score, it is not a playing job; it is composing music. I do what I want. But it has to be good to sell the ideas which are in the movie. I have the choice of the greatest musicians in the world——all seem to wind up in Los Angeles. I write solo material for great violinists. Film writing is the only place left for serious orchestral writing. It is not in concert halls because if you get a commission you can't live on the money; it will be performed once, it will not be recorded and the next album will be back to traditional classics. How many modern composers are recorded?"**

His collection of microscopes goes back 25 years. He attends museum symposiums and conferences four times a year. **"My hobby is the history of scientific instruments. Next to the wheel, the microscope is the most important invention. What we know of the world and the universe came from it. As an artist I go by gut instinct and never by formulas. So for a hobby I want a science which deals with the absolute and which can be discussed in conformity with scientists all over the world."**

Gil Mellé has the freedom to live the way he wants to. And to choose from various options. He paints when the urge or time presents itself, or if the subject appeals to him. Fortunately, the cover of this book did appeal to him. My grateful thanks, Gil, for taking the time and the interest to do it.

Some explanation about the jackets which follow.

They are in two categories. First, recordings made by Gil Mellé's groups—— the jackets of some of which are also designed by him. Second, jackets designed by Mellé for recordings made by other musicians. The records for **Blue Note** are from 1952 to 1956. Those on **Prestige** are 1956 and 1957. On these records, Mellé plays the family of saxophones——alto, tenor and baritone. Except for an occasional 'standard' the music is of his own composition.

The one exception is the 'Mindscape' album which though on **Blue Note** was recorded and issued in 1989 as a tribute to the memory of Alfred Lion. It features Mellé on many instruments——mostly keyboards.

Thirteen of the **Blue Note's** are 10" records——whose jackets have basically not been used outside of the very limited first issue. The 12" jackets are much better known——both the music and the jackets have been reissued several times. The 12" jackets shown here are the first issues.

ー・クリスチャンとライオネル・ハンプトンのレコードジャケットをデザインしてみないかと言われたんだ。アルフレッドがいなかったら，ジャケットなんて手がけなかっただろうね」

メレはブルーノートの中で最初にルディ・ヴァン・ゲルダーの噂を耳にした。ヴァン・ゲルダーは検眼士であったが，心底好きなのは音響技術だった。彼の自宅は録音スタジオも兼ねていて，アンペックス・テープレコーダーの2番目のモデルを完備していた。それまで録音はディスクにされていたから，テープはまだ新しい未知の音響技術だった。しかし，メレは磁気テープがどんなものか研究し，ヴァン・ゲルダーに会いに行った。そして確かな手応えを得て帰ると，ブルーノートにヴァン・ゲルダーの技術を使うようアルフレッド・ライオンに求めた。結局メレ自身がモルモットになり彼の録音で試してみることになる。それがヴァン・ゲルダーの監督下で録音された数えきれないブルーノート盤の第1号となった。5年後，メレはプレスティッジ・レーベルに吹込み，これもまたルディ・ヴァン・ゲルダーが録音を担当した無数のプレスティッジのセッションの第1号となった。

1964年，メレはニューヨークからニューオリンズに移り，フェスティバルやときおりジャズ・クラブで演奏をつづけた。しかし，フルタイムに雇われることが難しくなり，また，彼の進歩的な音楽を演奏できるだけのトップミュージシャンをそろえたようなバンドを維持するのが次第に困難になってきた。メレは映画に転向。米国地理学協会やサイエンティフィック・アメリカン社製作の専門映画の音楽を担当した。大きな転換期が訪れたのは，1968年，大ヒットした映画『アンドロメダ病原体』の音楽を引き受けたときだった。彼の作った電子音楽は絶賛を浴び，何度も複製され，電子音楽の草分けとなったのである。「映画音楽では，演奏ではなくて作曲が私の仕事だ。私は自分の好きなようにやらせてもらってるよ。もちろん映画の意図を伝えるものじゃなければならないがね。演奏には世界的な大物ミュージシャンを起用するーみんな最後はやっぱりロサンゼルスなんだな。名ヴァイオリン奏者のためのソロも作る。映画は本格的なオーケストラの曲を発表するために残されたたった一つの場所なんだ。コンサートホールじゃだめだ。

手数料をもらったって，それじゃあ食べていけない。公演したらそれきりで，録音されることはないし，次のアルバムはまた昔ながらの名作だ。いったいどれだけの現代の作曲家の作品が録音されてるっていうんだい？」

メレの顕微鏡のコレクションは25年前から始まった。彼は年に4回も博物館のシンポジウムや会議に出席している。「私の趣味は道具史の研究でね。顕微鏡は車に次ぐ人類の偉大な発明だよ。顕微鏡のおかげで，世界や宇宙のことがわかってきたんだ。アーチストは本能的なもので，お決まりのやり方に従っているわけじゃない。だから，趣味の方は絶対的なものを扱い，世界中の科学者と一つになって話し合えるような科学がいいんだよ」

ギル・メレは自分の思うままに自由に生き，様々な選択肢から自由にやりたいことを選べる。だから，彼は自分が絵を描きたいと思ったときか，主題が気に入ったときにしか描かない。さいわい本書の表紙の仕事は気に入ってもらえた。時間をさき熱心に描いてくれたギルに，心からお礼を言いたい。

以下，ジャケットについて少し説明しよう。ジャケットは2つに分類した。ひとつはギル・メレのグループが吹込んだもので，そのいくつかはジャケットもメレがデザインしている。もう一つは，メレがジャケットをデザインした他のミュージシャンのレコードである。ブルーノート盤は1952年から57年，プレスティッジ盤は1956年から57年の作品。これらのレコードでメレは，アルト，テナー，バリトン等のサックス陣のひとりとして演奏している。ときどき収録されている「スタンダードナンバー」を除いて，すべて彼の作曲した作品である。

ただし『マインドスケープ』というアルバムだけは例外だ。これはブルーノート盤であるが，1989年にアルフレッド・ライオンの追悼盤として録音し発売されたもので，メレはキーボードを中心に多くの楽器を演奏している。

ブルーノート盤のうち13枚は10インチ盤で，ジャケットはごく少数の初発盤にしか用いられていない。12インチ盤のジャケットの方は，音楽ともども再版を重ねているためずっとよく知られている。ここでは初回プレスのものを紹介した。

Gil Mellé · MUSICIAN AND DESIGNER

Blue Note 5020 (10")
Gil Mellé Quintet/Sextet
New Face · New Sounds
Design : Gil Mellé
(Mellé's first leader album. His own cover design is based on his interest in science fiction and astronomy. This is also the first **Blue Note** recording made in the studio of Rudy Van Gelder.)

Blue Note 5054 (10")
Gil Mellé Quartet
Featuring Lou Mecca
Photo : Bill Hughes
(Photographed in concert at New York City's Town Hall. Mellé plays the best instrument he ever had, a 1932 Selmer make baritone saxophone. Sadly, this instrument was stolen at a later Monterey Festival. Mellé is still searching for an identical replacement.)

ミュージシャン兼デザイナーのギル・メレ

Blue Note 5020（10インチ盤）
Gil Mellé Quintet/Sextet-New Face/New Sounds
Design: Gil Mellé
メレの初リーダー作。自ら手がけたジャケットのデザインは、ＳＦ小説や天文学への興味に基づいている。ルディ・ヴァン・ゲルダーのスタジオで録音された最初のブルーノート作品でもある。

Blue Note 5054（10インチ盤）
Gil Mellé Quartet-Featuring Lou Mecca
Photo: Bill Hughes
ニューヨーク，タウンホールのコンサートにて撮影。メレはこれまでで最高の楽器，1932年セルマー製のバリトン・サックスで演奏している。残念なことに，この名器は後にモンタレー・ジャズ祭で盗まれ，彼は現在も同じサックスを探している。

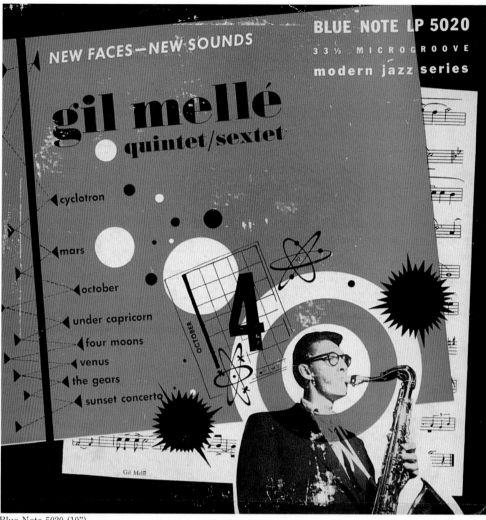

Blue Note 5020 (10")

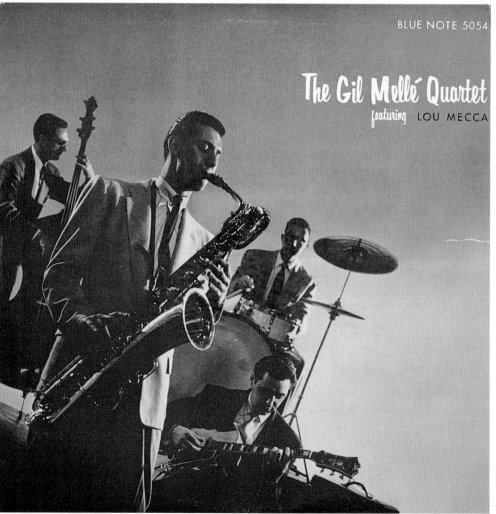

Blue Note 5054 (10")

Blue Note 5033 (10")
Gil Mellé Quintet
With Urbie Green and Tal Farlow
Design : Jerome Kuhl

Blue Note 5063 (10")
Gil Mellé Quartet
5 Impressions of Color
Photo : Francis Wolff
Design : Gil Mellé (1955)
(The few extended jazz suites recorded earlier were
written for and played by full orchestras. But Mellé's
suite 5 Impressions of Color (one side of the record) was
for a quartet. That too for a specific format——saxo-
phone, tuba, bass and drums——which remains as
'scary' to write for today as it was for Mellé 38 years
ago! The cover photo is of Mellé and the tuba player
Don Butterfield.)

Blue Note 1517
Gil Mellé Sextet
Patterns in Jazz
Photo : Francis Wolff
Design : Reid Miles
(The great bassist Oscar Pettiford played a crucial note
exactly as Mellé had written it and wanted it played.
But Pettiford with all respect to Mellé remained convin-
ced for the rest of his life, that it was a wrong note!)

Blue Note 5033 (10 インチ盤)
Gil Mellé Quintet-With Urbie Green and Tal Farlow
Design: Jerome Kuhl

Blue Note 5063 (10 インチ盤)
Gil Mellé Quartet-5 Impressions of Color
Photo: Francis Wolff
Design: Gil Mellé (1955)
これ以前の数少ないジャズ組曲は，フルオーケストラのた
めに書かれ，フルオーケストラで演奏された。しかし，メ
レの作った組曲『5・インプレッションズ・オブ・カラー』
〈片面〉は，カルテット，しかもサックス，チューバ，ベ
ース，ドラムスというフォーマットで演奏された。36年前
のメレがこんなこの曲を作曲したとは〝驚き〟だ！ ジャ
ケット写真はメレとチューバ奏者のドン・バターフィール
ド。

Blue Note 1517
Gil Mellé Sextet-Patterns in Jazz
Photo: Francis Wolff
Design: Reid Miles
名ベーシスト，オスカー・ペティフォードがある難しい音
を弾いた。まさにメレが音符にし，望んだどおりの音だっ
たが，彼を心底尊敬するペティフォードは，生涯これは間
違った音符だと確信していた！。

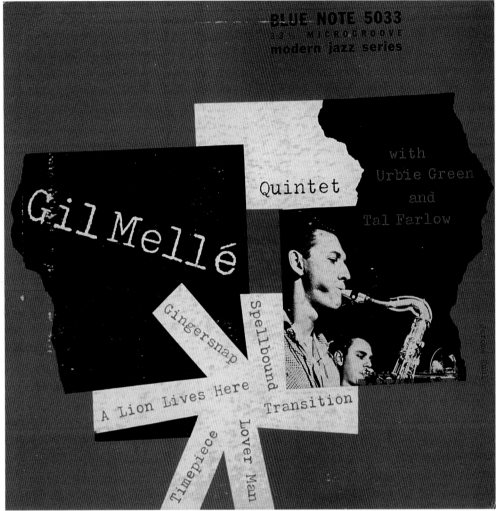

Blue Note 5033 (10")

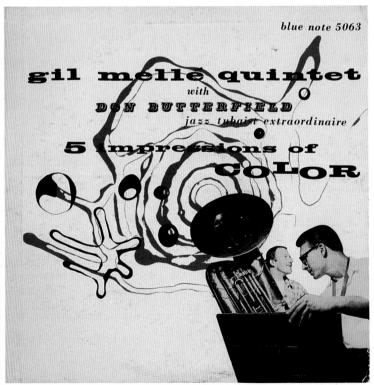

Blue Note 5063 (10")

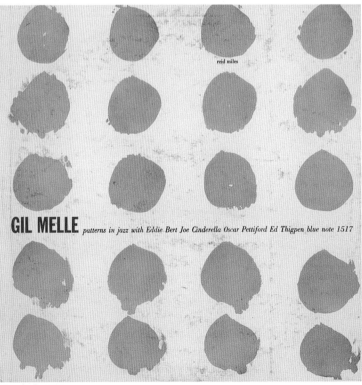

Blue Note 1517

Gil Mellé - DESIGNER

Blue Note 5026 (10")
Tracks by Edmond Hall - Charlie Christian - and others
Memorable Sessions
Design : Gil Mellé
(Mellé's first cover design. An early LP. A potpourri of earlier 78 rpm material collated on LP.)

Blue Note 5025 (10")
Wynton Kelly Trio
Piano Interpretations
Design : Gil Mellé
(Mellé was only 19 or 20 when he drew this. Trees are a subject often favored by him.)

Blue Note 5027 (10")
Various Artists
Swing Hi Swing Lo
Design : Gil Mellé

Blue Note 5046 (10")
Lionel Hampton
And his Paris All Stars
Design : Gil Mellé
(Recorded in Paris; leased by **Blue Note** from the French Vogue label. Hampton had just returned from Europe. Alfred Lion kept repeating, "**Hampton was a smash, he was a complete smash..** ". So Mellé decided to design a cover with a 'smash', a sheet of broken glass. Easier said than done though. It took 12 attempts at smashing glass in different ways and even more with the lighting, to get the final effect.)

Blue Note 7028 (10")
George Lewis
And his New Orleans Stompers Vol 4
Photo : Frank Wolf
Design : Gil Mellé
(Mellé was also the Artists & Repertoire Manager for this session. Cover drawn and designed with a New Orleans touch.)

Blue Note 5026 (10")

Blue Note 5027 (10")

デザイナーとしてのギル・メレ

Blue Note 5026 （10 インチ盤）
Tracks by Edmond Hall/Charlie Christian/and others
-Memorable Sessions
Design: Gil Mellé
メレが最初にデザインしたジャケット。78回転盤録音を編集した初期のLP盤。

Blue Note 5025 （10 インチ盤）
Wynton Kelly Trio-Piano Interpretations
Design: Gil Mellé
これを描いたとき，メレは若干19か20才だった。木は彼が好んで用いた画題。

Blue Note 5027 （10 インチ盤）
Various Artists-Swing Hi Swing Lo
Design: Gil Mellé

Blue Note 5046 （10 インチ盤）
Lionel Hampton-And his Paris All Stars
Design: Gil Mellé
パリにて録音。フランスのヴォーグ・レーベルよりブルーノートがリース。ハンプトンはヨーロッパから帰ったばかりだった。アルフレッド・ライオンはあちこちで「ハンプトンはきめてくれた。完璧にきめてくれたよ」と繰り返し，そこで，メレはジャケットで砕けた板ガラスを使って「スマッシュ」を表すことにした。だが，言うは易く行なうはかたし。あの手この手でガラスを打つこと12回，照明となるとさらに何度もやり直し，やっと満足のいく効果が得られた。

Blue Note 7028 （10 インチ盤）
George Lewis-And his New Orleans Stompers Vol. 4
Photo: Frank Wolf
Design: Gil Mellé
メレはこのセッションのアーチスト兼レパートリー監督であった。ニューオリンズの雰囲気を狙ったジャケット。

Blue Note 5025 (10")

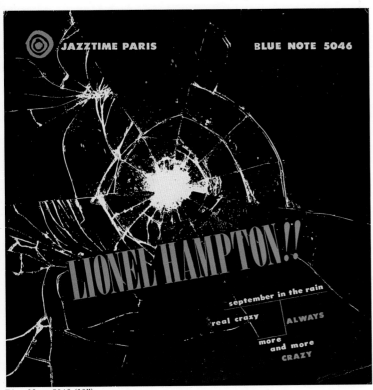

Blue Note 5046 (10")

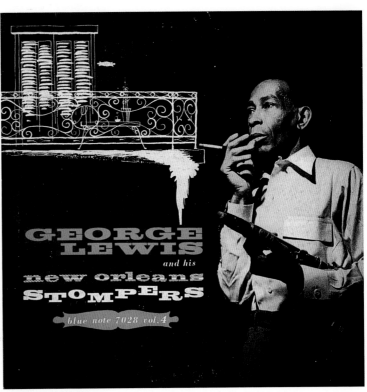

Blue Note 7028 (10")

Blue Note 5036 (10")
Urbie Green
Urbie Green Septet
Photos : Francis Wolff
Design : Gil Mellé

Blue Note 5047 (10")
Clifford Brown Quartet
Jazz Time Paris
Photo : Francis Wolff
Design : Gil Mellé
(Mellé's drawing of Clifford Brown was scheduled to be
the inset. But Alfred Lion felt Mellé had drawn Clifford's
nose too large. Mellé lost the good humored argument
about Clifford Brown's nose ! And Lion used a Francis
Wolff photograph instead.)

Blue Note 5036 （10 インチ盤）
Urbie Green-Urbie Green Septet
Photos: Francis Wolff
Design: Gil Mellé

Blue Note 5047 （10 インチ盤）
Clifford Brown Quartet-Jazz Time Paris
Photo: Francis Wolff
Design: Gil Mellé
初めはメレの描いたクリフォード・ブラウンの絵をジャケ
ットに使う予定だったが，アルフレッド・ライオンはクリ
フォードの鼻が大きすぎると考えた。クリフォード・ブラ
ウンの鼻をめぐる陽気な議論に，メレは敗北！　ライオン
はかわりにフランシス・ウルフの写真を用いた。大きすぎ
るかすぎないか，どうぞご判断を。

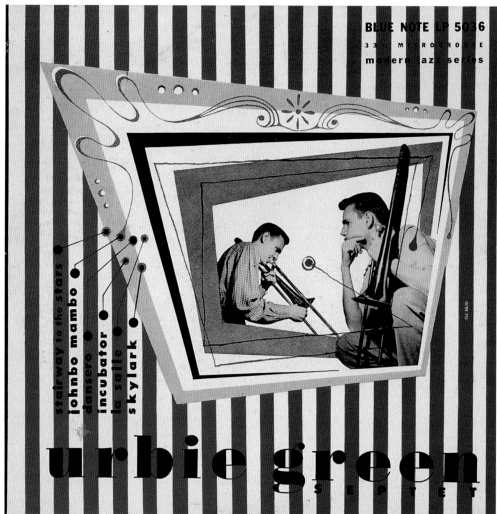

Blue Note 5036 (10")

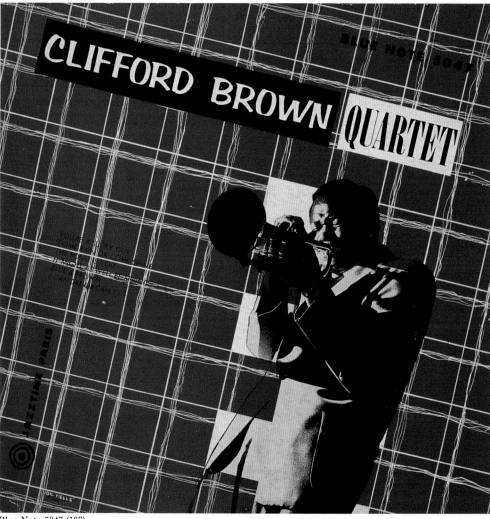

Blue Note 5047 (10")

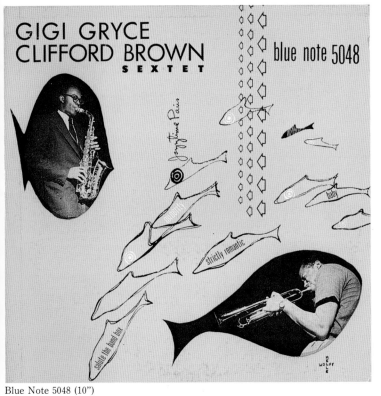

Blue Note 5048 (10")

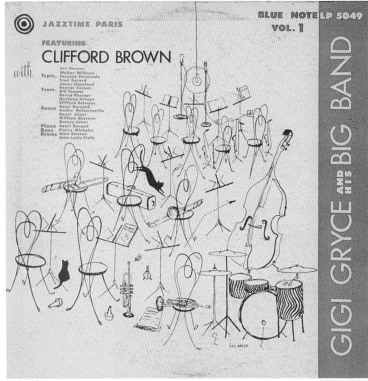

Blue Note 5049

Blue Note 5048 (10")
Gigi Gryce-Clifford Brown Sextet
Photos : Francis Wolff
Design : Gil Mellé
(Gil is not quite sure today why he designed this 'fish'
cover. He offers a possible but quirky explanation. For
jazz musicians the 'world' was the small area (like a
fish tank) between New York's 49th and 52nd Streets.
The musicians were like fish delighted to spend all their
time meeting and talking with other musicians. "If you
walked around there, you would meet every jazz
musician who was in New York then.")

Blue Note 5049
Gigi Gryce and his Big Band
Featuring Clifford Brown
Design : Gil Mellé
(Mellé's own family apartment was too cramped to
accommodate a drawing table. Often, Mellé worked in
Alfred Lion's spacious apartment. The problem there
was Alfred Lions's black cat named 'Ticky' who would
wander all around the artist Mellé. However 'Ticky'
became enough of a friend to become a part of this
jacket.)

Blue Note 5065 (10")
Kenny Dorham
Afro Cuban
Design : Gil Mellé
(Designed after visits to museums to study African
artifacts.)

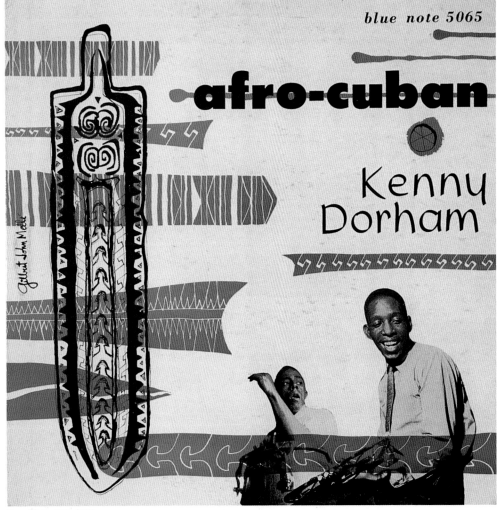

Blue Note 5065 (10")

Blue Note 5048 (10インチ盤)
Gigi Gryce-Clifford Brown Sextet
Photos: Francis Wolff
Design: Gil Mellé
メレはなぜこの「魚」のジャケットをデザインしたか，今
ではよくわからないと言う。この「魚」のジャケットにつ
いて，ありえなくはないがちょっと苦しい説明をしている。
ジャズ・ミュージシャンにとって「世界」は，ニューヨー
クの49番街から52番街の水槽のような狭い範囲で，彼ら
は魚みたいにいつも他のミュージシャンと会って話をして
いた，というのである。「そこを歩くと，ニューヨーク中の
ジャズ・ミュージシャンに会えたもんだよ」

Blue Note 5049
Gigi Gryce and his Big Band-Featuring Clifford Brown
Design: Gil Mellé
メレが家族と住む狭いアパートにはデッサン机を置く余裕
がなかったため，メレはよく広いアルフレッド・ライオン
のアパートで仕事をした。ただ悩みの種は，アルフレッド・
ライオンの飼う黒猫「ティッキー」がアーチスト，メレの
まわりを歩き回ることだった。しかし「ティッキー」はす
っかりなつき，このジャケットの一部におさまった。

Blue Note 5065 (10インチ盤)
Kenny Dorham-Afro Cuban
Design: Gil Mellé
博物館に通ってアフリカの工芸品を研究した後，デザイン
された。

Prestige 7014

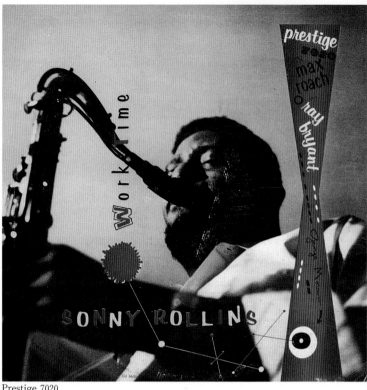

Prestige 7020

Prestige 7014
Miles Davis Quintet
The New Miles Davis Quintet
Photo : Probably - Gil Mellé
Design : Gil Mellé

Prestige 7020
Sonny Rollins Quartet
Work Time
Photo : Uncredited
Design : Gil Mellé

Prestige 7029
Sonny Rollins
Sonny Rollins with the Modern Jazz Quarterd
Design : Gil Mellé

Prestige 7014
Miles Davis Quintet-The New Miles Davis Quintet
Photo: Probably-Gil Mellé
Design: Gil Mellé

Prestige 7020
Sonny Rollins Quartet-Work Time
Photo: Uncredited
Design: Gil Mellé

Prestige 7029
Sonny Rollins
With the Modern Jazz Quartet
Design: Gil Melle'

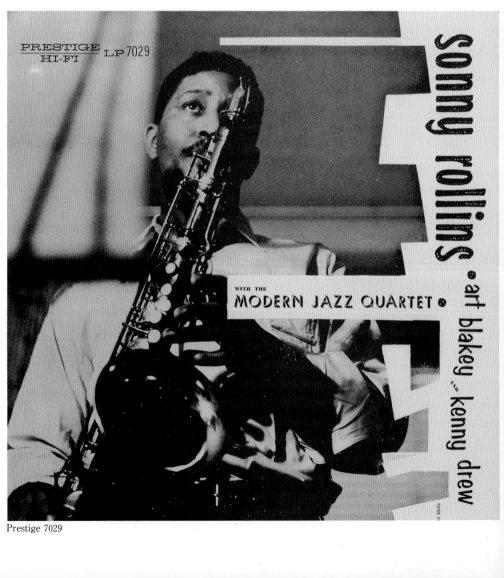

Prestige 7029

Prestige 7027
Thelonious Monk Trio
Thelonious Monk
Design : Gil Mellé
(Mellé's three favorite musicians are Thelonious Monk,
Duke Ellington and Bela Bartok. So many listeners
'like' Monk's music. But so few truly 'understand' it.
This abstract represents a stylized couple, wanting to
but not being quite able to understand the music.)

Prestige 7037
Tadd Dameron and his Orchestra
Fontainebleau
Design : Gil Mellé
(A landmark recording by the musician, Tadd Damer-
on, for whom Mellé has the highest respect.)

Prestige 7027
Thelonious Monk-Thelonious Monk Trio
Design: Gil Mellé
メレのお気に入りのミュージシャンは，セロニアス・モン
ク，デューク・エリントン，ベーラ・バルトークの3人だ。
モンクの音楽を「好む」聴き手は実に多いが，モンクの音
楽を本当に「理解」している者はごく少ない。この抽象画
は，モンクの音楽を理解したくても理解しきれずにいる男
女を表現している。

Prestige 7037
Tadd Dameron and his Orchestra-Fontainebleau
Design: Gil Mellé
ミュージシャン，タッド・ダメロンによる画期的な録音。
メレは彼を最高に尊敬している。

Prestige 7027

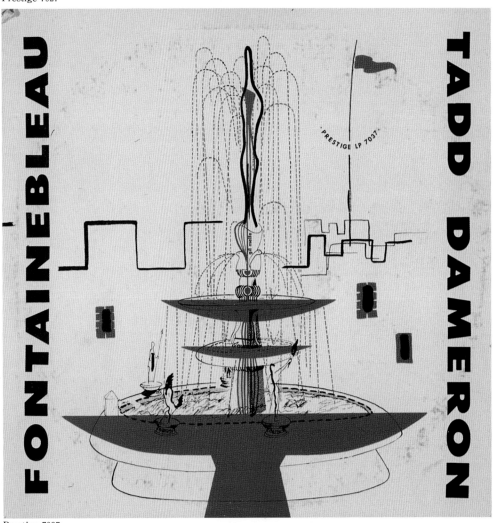

Prestige 7037

Prestige 7033
Jon Eardley
The Jon Eardley Seven
Photos : Uncredited
Design : Gil Mellé
(Mellé was given individual photos of the seven musi-
cians to be included in a design for this cover. The
photos looked as bad as prisoner mug-shots or at best
like passport photos. But Mellé's design took care of
this.)

Prestige - 7040
Gil Mellé Quartet
Primitive Modern
Photo/Design : Gil Mellé
(Mellé considers this his best record——so far! The
photo is of climbing bars in a children's park; on a rainy
day.)

Prestige 7063
Gil Mellé
Quartet + Guests
Photo : Uncredited
Design : Gil Mellé

Prestige 7033
Jon Eardley-The Jon Eardley Seven
Photos: Uncredited
Design: Gil Mellé
メレは，ジャケットのデザインに入れる7人のミュージシ
ャンの個々の写真を受け取った。その写真は囚人の顔写真
みたいにひどいか，パスポート写真みたいに妙にきれいに
写っているかの両極端だったが，メレはこれを見事に処理
している。

Prestige 7040
Gill Mellé Quartet-Primitive Modern
Photo/Design: Gil Mellé
メレはこれを自分の最高傑作としている。ただし，これま
でのところはだ！　写真は，雨の日の児童公園の登り棒。

Prestige 7063
Gil Mellé-Quartet+Guests
Photo: Uncredited
Design: Gil Mellé

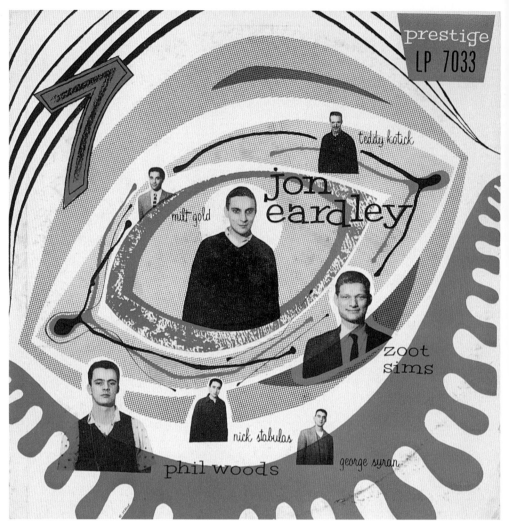

Prestige 7033

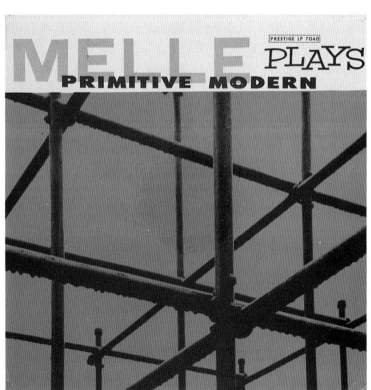

Prestige - 7040

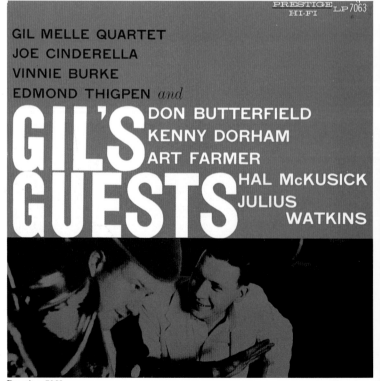

Prestige 7063

Prestige 7097
Gil Mellé Quartet
Quadrama
Design : Reid Miles

Blue Note 92168 (issued 1989)
Gil Mellé
Mindscape
Design : Gil Mellé
(Mellé's personal tribute to Alfred Lion of *Blue Note*.
All instruments and all compositions, recording, mix
and art work by Mellé. **"It was a one pass thing——
did it in five minutes after I heard that Alfred had
died. It's funereal——the kind of music that Alfred
liked."** The figure on the cover a Blue (Note) Lion
(Alfred) is also drawn by Mellé who cut and rearranged
the original art work to achieve the exact eerie feeling
he wanted.)

Prestige 7097
Gil Mellé Quartet-Quadrama
Design: Reid Miles

Blue Note 92168 (1989 年盤)
Gil Mellé-Mindscape
Design: Gil Mellé
ブルーノートのアルフレッド・ライオンにメレが個人的に
捧げた追悼盤。楽器，作曲，録音，ミックス，アート，す
べてメレが担当している。「思いつきだったんだ。アルフレ
ッドが亡くなったと聞いて，5分で決めていた。これは葬式
なのだ―アルフレッドが好きそうだった音楽だよ」
ジャケットのブルー〈ノート〉のライオン〈アルフレッド〉
の絵もメレが描いた。オリジナルの作品を切り取って配置
しなおし，狙いどおりの無気味な雰囲気を出している。

Prestige 7097

Blue Note 92168 (issued 1989)

PIERRE MERLIN

ピエール・メルラン

One of the pleasures to put together a book of this kind is discovering new aspects of things we already know well. Another is encountering highly distinguished work for the very first time. Having said that, I must admit that nothing quite prepared me for the impact delivered by the 'art of the jacket' interpretations of the French designer, Pierre Merlin. As Merlin himself points out, the influence of David Stone Martin is immediately apparent in his work, which is true enough. But then again no serious designer of the time could really escape the radiant DSM line. What matters is that Merlin always forces us to read between the lines: in the Merlin covers we step into another world, light years away from the American terrain to which we have grown so accustomed.

At this point, I remind readers, as detailed in my introduction, of my huge debt to Dr. Francis Hofstein for bringing Merlin to public attention. As also to Pierre Merlin himself for producing the printer's proofs from which many of the jacket reproductions are made. Without this help, this extensive presentation would have been impossible. For let us not forget——the Pierre Merlin covers were done between 1950 and 1954 for the 10" LP's of the *Vogue* and *Swing* labels of France when the LP was still a novelty. I do not imagine these records being printed in more than several hundred copies. Any collector fortunate to have these original issue records complete with their Merlin jackets does not own records——he has true acquisitions. For one can wade through innumerable auction or record sale lists without finding any of these records.

I am delighted to have the opportunity to unveil a part of the well kept secret of the Pierre Merlin jacket designs. The data and quotes used by me are from a 1988 taped interview of Pierre Merlin by Dr. Francis Hofstein.

Merlin was a musician for almost 10 years before be became a jacket designer and a jazz fan for another 10 years before that. His earliest memory of jazz was as a teenager in 1939. He had taken on a summer holiday his small portable gramophone, which stored 5 or 6 records, choosing a Tommy Ladnier -Mezz Mezzrow, a Sidney Bechet, a Louis Armstrong Hot Five and a Bix Beiderbecke. He continued collecting records, scavenging for these in the flea market of his native Bordeaux.

His first instrument was a table top drum set made from his toy construction set complete with coconut halves to serve as wooden blocks. His first real instruments alternated between a trumpet and a cornet. These he either rented or bought and resold, for his finances never permitted him to keep them permanently. In 1942 he got a scholarship to study at the Fine Arts School of Paris. The school had other amateur musicians too, but these were years of the German occupation when it was dangerous to play jazz. **"We could hardly play except at surprise parties. But that was risky, amateurish and the musicians were never the same."**

In Paris he met and occasionally played with Claude Luter. And through Luter he met and played also with Sidney Bechet. The experience with these two giants of the clarinet and soprano saxophone makes him comment **"I left Luter because I could not measure up to the task of accompanying Bechet. The speed with which Bechet expected one to respond to his instructions frightened me."** But this was just false modesty for Merlin was to continue to be a sought after cornet player all his life.

His career as a jazz album designer had followed immediately.

"Like all children I drew. But I had never stopped. Besides I had studied for 15 years at the Fine Art Schools in Bordeaux and Paris. I had a very classic education. I studied architecture, then passed on to painting, to engraving, to decoration. I could and used to draw everything. My first graphic jobs

　この種の本を編集する楽しみの一つは，すでによく知っている事柄の新たな面を発見できること，そしてもう一つは，卓絶した傑作にまさしく初めて出会えることである。先に述べたように，正直言って私は，「ジャケットは芸術なり」とするフランスのデザイナー，ピエール・メルランの作品から思いがけない衝撃を受けてがく然とした。メルラン自身が指摘するとおり，彼の作品にはデヴィッド・ストーン・マーチンの影響がまともに認められる。確かにそうではあるが，しかし当時，あの強烈な魅力を放ったデヴィッド・ストーン・マーチンの線の影響をまったく受けなかったデザイナーなどいようか。重要なのは，メルランの描く線には必ずその奥から迫ってくるものがあるということだ。彼のジャケットを見ていると，私達はなじみのあるアメリカ地域から何光年もかなたの別世界に足を踏み入れてしまう。

　ここで皆さんに思い出していただきたい。序文で詳しく述べたように，今回メルランを世に紹介するに当たって，フランシス・ホフスタイン博士に並々ならぬお力添えをいただいた。また，ありがたいことにピエール・メルラン本人にも，多くのジャケットを再現するための試験刷りを提供していただいた。この助けがなければ，これほど広範囲の作品を紹介することはできなかっただろう。なにしろ，ピエール・メルランのジャケットは1950年から54年，まだLP盤の走りのころにフランスのヴォーグとスイング・レーベルの10インチLP盤のために描かれたものなのだ。これらのレコードが数百枚以上も生産されたとはまず考えられない。運よくメルランのジャケットを備えた完璧なオリジナル盤を手に入れたコレクターも，自分がいかに価値ある貴重盤を持っているか気づいていまい。数知れないオークションやレコード販売の目録を隅から隅まで探しても，これらのレコードは見つからないからである。

　今回，これまで秘密のベールに閉ざされていたピエール・メルランのジャケット・デザインの一部を紹介できて，たいへん嬉しく思っている。資料と引用には，1988年にフランシス・ホフスタイン博士がピエール・メルレンにインタビューしたときの録音テープを使わせていただいた。

　ジャケット・デザイナーとなる前，メルランはミュージシャンとして10年近く，さらにその前にジャズ・ファンとして10年過ごしている。ジャズに関わるいちばん古い思い出は，1939年，10代の頃にさかのぼる。彼は夏休みにポータブルの小型蓄音機を手に入れ，5枚ばかりレコードを買った。トミー・ラドニアとメズ・メズロウの共演盤と，シドニー・ベシェ，ルイ・アームストロング・ホット・ファイブ，ビックス・バイダーベックの作品であった。それから，故郷ボルドーの蚤の市をあさってレコードを集めつづけた。

　メルランが初めて手にした楽器は，おもちゃの積み木で作ったミニチュアのドラムセットで，仕上げに積み木のかわりに二つに割ったココナッツを載せてあった。本物の楽器はというと，最初はトランペットとコルネットをかわるがわる使った。これらの楽器は借りるか，買ってまた売るかのどちらかだった。永遠に自分の手元に置くだけの金銭的な余裕はなかったのだ。1942年，彼は奨学金を受けて，パリの美術学校に学ぶ。学校にはほかのアマチュアのミュージシャンもいたが，ドイツの占領下にあった当時，ジャズを演奏するのは危険なことだった。「不意打ちパーティーぐらいで，あとはほとんど演奏はできなかった。それでも危険だった。素人とミュージシャンは決していっしょにはならないのだ」

　パリでメルランはクロード・ルッターに出会い，ときどき一緒に演奏した。そして，ルッターを通してシドニー・ベシェとも知り合い，共演した。このふたりのクラリネットとソプラノ・サックスの巨人との経験を，彼はこう語っている。「私がルッターにやめさせてもらったのは，ベシェの伴奏をちゃんと務める力がなかったからだ。なかなか演奏のスピードなどの点でベシェの指導どうりやれなくて，期待に添えなかったんだよ」と。しかし，これは誤った謙遜にすぎない。なぜなら，メルランは生涯コルネット奏者として引っぱりだこだったからだ。

　この後，メルランはジャズ・アルバムのデザイナーとしてスタートを切ることになる。「子供がみな絵を描くように，私も絵を描いた。ただ，私の場合はいつまでも描くのをやめなかったんだ。しかも，ボルドーとパリの美術学校で15年間も勉強した。まさに伝統的な教育を受けたんだ。建築学，それから絵画，彫刻，装

related to jazz were the decorations of the Hot Club of France at Bordeaux in 1940-41. But the first sketches on jazz were at the Festival of Nice in 1948 where Louis Armstrong and Mezz Mezzrow played. And from 1950 to 1953 I designed the covers for Vogue and Swing."

How did he work? What was he aiming for in his *Swing* and *Vogue* jackets? "My resources were very limited. They gave me the title of the record, sometimes some photos, sometimes the list of the titles. I would try to imagine the style of the orchestra when I did not know of them and sometimes I would request to hear them. At times the record company could only tell me the music was in this or that genre. I had to be very simple since I had only two colors of which one was black. It was line drawing with flat colors."

Merlin's covers reveal two strong characteristics. First is his admiration for and the influence of David Stone Martin. "DSM's work was the most interesting and he had done a large number of superb jackets. I could not help admiring him and being inspired by him, even involuntarily."

Merlin's covers show an almost constant influence of the same 'line' which DSM used.

The other characteristic is wit. "I always thought that jazz had a relationship with humor. Jazz musicians often have a sense for humor as otherwise the lives they lead would be too difficult. So I did not want to deprive myself of this element. I would also often try for graphics with a play on words."

In 1953, Merlin stopped designing jacket covers. His work in jazz continued with special commissions to design posters, programs, murals, wall decorals etc. On a professional level, he made a career of his training as an architect ——specializing in the design of railway stations. Though success in other fields came to him in constant measure, he does miss not designing more jackets. But "when one has passed on to methods of big publicity and when the media have come to have more influence on sales, one has passed from relatively modest processes to the use of color photography, processes in which expense is no more an object. During my time, if I may dare say so, it was craftsmanship."

All the Pierre Merlin jackets are 10" and were issued from 1950 to 1954. I have grouped these in three categories.

First, Traditional Jazz-recordings made in both Paris and America. Many performances by Sidney Bechet were originally recorded and issued in Paris. Several of these were issued in America on Blue Note 10" and can be found in that section of this book, but these Pierre Merlin's are the first issues.

In the second category are the French issues of original American recordings. Somehow the French companies leased these recordings without the use of the original design American jacket. My own feeling is that this was done to save in dollar costs. No matter what the reason was, it gave the opportunity to Merlin to design jackets which are consistently more striking than the original American ones.

The first and second categories are very rare in themselves, which makes the third category incredibly so. This third category is of recordings made in Paris by visiting or temporarily resident American musicians. Often, the records for contractual or other reasons were restricted to just these first and only issues. These are records which collectors, myself included, try all their lives to get. Ultimately, the Merlin covers are, without exception, gems of beauty. Merlin has obviously done more covers for the French labels of the time than can be shown here. It is a real need for collectors to bring these together to form a collection.

飾と学んだ。なんだって絵に描けたし，実際描いたもんだよ。最初にジャズに関連した美術の仕事をしたのは，1940，41年，ボルドーのホット・クラブ・オブ・フランスの装飾だった。でも，初めてジャズのスケッチをしたのは，1948年のニース・ジャズ祭だった。ルイ・アームストロングやメズ・メズロウが出演していたっけ。で，その後1950年から53年まで，ヴォーグとスイング盤のジャケットのデザインをするようになったんだ」

では，どのように彼は仕事をしたのだろう？　スイングとヴォーグのジャケットでなにを表現しようとしていたのだろう？「とにかく情報が少なくてね。レコードのタイトルと，ときどき写真や曲目のリストを渡されるていどだった。曲を知らないときはその楽団の演奏法を思い浮べようとしたし，聴かせてくれるよう頼んだこともあった。たまにレコード会社側も，こんな形式だとかあんな形式だとかしか言えないこともあった。黒ともう1色の2色しか使えなかったから，ひどく簡単な絵にするしかなかった。で，平塗の線画にしたんだ」

メルランのジャケットには二つの大きな特徴がある。一つは，彼がデヴィッド・ストーン・マーチンを崇拝し，その影響を受けていることだ。「デヴィッド・ストーン・マーチンの作品はだれより興味深かったし，彼は多くのジャケットの傑作を描いた。いやでも彼には感心したし，刺激されたよ」と言う。メルランのジャケットはほぼどれにもデヴィッド・ストーン・マーチンが用いた「線」の影響が見られる。

もう一つの特徴は，機知に富んでいるということだ。「私はつねづねジャズはユーモアとつながっていると考えていた。実のところ，ジャズ・ミュージシャンの多くはユーモアのセンスをもっていた。そうでなければ，人生を送るのは大変だったんだ。私は絶対そうなりたくはなかった。よくごろ合わせの絵も描いたものさ」

1953年，メルランはジャケットのデザインをやめ，ポスターやプログラム，壁画や壁の装飾などに限ってジャズ界の仕事をつづけた。また，駅舎のデザインを専門とする建築家としてもプロ顔負けの業績を上げた。こうして他の分野でも次々と成功をおさめたにもかかわらず，もうジャケットのデザインをしないことを寂しがってもいる。だが，彼は言う。「大規模な宣伝法が用いられ，マスコミが売上げに及ぼす影響が大きくなるにつれて，ジャケットも比較的地味な方法からカラー写真を使うようになってきた。しかも金はいくらでも出す。私の時代は，こう言ってはなんだが，肝心なのは職人の腕だったよ」

ピエール・メルランのジャケットはいずれも10インチ盤で，1950年から54年に発売されている。私はこれらを三つに分類した。

一つ目は，パリとアメリカで録音されたトラディショナル・ジャズ。シドニー・ベシェによる多くの演奏はもともとパリで録音，発売され，そのいくつかがブルーノートの10インチ盤としてアメリカで発売された。本書でもブルーノート・レーベルのところで紹介したが，これらピエール・メルランのものは初発盤である。

二つ目は，アメリカ盤をオリジナルとするフランス盤。しかし，なぜかフランスの会社は中身だけをリースして，アメリカのオリジナル盤のジャケットのデザインは用いなかった。おそらくドル経費を節約するためだったのではないかと思う。まあ理由はともあれ，そのおかげでメルランがフランス盤のジャケットをデザインすることになり，いずれもオリジナルのアメリカ盤をしのぐ秀作となった。

一つ目と二つ目だけでも非常に数が少ないため，三つ目のグループともなると驚くほど希少である。

その三つ目とは，アメリカのミュージシャンがパリを訪れたり，一時的に住んだりしたときに録音されたものだ。契約上の理由など諸事情から，しばしばこれらのレコードは初発にして廃盤となった。私はもちろん，コレクターたちが一生のうちにぜがひでも手に入れたい貴重盤である。

要するに，メルランのジャケットはどれも美しく貴重な宝石のようなものである。ここで紹介したジャケットのほかにも，彼が当時のフランスのレーベルにデザインしているのは明らかだ。これらをすべて集めた完全な作品集の作成が，コレクターのためにぜひとも必要である。

TRADITIONAL JAZZ
Recorded in both Paris and America

Pathe 1011
Surprise Partie au Palm Beach
Moustache Jazz Seven
(The drummer Francois 'Moustache' Galapides leads
his sextet in a June 1953 recording.)

Vogue 006
Sidney Bechet Avec Claude Luter & Son Orchestre
Sidney Bechet/Claude Luter
(Paris-October 6/9 1950. Some of these tracks were
later issued in America on the **Dial** label.)

Vogue 007
Claude Luter et son Orchestre du vieux Colombier
Claude Luter
(Paris, January 24 1950)

Vogue 008
Willie 'The Lion' Smith
Reminiscing the Piano Greats
(Paris January 29, 1950. In America, issued on the **Dial**
label.)

Vogue 012
New Stars – New Sounds
(A compilation of 78 rpm recordings, mainly from the
American Mercer label.)

Vogue 015
Sidney Bechet Avec Claude Luter & Son Orchestre
Bechet – Luter Favorites
(Paris, October 14 1949. Issued subsequently in America
on Blue Note.)

Vogue 017
Sidney Bechet/Mezz Mezzrow Quintet
Really the Blues
(The LP issue of a New York City August/September
1945 session.)

Vogue 033
Mezz Mezzrow with Claude Luter Orchestra
Mezz Mezzrow – Claude Luter
(Paris, October 30 1951)

Vogue 048
Sidney Bechet Avec Claude Luter et son Orchestre
Bechet – Luter On Parade
(Paris, January 18 1952.)

Vogue 049
Sidney Bechet and his All Stars – Ambiance Bechet
(Paris, January 21 1952)

パリとアメリカ録音の
トラディショナル・ジャズ

Pathe 1011
Moustache Jazz Seven-Surprise Partie au Palm Beach
ドラマー、フランソワ・'ムスターシュ'・ガラピデスがセク
ステットを率い、1953年6月に録音。

Vogue 006
Sidney Bechet Avec Claude Luter & Son Orchestre-
Sidney Bechet/Claude Luter
1950年10月6, 9日、パリにて録音。うち何トラックかは
後にアメリカでダイアル・レーベルから発売された。

Vogue 007
Claude Luter et son Orchestre du vieux Colombier-
Claude Luter
1950年1月24日、パリにて録音。

Vogue 008
Willie 'The Lion' Smith-Reminiscing the Piano Greats
1950年1月29日、パリにて録音。アメリカではダイアル・
レーベルにて発売された。

Vogue 012
New Stars-New Sounds
アメリカのマーサー・レーベルを中心とする78回転盤の編
集。

Vogue 015
Sidney Bechet Avec Claude Luter & Son Orchestre-
Bechet/Luter Favorites
1949年10月14日、パリにて録音。アメリカではブルーノ
ートにて発売。

Vogue 017
Really the Blues-Sidney Bechet/Mezz Mezzrow Quin-
tet
1945年8, 9月のニューヨークでのセッションをおさめた
LP盤。

Vogue 033
Mezz Mezzrow with Claude Luter Orchestra-Mezz
Mezzrow/Claude Luter
1951年10月30日、パリにて録音。

Vogue 048
Bechet/Luter On Parade-Sidney Bechet Avec Claude
Luter et son Orchestre
1952年1月18日、パリにて録音。

Vogue 049
Ambiance Bechet-Sidney Bechet and his All Stars
1952年1月21日、パリにて録音。

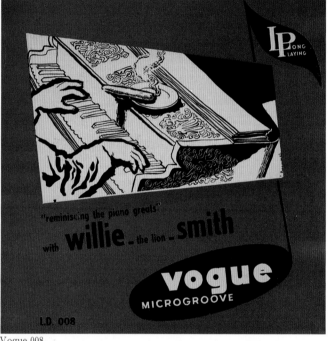

Vogue 008

Vogue 006

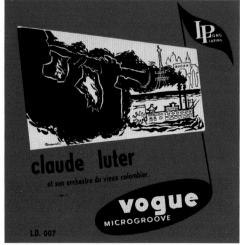

Vogue 007

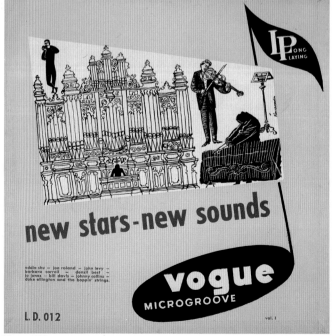

Vogue 012

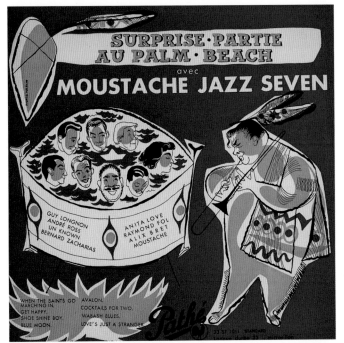

Pathe 1011

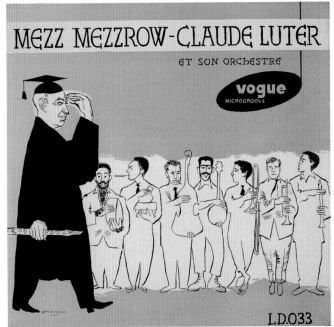

Vogue 033

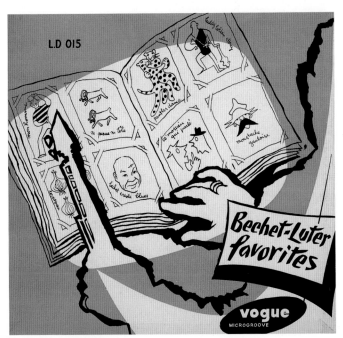

Vogue 015

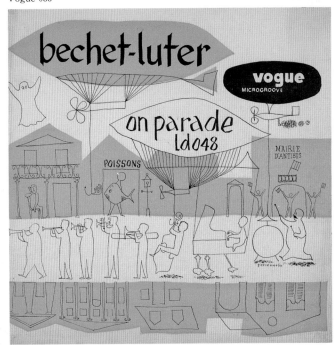

Vogue 048

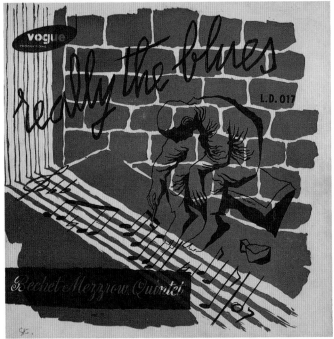

Vogue 017

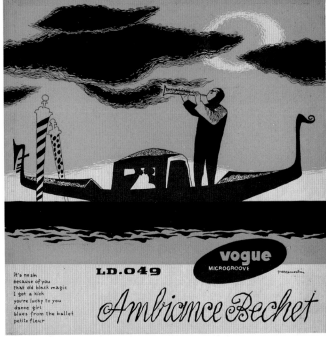

Vogue 049

71

Vogue 055
Kid Ory and his Creole Jazz Band
Dixieland Jubilee Vol. 2
Albert Nicholas Alexander's Jazz Band
(LP compilation of 78 rpm tracks from the American
labels, Crescent and Jazz Men.)

Vogue 061
Sidney Bechet and Claude Luter Quintet-Bechet-Luter
(A live recording from Salle Pleyel, Paris, January 31
1952. Issued in America by Blue Note.)

Vogue 070
Mezz Mezzrow and his Orchestra
Mezz Mezzrow "Jazz Concert"
(From two 1952 concerts——Paris and Algiers.)

Vogue 080
Claude Luter/Andre Reweliotty Quintet
Une Nuit A Saint Germain des Pres
(Paris, May 14 1952.)

Vogue 123
Mezz Mezzrow/Sidney Bechet Quintet
Mezzrow, Bechet, Avec Lips Page
(Hot Lips Page added on one track. The first LP issue
of New York City recordings of 1948.)

Vogue 135
Bobby Smith's Orchestra - Jazz at the Apollo
(78 rpm's of the Apollo label now compiled on LP.)

Vogue 142
Sidney Bechet with Andre Reweliotty Orchestra
Rendez - Vous Avec Sidney Bechet
(Paris 1953.)

Vogue 182
Buck Clayton with Alix Combelle's Orchestra
Danse Parade
(Paris, October 1953. Issued later in America on the
Storyville label.)

Jazz Society 6
King Oliver - Savannah Syncopators
(1926/27 recordings by King Oliver's Savannah
Syncopators put together for LP issue)

Vogue 055
Kid Ory and his Creole Jazz Band/Albert Nicholas
Alexander's Jazz Band-Dixieland Jubilee Vol. 2
アメリカのクレセントとジャズメン両レーベルの78回転
盤トラックを編集，ＬＰ化したもの。

Vogue 061
Sidney Bechet and Claude Luter Quintet-Bechet・Luter
1952年1月31日，パリのサル・プレイルにてライブ録音。
アメリカではブルーノートにて発売。

Vogue 070
Mezz Mezzrow and his Orchestra-Mezz Mezzrow "Jazz
Concert"
1952年，パリとアルジェで行なわれた二つのコンサートよ
り。

Vogue 080
Claude Luter-Andre Reweliotty Quintet-Une Nuit A
Saint Germain des Pres
1952年5月14日，パリにて録音。

Vogue 123
Mezz Mezzrow-Sidney Bechet Quintet-Mezzrow, Be-
chet, Avec Lips Page
ホット・リップス・ペイジ参加の1トラックも収録。1948
年，ニューヨークにて録音された最初のＬＰ盤。

Vogue 135
Bobby Smith's Orchestra-Jazz at the Apollo
アメリカ・アポロ・レーベルの78回転盤のＬＰ化。

Vogue 142
Sidney Bechet with Andre Reweliotty Orchestra-Ren-
dez-Vous Avec Sidney Bechet
1953年，パリにて録音。

Vogue 182
Buck Clatyon with Alix Combelle's Orchestra-Danse
Parade
1953年10月，パリにて録音。後にアメリカでストーリー
ヴィル・レーベルから発売。

Jazz Society 6
King Oliver-Savannah Syncopators
1926,27年に録音したキング・オリバーのサヴァナ・シン
コペイターの演奏を，まとめてＬＰ化したもの。

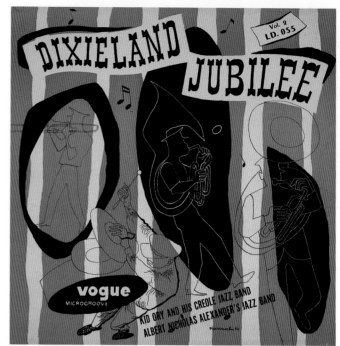

Vogue 055

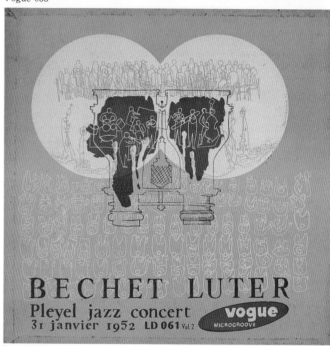

Vogue 061

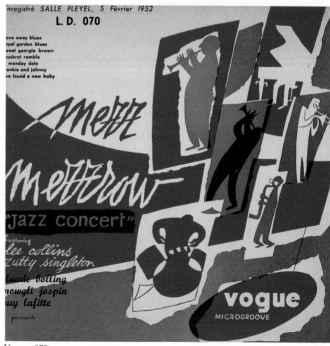

Vogue 070

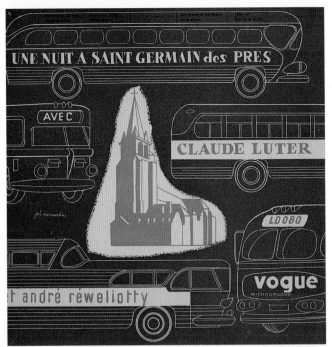

Vogue 080

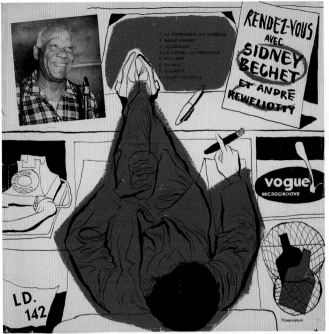

Vogue 142

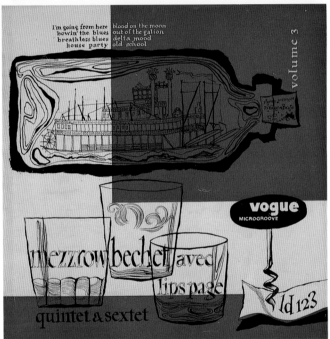

Vogue 123

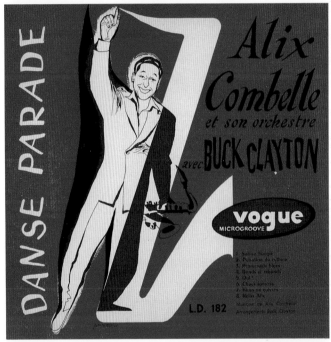

Vogue 182

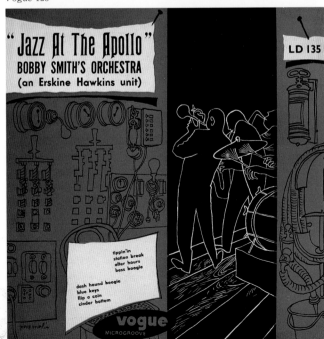

Vogue 135

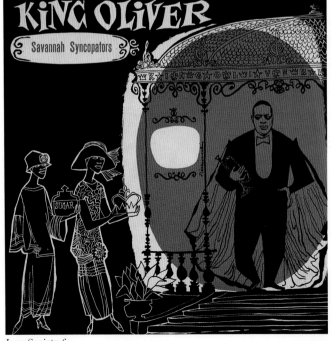

Jazz Society 6

FRENCH ISSUES OF AMERICAN
ORIGINAL ISSUES

Vogue 035
Charlie Christian, Thelonious Monk – At Minton's
(Recorded 1941 at Minton's in New York. The first
issue are 78 rpm's on the **VOX** label. I am unsure if the
first LP issue is this **Vogue** or the American **Esoteric**
label.)

Vogue 033
Johnny Richards Conducts – Dizzy Gillespie Plays
(Recorded September 1950 in Los Angeles for the
Discovery label. This is the issue for France.)

Vogue 009
Stan Getz – Stan Getz Quartet
(The classic 1948/9 recordings by the Getz Quartet.
Originally issued on the **Roost** label. This is the issue
for France.)

Vogue 010
Bud Powell Trio – Bud Powell
(The French issue of American **Roost's** 1947 record-
ings. The first leader recording by Bud Powell.)

Vogue 019
Erroll Garner Trio – Gene Norman's 'Just Jazz'
(Pianist Erroll Garner recorded these in the 1940s. They
have been constantly reissued since then.)

Vogue 020
George Shearing – George Shearing Quintet
(French issue of the first LP recorded by the Shearing
Quintet in America. This is the quintet with Marjorie
Hyams, Chuck Wayne, John Levy and Denzil Best——
all pictured on the jacket.)

Vogue 023
Dave Brubeck – Dave Brubeck Octet
(Early recordings by the Brubeck Octet for the Fantasy
label. This is the French issue.)

Vogue 028
Duke Ellington's Coronets
(A relaxed 1951 New York by a sextet of well known
musicians of the Duke Ellington band. Issued on the
Mercer label in America; and by **Vogue** in France.
Ellington himself and Billy Strayhorn share being the
session's pianist.)

Vogue 029
Art Tatum – Art Tatum
(Recorded at a Gene Norman 'Just Jazz' concert, Los
Angeles 1949.)

Vogue 038
Sir Charles Thompson and his All Stars
Sir Charles All Stars featuring Charlie Parker
(The only LP issue of 4 very rare 78 rpm tracks record-
ed in 1945 for the American **Apollo** label. Truly an All
Star group——with Sir Charles leading Parker, Buck
Clayton, Dexter Gordon, Jimmy Butts and J.C. Heard.)

アメリカ盤をオリジナルとするフランス盤

Vogue 035
Charlie Christian, Thelonious Monk-At Minton's
1941 年、ニューヨークのジャズ・クラブ『ミントンズ』に
て録音。最初はヴォックス・レーベルの 78 回転盤として発
表された。初ＬＰ盤がこのヴォーグ盤かアメリカのエソテ
リック盤かははっきりしない。

Vogue 033
Johnny Richards Conducts-Dizzy Gillespie Plays
1950 年 9 月，ロサンゼルスにてディスカヴァリー・レーベ
ルで録音。これはフランス盤。

Vogue 009
Stan Getz-Stan Getz Quartet
1948,49 年のゲッツ・カルテットによる名演奏の録音。ルー
スト・レーベルにて発表された。これはフランス盤。

Vogue 010
Bud Powell Trio-Bud Powell
1947 年、アメリカのルーストにて録音。これはフランス
盤。バド・パウエルの初リーダー作品である。

Vogue 019
Erroll Garner Trio-Gene Norman's 'Just Jazz'
1949 年に録音されたピアニスト，エロール・ガーナーの作
品。以来ずっと再版を重ねている。

Vogue 020
George Shearing-George Shearing Quintet
アメリカのシアリング・クインテットによる初ＬＰ作のフ
ランス盤。マージョリー・ハイアムス，チャック・ウエイ
ン，ジョン・レヴィー，デンジル・ベストとから成るクイ
ンテットで，全員ジャケットに描かれている。

Vogue 023
Dave Brubeck-Dave Brubeck Octet
ブルーベック・オクテットがファンタジー・レーベルに吹
込んだ初期の作品。これはフランス盤。

Vogue 028
Duke Ellington-Duke Ellington's Coronets
1951 年，ニューヨークにて録音された，デューク・エリン
トン楽団の有名ミュージシャンのセクステットによるのび
のびとした演奏。アメリカではマーサー・レーベル，フラ
ンスではヴォーグにて発売された。エリントン本人とビリ
ー・ストレイホーンがセッションのピアノを分担している。

Vogue 029
Art Tatum-Art Tatum
1949 年，ロサンゼルスにてジーン・ノーマン「ジャスト・
ジャズ」コンサートをライブ録音。

Vogue 038
Sir Charles Thompson and his All Stars-Sir Charles All
Stars featuring Charlie Parker
1945 年，アメリカのアポロ・レーベルにて録音されたたい
へん希少な 78 回転の 4 トラックをおさめた唯一のＬＰ盤。
サー・チャールス・トンプソンをリーダーに，パーカー，
バック・クレイトン，デクスター・ゴードン，ジミー・バ
ッツ，Ｊ．Ｃ．ハードから成るまさにオールスター・グル
ープだ。

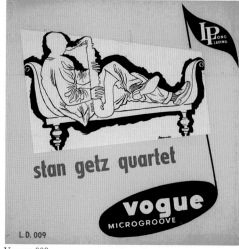
Vogue 009

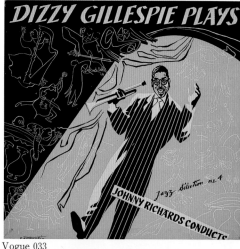
Vogue 033

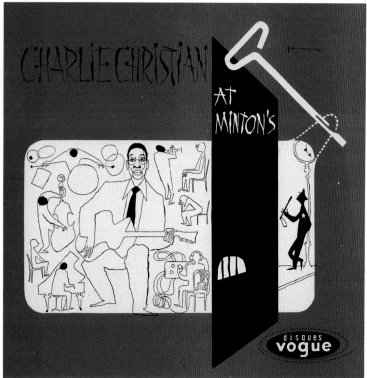
Vogue 035

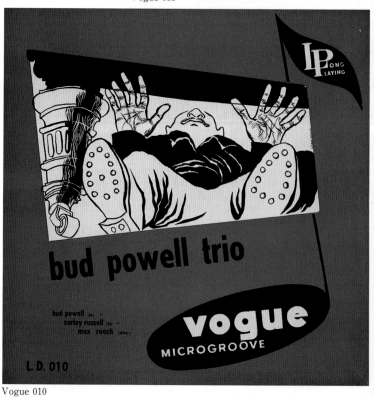
Vogue 010

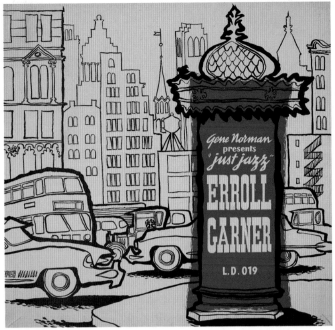

Vogue 019

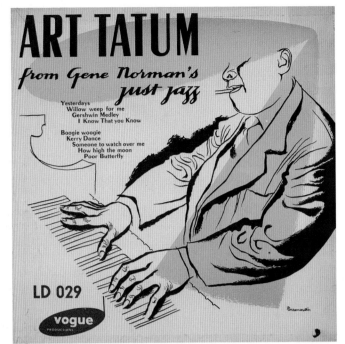

Vogue 029

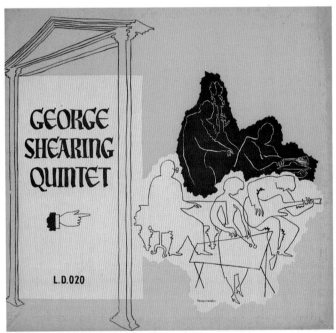

Vogue 020

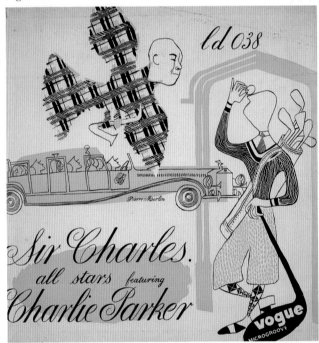

Vogue 038

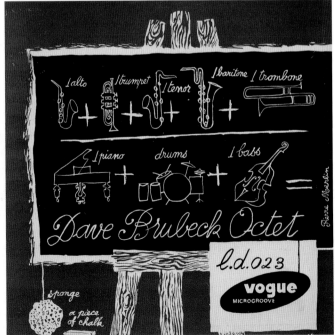

Vogue 023

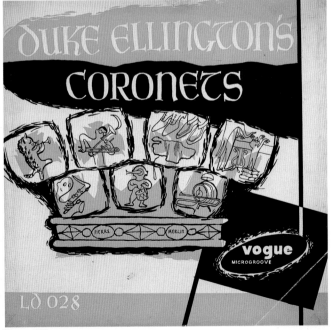

Vogue 028

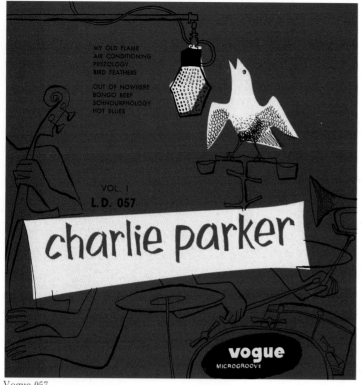

Vogue 057

Vogue 095

Vogue 051

Gene Norman's Just Jazz

Vogue 128

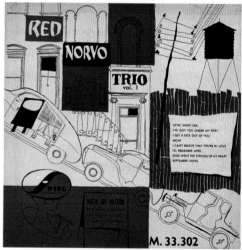

Swing 33.302

Swing 33.308

Vogue 051
Frank Bull and Gene Norman's - Jazz Jubilee
(Tracks featuring Pete Johnson, Jimmy Witherspoon and Helen Humes.)

Vogue 057
Charlie Parker Quintet - Charlie Parker
(The magnificent 1945 recordings by Parker for Dial. This is the issue for France.)

Vogue 095
Fats Navarro, Bill Harris and others
Jazz off the Air
(From the American Esoteric label. A live April 1947 broadcast from Station WNEW New York City.)

Vogue 128
Ernie Royal, Wardell Gray and others
Gene Norman's Just Jazz
(December 1947 recording of a Gene Norman 'Just Jazz' concert. First issued on the Modern label 78 rpms and then on a Crown LP. This is the French issue).

Swing 33.302
Red Norvo Trio - Vol. 1 Men at Work
(The French issue of the original issue on the Discovery label.)

Swing 33.308
Chet Baker - Chet Baker Quartet
(From the Pacific Jazz label——very early recordings of the Chet Baker Quartet.)

Vogue 051
Frank Bull and Gene Norman's-Jazz Jubilee
ピート・ジョンソン，ジミー・ウイザースプーン，ヘレン・ヒュームズが共演。

Vogue 057
Charlie Parker Quintet-Charlie Parker
1945 年，パーカーがダイアル・レーベルに吹込んだ傑作。これはフランス盤。

Vogue 095
Fats Navarro, Bill Harris and others-Jazz off the Air
オリジナルはアメリカのエソテリック盤。1947 年 4 月，ニューヨークの WNEW 局から放送されたライブ。

Vogue 128
Ernie Royal, Wardell Gray and others-Gene Norman's Just Jazz
1947 年 12 月，ジーン・ノーマン「ジャスト・ジャズ」コンサートにてライブ録音。最初はモダン・レーベルが 78 回転盤で発売，その後クラウンが L P 化した。これはフランス盤。

Swing 33.302
Red Norvo Trio Vol. 1-Men at Work
ディスカヴァリー盤をオリジナルとするフランス盤。

Swing 33.308
Chet Baker-Chet Baker Quartet
パシフィック・ジャズ・レーベルより。チェット・ベイカー・クインテットのごく初期の録音作。

AMERICAN MUSICIANS RECORDED IN FRANCE

Swing 33.301
Dizzy Gillespie - The Fabulous Dizzy Gillespie
(Paris, live concert February 28 1948 by the touring Gillespie big band.)

Vogue 004
Roy Eldridge Quintet
Roy Eldridge and his "little jazz"
(Trumpeter Roy Eldridge and tenor saxophonist Don Byas with a French rhythm section. Paris, March 28 1951. Some of these tracks were issued later on the **Dial** label.)

Vogue 005
Coleman Hawkins and his Orchestra
Coleman Hawkins
(A Paris, December 21, 1949 recording by the visiting big band of the pioneer of the tenor saxophone——Coleman Hawkins.)

Vogue 014
Max Roach Quintet - Max Roach
(Paris, May 15 1949. The Quintet was Kenny Dorham, James Moody, Al Haig, Tommy Potter and Max Roach. The next issue was on a Blue Note 10").

アメリカのミュージシャンの
フランス・レコーディング

Swing 33.301
Dizzy Gillespie-The Fabulous Dizzy Gillespie
1948 年 2 月 28 日，パリにてツアー中のガレスピー・ビッグ・バンドのコンサートをライブ録音。

Vogue 004
Roy Eldridge Quintet-Roy Eldridge and his "little jazz"
トランペット奏者のロイ・エルドリッジとテナー・サックス奏者のドン・バイアスがフランスのリズム・セクションと共演。1951 年 3 月 28 日，パリにて録音。これらのトラックのいくつかは後にダイアル・レーベル盤に収録された。

Vogue 005
Coleman Hawkins and his Quintet-Coleman Hawkins
1949 年 12 月 21 日，パリにて，渡欧中のテナー・サックスの先駆者，コールマン・ホーキンスのビッグ・バンドが吹込んだ作品。

Vogue 014
Max Roach Quintet-Max Roach
1949 年 5 月 15 日，パリにて録音。ケニー・ドーハム，ジェイムス・ムーディ，アル・ヘイグ，トミー・ポッター，マックス・ローチから成るクインテット。つづいてブルーノートの 10 インチ盤で発売された。

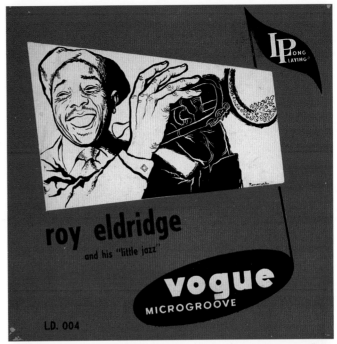

Vogue 004

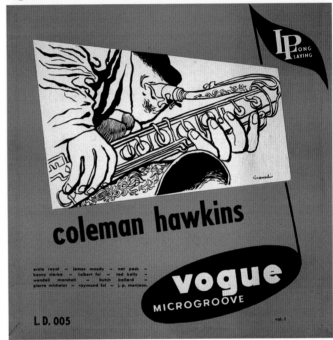

Vogue 005

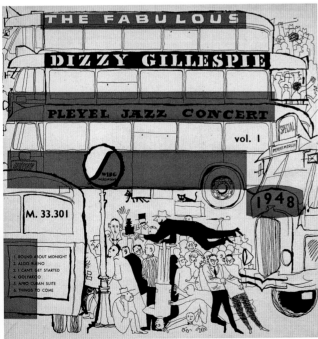

Swing 33.301

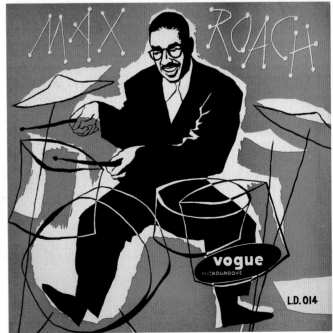

Vogue 014

Vogue 030
Big Bill Broonzy - Blues Singer Vol. 1
(Paris recording of September 20/21 1951.)

Vogue 039
Roy Eldridge Quartet and Septet
Roy Eldridge Joue pour la Danse
(Paris recordings of June and October 1950. In America on the Dial and Discovery labels.)

Vogue 047
Joe Turner - Piano Mood
(Recorded in Paris, 1952.)

Vogue 052
Nelson Williams & His Orchestra
Five Horn Groove
(Paris, April 15 1950. The Paris based trumpeter, Nelson Williams, fronting an all star group from the Duke Ellington band.)

Vogue 053
Earl Hines - "Encores"
(Paris November 4, 1949. This precedes the American issue on Dial.)

Vogue 075
Arnold Ross - Arnold Ross Trio
(Paris April 1, 1952. Extremely rare.)

Vogue 124
Mary Lou Williams Trio - Mary Lou Williams Plays in London
(London, January 23rd 1953.) Issued only by French and English Vogue—both have the same cover.)

Vogue 133
Wade Legge - Wade Legge Trio
(Paris, February 27 1953. The trio was in Paris as part of the visiting Dizzy Gillespie band. This is pianist Legge's only leader album. Issued next on the Blue Note 10".)

Vogue 134
Dizzy Gillespie Quintet/Sextet - Jazztime Paris Vol. 2
(The touring Gillespie band recorded in Paris Concerts ——February 1953.)

Vogue 030
Big Bill Broonzy-Blues Singer Vol. No.1
1951 年 9 月 20，21 日，パリにて録音。

Vogue 039
Roy Eldridge Quartet and Septet-Roy Eldridge Joue pour la Danse
1950 年 6 月，10 月，パリにて録音。アメリカでは、ダイアルとディスカヴァリーのレーベルで発売された。

Vogue 047
Joe Turner-Piano Mood
1952 年，パリにて録音。

Vogue 052
Nelson Williams & His Orchestra-Five Horn Groove
1950 年 4 月 15 日，パリにて録音。パリを活動の拠点とするトランペット奏者、ネルソン・ウイリアムスが、デューク・エリントン楽団の豪華メンバーによるグループを迎えて演奏した。

Vogue 053
Earl Hines-"Encores"
1949 年 11 月 4 日，パリにて録音。つづいてアメリカでダイアル・レーベルにて発売。

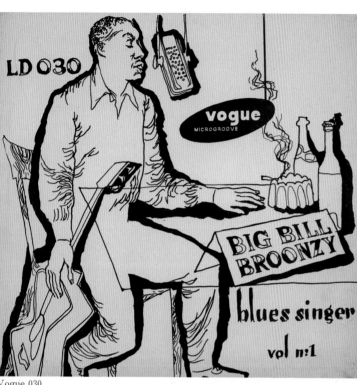

Vogue 030

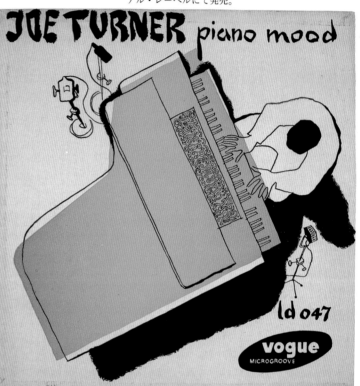

Vogue 047

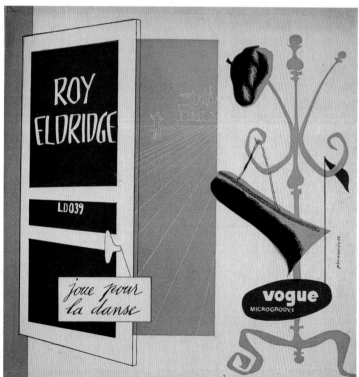

Vogue 039

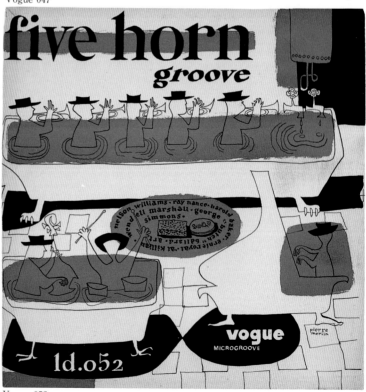

Vogue 052

Vogue 075
Arnold Ross-Arnold Ross Trio
1952 年 4 月 1 日，パリにて録音。究極の希少盤。

Vogue 124
Mary Lou Williams Trio-Mary Lou Williams Plays in
London
1953 年 1 月 23 日，ロンドンにて録音。フランスとイギリス
のヴォーグからのみ発売。どちらも同じジャケットを使っ
ている。

Vogue 133
Wade Legge-Wade Legge Trio
1953 年 2 月 27 日，パリにて録音。渡欧中のディジー・ガレ
スピー・バンドからパリで組まれたトリオ。ピアニスト，
レッジの唯一のリーダー・アルバムである。つづいてブル
ーノートの 10 インチ盤で発売された。

Vogue 134
Dizzy Gillespie Quintet/Sextet-Jazztime Paris Vol. 2
1953 年 2 月，パリにて渡欧中のガレスピー・バンドのコン
サートをライブ録音。

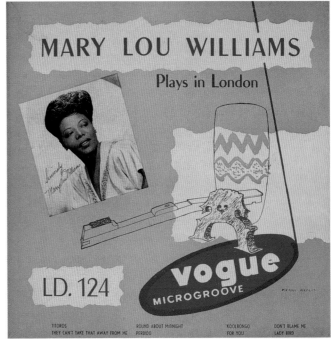

Vogue 124

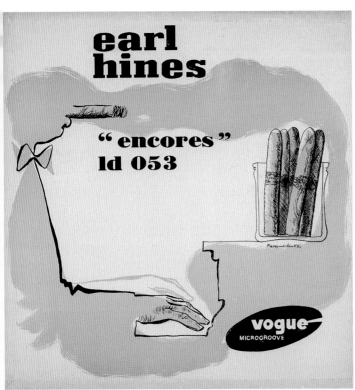

Vogue 053

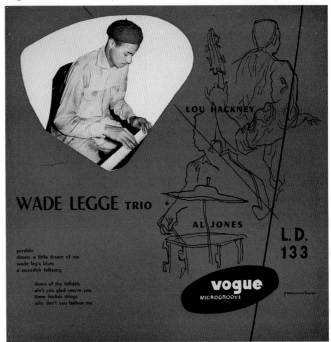

Vogue 133

Vogue 075

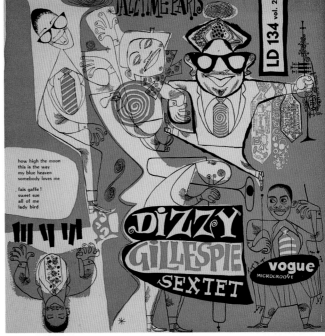

Vogue 134

FRANK GAUNA

フランク・ガウナ

Frank Gauna is honest in his opinions. The first time we met he told me "To this day I don't know jazz. I liked jazz because I knew the musicians who were doing it. I knew they knew what they were doing and then knew I knew what I was doing. Like artist to artist." But Frank Gauna is a real artist——who was once at home with record jackets for all types of music and is now at home with oils and sculpture. Along the way he designed a superb series of jazz covers mainly for the *United Artists* and *Candid* labels. In a world where colour ran rampant over record covers, the master craftsman in Gauna produced creations with soft hues and more importantly in black and white.

Gauna was born in Newark, New Jersey——close to New York, in 1930. He cannot remember a time when he did not draw. It was a totally natural talent, which made him stand out in school. In 1949 he enrolled at the Newark School of Fine and Industrial Art. The school was unique in that their teachers were not academics but successful practicing artists. One of his teachers, Ben Cunningham, was later to influence directly one of Gauna's special techniques. "At the Newark school I was lucky to have Ben Cunningham, Hans Weingarner, Marshall Simson, Roselyn Middleman as my instructors. They were important painters and we were friends who also worked together on projects after I finished school. Also at the school was Eric Muhler, a lettering designer from Germany who taught me the importance of strong lettering design."

Gauna's own professional career started in 1953 at a conventional advertising agency——drawing everything the agency needed. The office of *Cadence* records was in the same building. A nodding friendship with *Cadence's* owner Archie Blyer led to Blyer offering and Gauna accepting a job as designer for the *Cadence* album jackets. Gauna designed all the jackets for *Cadence*—— the Eberley Brothers, Andy Williams, Don Shirley were among the big sellers These *Cadence* jackets were for music forms outside the scope of this book Archie Blyer was diversified enough to want a separate jazz label. For which he enlisted the musical help of Nat Hentoff. Then, as today, Nat Hentoff remains a superb judge of the best in jazz with a skill in writing about jazz to match. From this was born the *Candid* label for which Gauna did the jackets *Candid* immediately became a label with outstanding jazz music, and with completely distinctive packaging. The jackets by Gauna were a visual delight the letterings on both the jackets and the liner notes remain extremely distinguished, even today. The back liners set a standard hard to match—— excellent notes by Hentoff but also framed in attractive columns and out-standing type. The lettering was the joint effort of Gauna and George Butner. "I wanted the back to be as important as the front and for the album to become a bench mark in design. I wanted *Candid* to have a solid base so that when someone saw it they would know it was a *Candid* cover. And in the record store racks they would know right away it was *Candid* and *Jazz*".

In 1962, Archie Blyer struck gold. He issued what was at that time the greatest selling album of all time. Not a music record——but a spoken word one. Called 'The First Family' it was a good natured spoof on President Kennedy and his family. Gauna designed this cover too——the spoken word 'cast' photos were

フランク・ガウナは嘘のつけない性格らしい。初めて会ったとき，彼は私に言った。「今もって，私にはジャズというものがわかっていない。ジャズを好きだったのは，それを演奏するミュージシャンと知り合いだったからにすぎないんだ。彼らは自分達の仕事を心得ていたし，私も自分の仕事を心得ているつもりだった。アーチスト同士みたいな関係だった」と。しかし，フランク・ガウナは正真正銘のアーチストである。かつてあらゆる音楽のレコード・ジャケットのデザインをこなし，現在も油絵と彫刻に見事な腕をふるっている。こうした創作活動のなかで，彼はユナイテッド・アーティッツとキャンディドの両レーベルを中心に，一連のすばらしいジャズ・アルバムのジャケットをデザインした。鮮やかな色が氾濫するレコード・ジャケット界にあって，卓越した技術と感性で，落ち着いた色調や，さらに注目すべきことにはモノクロの秀作を生んだ。

ガウナは1930年，ニューヨークにほど近い，ニュージャージー州はニューアークで生まれた。とにかく絵ばかり描いていたのを覚えていると言う。まさに天賦の才能に恵まれた彼は，学校でも一際異彩を放つ存在だった。1949年，ニューアーク美術工芸学校に入学。大学教員ではなく，実際に一線で活躍する芸術家を教師陣に迎えた珍しい学校であった。このときの教師のひとり，ベン・カニンガムは後にガウナの特殊手法の一つに直接影響を与えることになる。「ニューアークの学校で，ベン・カニンガム，ハンス・ワインガーナー，マーシャル・シムソン，ローズリン・ミドルマンから指導を受けられたのは幸運だった。一流の画家だった彼らとは，卒業後も友人づきあいがつづき，仕事で組むこともあった。他にドイツ出身のレタリング・デザイナー，エリック・ミューラーもいて，レタリングのデザインの印象がいかに重要か教えられた」

ガウナ自身は1953年に，ごく普通の広告代理店でプロの画家としてスタートをきり，代理店の要望に応じてなんでも描いた。たまたまこれと同じビルに，ケイデンス・レコードのオフィスがあった。ケイデンスのオーナー，アーチー・ブラ

イアーとは会えば会釈しあう程度の間柄であったが，これが縁で，ブライアーがケイデンスのアルバム・ジャケットのデザイナーとしての仕事を申し出，ガウナはその仕事を受ける。そして，エバリー・ブラザーズ，アンディ・ウイリアムス，ドン・シャーリーのヒット作品を初め，ケイデンスのジャケット・デザインを一手に担うことになった。だが，これらのジャケットは本書が対象とする音楽ジャンルのものではなかった。

アーチー・ブライアーはレコード分野の拡大を目指し，新たにジャズ専門のレーベルを作ろうとした。そこで，音楽面での協力をあおいだのがナット・ヘントフであった。すでに当時から，ナット・ヘントフは図抜けたジャズの鑑識眼を持ち，ジャズについて書かせたら右に出る者がないほどだった。こうしてヘントフを責任者にキャンディド・レーベルが誕生し，ガウナがそのジャケットのデザインを手がけることになったのである。

キャンディドは傑出したジャズ音楽と，他に見られない独特のパッケージで，たちまち注目を集めるようになった。ガウナのデザインしたジャケットは，目を楽しませてくれた。ジャケットとライナーノーツのレタリングは，今日でも傑出した出来栄えである。また，裏面の解説も比類なき高水準を示していた。ヘントフによる見事な解説に加えて，すばらしい活字と魅力的な構成で仕立てられていたのである。レタリングにはガウナとジョージ・バトナーが共同してあたった。ガウナは言う。「裏も表と同じくらい大事にしたかった。ジャケットのデザインが，アルバムを見分けるひとつの目安になればと思っていたんだ。一目見ただけでキャンディドのジャケットだとわかるような，レコード店の棚に並んでいても，すぐにキャンディドのジャズのレコードだとわかるような，基盤を固めたかったんだ」

1962年，アーチー・ブライアーは金脈を掘り当てた。アルバムが当たって，当時，空前の大ヒットとなったのである。これは音楽ではなく，語りのレコードで，

superimposed in front of the White House. **"The record sold in innumerable of copies, we just lost count."** It was too great a success for Archie Blyer to need a follow up for. He sold the label and retired from the record business. Just before *Cadence* closed, Gauna had a freak accident. While cutting a matte, he partially knifed through and broke his index finger. It was to take a year to heal, making it immensely difficult for Gauna to draw. That is when he concentrated more on photography.

Gauna freelanced, working for record companies, advertising agencies, and special projects. He freelanced also with *United Artists* which was in various forms of the entertainment business. He conceived the designs used for the publicity for movies among them 'Mash' and 'Tora Tora'.

United Artists decided to issue a committed series of jazz albums with Gauna designer for the jackets. He drew for this series the beautiful 'saxophone logo' ——copied from one of his earlier *Candid* jackets. In a world where color was taken for granted, he produced in black and white. **"Everyone was using colors and I always used muted colors anyway."** The 'saxophone logo' was strongly featured by United Artists on jackets and records.

United Artists was in turn bought by Transamerica who decided to merge the New York art office into the West Coast one. Gauna was not prepared to shift and also had doubts about how he personally would fit into the huge Transamerica organization. So when the New York Art office closed, it was back to free lancing as a New York based designer for innumerable products and projects. He continued **"I could not go to a super market without seeing something I had done."** His varied assignments included record jackets too-

but for music outside the scope of this book.

In 1970 he travelled to Europe. He fell in love with Spain——a country of special significance since Gauna is of Basque origin. He worked for a while with advertising agencies **"but I became more involved in painting and that's all I did. I started sculpture and had shows in Spain, Germany and England."** He found a core of collectors from both continents who bought whatever he did.

After 8 years in Spain, he returned to America, set up home and studio in Los Angeles and continued as a full time painter in oils, working on several paintings at the same time. He keeps part of his own work and sells the rest to collectors already familiar with his own work. One of the record producers at *United Artists* was Alan Douglas who now owns his own labels and issues many of the Jimi Hendrix recordings. Gauna designed some of Jimi Hendrix as also other jackets for Douglas.

Gauna's original and alternate negatives are lost both to him and to us. Some were transferred with the recording rights to the respective new owners. But the major part were left behind in America by Gauna when he left for Europe and for various reasons cannot be traced now.

Both *Candid* and *United Artists* issued their records simultaneously in Mono and Stereo. Identical jackets were used. For uniformity, mono numbers are mentioned for each jacket illustration. These records were released between 1960 and 1963.

『ザ・ファースト・ファミリー』という題の，ケネディ大統領一家を好意的にもじったパロディだった。このジャケットもガウナが手がけ，語りを担当する「キャスト」の写真を，ホワイトハウスの正面写真に重ね合わせたデザインになっている。「レコードは百万枚単位で売れて，しまいには数がわからなくなった」と言う。この大成功によって，アーチー・ブライアーはもはや仕事をつづける必要がなくなり，レーベルを売却。レコード業界を退いた。

ケイデンスが消滅する直前，ガウナはとんでもない災難に見舞われた。台紙を切っているとき，あやまって人さし指をナイフでざっくり切ってしまったのだ。傷が治るまで１年もかかり，絵を描くのはかなり困難だった。ガウナがもっぱら写真に力を入れたのはこの間である。

その後，ガウナはフリーランサーとして，レコード会社や広告代理店，特別企画の仕事を手がけた。種々の娯楽産業経営で知られるユナイテッド・アーティスツもクライアントのひとつで，『マッシュ（MASH）』や『トラ・トラ・トラ！』など映画のパブリシティ用のデザインに取り組んだ。

そのユナイテッド・アーティスツが明確な方針の一連のジャズ・アルバムを発表することになり，ガウナがジャケット・デザイナーに迎えられた。このシリーズのために，彼は美しい「サックス奏者のロゴ・マーク」をデザインした。初期に手がけたキャンディドのジャケットからとったもので，鮮やかな色が当たり前とされるなかにあって，モノクロで描かれている。「猫も杓子も派手な色を使っていたが，私は抑えた色しか使わなかった」ユナイテッド・アーティスツは「サックス奏者のロゴ・マーク」をジャケットとレコードに配し，大々的にアピールした。

ユナイテッド・アーティスツはやがてトランザメリカに買収され，ニューヨークのアート・オフィスもウエストコーストのオフィスに合併されることになった。しかし，ガウナは移転には気が進まなかったし，トランザメリカという巨大な組織の歯車の一つとしてやっていくことにも疑問があった。そこで，ニューヨーク・アートのオフィスがたたまれたのを機に，再びフリーのデザイナーとなり，ニューヨークを活動の拠点として数知れぬ作品や企画に取り組んだ。「スーパーマーケットに行けば，なにかしら自分のデザインにお目にかかれた」と言う。ガウナの手がけた様々な仕事のなかには，レコード・ジャケットのデザインも含まれていたが，残念ながら，本書で扱うジャンルの音楽ではなかった。

1970年，ガウナはヨーロッパに渡り，スペインに魅せられる。バスク人の血を引くガウナにとって，スペインは特別な意味を持つ国だった。彼はここでしばらく広告代理店の仕事をする。「ところが，だんだん絵を描くことに夢中になって，絵に専念するようになった。それから彫刻も始めて，スペイン，ドイツ，イギリスで個展を開いた」そして，ガウナの作品なら何でも買おうという熱烈なコレクターを，欧米両大陸に獲得するに至ったのである。

スペインで８年を過ごした後，ガウナはアメリカに帰国。ロサンゼルスに家とアトリエを構え，油絵の画家として，同時に複数の作品に取り組む精力的な活動をつづけた。作品の一部は自らの手もとに残し，あとはすでに定着した熱心なコレクターたちに売っている。また，ユナイテッド・アーティスツのレコード・プロデューサーのひとりだったアラン・ダグラスは，現在，自己レーベルを主宰し，ジミ・ヘンドリックスのレコードの多くを発表しているが，ガウナはジミ・ヘンドリックスの数作品など，ダグラスのレーベルのジャケット・デザインも手がけた。

ガウナのオリジナル写真と控えのネガは，もはや本人にも私たちにも手に入れることはできない。レコードの版権とともに，それぞれの新しいオーナーの手に渡ったものもあるが，大半はガウナがヨーロッパに渡る際にアメリカに残していったまま，さまざまな理由で今では行方がわからなくなっている。

Candid 8019
Various Artists - The Jazz Life!
Photo/Design: Frank Gauna
(This is a 'sampler' record comprising tracks from various individual Candid albums. The saxophone player was later to become the logo on the United Artists Jazz series albums. **"The model was not a professional musician but was a young actor who knew how to play. I liked it so much that when some years later, I had to make a jazz logo for United Artists, I made a line drawing of it. In 1992, 30 years later I was commissioned to do an oil painting of it."**)
Frank Gauna's oil painting done in 1992 of the Saxophone Player which is now in Japan in a private collection.

　キャンディドもユナイテッド・アーティスツも，モノラル盤とステレオ盤を同時に発売し，どちらも同じジャケットを使った。ジャケットを紹介するにあたって，本書では統一してモノラル盤のナンバーをあげておいた。これらは 1960 年から 63 年にかけて発売されたレコードである。

Candid 8019
Various Artists-The Jazz Life！
Photo/Design: Frank Gauna
キャンディドの各アルバムからトラックを集めた「選集」盤。このサックス奏者の写真が後に，ユナイテッド・アーティスツ・ジャズのシリーズのアルバムのロゴ・マークになった。「モデルはプロのミュージシャンじゃなくて，演奏法を心得た若い役者だった。私はこの写真がひどく気に入っていたんで，数年後にユナイテッド・アーティスツのジャズのロゴ・マークを作ることになったとき，イラストにしたんだ。30 年経って，今度はこれを油絵にするよう依頼された」

1992 年にフランク・ガウナが描いたサックス奏者の油絵

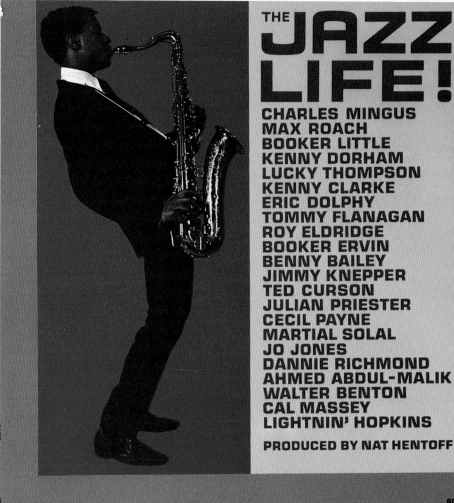

Candid 8019

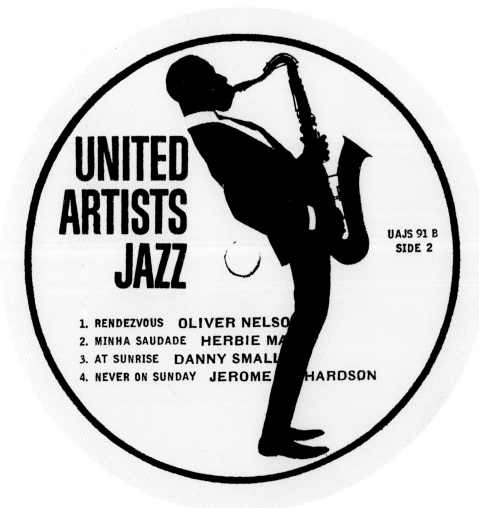

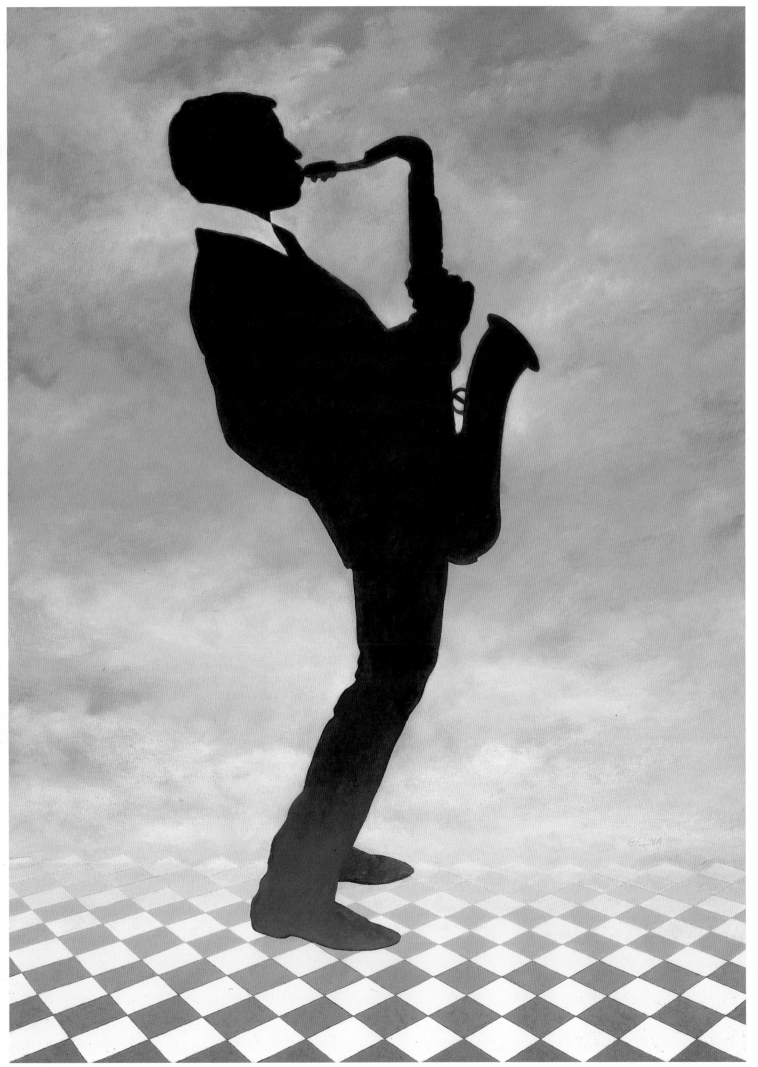

Candid 8002
Max Roach - Freedom Now Suite - We Insist！
Photo: Hugh Bell
Design: Frank Gauna
（This record was issued in 1960 when sit-in demonstrations were springing up all over America to bring down the last barriers of segregation. Max Roach's music and Frank Gauna's jacket emphatically capture this mood. "I used a photo of a sit-in in Alabama. It was done on a coarse screen; I used matte finish paper and used bold newspaper type lettering to simulate the front page of a newspaper——specifically the Daily News of New York"）

Candid 8001
Otis Spann - Otis Spann is the Blues
Photo/Design: Frank Gauna
（"I wanted him to look like he was in his natural setting. He came in with a bottle of booze and just started playing and drinking. The room was air conditioned. So I took a glass of water, poured it over his head, and photographed him like that to give it a club type atmosphere."）

Candid 8003
Richard Williams - New Horn in Town
Photo/Design: Frank Gauna
（"Nat Hentoff gave the title and I kept it in mind for the cover. Shot on a New York Street."）

Candid 8006
Cecil Taylor - The World of Cecil Taylor
Photo/Design: Frank Gauna
（"A very nice guy to deal with. I went to his house. We sat in his house, ate a sandwich, he played, I talked of my art, he of his music. I did this jacket at his house. Everyone seemed to want a black man to look white, I wanted him to look as he was."）

Candid 8007
Steve Lacey - The Straight Horn
Photo/Design: Frank Gauna

Candid 8002
Max Roach-Freedom Now Suite-We Insist！
Photo: Hugh Bell
Design: Frank Gauna
1960年，座り込みデモの嵐がアメリカ全土で吹き荒れ，人種差別の最後の障壁を倒した年に発売されたレコード。マックス・ローチの音楽とフランク・ガウナのジャケットは，この社会の雰囲気を鋭くとらえている。「アラバマでの座り込みデモの写真を使った。それを粗い網版にして，つや消し紙と肉太書体の新聞活字を使い，そっくり新聞の第一面に仕立てようとしたんだ」

Candid 8001
Otis Spann - Otis Spann is the Blues
Photo/Design: Frank Gauna
「酒豪っぽい感じを出したかったんだ。実際，スパンは相当いけるからね。部屋はエアコンがきいていた。そこで私はコップに水を汲み，彼の頭の上から浴びせて，いかにもそれらしく撮ったんだ」

Candid 8003
Richard Williams-New Horn in Town
Photo/Design: Frank Gauna
「ナット・ヘントフがつけたタイトルをずっと頭においてジャケットのデザインを考えた。これはニューヨークの通りで撮った写真だ」

Candid 8006
Cecil Taylor-The World of Cecil Taylor
Photo/Design: Frank Gauna
「とても気の合う相手だった。私は彼の家を訪ねては，よく一緒にサンドイッチを食べた。セシルは演奏をしてくれて，私たちはお互いに芸術と音楽の話をしたものだよ。このジャケットも彼の家で撮ったんだ。だれもが黒人を白く見せようとしているようだったけれど，私はあるがままのセシルの姿を写したかった」

Candid 8007
Steve Lacey-The Straight Horn of Steve Lacey
Photo/Design: Frank Gauna

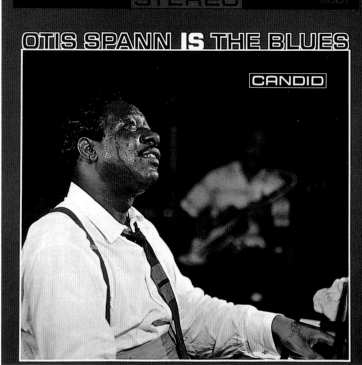

Candid 8002

Candid 8001

Candid 8003

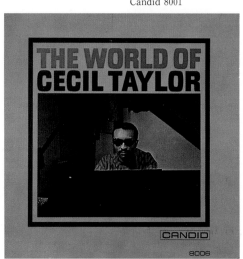

Candid 8006

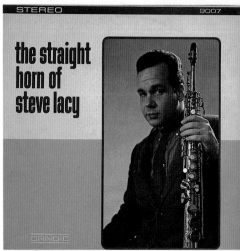

Candid 8007

Candid 8004
Don Ellis – How Time Passes
Drawing: Ben Cunningham
Photo/Design: Frank Gauna
Candid 8009
Clark Terry – Color Changes
Painting: Leo Dee
Photo/Design: Frank Gauna
United Artists 15007
Kenny Dorham – Matador
Design: Frank Gauna-Ben Cunningham
Photo: Frank Gauna
(These three jackets show a technique taught to Gauna by Ben Cunningham, one of his instructors at the Newark School of Fine Art. They were to become close friends and worked together on various projects. "Ben Cunningham was the first to use the system of giving straight lines and squares a 3 dimensional look. He felt that the system only worked with symmetrical objects. I learned to design within his system and was able to expand upon it. I drew individual components to form objects. Apart from these three covers, I used this concept on jackets I designed for the Mamas and Papas and other groups.")

Candid 8004
Don Ellis-How Time Passes
Drawing: Ben Cunningham
Photo/Design: Frank Gauna
Candid 8009
Clark Terry-Color Changes
Painting: Leo Dee
Photo/Design: Frank Gauna
United Artists 15007
Kenny Dorham-Matador
Design: Frank Gauna-Ben Cunningham
Photo: Frank Gauna
この３枚のジャケットには，ガウナをニューアーク美術学校で指導してくれた講師のひとり，ベン・カニンガムから学んだ手法が見られる。卒業後，ふたりは親友となり，様々な企画に一緒に取り組んだ。「ベン・カニンガムは直線で仕切った四角形を使って立体感を与える方法をあみだした。ただその方法は対照形にしか使えないとされていたから，私はそういう形のものを半分に切って，異なる左側と右側を合わせて使ったものだった。こうして彼の手法を身につけた私は，それを独自に発展させた。それぞれに描いた部分を組み合わせて，全体像を作るんだ。この３枚の他にも，同じやり方で，パパス＆ママスなどのグループのジャケットをデザインした」

United Artists 15007

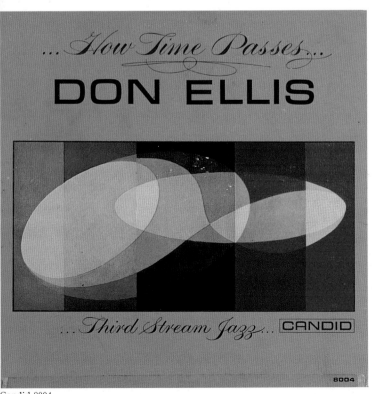

Candid 8004

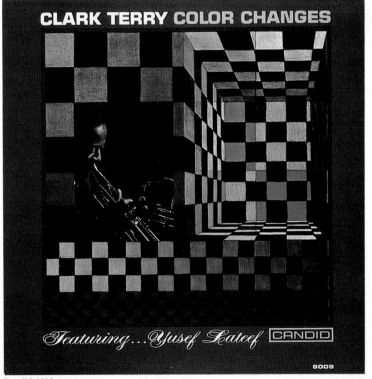

Candid 8009

Charles Mingus recorded both for *Candid* and *United* Artists. Mingus and Gauna were friends——explaining their work to each other. Gauna designed 6 jackets for recordings by Mingus:

Candid 8005
Charles Mingus - Presents Charles Mingus
Photo/Design: Frank Gauna
("I did this at Mingus's house. It does not look like there were lights but I took off all the reflectors. I tried to light my photography like the great artists who use internal light that I saw in museum paintings.")

Candid 8021
Charles Mingus - Mingus
Photo/Design: Frank Gauna
(Gauna comments with much affection "This was done at my studio apartment. He was a unique guy——when he came in to do this he was carrying a gun. I took the lettering off something he signed——it is his signature. You could always expect the unexpected from him. But he was always friendly.")

United Artists 14017
Duke Ellington - Charles Mingus-Max Roach

Money Jungle
Photo/Design: Frank Gauna
(A landmark recording by a trio of giants. "They knew each other very well, they sat down together, talking and asked how I wanted them to pose. I said that's just it, and shot it on my Linhof.")

United Artists 14005
Charles Mingus - Wonderland
Photo/Design: Frank Gauna
("I took a photograph and air brushed it. I wanted just a powerful face, a wonderland look.")

Candid 8022
Charles Mingus - Newport Rebels
Photo: Not credited
Design: Frank Gauna
(This is the Mingus 'rebel' group who were not included for the Newport Jazz Festival of 1960. "It was not a great photo and I wanted to make the lettering look very strong.")

United Artists 14024
Charles Mingus - Town Hall Concert
Photo: Uncredited
Design: Frank Gauna

ミンガス6枚のアルバム

　チャールス・ミンガスはキャンディドとユナイテッド・アーティスツの両レーベルに作品を残した。ミンガスとガウナは互いの仕事を語り合ういい友人で，ガウナはミンガスの6枚のアルバムのジャケットをデザインしている。

Candid 8005
Charles Mingus-Presents Charles Mingus
Photo/Design: Frank Gauna
「これはミンガスの自宅で撮ったんだ。照明を当てていないように見えるけれど，反射をすっかり取り除いたからなんだよ。偉大な芸術家はそれ自体に備わる輝きをとらえて名画に描く。そんなふうに撮りたかったんだ」

Candid 8021
Charles Mingus-Mingus
Photo/Design: Frank Gauna
ガウナは思い入れたっぷりに言う。「これは私のスタジオで撮ったんだ。チャールズはユニークなやつでね，この撮影にやって来たとき，銃を持ってきた。レタリングは彼がサインしたものを写しとった。つまり本人のサインなんだ」

Candid 8005

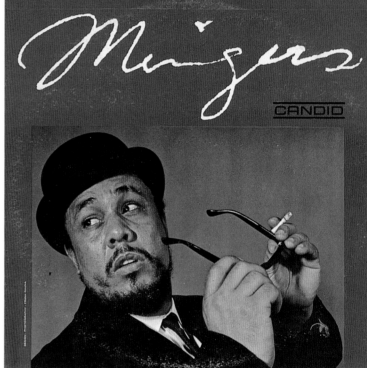

Candid 8021

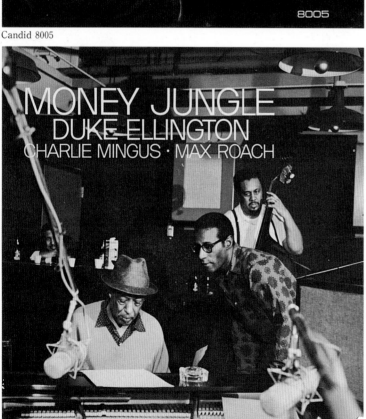

United Artists 14017

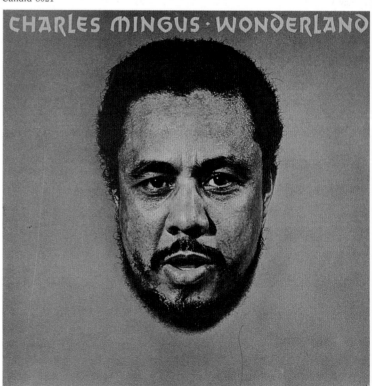

United Artists 14005

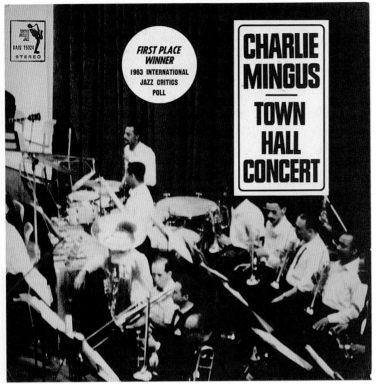

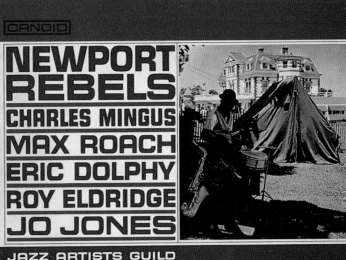

United Artists 14024

Candid 8022

United Artists 14017
Duke Ellington-Charles Mingus-Max Roach
Money Jungle
Photo/Design: Frank Gauna
ジャズ界の巨匠トリオが顔を合わせた画期的なレコーディング。「3人とも気心知れた仲で、座って話をしていた。で、どんなポーズをとればいいか私に訊くもんだから、そのままがいいんだと答えて、リンホフのカメラにおさめたんだ」

United Artists 14005
Charles Mingus-Wonderland
Photo/Design: Frank Gauna
「写真を撮ってから、気に入らないものは全部エアブラシで消した。力に満ちた顔、そのすばらしい表情さえあればよかったんだ」

United Artists 14024
Charles Mingus-Town Hall Concert
Photo: Uncredited
Design: Frank Gauna

Candid 8022
Charles Mingus-Newport Rebels
Photo: Not credited
Design: Frank Gauna
1960年のニューポート・ジャズ祭への参加を拒んだ、ミンガス率いる「反逆者」グループのレコーディング。「写真はたいしたことがなかったので、強烈なインパクトのあるレタリングにしたかった」

Candid 8008
Nancy Harrow - Wild Women Don't Have the Blues
("**She didn't like people photographing her. I had her relax and kept shooting and it was a different kind of look for the day. I liked her in the red sweater. I wanted colors to be forceful without being parrot like.**")

Candid 8011
Benny Bailey - Big Brass
Photo/Design: Frank Gauna

Candid 8012
Toshiko - Toshiko Mariano Quartet
Photo/Design: Frank Gauna

Candid 8014
Booker Ervin - That's It!
Photo/Design: Frank Gauna

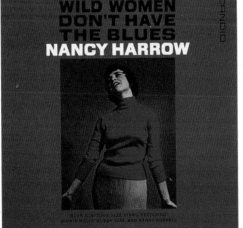

Candid 8008

Candid 8011

Candid 8008
Nancy Harrow-Wild Women Don't Have the Blues
「彼女は写真嫌いでね、私はリラックスさせながらシャッターを押しつづけ、ようやくちょっと表情が違う1枚が撮れたんだ。彼女には赤いセーターが似合うと思った。オウムみたいに派手にならず、力強い色調にしたかったんだ」

Candid 8011
Benny Bailey-Big Brass
Photo/Design: Frank Gauna

Candid 8012
Toshiko-Toshiko Mariano Quartet
Photo/Design: Frank Gauna

Candid 8014
Booker Ervin-That's It!
Photo/Design: Frank Gauna

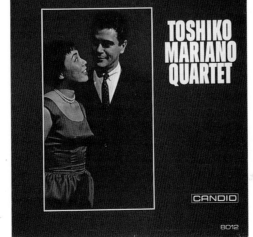

Candid 8012

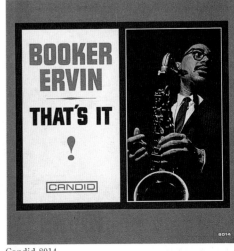

Candid 8014

Candid 8015
Abbey Lincoln - Straight Ahead
Photo/Design: Frank Gauna

Candid 8016
Phil Woods - Rights of Swing
Photo/Design: Frank Gauna
("As I remember, the people on the cover are not the musicians of the record. I just wanted to bring home the feel.")

Candid 8020
Pee Wee Russell - Coleman Hawkins
Jazz Reunion
Photo/Design: Frank Gauna
(Gauna's relaxed portrait of 8 legends of jazz who came together for this happy recording. The colors are the typical soft Gauna hues.)

United Artists 15004
Danny Small - Woman, She Was Born For Sorrow
Design/Photo: Frank Gauna
(This is Gauna's favorite cover. "**Alan Douglas**

produced this record and he wanted me to design a cover using a close up color photo he had on a woman crying. I felt it a rather predictable image. So I redesigned it by making an engraving style drawing of a girls eye. I photographed it out of focus, added the lettering and painted a tear drop to overlap part of the lettering. I made the background gray, so the highlights on the tear would be white. **The eye being out of focus made the tear very real looking.**")

United Artists 14029
Moe Koffman - Tales of Koffman
Photo/Design: Frank Gauna

United Artists 14003
Bill Evans / Jim Hall - Undercurrent
Back Cover Photo: Frank Gauna
Design: Frank Gauna - Alan Douglas
("**I did the lettering and put it in the developer. And while it was developing I shook the developer to get the rippling 'undercurrent' feel I wanted, then I photographed it.**")

Candid 8015
Abbey Lincoln-Straight Ahead
Photo/Design: Frank Gauna

Candid 8016
Phil Woods - Rights of Swing
Photo/Design: Frank Gauna
「確か，ジャケットに写っているのは中身を吹込んだミュージシャンじゃない。とにかく雰囲気を強く訴えたかったんだ」

Candid 8020
Pee Wee Russell-Coleman Hawkins
Jazz Reunion
Photo/Design: Frank Gauna
夢の顔合わせとなった伝説のジャズ・ミュージシャン8人の，くつろいだ姿をとらえたポートレート写真。ガウナならではの落ち着いた色調である。

United Artists 15004
Danny Small-Woman, She was Born for Sorrow
Design/Photo: Frank Gauna

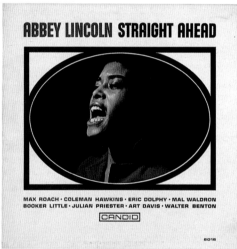

Candid 8015

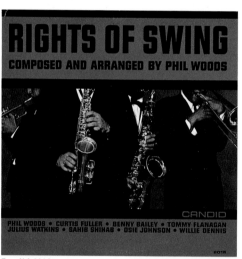

Candid 8016

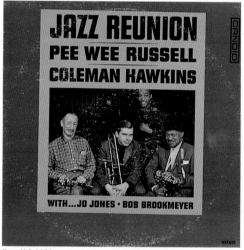

Candid 8020

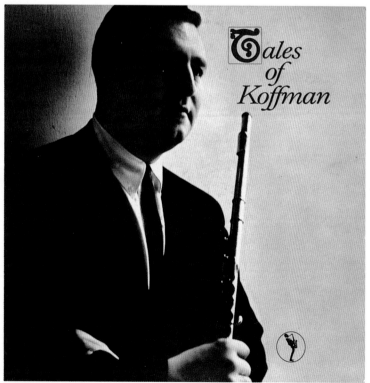

United Artists 14029

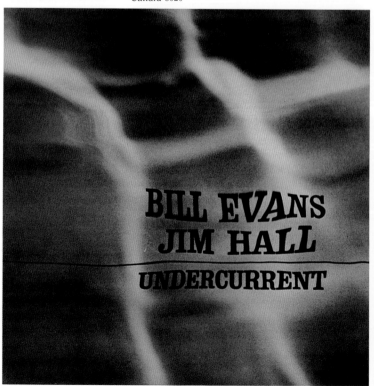

United Artists 14003

ガウナお気に入りのジャケット。「このレコードをプロデュースしたアラン・ダグラスから，泣いている女性を大写しにしたカラー写真を渡され，それを使ってジャケットをデザインしてほしいと言われたんだ。それで，写真をもとに女の目を版画風に描いて，焦点をずらして写真に撮り，レタリングを加え，レタリングに少し重なるように一粒の涙を描き入れた。バックを灰色にしたので，涙のいちばん明るい部分には白を使った。ピンボケの目のおかげで，涙がいかにも本物らしくなった」

United Artists 14029
Moe Koffman-Tales of Koffman
Photo/Design: Frank Gauna

United Artists 14003
Bill Evans/Jim Hall-Undercurrent
Back Cover Photo: Frank Gauna
Design: Frank Gauna-Alan Douglas
「レタリングをデザインして，それを現像液に入れた。そして現像中に液を揺すって，狙ったとおりの「アンダーカレント（底流）」の雰囲気が出たところを，写真に撮ったんだ」

WOMAN, SHE WAS BORN FOR SORROW
DANNY SMALL

United Artists 15004

Candid 8023
Memphis Slim - Tribute to Bill Broonzy

Candid 8024
Memphis Slim - Memphis Slim, U.S.A.
Photo/Design: Frank Gauna
(The jacket photographs are from the same session. "I wanted the Memphis Slim covers to look strong, manly and sharp. To be posed simply but with strong letterings. At that time record companies wanted large close ups of the head to the very top of the hair.

I felt you didn't have to see the full face to know who it was.")

Candid 8023
Memphis Slim-Tribute to Bill Broonzy

Candid 8024
Memphis Slim-Memphis Slim, U.S.A.
Photo/Design: Frank Gauna

ジャケット写真は同じセッションのもの。「メンフィス・スリムのジャケットでは，たくましさと男らしさと鋭さを表わしたかった。それで，ポーズはさりげなく，レタリングは力強くしたんだ。当時，レコード会社は，髪の一本一本までわかるくらいの顔のクローズアップ写真を好んだものだった」

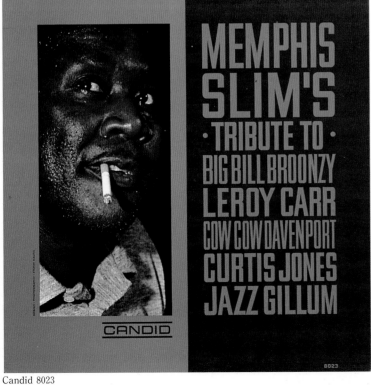

Candid 8023

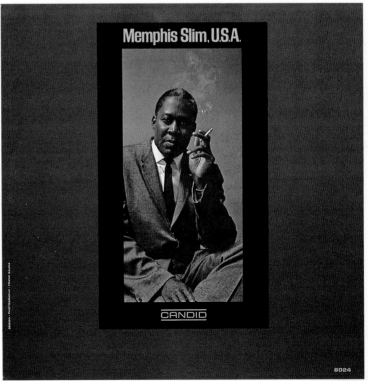

Candid 8024

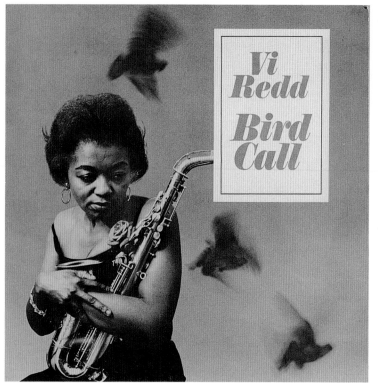

United Artists 14016

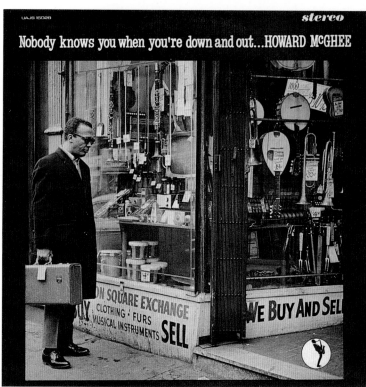

United Artists 14028

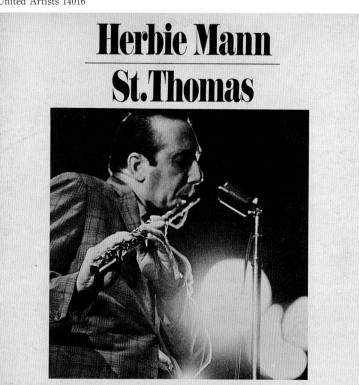

United Artists 14022

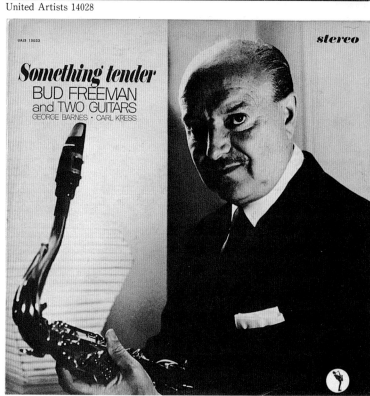

United Artists 14033

United Artists 14016
Vi Redd - Bird Call
(The album comprises compositions by or associated with Charlie Parker - hence the title 'Bird' call. "**I knew a man who kept pigeons-I photographed the pigeons out of focus. Then I shot Vi Redd and made a montage of the two shots.**")

United Artists 14028
Howard McGhee
Nobody Knows You when You're Down and Out
Photo/Design: Frank Gauna
(**"The title is one of the tracks. I wanted the cover to work with it. So I walked him over to 8th Avenue and asked him for the look."**)

United Artists 14022
Herbie Mann - St Thomas
Photo: Chuck Stewart
Design: Frank Gauna

United Artists 14033
Bud Freeman - Something Tender
Photo/Design: Frank Gauna

United Artists 14016
Vi Redd - Bird Call
チャーリー・パーカーの作った曲，または彼に関連する曲を集めたアルバム。そこから彼の愛称をとって，『バードコール』というタイトルがついた。「知り合いに鳩を飼っている男がいて，まずその鳩をピントをはずして撮り，つづいてヴァイ・レッドを撮って，２枚の写真を合成したんだ」

United Artists 14028
Howard McGhee-Nobody Knows You When You're Down and Out
Photo/Design: Frank Gauna
「収録曲の一つからとったタイトルで，ジャケットでもこれを表現したかった。そこで，８番街まで彼を歩かせていって，落ちぶれはてた感じを出してもらったんだ」

United Artists 14022
Herbie Mann-St Thomas
Photo: Chuck Stewart
Design: Frank Gauna

United Artists 14033
Bud Freeman-Something Tender
Photo/Design: Frank Gauna

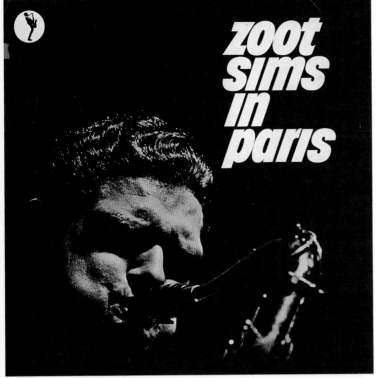

zoot sims in paris

United Artists 14013

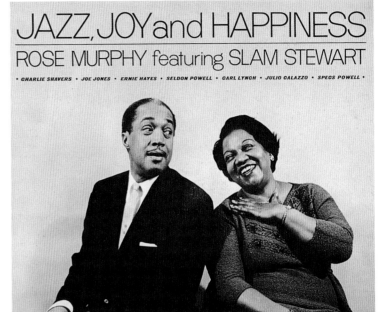

JAZZ, JOY and HAPPINESS
ROSE MURPHY featuring SLAM STEWART
• CHARLIE SHAVERS • JOE JONES • ERNIE HAYES • SELDON POWELL • CARL LYNCH • JULIO CALAZZO • SPECS POWELL •

United Artists 14025

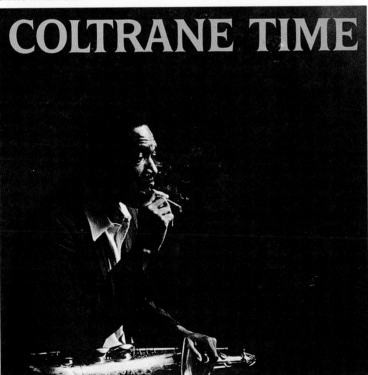

COLTRANE TIME

United Artists 14001

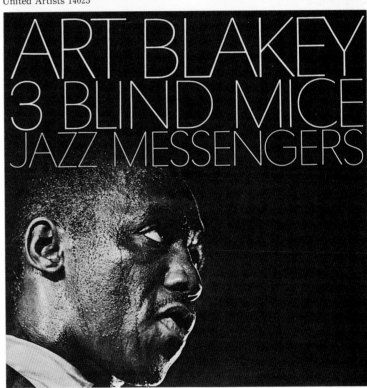

ART BLAKEY
3 BLIND MICE
JAZZ MESSENGERS

United Artists 14002

United Artists 14013
Zoot Sims-In Paris
Design: Frank Gauna

United Artists 14025
Rose Murphy / Slam Stewart
Jazz, Joy and Happiness
Photo/Design: Frank Gauna
("I wanted a nice comfortable pose.")

United Artists 14001
John Coltrane - Coltrane Time
Photo: Chuck Stewart
Design: Frank Gauna

United Artists 14002
Art Blakey - Three Blind Mice
Photo: Chuck Stewart
Design: Frank Gauna

United Artists 14014
Billie Holiday - Lady Love
Photo: Buck Hoeffler
Design: Frank Gauna

("I took the photograph, air brushed out all the things I didn't like. I wanted to keep it very simple ──to be Lady Love.")

United Artists 14015
Ken McIntyre - Year of the Iron Sheep
Photo: Chuck Stewart
Design: Frank Gauna

United Artists 14006
Jerome Richardson - Going to the Movies
Photo/Design: Frank Gauna
(A marvelously witty 'poster' for Jerome Richardson inserted along with posters of movies whose music Richardson plays.)

United Artists 91
Various Artists - United Artists Jazz
Design: Frank Gauna
(United Artist's own tribute to Frank Gauna. A 'sampler' record with a jacket featuring 8 of the Gauna jackets.)

Douglas 798
Dave Burrell - High
Photo/Design: Frank Gauna
(Done for the Douglas label, the piano keys at D and B represent Dave Burrell "which Dave noticed the moment he saw the painting.")

United Artists 14013
Zoot Sims-In Paris
Design: Frank Gauna

United Artists 14025
Rose Murphy/Slam Stewart
Jazz, Joy and Happiness
Photo/Design: Frank Gauna
「ゆったりとくつろいだポーズを撮りたかった」

United Artists 14001
John Coltrane-Coltrane Time
Photo: Chuck Stewart
Design: Frank Gauna

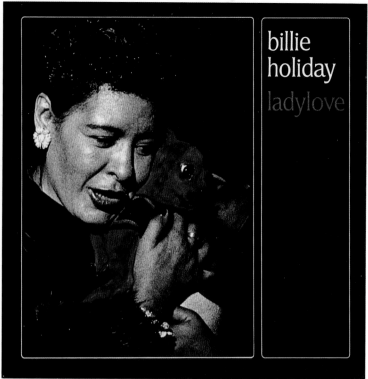

United Artists 14014

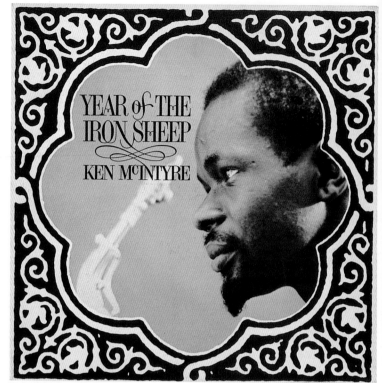

United Artists 14015

United Artists 14006

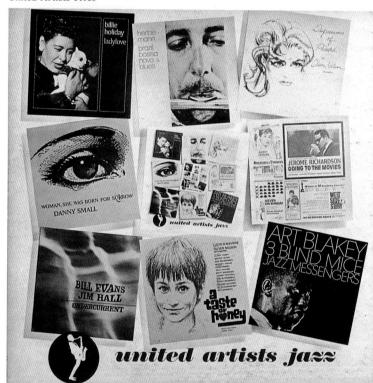

United Artists 91

United Artists 14002
Art Blakey-Three Blind Mice
Photo: Chuck Stewart
Design: Frank Gauna

United Artists 14014
Billie Holiday-Lady Love
Photo: Buck Hoeffler
Design: Frank Gauna
「写真の気に入らないところは全部エアブラシで消した。飾らず純粋に，レディ・ラヴ愛すべきビリーの姿を表わしたかったんだ」

United Artists 14015
Ken McIntyre-Year of the Iron Sheep
Photo: Chuck Stewart
Design: Frank Gauna

United Artists 14006
Jerome Richardson-Going to the Movies
Photo/Design: Frank Gauna

ジェローム・リチャードソンの演奏を用いた映画のポスターにまじえて，本人の姿も「ポスター」として載せた実にしゃれたジャケット。

United Artists 92
Various Artists-United Artists Jazz
Design: Not Credited
ユナイテッド・アーティスツがフランク・ガウナに贈った「選集」盤。ジャケットにはガウナの手がけた8枚のジャケットを組み合わせている。

Douglas 798
Dave Burrell-High
Photo/Design: Frank Gauna
アラン・ダグラスのレーベルの作品。ピアノのD音とB音の鍵は，デイヴ・バレルの頭文字を表している。「デイヴは一目でそれに気づいてくれたよ」

Douglas 798

ANDY WARHOL

アンディ・ウォーホル

Throughout the 1960s till his death in 1987, no artist had been written, about, discussed, or argued over, as much as Andy Warhol. More has been written about this cryptic genius than any other artist of his time. In the 1960s, he was the founding father of the Pop Art Movement but went on to screen printing and film making, influencing an entire life style——the list is endless.
To quote the entry (by Alistair MacKintosh), in the standard reference book 'Contemporary Artists': **"To consider his paintings by themselves is to miss the point. Warhol's subject is society, which he manipulates in actuality as a painter manipulates his paint and for the same purpose, to create, to comment upon and to illustrate."**
Equally endless are the countless books written on Warhol's varied talents. Essentially they start from his New York showings of the early 1960s. Prior to that Warhol was an independent artist and like most independent artists, a struggling one. In 1957 and 1958 Warhol drew a few jazz album covers——in total 4 for Blue Note, 1 for Prestige and a couple for other labels. Curiously, these are not mentioned in the many reference books on his work. But they are fine designs even though the use of the 'DSM line' and of the 'DSM frame' is immediately evident.

　1960年代から1987年に没するまで，アンディ・ウォーホルほど多く書かれ，論じられ，なにかと物議をかもしたアーチストはいない。このなぞめいた天才について書かれた著作は，同時代のどのアーチストより多い。1960年代，彼はまさにポップ・アート運動の草分であったが，スクリーン印刷や映画にも進出し，まったく新しい生活様式に影響を与えるなど，その活動は数えあげたらきりがない。権威ある参考書『コンテンポラリー・アーティスツ』からウォーホルについての記述（アリスター・マッキントッシュ記）を引用してみよう。「ウォーホルの絵だけを見てそれを論ずるのは，まるで的を得ていない。彼の主題は社会であり，実際，画家が絵の具を扱うように巧みに社会を扱っている。創作も批評もイラストも目指すところは同じである」

　また，ウォーホルの多彩な才能について書かれた著作も枚挙にいとまない。このように彼が脚光を浴びるようになったのは，1960年代初め，ニューヨークで作品を発表してからのことだ。それ以前からウォーホルは独立したアーチストであり，若い独立したアーチストの例にもれず，世に認められようと苦闘していた。1957，58年，ウォーホルはジャズ・アルバムのジャケットを描いた。ブルーノート盤を4枚と，プレスティッジ盤を1枚である。不思議なことに，これらは彼の作品を扱ったどの書物にもとりあげられていないが，たとえ「デヴィッド・ストーン・マーチンの線」や「デヴィッド・ストーン・マーチンの構図」がありありと見られるにしても，これらが傑作であることは間違いない。

Blue Note 1543
Kenny Burrell-Kenny Burrell

Blue Note 1580
Johnny Griffin-The Congregation

Blue Note 1543
Kenny Burrell - Kenny Burrell

Blue Note 1580
Johnny Griffin - The Congregation

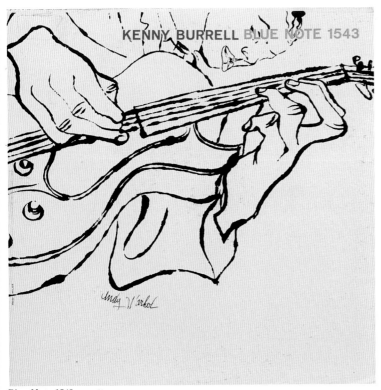

Blue Note 1543

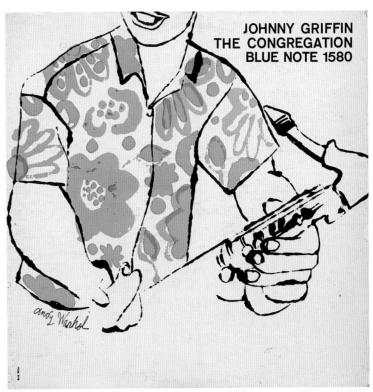

Blue Note 1580

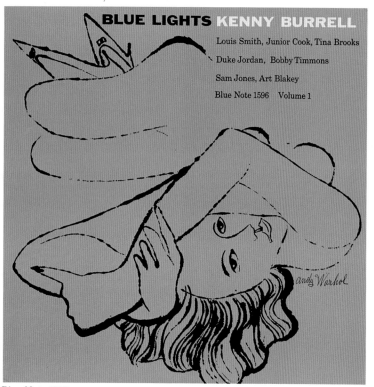

Blue Note 1596

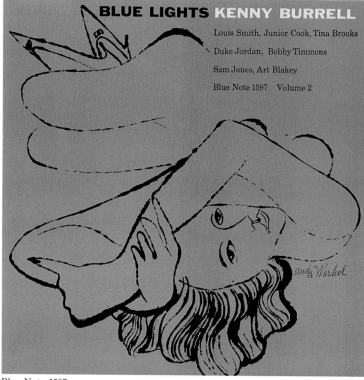

Blue Note 1597

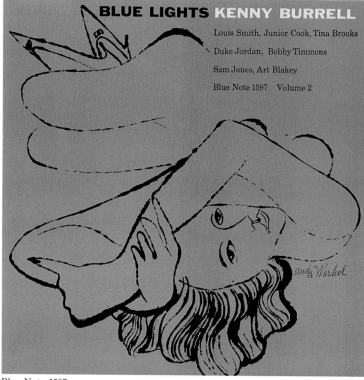

Prestige 4 (16 rpm)

Blue Note 1596
Kenny Burrell - Blue Lights Vol. 1

Blue Note 1597
Kenny Burrell - Blue Lights Vol. 2

Prestige 4 (16 rpm)
Jay Jay Johnson-Kai Winding-Bennie Green
Trombone by Three
(The 16 rpm album was an experiment to combine the equivalent of two 12" conventional LPs in one disc. The 16 RPM format never succeeded. Prestige were to issue this album as a regular 33.1/3 rpm LP too-but with a different cover. The Andy Warhol cover is only on this 16 RPM issue.)

Blue Note 1596
Kenny Burrell-Blue Lights Vol. 1

Blue Note 1597
Kenny Burrell-Blue Lights Vol. 2

Prestige 4 (16 回転盤)
Jay Jay Johnson・Kai Winding・Bennie Green-Trombone by Three
この16回転盤のアルバムは，一般的な12インチLP盤の2枚分を1枚にまとめたいわば試験盤であった。だが，16回転式はそれきり採用されなかった。プレスティッジはこのアルバムをこれまでどおりLP盤でも発売したが，ジャケットは変えられた。アンディ・ウォーホルのジャケットはこの16回転盤だけである。

RCA 1201
Artie Shaw - Both Feet in the Groove
(Though signed just with the initial 'A.W.', this is
Warhol's cover.)

Groove 1003
Conte Candoli Band
Cool Gabriels

RCA 1201
Artie Shaw-Both Feet in the Groove
「A.W.」とイニシャルが書かれているだけだがこれはアン
ディ・ウォーホルの描いたカバーである。

Groove 1003
Conte Candoli Band
Cool Gabriels

RCA LPM-1201

Groove 1003

K. ABÉ
K. アベ

It was Benny Goodman's guitarist Charlie Christian [1] who inadvertently launched Katsuji Abé's career as Japan's great photographer and record cover designer. To his many American musician friends he is more often known as 'Pencil Abé' because of his very slim build.

1948——Japan was occupied by the Allied Forces. Abé, a freshman at Tokyo's Waseda University was a self taught guitar player. He played most nights in swing and dance bands at various American army and navy camps. Until he heard his first Charlie Christian record. **"I didn't want to be an average guitar player. So when I heard someone so much much better than me, I immediately quit playing. I just could not play any more."**

Yet, he wanted more than anything to be part of the jazz music world. Particularly as he had just read Leonard Feather's book 'Inside Bebop'. One of his friends specialized in photographing musicians. This friend opted for marriage and more normal working hours. Abé bought a camera and took over **"I wanted any chance to speak and be near to American musicians—— so I became a photographer."**

His early photography was for his own pleasure——the reward being to talk with the musicians. For money he worked at various jobs, with an airline, designing store windows and as a store salesman. Japan produced so little in those years——so the Japanese looked for imports. Abé persuaded an import goods store for whom he dressed windows to import a few copies of the first American jazz LP's. ***Blue Note, Dial, Circle, American Music, Jazz Panorama***——hardly any copies sold. The Japanese store in desperation sold these at a dollar each to the Post Exchange Store at one of the American bases. At the bases, these records did sell and went back to America.

A few years later though, importing LPs did become commercial. Quite often, the jackets were printed in Japan——with cover notes in Japanese, by Japanese critics. Jacket covers also needed to be modified to appeal to the Japanese. King Records were the first to use Abé as a cover designer and photographer. By 1955, Abé was busy enough to give up all other work to be a full time photographer and jacket designer, essentially for jazz.

In the 30 years or more, Abé was to photograph and design a countless number of jackets. Abé was also renowned for his live jazz photography. He travelled extensively to jazz festivals all over the world. Friendly and helpful, Abé became more than just a friend or confidante to the never ending stream of great jazz musicians visiting Japan. In turn, they were at home to Abé during Abé's frequent visits to America.

Abé remains a self taught photographer. His first cameras were very simple family types. Later, Hasselblads were his work horses for studio work; for concerts and live performances again Hasselblads and Nikons. He never uses a flash and does his own developing and printing. He has always been and continues to be a good humored enthusiast on everything. Except on the future of CD record cover art. For him the CD remains too limited a frame to be creative in. He has published two books on jazz photography and one on New York City. He also compiled and designed 'Jazz Giants——Vision of the Great American Legend', which is beyond doubt the greatest compilation ever of jazz photographs. Apart from his own exhibitions he has also put together collections of jazz artifacts for public displays. In 1986 the American Postal department honored Abé by using his photograph as the commemorative postage stamp honoring Duke Ellington.

Abé's work has graced many American issue covers. Since I can include just a limited number——my choice is from his Japanese issues. Japan has no system of discount sales of Japanese issues; nor space to store slow selling records. So Japanese issues are invariably produced in limited quantities and expected to sell out quickly. This makes even relatively recent issues rare and the earlier records used here to demonstrate 'Pencil' Abé's work, very rare.

(1) Christian's short recording career——1939 to 1942 mainly with Benny Gooodman's groups——is still an influence on jazz guitar playing.

日本の音楽写真家でレコード・ジャケット・デザイナーのパイオニア的存在のK.アベに，はからずもこの道に入るきっかけを与えたのは，ベニー・グッドマンのギタリスト，チャーリー・クリスチャン（注）であった。（“K”は名前の“カツジ”の頭文字だが，アメリカのミュージシャンからはほっそりした体つきから，“ペンシル・アベ”と呼ばれることもある）

1948年，日本は連合国軍の支配下にあった。東京の早稲田大学の1年生だったアベは，独学でギターを覚え，夜はあちこちの米軍キャンプのスイングやダンスのバンドで演奏していた。そうして，初めてチャーリー・クリスチャンのレコードを耳にしたのである。「私は一流のギター奏者になりたかった。だから，自分など足下にも及ばない演奏を聴いたとたん，ギターを諦めた。もうとても弾く気になれなかったんだ」

それでもアベがなによりジャズの世界に居場所を求めたのは，ジャズ評論家レナード・フェザーの『インサイド・ビバップ』を読んだ影響が大きかった。折しも，ミュージシャンの写真撮影をしていた友人のひとりが，結婚して普通の勤めに就くことになった。そこでアベはすぐさま，カメラ屋に飛び込んだのである。「なんでもいいから，アメリカのミュージシャンに近づいて触れる機会がほしかった。それで写真家になったんだ」

初めのころ，アベは趣味で写真を撮っているにすぎなかった。相手のミュージシャンと話せればそれだけでよかった。金のために，航空会社，ショーウインドーの装飾，セールスマンなど職を転々としていた。当時の日本は生産力が乏しく，輸入に頼らざるをえなかった。アベはショーウインドーのディスプレイをする輸入品店を説得して，アメリカの初期のジャズLPを試しに輸入させた。だが，ブルーノート，ダイアル，サークル，ジャズパノラマ，アメリカン・ミュージック等のレーベルのLPは，ほとんど売れなかった。がっかりした輸入店側は，これを米軍基地のPXに1枚1ドルでまとめて売却。しかし皮肉なことにレコードは米軍基地で売れ，再びアメリカに持ち帰られたのである。

数年後には，輸入LPも商業ベースにのり，ジャケットを日本で制作することが多くなった。日本人の評論家による解説を載せ，カバーデザインも日本人受けするよう変える必要があったのだ。その初期のころ，キングレコードが写真家兼ジャケット・デザイナーとしてアベを起用。1955年には，アベは片手間仕事ではできないほどの売れっ子となり，ジャズを中心とする写真とジャケットのデザインに専念するようになった。

30年あまりの間に，アベはシングルカードを含めて数千枚にのぼるレコードジャケットを撮影しデザインした。ジャズのライブ写真でも有名で，世界狭しと各国のジャズ祭に飛んだ。また，次々と来日する大物ジャズミュージシャン達を心から歓迎し助け，単なる友人，親友という以上の関係になった。そのお返しに，彼らはアベがちょくちょくアメリカを訪れたときには自宅に迎えてくれたのである。

アベの写真はあくまでも彼独特のものである。最初に使用していたのはごく普通の「家庭用」カメラだった。後に，スタジオの撮影にはビューカメラとハッセルブラッドを，コンサートやライブの撮影には同じくハッセルブラッドとニコンFを使うようになった。彼は決してフラッシュをたかないし，必ず自分の手で現像しプリントする。なにごとにも常に陽気に一生懸命取り組んできたその姿勢は今も変わらないが，CDレコードのカバーアートだけには先を案じている。CDのジャケットは小さすぎて，まったく魅力に欠ける商品だという。また，アベはジャズの写真に関する著作を2冊と，ニューヨーク市に関する著作を1冊発表している。自ら編集・デザインした『ジャズ・ジャイアンツ ─ ヴィジョン・オヴ・ザ・グレイト・アメリカン・レジェンド』は，疑いの余地なくジャズ写真集の傑作である。自分の作品展の他に，ジャズにちなんだコレクションも公開してきた。1986年，米郵政局が発行したデューク・エリントンの記念切手には彼の写真が使用されるという光栄にも浴した。

アベの作品は，多くのアメリカ盤のジャケットも飾ってきた。しかし，本書では限られた数しかご紹介できないので，日本盤のジャケットのなかから選ばせていただいた。日本には国内盤を安売りするシステムがないし，売れ行きの悪いレコードを保管しておくような場所もないため，少ない発行枚数で短期間に売りさばく方針をとっている。したがって，比較的最近の日本盤でさえ手に入りにくく，ここに載せたそれ以前の“ペンシル・アベ”のジャケット盤ともなるとめったにお目にかかれない。

（注1）クリスチャンが主としてベニー・グッドマンのグループと吹込んだ演奏は，1939年から42年という短い期間ではあったが，今なおジャズ・ギターの演奏に影響を与えつづけている。

Abé——AND THE RIVERSIDE-JAPAN ISSUES

Riverside was a popular jazz label well known for its 'straight ahead' style of recorded jazz. The **Riverside** recording stable included Thelonious Monk, Cannonball Adderley, Wes Montgomery——musicians who had large followings. Sadly, the label folded with commercial sales not matching the high musical output. The **Riverside** catalogue was ultimately transferred to Fantasy records.

Japanese interest in the backlog of unissued *Riverside* recordings remained strong. Around 1980, Fantasy licensed Victor-Japan to issue a series of 'new' **Riverside** recordings. These comprised unissued or alternate tracks. Abé was commissioned to design many of the covers. Some of these are shown here.

Riverside 4028
Wes Montgomery - Moanin'
Photo: K. Abé
(At the Monterey Festival, early 1960s.)

Riverside 4030
Julian 'Cannonball' Adderley - Straight, No Chaser
Photo: K. Abé
(Also from Monterey, early 1960s.)

Riverside 6247
Bill Evans - Green Dolphin Street
Photo/Design: K. Abé
(Shot for personal pleasure——a street in Amsterdam, Holland; in thick fog. But it fits perfectly into the mood of both the title and of Bill Evans's music.)

Riverside 9501
Julian 'Cannonball' Adderley - Live in Tokyo
Photo/Design: K. Abé
(A Tokyo concert of 1966——but remixed and issued only in 1975. The photo is from one of Cannonball's concerts in Japan.)
An alternate photo of Cannonball Adderley.

Riverside 4032
Thelonious Monk - 'Round Midnight
Photo: K Abé
(Taken at the Monterey Festival of 1961. A standard shot, given a special grainy effect by Abé.)

リヴァーサイド日本盤

　リヴァーサイドは「正統派」の録音で知られる人気のジャズ・レーベルであった。リヴァーサイドには、セロニアス・モンク、キャノンボール・アダレイ、ウエス・モンゴメリーなど、多くの信奉者を持つ先駆的なミュージシャンが属していた。だが残念なことに、大量なレコード生産に見合う売上が得られず廃業。結局、リヴァーサイドの目録はファンタジーレコードに移った。リヴァーサイドの未発表作品に日本人の熱い声は、衰えることを知らなかった。1980年頃、ビクター・ジャパンがファンタジーレコードの許可を得て、新しいリヴァーサイド作品のシリーズを発表。未発表、あるいは控えのトラックの編集盤である。ジャケットの多くはアベが手がけた。そのいくつかを紹介しよう。

Riverside 4028
Wes Montgomery-Moanin'
Photo: K. Abe
1960年代初頭のモンタレー・ジャズ祭にて撮影。

Riverside 4030
Julian 'Cannonball' Adderley-Straight, No Chaser
Photo: K. Abe
1960年代初頭のモンタレー・ジャズ祭にて撮影。

Riverside 6247
Bill Evans-Green Dolphin Street
Photo/Design: K. Abe
趣味で、オランダのアムステルダムの通りを撮ったもの。深い霧に包まれているが、それがタイトルとビル・エヴァンスの演奏の両方の雰囲気にぴったり合っている。

Riverside 9501
Julian 'Cannonball' Adderley-Live in Tokyo
Photo/Design: K. Abe
1966年、東京のコンサートのライブ録音だが、ミキシング録音し直し、1975年になってようやく発売された。写真はキャノンボールの日本でのコンサートより。キャノンボール・アダレイの別ショット。

Riverside 4032
Thelonious Monk-'Round Midnight
Photo: K. Abe
1961年のモンタレー・ジャズ祭にて撮影した、秀逸の1枚。アベは粒子を粗くする特殊処理をしている。

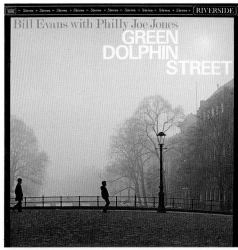

Riverside 6247

Riverside 4028

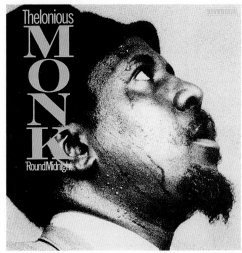

Riverside 4030

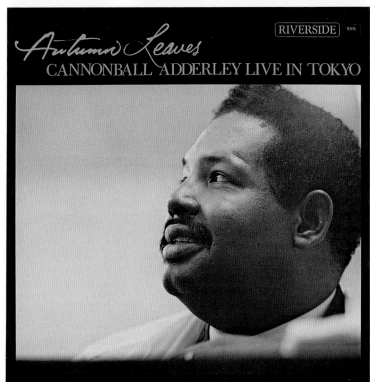

Riverside 9501

Riverside 4032

Abé——AND THE BEAUTIFUL LADIES

Japan is a particularly responsive audience for the great female interpreters of 'standard' songs. Quite often these visits included recordings made either 'live' at concerts or recordings made in America under commission from Japanese record producers and issued only in Japan.

TRIO 9104
Irene Kral - Live in Tokyo
Photo/Design: K. Abé
(Ms. Kral photographed at sunset in her Tokyo hotel room. Photographed at the time of this recording. Tokyo, July 20 1977.)

TRIO 7105
Anita O'Day - Anita
Photo/Design: K. Abé
(A Tokyo photograph on one of Ms. O'Day's frequent tours. The music itself was recorded in California in April 25 1975.)

TRIO 7140 (Recorded live Tokyo, June 19 1975)
Anita O'Day - Live in Tokyo, 1975
Photo/Design: K. Abé

(Shot and recorded——Tokyo concert June 19 1975.)
TRIO 9059 (Live at 'Mingos' Tokyo October 22 1976)
Anita O'Day - Live at Mingos
Photo/Design: K. Abé
(Photographed outside Mingos once a landmark 'live' jazz club of Tokyo's Roppongi entertainment strip. Mingos is no longer in existence.)

美しい女性ミュージシャン達

日本では，特に「スタンダードナンバー」を歌う大物女性シンガーの人気が高い。来日した彼女たちのコンサートを「ライブ」録音するか，日本の製作者の依頼でアメリカで録音するかして，国内盤として日本でのみ発売することが多かった。

TRIO 9104
Irene Kral-Live in Tokyo
Photo/Design: K. Abé
ミス・クラールの写真は，録音と同じときに，東京のホテルの部屋で日没時に撮影したもの。1977年7月20日，東京にてライブ録音。

TRIO 7105
Anita O'Day-Anita
Photo/Design: K. Abe
たびたび日本ツアーを行なったミス・オデイを東京で撮影した1枚。音楽自体は1975年4月25日，カリフォルニアにて録音。

TRIO 7140
Anita O'Day-Live in Tokyo, 1975
Photo/Design: K. Abe
1975年6月19日，東京のコンサートにて撮影，録音。

TRIO 9059
Anita O'Day-Live at Mingos
Photo/Design: K. Abe
かつて東京六本木の歓楽街で画期的存在だった「ライブ」ジャズ・クラブ『ミンゴス』の外にて撮影。1976年10月22日，東京『ミンゴス』にてライブ録音。このクラブは既に存在しない。

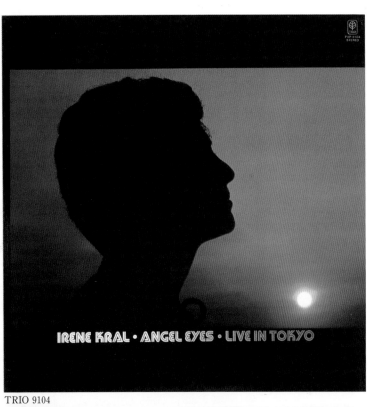

TRIO 9104

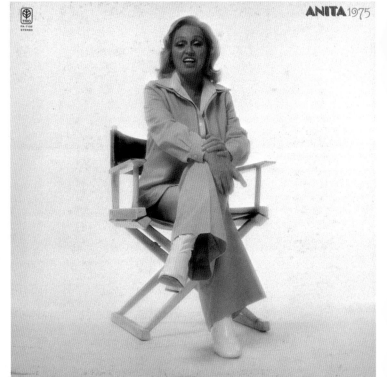

TRIO 7105

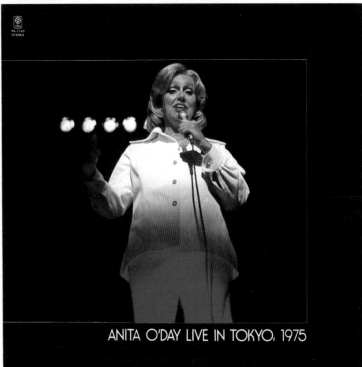

TRIO 7140 (Recorded live Tokyo, June 19 1975)

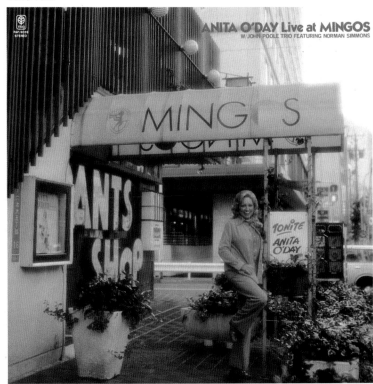

TRIO 9059 (Live at 'Mingos' Tokyo October 22 1976)

TRIO-9086
Helen Merrill - Love in Song
Photo/Design: K. Abé
(Tokyo studio, late 1970s. Abé's assistant blew a strong fan through Helen Merrill's hair till Abé got the effect he wanted.) An alternate photograph.

Victor 10132
Helen Merrill/Gary Peacock Trio - Sposin'
Photo/Design: K. Abé
(Λ sandwich print of several color positive transparencies. A Tokyo studio recording of March 1971. The cover photo is from a Tokyo concert of July 1971.)
The original shot——black and white——when Helen Merrill sang with Teddy Wilson in a Tokyo recording. Double spread albums were popular in the 1970s. The original negative was treated in the dark room with different exposures and transformed into several color positive transparencies "Sometimes it takes a week only for the purpose——just like it were a drawing."

Trio 9146
Lorez Alexandria
From Broadway to Hollywood
Photo/Design: K. Abé
(Recorded Hollywood August/October 1977.)

Trio 9099
Carol Sloane - Sophisticated Lady
Photo/Design: K. Abé
(Tokyo studio shot, October 1977; same time as the recording.)

TRIO 9086
Helen Merrill-Love in Song
Photo/Design: K. Abe
1970年代末，東京のスタジオにて撮影。アベのアシスタントが強力な扇風機でヘレン・メリルの髪をなびかせ，狙いどおりの効果を得た。

Victor 10132
Helen Merrill/Gary Peacock Trio-Sposin'
Photo/Design: K. Abe
数枚のカラーポジを重ねて仕上げたもので，もともとはモノクロだった。1971年3月，東京のスタジオにて録音。カバー写真は1971年7月，東京で行なわれたコンサートにて撮影。
　東京のレコーディングでディ・ウイルソンと歌うヘレン・メリルを撮ったモノクロのオリジナル写真。2ページ大の見開き型のアルバムは1970年代に流行した。原版ネガを数枚のカラーポジに変換すべく暗室内で処理している。「たったそれだけのために，ときには1週間かかることもある。ちょうど絵を描くみたいなもんだよ」

TRIO 9146
Lorez Alexandria
From Broadway to Hollywood
Photo/Design: K. Abe
1977年8月，10月，ハリウッドにて録音。

TRIO 9099
Carol Sloane-Sophisticated Lady
Photo/Design: K. Abe
1977年10月，東京のスタジオにて撮影，録音。

Trio 9146

Trio 9099

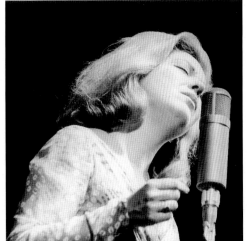

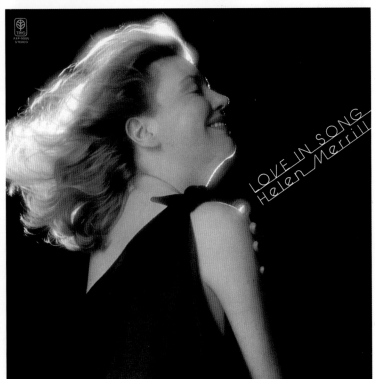

TRIO-9086

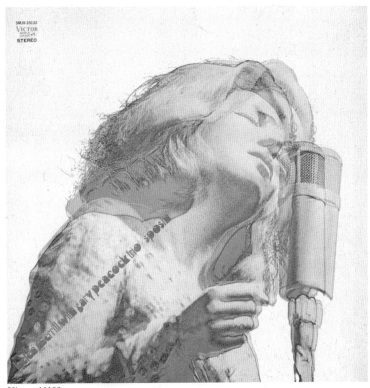
Victor 10132

Abé—COVERS THROUGH HIS CAREER

London 295 - Blues Super Session
A compilation of tracks by groups including Otis Spann, Champion Jack Dupree
Photo/Design: K. Abé
(An early Stereo record. The Japanese distributor did not like the original English jacket and had Abé design a new one using a professional model. 1970 issue.)

London 321
Jacques Loussier - Play Bach
Photo/Design: K. Abé
(Again, the Japanese distributor did not like the original cover from England. Abé made this new design. The cover is not hand drawn but is part of the facade of a church in Europe, a technical photograph sandwiched as several exposures. 1970.)

Paddle Wheel 3220
Red Mitchell - Bass Club
Photo/Design: K. Abé
(Another Japan-only issue. A duo record of Red Mitchell on Bass along with Japan's Isao Suzuki on Piccolo-Bass. Photographed/recorded at a Tokyo studio - August 21 1979.)

LOB 1030
Benny Carter - Street of Dreams
Photo/Design: K. Abé
(Another Japan-only issue. The ever-young Benny Carter photographed during a July 1981 Tokyo recording. Backed by a Japanese rhythm section.)

CBS Sony 2775
Stan Getz - The Master
Photo/Design: K. Abé
(One of Abé's most famous shots——taken during Stan Getz's first concert tour of Japan——July 1965. The record itself is a 1975 American recording. CBS, however, wanted a photograph of a younger Getz.)

An alternate shot

Baybridge 2172
Thelonious Monk - In Japan 1963
Photo: K. Abé
Design: H. Sakakibara
(Recorded in Tokyo, May 1963. The photograph is of May 1966.)

ABC Paramount 3012
Quincy Jones - This is How I Feel About Jazz
Photo/Design: K. Abé
(The Japanese version of the American issue. Another of Abé's shots from the Monterey Festival, early 1960s.)

Contemporary 7614
Jimmy Woods - Conflict
Photo/Design: K. Abé
(Photographed when Woods toured Japan with the Chico Hamilton Group——August 1964.)

KING 1075
Sadao Watanabe - Akira Miyazawa
Latin Barock (1968)
(A professional model wearing Abé's sweat shirt—— with Abé's hurriedly drawn interpretation of a jazz baroque player.)

実績を生かした数々の作品

London 295-Blues Super Session
A compilation of tracks by groups including Otis Spann, Champion Jack Dupree
Photo/Design: K. Abe
初期のステレオ録音盤。日本の発売元はオリジナルのイギリス盤のジャケットが気に入らず、アベにプロのモデルを使った新しいジャケットを依頼した。

London 321
Jacques Loussier-Play Bach
Photo/Design: K. Abe
またも、日本の発売元はイギリスから届いたオリジナルのジャケットが気に入らず、アベが新しいデザインを手がけた。同じ手法のデザインが使われた。手書きの絵ではなく、1968 年、ヨーロッパの教会の正面を撮影したオリジナル写真の一部を，多重露光という技術を用いて処理した写真。

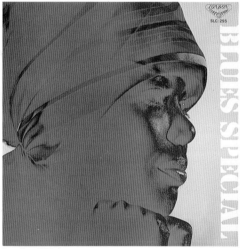

London 295

London 321

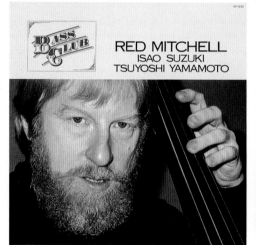

Paddle Wheel 3220

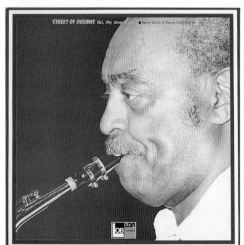

LOB 1030

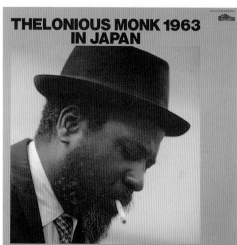

Baybridge 2172

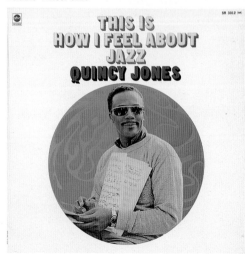

ABC Paramount 3012

使われたのは教会の一部だけだが，興味深い装飾部分を
マスキングし縮小複写するという暗室作業を重ねた末に作
品となった。1970年。

Paddle Wheel 3220
Red Mitchell-Bass Club
Photo/Design: K. Abe
これも日本限定盤。レッド・ミッチェルのベースと日本の
イサオ・スズキ（鈴木勲）のピッコロ，ベースによるデュ
オのレコード。1979年8月21日，キングのスタジオにて撮
影，録音。

LOB 1030
Benny Carter-Street of Dreams
Photo/Design: K. Abe
同じく日本限定盤。1981年7月，東京でレコーディング中
の永遠の青年ベニー・カーターを撮影。後ろは日本人のリ
ズム・セクション。

CBS Sony 2775
Stan Getz-The Master
Photo/Design: K. Abe
アベの最も有名な写真の一つ。1965年7月，スタン・ゲッ
ツの初めての日本コンサートツアー中に撮影。演奏は1975
年にアメリカにて録音されたものだが，CBSは若いゲッツ
の写真を選んだ。別ショット。

Baybridge 2172
Thelonious Monk-in Japan 1963
Photo: K. Abe
Design: H. Sakakibara
1963年5月，東京にて録音。写真は1966年5月に撮影。

ABC Paramount 3012
Quincy Jones-This is How I Feel About jazz
Photo/Design: K. Abe
アメリカ盤をオリジナルとする日本盤。1960年代初頭，モ
ンタレー・ジャズ祭にて撮影した1枚。

Contemporary 7614
Jimmy Woods-Conflict
Photo/Design: K. Abe
1964年8月，ウッズがチコ・ハミルトン・グループと日本
ツアー中に撮影。

KING 1075
Sadao Watanabe-Akira Miyazawa
Latin Barock (1968)
プロのモデルが着ているスウェットシャツには，アベが大
急ぎで描いたジャズ風バロック奏者の顔がある。

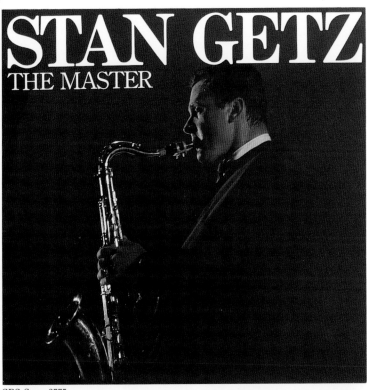

CBS Sony 2775

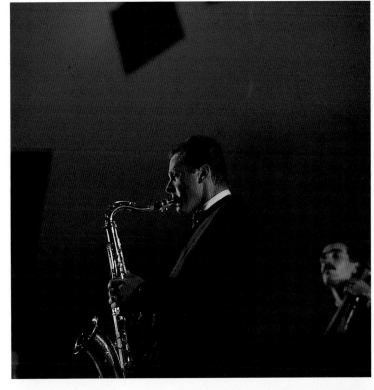

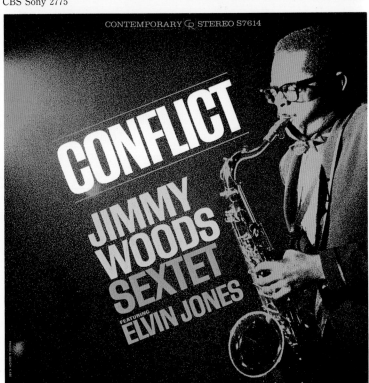

Contemporary 7614

KING 1075

Abé——AND HIS GREAT FRIENDS OF JAZZ

Month after month, the greatest international jazz names visit Japan. One reason is the high level of musical awareness in the audience. Abé has been a good personal friend to most visiting musicians. Some have come not once, not twice but several times. The friendships have extended to Abé's return visits to their own homes.

Elec 117
Count Basie - Basie Strides Again
Photo/Design: K. Abé

(Abé and Basie knew each other well. But Abé could never bring himself to call the Count anything but 'Mr Basie'. One time Abé said 'Mr Basie' once too often, Basie stepped back in mock surprise with an exaggerated adjustment of his neck tie——Abé shot immediately. The background is a shot of the 'Northern Lights' shot at dawn from the cockpit of a Polar Route flight. So, a montage of two shots.

The record itself is a collection of V-Discs. V-Discs are single tracks recorded specially for the Allied forces of World War II. The V-Discs (usually 12" 78 rpm) were later coveted by collectors and also compiled on LP to reach a wider listening audience.)

An alternate shot of Count Basie without the Northern sky background.

Elec - 50676
Thad Jones/Mel Lewis Quartet
You Made me Love You
Photo/Design - and Producer: K. Abé

(The first tour of Japan by the Thad Jones/Mel Lewis big Band was dogged by every possible misfortune. Abé helped them out immensely. From this, there developed a special friendship with Thad Jones who called Abé his 'brother' and often said 'You made me Love you'. In a subsequent tour of their big band, Thad Jones and Mel Lewis took time off to record with a quartet selected from their big band. Which Abé apart from photographing and designing, produced too. Photo/recording——Tokyo November 14 1975.)

Polydor 3081
Shelly Manne - Goodbye for Bill Evans
Photo/Design: K. Abé

(Both Shelly Manne and Abé are freaks for unusual caps and hats. On a walk round Tokyo, Manne was fascinated by the window display of a shop specializing in caps worn by students of the major Japanese universities. Manne bought one, wore it and was happily photographed with the insignia cap worn by students of Japan's prestigious Keio University. The music is a live Tokyo concert of April 21 1981.)

TXM 4056
Toshiko Akiyoshi - Long Yellow Road
Photo/Design: K. Abé (1972)

(The front cover was shot in Los Angeles. But the back cover is more interesting. On Toshiko's lap is her daughter Michiru. Michiru herself is now a popular successful film and TV star.)

An alternate shot of Toshiko and daughter Michiru

Teichiku Joker 2066
Dizzy Gillespie - Dizzy Great (Recorded NYC 1952)
Photo/Design: K. Abé (Record issued 1977)

(Taken November 1973——Dizzy's New Jersey home. **"He was so relaxed. Dizzy is crazy about cameras and he would always ask me lots of things on photography. I would joke——don't ask me because I am not a photographer.**)
An alternate photograph——Gillespie holds Abé's Nikon-F while Abé shot with another camera.

親友のジャズ・ミュージシャン達

次々と世界的な大物ジャズ・ミュージシャンが日本を訪れている。日本の聴き手の音楽意識が高いことが，理由のひとつだ。アベはそんな大部分の来日ミュージシャンと個人的に親しくなった。なかには一度や二度ならず数度来日するミュージシャンもいて，今度はお返しにアベが彼らの国を訪ね，ますます親交が深まっていった。

Elec 117
Count Basie-Basie Strides Again
Photo/Design: K. Abe

アベはベイシーと親しい間柄だったが，どうしても「ミスター・ベイシー」という呼び方しかできなかった。あるとき，ついまたアベが「ミスター・ベイシー」と口にしてしまうと，ベイシーはさもおどけたふりをして，大袈裟にネクタイを直しながら後退りした。そこをすかさずアベがパチリ。背景に使われているのは，北極経由便のコックピットから夜明けの北極光を撮った写真。したがって，2枚のモンタージュ写真である。

Elec 117

Elec - 50676

Polydor 3081

このレコードはVディスクを集めたもの。Vディスクとは、第二次世界大戦中、連合国軍の士気を高めるため特別に録音されたシングルトラックのことである。このVディスク（普通は78回転の12インチ盤）は後にコレクターたちの垂涎の的となり、またLP盤に編集されてより多くの人々に聴かれるようにもなった。

北極光の背景のないカウント・ベーシーの写真

Elec 50676
Thad Jones/Mel Lewis Quartet-You Made me Love You
Photo/Design and Producer: K. Abe
サド・ジョーンズ／メル・ルイス・ビッグ・バンドの最初の日本ツアーは、度重なる不運に見舞われたが、そんな彼らの大きな力となりツアーを成功させたのがアベだった。ここから、特別な友情が生まれた。サド・ジョーンズはアベを「ブラザー」と呼び、「君にいかれちゃったよ」としょっちゅう口にしたものだ。ビッグ・バンドを率いた次のツアーのとき、サド・ジョーンズとメル・ルイスは時間をさいてカルテットのレコーディングをした。アベはこの作品

の写真撮影とデザインだけでなく、製作も手がけている。1975年11月14日、東京にて撮影、録音。

Polydor 3081
Shelly Manne-Goodbye for Bill Evans
Photo/Design: K. Abe
シェリー・マンとアベは2人とも帽子マニアで、変わった帽子には目がない。東京を散策中、マンは日本の主要大学の学生帽を専門に扱う帽子屋のウインドーに心を奪われた。そして、さっそくその一つを購入。名門慶応大学の学生のかぶる校章入りの帽子を頭に、ご機嫌で写真におさまった。音楽は1981年4月21日、東京にてライブ録音。

TXM 4056
Toshiko Akiyoshi-Long Yellow Road
Photo/Design: K. Abe(1972)
ジャケットの表の写真は、ロサンゼルスにて撮影。だが、おもしろいのは裏のほうだ。トシコの膝に乗っているのは娘のミチルで、ミチルは現在、人気女優として映画やテレビで活躍している。

トシコと娘のミチルを撮った別ショット

Teichiku Joker 2066
Dizzy Gillespie-Dizzy Great (1952年ニューヨークにて録音)
Photo/Design: K. Abe（1977年盤）
1973年11月、ニュージャージー州のディジーの自宅にて撮影。「ディジーはとてもリラックスしていた。カメラ・マニアの彼は、いつも写真の撮り方をあれこれ訊いてきてね、私は冗談で答えたもんだよ。"おれに訊かないでくれよ、写真家じゃないんだから"って。」
別ショット。ガレスピーがアベのニコンFを手にしているところを、アベが別のカメラで撮ったもの。

TXM 4056

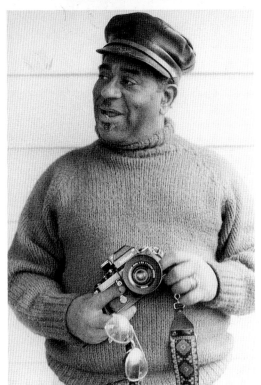

Teichiku Joker 2066

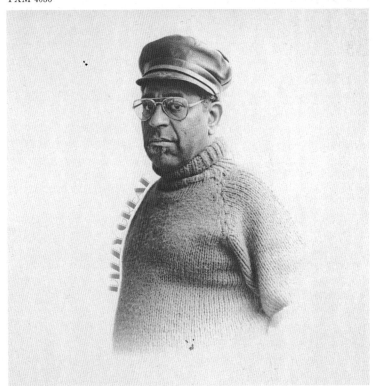

Teichiku Joker 2060
Art Blakey - Art's Break (Recorded Europe 1972)
Photo/Design: K. Abé (Issued Japan 1977)
(During the American Bicentennial celebration of 1976,
Abé joined Art Blakey's family on a boat cruise on New
York's Hudson River. Blakey holds his young son, who
is now a professional musician in his own right.)

Teichiku Joker 2055 (Recorded Rome, 1967/68)
Hampton Hawes - Piano Improvisation (Record issued
1977)
Photo/Design: K. Abé
(The end of World War II found Hampton Hawes in
the American Army and posted in Japan. While waiting
to return to the states he played piano, dressed in his
uniform, at Army Clubs in and around Tokyo. This
cover is May 1968 on his second visit to Japan. Hawes
joked with Abé that this time he should be photograph-
ed not in uniform but in natty civilian clothes.)

Teichiku Joker 2060
Art Blakey-Art's Break (1972 年ヨーロッパにて録音)
Photo/Design: K. Abe (1977 年日本盤)
1976年のアメリカ独立200年祭のとき，アベはアート・ブ
レイキーの家族と一緒に，ニューヨークのハドソン川でボ
ートクルーズを楽しんだ。ブレイキーの抱いているのは下
の息子で，現在，親譲りのプロのミュージシャンとして活
躍中。

Teichiku Joker 2055 (1967-68 年ローマにて録音)
Hampton Hawes-Piano Improvisation (1977 年盤)
Photo/Design: K. Abe
第二次世界大戦が終結し，ハンプトン・ホーズはアメリカ
軍兵士として日本に駐留していた。帰国を待つ間，彼は東
京内外の米軍クラブで，軍服姿でピアノを弾いた。ジャケ
ット写真は，1968 年5月，再来日したときに撮影。ホーズ
は「今度は軍服じゃなくて，しゃれた民間人の格好で撮っ
てもらわなきゃな」とアベをからかった。

Abé——HIS VISUAL COMPOSITIONS AND
PENCIL DRAWINGS
ELEC 110
Duke Ellington - These V-Disc Years
Drawing/Design: K. Abé
("I did it with colored pencils——it took me two
weeks". The record is a compilation of V-Discs recor-
ded by the Duke Ellington Orchestra as part of the
World War II effort.)
ELEC 121
Muggsy Spanier - Dixieland Horn
Drawing/Design: K. Abé
(Also done with colored pencils. A compilation of
Muggsy Spanier 78 rpm records.)
ELEC 124
Various Artists
V-Disc Juke Box Saturday Night
Design: K. Abé

Teichiku Joker 2060

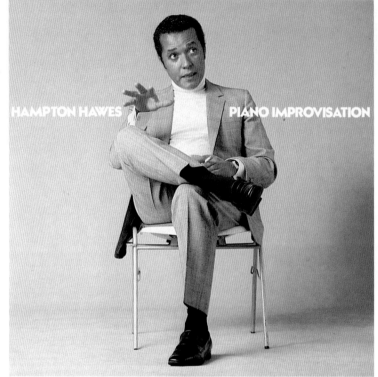

Teichiku Joker 2055 (Recorded Rome, 1967/68)

ELEC 110

ELEC 121

("I put the lettering on an illustration board and took it to the printer. We put it directly on the four color separation machine. But I added my packet of cigarettes, some American coins, and a Coke cap." The record is another compilation of rare V-Discs.)

CBS 1205
Various Artists
The Sound of Chicago 1923-1940
Photo/Design: K. Abé
(The cover for a limited edition box set issue. Professional American model. Early 1970's.)

Progressive
The All Star Trombone Spectacular
Photo/Design: K. Abé
(The American issue of this New York City 1977 recording featured a jacket by David Stone Martin. For the photo for the Japanese issue, Abé photographed this with a large loan of trombones from Selmer-Japan.)

Impulse 3052 102
Various Artists - The Definitive Jazz Scene Vol.2
Photo/Design: K. Abé
(This Impulse record was issued just in Japan.)

色鉛筆によるドローイング

ELEC 110
Duke Ellington-These V-Disc Years
Drawing/Design: K. Abe
「色鉛筆を使ったんだ。2週間がかりだったね」レコード
は，第二次世界大戦の遂行活動の一環として録音されたデ
ューク・エリントン・オーケストラのVディスクを編集し
たもの。

ELEC 121
Muggsy Spanier-Dixieland Horn
Drawing/Design: K. Abe
これも色鉛筆を使っている。マグシー・スパニアの78回転
盤を編集。

ELEC 124
Various Artists
V-Disc Juke Box Saturday Night
Design: K. Abe
「イラスト地の台紙に文字を配置してから印刷業者に持っ
ていって，直接製版用の4色分解機にかけた。その台紙の
上にポケットに用意してあったタバコとアメリカの硬貨と
コーラのキャップを乗せて写真原稿にしたんだ」希少なV
ディスクの別の編集盤。

CBS 1205
Various Artists
The Sound of Chicago 1923-1940
Photo/Design: K. Abe
限定発売の箱入りセット盤のジャケット。プロのアメリカ
人モデルを使って撮影。1970年代初め。

Progressive
The All Star Trombone Spectacular
Photo/Design: K. Abe
1977年，ニューヨークで録音されたアメリカ盤は，デヴィ
ッド・ストーン・マーチンのジャケットを使っていた。日
本盤の写真は，アベがセルマー・ジャパンからトロンボー
ンを大量に借りて撮影した。

Impulse 3052
Various Artists-The Definitive Jazz Scene Vol. 2
Photo/Design: K. Abe
このインパルス盤は日本でのみ発売された。

ELEC 124

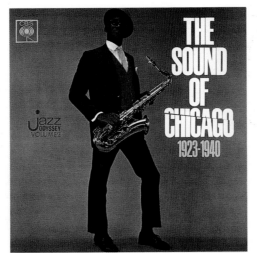

CBS 1205

Progressive

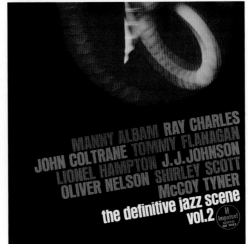

Impulse 3052

THE 'BLUE NOTE' 10" LABEL

「ブルーノート」レーベル　10 インチ盤

Recorded jazz is a business in which for labels, fatalities or sudden disappearances and unnoticed fade-aways are only too common. True, sometimes the music was ahead of its time. More often, music was not the problem. But rather it was the economics and the physical impossibilities of national and international marketing by specialized jazz record companies. Many first issues had been so limited that the magazines of the day carried no reviews of them. The label owners obviously did not, or could not, afford to send copies for review.

In time the 'market' did catch up. Virtually every jazz label was revived through reissues. And with Japan becoming a large market——many labels on their second, third, later, even CD time around (or sadly, sometimes on their bootleg time around) achieved a success which their original promoters could not have imagined.

All the more incredible then, that one label——*Blue Note*——has not just survived but flourished as an exclusive jazz label, now for over 50 years. Quite a history and created by two Germans from Berlin who migrated to America without any background in jazz.

Alfred Lion who was born in Germany in 1909, heard a visiting American band there in 1925. Emboldened, he came to America in 1930 to further his involvement as a part-time listener and collector. In 1938 he produced his own label called *Blue Note* and his first recordings were of the pianists Albert Ammons and Meade Lux Lewis. Followed by recordings of the soprano saxophonist and clarinetist Sidney Bechet and other musicians of the time.

Blue Note really got going in 1941 when Lion's friend Francis Wolff arrived also from Berlin. Wolff who became a photographer, shared Lion's interest in jazz and became a full time partner in *Blue Note*. The Lion/Wolff combination continued to record the best in jazz——Edmond Hall (clarinet), Charlie Christian (guitar), Art Hodes (piano), Ike Quebec (tenor saxophone). As Word War II neared en end, they showed great foresight, even clairvoyance, to record the first of the bop musicians——the pianists Thelonious Monk, Bud Powell, Tadd Dameron; drummer Art Blakey, and saxophonist James Moody.

Lion and Wolff were jazz lovers first and foremost. They did not hesitate to record, support and persevere with new talents and sounds that they personally liked. They aimed for the best in everything. Gil Melle introduced them to Rudy Van Gelder——Jazz's greatest sound engineer. From then on, Van Gelder recorded all the *Blue Note* sessions. Van Gelder produced a sound which three decades later is hard to match in freshness and balance. The musicians sounded and played superbly, for Lion allowed plenty of time for rehearsals and for different 'takes'. There was simply no rushing through a Lion/Wolff recording for *Blue Note*.

The jackets matched the high class of *Blue Note* music. Each cover was individually designed using the talents of Wolff, John Hermensader, Burt Goldblatt, Paul Bacon, Gil Mellé, Reid Miles and Andy Warhol among others. Thoughtfully, each jacket credited its designer and/or photographer.

In 1965, Lion and Wolff sold the label to the Liberty group. Lion retired, but Wolff continued working till his own death in 1971. The label has seen several ownership changes since then. But *Blue Note* has always remained a jazz label with two great strengths: first——it always reflected the sound of the times; second-each year brought greater appreciation for the early LP issues

ジャズ・レコード業界では，レーベルが突然姿を消したり，気づかないうちになくなっていたりということは日常茶飯事である。確かにジャズは時代に先行しすぎていることもあったが，音楽自体が問題となることはあまりなかった。むしろ問題は，経済的な側面や，細分化したジャズ・レコード会社では国内市場や国際市場で生き延びる力がないことにあった。多くのレコードは初回の発売枚数がごく限られていたため，当時の雑誌が批評を載せることはなかったし，むろんレーベル側も批評用に作品を送る余裕はなかった。

だが，やがて「市場」も巻き返しを図る。ほぼすべてのジャズ・レーベルが，再版によってよみがえったのである。そして，大市場に成長した日本で，多くのレーベルが二度三度と次々と再版を重ね，のちにはＣＤ化までされて，（ときには海賊盤製作という残念な事態もあったものの）レーベル創立者が想像もしなかった大成功をおさめたのである。

こうなると，「ブルーノート」という一つのレーベルが生き残っているばかりか，50 年以上もの間，名門レーベルとして君臨していたことは，ますますもって驚くべきことである。この由緒あるブルーノート・レーベルは，ベルリンからアメリカに移住したジャズ経験のまったくないふたりのドイツ人によって創設された。

1909 年にドイツに生まれたアルフレッド・ライオンは，1925 年，母国でアメリカから来たバンドの演奏を聴く。1930 年，これに勇気づけられて渡米し，暇をみてはジャズを聴きレコードを集め始める。1938 年，自己のレーベル「ブルーノート」を創設。第 1 作目は，ピアニストのアルバート・アモンズとミード・ラックス・ルイスの作品だった。つづいて，ソプラノ・サックス奏者でクラリネット奏者のシドニー・ベシェを初め，次々と当時のミュージシャンの作品を発表した。

ブルーノートが本格的に活動しだしたのは，ライオンの友人フランシス・ウルフがベルリンから渡米した 1941 年のことだった。写真家であるウルフは，ライオンと同じようにジャズに興味を持ち，ブルーノートの常勤の共同経営者となった。

ライオンとウルフのふたりは，エドモンド・ホール（クラリネット），チャーリー・クリスチャン（ギター），アート・ホーディズ（ピアノ），アイク・ケベック（テナー・サックス）など最高のミュージシャンの演奏を録音しつづけた。第二次世界大戦が終わりに近づくと，神がかった先見の明を発揮し，初めてバップのミュージシャンのレコードを製作。ピアノのセロニアス・モンク，バド・パウエル，タッド・ダメロン，ドラムスのアート・ブレイキー，サックスのジェイムス・ムーディというそうそうたる顔触れであった。

ライオンとウルフはなによりジャズを愛した。ためらうことなく，自分達の気に入った新しい才能と音を録音し支援しつづけ，また，すべての面で最高を目指した。ギル・メレがふたりを敏腕の録音エンジニア，ルディ・ヴァン・ゲルダーに紹介。以来，彼にブルーノートのセッションの録音をいっさい委ねることになる。ヴァン・ゲルダーの作り出した音は，鮮明さといい絶妙のバランスといい，30 年たった今もめったに耳にできないほどすばらしい。ミュージシャン達もとびきりの演奏をしている。というのも，ライオンは時間をかけて入念にリハーサルを重ね，何度も「テイク」しなおしたからだ。ライオンとウルフのブルーノート盤は，ほとんど急がされることなく，初めから終わりまでじっくりと仕上げられている。

ブルーノート盤のジャケットも，質の高い録音にひけをとっていない。ウルフ，ジョン・ハーマンセイダー，バート・ゴールドブラット，ポール・ベーコン，ギル・メレ，リード・マイルス，アンディ・ウォーホルなどの精鋭を起用して，一枚一枚デザインされた。どのジャケットにもデザイナー，写真家の名前を表示するという行き届いた配慮もみせている。

1965 年，ライオンとウルフはレーベルをリバティ・グループに売却。ライオンは現役を退いたが，ウルフは 1971 年に他界するまで働きつづけた。以後，ブルーノート・レーベルは何度か所有者を変えてきたが，しかし，ジャズのレーベルとして二つの強力な強みを守りつづけてきた。一つはその時代その時代の音を反映

of the Lion/Wolff combination. Whatever the shifts or emphasis over time, it is the 'early bop' or the 'hard bop' Blue Notes of the 1960's which are the label's hallmark.

Today, Michael Cuscuna and Charlie Lourie of Mosaic Records provide the unique service of issuing boxed sets that combine earlier issues with freshly discovered and previously unissued tracks. King Records of Japan issued as 'Blue Note of Japan', entire sessions of the 1960s which Lion and Wolff had somehow not issued. **Blue Note** became a generic word——an integer of spoken jazz, associated also with the live music clubs in New York, Tokyo and Osaka bearing its name.

From 1939 to 1953 Lion and Wolff recorded on the 78 rpm format (though mainly on 12" for added playing time). From 1951 to 1955, they issued LPs in the 10" format. From 1956, all issues were 12" LP. The first batch of 10" LPs (1951 to 1953) were compilations of earlier 78 rpm recordings. Recordings from mid 1953 were made and issued directly under the LP format.

Blue Note's Dixieland series comprised 30 10" LPs and 9 12" LPs——these were LPs of earlier 78 rpm recordings. The last recording for the Dixieland series was in 1954.

It was the 'Modern Jazz Series' which established **Blue Note**'s identity in modern jazz. These comprised 70 10" LPs in their 5000 Series. These were followed by 99 12" LPs records in the legendary 1500 Series. After which came more than 500 **Blue Note** Lps in the 4000 series.

But it remains the first batch of LPs——that is the 10" 5000 Series; the 12" 1500 Series and perhaps the first 75 issues of the next series——the 4,000 (4,000 to 4075), that reign as among the most popular and most listened to of all jazz records. The 12" records of the 1500 and of the early 4000 Series have been reissued repeatedly and in various countries. They have even suffered the totally unnecessary 'enhancement' of fake stereo. Fortunately, the jackets used on the reissues of the many **Blue Note** 12" are replicas of the first issues.

Most of the music from the 5000 and 7000 Series 10" LPs were also issued also on subsequent 12" records. But the jackets of the 10" are a different story. For the 10" jacket designs were not used for the 12". Add to this that so few copies of these early 10" LPs were pressed. This makes the 10" **Blue Note** jackets extremely rare——their beauty too obvious to merit mention. Which is why I include just the 10" **Blue Note**'s in this book. There are rarities and great designs among the 1500 and 4000 series 12" **Blue Note**'s too-but these will have to wait for another opportunity.

The 10" jackets shown here include designs by Burt Goldblatt, Paul Bacon, Francis Wolff, John Hermensader, Reid Miles among others. Francis Wolff did almost all of Blue Note's photography. Reid Miles was to design great jackets later not just for the Blue Note 12" series but also for the Prestige label. Paul Bacon was already a busy designer——and continued to be so for many years——through his work for 'X', Riverside and other labels. And Burt Goldblatt is the designer's designer——at home with camera, abstracts, and pictorials. I hope to present fuller expositions of their individual work in the future. I make no comment on them now beyond the presentation of their Blue Note 10" covers.

Finally, the **Blue Note** 10" jackets designed by Gil Mellé are considered in the section devoted to his work.

してきたということ、そしてもう一つは、ライオンとウルフのコンビが製作した初期のLP盤の評価が年々高まってきたということだ。時代の流行がどう変わっても、1960年代のブルーノート盤「初期のバップ」、「ハード・バップ」こそがブルーノートの真髄なのである。

今日、モザイクレコードのマイケル・カスクーナとチャーリー・ローリーが、初期のブルーノート盤とこれまでの未発見、未発表トラックを編集してボックスセットで発売するという独自の企画を展開している。また、日本のキングレコードは『ブルーノート・オブ・ジャパン』と題して、なぜかライオンとウルフが発表しなかった1960年代の全セッションをを発売した。いつしかブルーノートは総称的な言葉、ジャズの代名詞として口にされるようになった。ニューヨーク、東京、大阪には『ブルーノート』という名のライブ・ミュージック・クラブもある。

1939年から53年、ライオンとウルフは78回転盤に録音した（それでも演奏時間の関係で、たいていは12インチ盤だった）。1951年から55年には、10インチLP盤を発売。1956年からは、すべて12インチLP盤となる。初期の10インチLP盤（1951年から53年）は、それ以前の78回転式の録音を編集したが、1953年半ば以降は、最初からLP盤として録音し発売された。

ブルーノートの「ディキシーランド・シリーズ」には、30枚の10インチLP盤と9枚の12インチLP盤がおさめられていた。これらはそれ以前の78回転盤の録音をLP盤に編集したもので、1954年の録音が「ディキシーランド・シリーズ」では最後だ。

ブルーノートの名を完全に不動のものとしたのは、「モダン・ジャズ・シリーズ」である。まずその5000シリーズとして70枚の10インチLP盤を発売、つづいて伝説の1500シリーズの99枚の12インチLP盤、さらに500枚を越える4000シリーズのLP盤を発売した。

初期の5000シリーズの10インチLP盤は残されてしまったが、1500シリーズの12インチLP盤と、次の4000シリーズ（4000から4075）のおそらく最初の75枚は、最も人気があり親しまれているジャズ・レコードとして広く行きわたっていて、この1500と4000シリーズの初期の12インチ盤は、これまで各国で繰り返し再版されてきた。ご丁寧にまるで必要ないまやかしのステレオ「効果」まで施されて。しかし、さいわい再版されたブルーノートの12インチ盤のジャケットの多くは、オリジナルをそのまま使用している。

5000と7000シリーズの10インチLP盤に収録された演奏も、ほとんどその後12インチ盤で発売されたが、ジャケットとなると話は別だ。10インチ盤のジャケットのデザインは、12インチ盤では用いられなかったのである。しかも、初期の10インチLP盤はごく少数しか発売されなかったから、ブルーノートの10インチ盤のジャケットは極めて希少だ。むろんその美しさは言うまでもない。というわけで、本書ではブルーノートの10インチ盤だけを紹介することにする。1500と4000のシリーズの12インチ盤にも、珍しいものや秀逸なデザインのジャケットはあるけれど、これらはまたの機会に譲るとしよう。

ここでご紹介する10インチ盤のジャケットは、バート・ゴールドブラット、ポール・ベーコン、フランシス・ウルフ、ジョン・ハーマンセイダー、リード・マイルスなどが手がけたものだ。フランシス・ウルフはブルーノートの写真の大半を引き受けていた。リード・マイルスはブルーノートの12インチ盤シリーズだけでなく、後にプレスティッジ・レーベルでもすばらしいジャケットをデザインしている。ポール・ベーコンは当時すでに売れっ子のデザイナーで、RCAの「X」やリヴァーサイド等のレーベルのジャケットも手がけ、長い間一線で活躍をつづけた。そして、デザイナー中のデザイナー、バート・ゴールドブラットは、家でもカメラと抽象主義の作品と画報を離さなかったという。将来それぞれの作品を心ゆくまで紹介し解説できることを祈って、ここでは彼らのブルーノートの10インチ盤のジャケットを紹介するのみにとどめよう。

最後に一つ。ギル・メレがデザインしたブルーノートの10インチ盤のジャケットは、ミュージシャンとは別の彼の才能を示す傑作とされている。

BLUE NOTE 10" LP'S —— TRADITIONAL JAZZ SERIES

The SIDNEY BECHET Albums

When **Blue Note** started in 1939, the first three musicians Alfred Lion recorded were two pianists Albert Ammons and Meade Lux Lewis and Sidney Bechet. Sidney Bechet —— playing clarinet and soprano Saxophone —— recorded continually for **Blue Note**. In 1951 Bechet settled on a semi-permanent basis in France to record for French labels. Blue Note still continued to issue the European recordings of Bechet in America-now leased from Vogue-France. All the Bechet **Blue Note**'s were recorded between 1939 and 1952. So, the LPs issued in the Traditional Series were essentially collations of earlier 78 rpm discs.

7001
Sidney Bechet's Blue Note Jazzmen
With 'Wild Bill' Davison
Photo: Francis Wolff
Design: Paul Bacon

7002
Sidney Bechet Groups - Jazz Classics Vol. 1

7003
Sidney Bechet Groups - Jazz Classics Vol. 2
Design: Paul Bacon
(This includes the classic 1939 recording of 'Summertime'.)

7008
Sidney Bechet Quintet with Bunk Johnson
Days Beyond Recall
Design: Paul Bacon

7009
Sidney Bechet and his Blue Note Jazzmen
Giant of Jazz
Photo & Design: Not Credited

7014
Sidney Bechet's Blue Note Jazz Men
With 'Wild Bill' Davison Vol. 2
Photo: Francis Wolff
Design: Paul Bacon

7020
Sidney Bechet and his Hot Six
The Fabulous Sidney Bechet
Design: Paul Bacon

7024
Sidney Bechet - Jazz Festival Concert Paris 1952
7025
Sidney Bechet
Jazz Festival Concert Paris 1952 Vol. 2
Design: Burt Goldblatt
(Leased from Vogue-France. January 31, 1952 Paris concert.)

7026
Sidney Bechet's Blue Note Jazz Men - Dixie
Photo: Francis Wolff
Design: John Hermensader

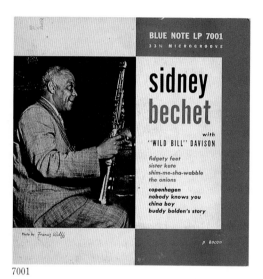

7001

7002

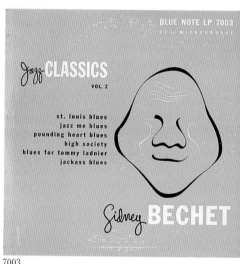

7003

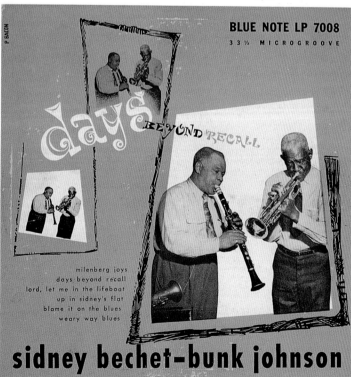

7008

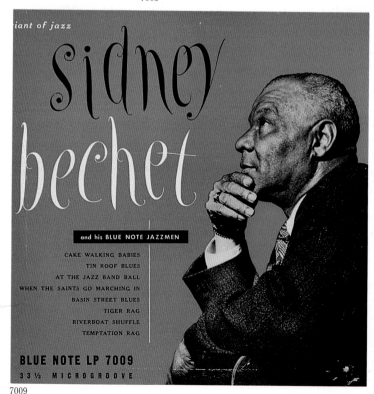

7009

トラディショナル・ジャズ・シリーズ

シドニー・ベシェ

1939 年，ブルーノートを設立して最初にアルフレッド・ライオンが録音したミュージシャンは，アルバート・アモンズとミード・ラックス・ルイスのふたりのピアニストとシドニー・ベシェの 3 人だった。クラリネットとソプラノ・サックスを演奏するシドニー・ベシェは，ブルーノートに次々とレコードを吹込んだ。1951 年，ベシェは半永久的にフランスに活動の拠点を移し，フランスのレーベルに録音を始める。だがなお，ブルーノートはヨーロッパで録音されたベシェの作品を，今度はヴォーグ・フランスからのリリースという形でアメリカで発売しつづけた。ブルーノート原盤のベシェの作品はいずれも 1939 年から 52 年に録音されたもので，したがって「トラディッショナル・シリーズ」の L P はそれ以前の 78 回転盤の L P 化盤である。

7001
Sidney Bechet's Blue Note Jazzmen
With 'Wild Bill' Davison
Photo: Francis Wolff
Design: Paul Bacon

7002
Sidney Bechet Groups-Jazz Classics Vol. 1

7003
Sidney Bechet Groups-Jazz Classics Vol. 2
Design: Paul Bacon
1939 年に録音された古典的名曲『サマータイム』も収録。

7008
Sidney Bechet Quintet with Bunk Johnson-Days Beyond Recall
Design: Paul Bacon

7009
Sidney Bechet and his Blue Note Jazzmen-Giant of Jazz
Photo/Design: Not Credited

7014
Sidney Bechet and his Blue Note Jazz Men
With 'Wild Bill' Davison Vol. 2
Photo: Francis Wolff
Design: Paul Bacon

7020
Sidney Bechet and his Hot Six-The Fabulous Sidney Bechet
Design: Paul Bacon

7024
Sidney Bechet-Jazz Festival Concert Paris 1952

7025
Sidney Bechet-Jazz Festival Concert Paris 1952 Vol. 2
Design: Burt Goldblatt
ヴォーグ・フランスよりリース。1952 年 1 月 31 日，パリのコンサート。

7026
Sidney Bechet's Blue Note Jazz Men-Dixie
Photo: Francis Wolff
Design: John Hermensader

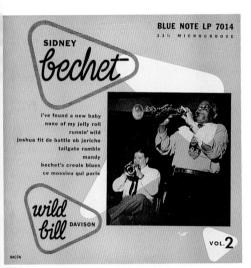

7014

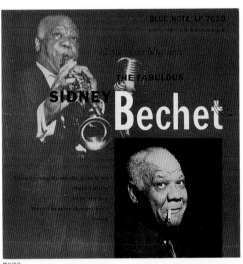

7020

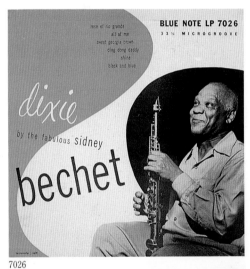

7026

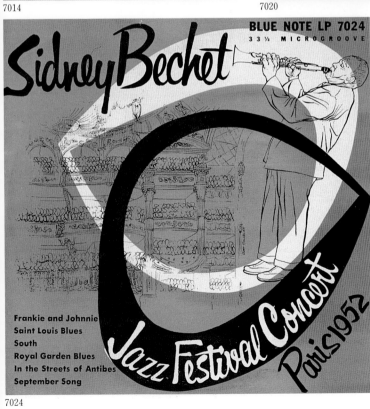

7024

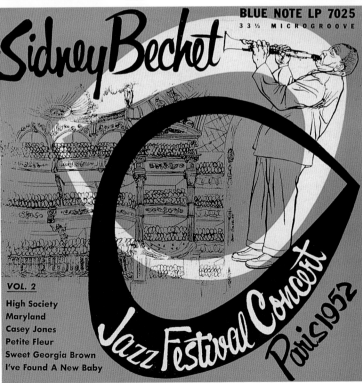

7025

The ART HODES Albums

The first time Art Hodes was heard on **Blue Note** was as pianist in the Sidney Bechet band. Alfred Lion liked Hodes's playing so much that starting in 1944, he issued several recordings by Art Hodes's own band. Hodes also toured France in 1949 with the Bechet Band——some of these tracks are also included in the general transfer of 78 rpm material to LP.

7004
Art Hodes' Chicagoans - The Best in 2 Beat
Design: Paul Bacon

7005
Art Hodes's Hot Five with Sidney Bechet
Hot Jazz at Blue Note
Design: Martin Craig

7006
Art Hodes and his Blue Note Jazz Men
Dixieland Jubilee
Design: Paul Bacon

7015
Art Hodes and his Hot 7 - Dixieland Clambake
Design: Paul Bacon

7021
Art Hodes' Back Room Boys
Out of the Back Room
Design: John Hermensader

アート・ホーディスが初めてブルーノートに吹込んだの
は、シドニー・ベシェ・バンドのピアニストとしてであっ
た。アルフレッド・ライオンがこのホーディスの演奏をひ
どく気に入り、1944 年から、アート・ホーディス自身のバ
ンドによる作品を数枚発表しはじめる。1949 年、ホーディ
スはベシェ楽団とフランス・ツアーも行なった。その数ト
ラックがやはり 78 回転盤からLP化されている。

7004
Art Hodes' Chicagoans-The Best in 2 Beat
Design: Paul Bacon

7005
Art Hodes's Hot Five with Sidney Bechet-Hot Jazz at Blue Note
Design: Martin Craig

7006
Art Hodes and his Blue Note Jazz Men-Dixieland Jubilee
Design: Paul Bacon

7015
Art Hodes and his Hot 7-Dixieland Clambake
Design: Paul Bacon

7021
Art Hodes' Back Room Boys-Out of the Back Room
Design: John Hermensader

Other Traditional Jazz Albums

These included original 78 rpm recordings for **Blue Note** by Alfred Lions's other favorite pianists——James P. Johnson, Albert Ammons and Meade Lux Lewis. Additionally, some leased and bought-in material.

7010
George Lewis and his New Orleans Stompers
Echoes of New Orleans Vol. 1

7013
George Lewis and his New Orleans Stompers
Echoes of New Orleans Vol. 2
Design: Paul Bacon
(Recorded independently in New Orleans in 1943, Blue Note purchased the recordings for their own issue.)

7011
James P. Johnson - Stomps, Rags and Blues
Cover: Paul Bacon

7012
James P. Johnson's Blue Note Jazz Men
Jazz Band Ball
Design: Paul Bacon

7018
Meade 'Lux' Lewis - Boogie Woogie Classics
Design: Paul Bacon

7019
Pete Johnson Blues Trio - Boogie Woogie Classics
Design: Paul Bacon

7016
Sidney de Paris and his Blue Note Stompers
Sidney de Paris
Photo/Design: Uncredited

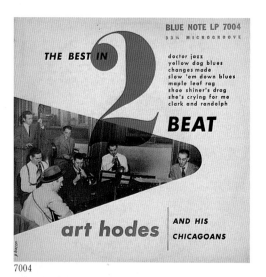

7004

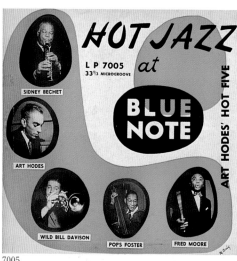

7005

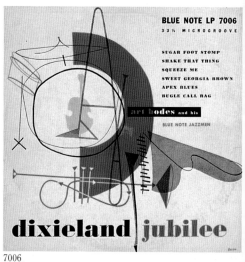

7006

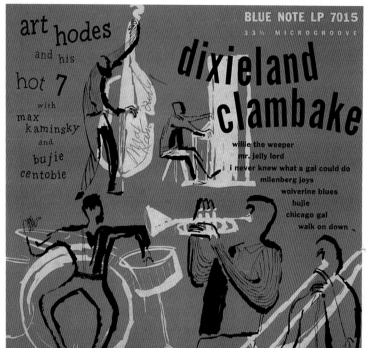

7015

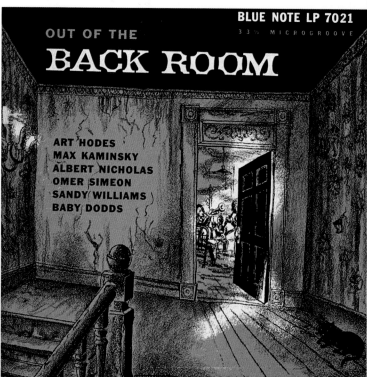

7021

7017
Albert Ammons
Memorial Album/Boogie Woogie Classics
Design: Paul Bacon
(The first recordings, January 6, 1939, made by Blue
Note. Transferred from 78 rpm onto LP.)

7023
Mezz Mezzrow with Lee Collins and Zutty Singleton-
Mezz Mezzrow and his Band
Design: John Hermensader
(Leased from Vogue-France. Paris concerts of November 15,1951)

その他

　このなかには，その他のアルフレッド・ライオンのお気に入りのピアニスト，ジェイムス・P・ジョンソン，アルバート・アモンズ，ミード・ラックス・ルイスがもともと78回転盤に吹込んだ作品が含まれている。また，いくつかはリースや買い取りによる。

7010
George Lewis and his New Orleans Stompers-Echoes of
New Orleans Vol. 1
7013
George Lewis and his New Orleans Stompers-Echoes of
New Orleans Vol. 2
Design: Paul Bacon
1943 年，ニューオリンズにて別に録音されたものを，ブルーノートが買い取り自己レーベルで発売した。

7011
James P. Johnson-Stomps, Rags and Blues
Cover: Paul Bacon

7012
James P. Johnson's Blue Note Jazz Men-Jazz Band
Ball
Design: Paul Bacon

7018
Mead 'Lux' Lewis-Boogie Woogie Classics
Design: Paul Bacon

7019
Pete Johnson Blues Trio-Boogie Woogie Classics
Design: Paul Bacon

7016
Sidney de Paris and his Blue Note Stompers-Sidney de
Paris
Photo/Design: Uncredited

7017
Albert Ammons-Memorial Album-Boogie Woogie
Classics
Design: Paul Bacon
1939 年 1 月 6 日，ブルーノートの録音第 1 号。78 回転盤からLP化。

7023
Mezz Mezzrow with Lee Coliins and Zutty Singleton-
Mezz Mezzrow and his Band
Design: John Hermensader
ヴォーグ・フランスからのリース。1951 年 11 月 15 日，パリのコンサートにてライブ録音。

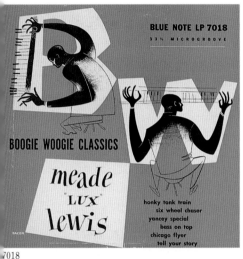

7018

7012

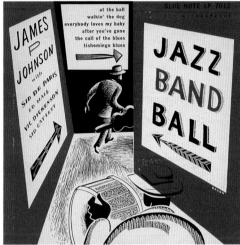

7011

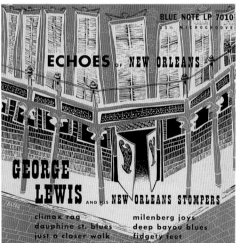

7013

7010

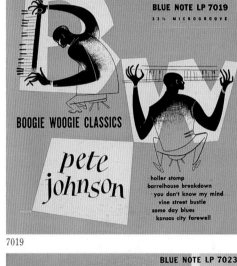

7019

7016

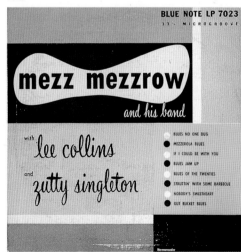

7017

7023

NOTE 10" LPS – MODERN JAZZ SERIES

1939 to 1944, *Blue Note*'s recordings were of traditional groups such as Albert Ammons, Meade Lux Lewis and Sidney Bechet. Logically, the next step should have been the swing and dance groups so popular in the late 1940s. *Blue Note* however, skipped the entire generation of swing groups and moved directly to musicians like Thelonious Monk, Bud Powell, James Moody and others—whose sounds then were more than just 'modern'. Their sounds were ahead of their time to the extent that, when issued firstly on *Blue Note*'s 78 rpm series, they were often beyond the appreciation of even hard core jazz listeners. History was to prove how right and ahead of his time Alfred Lion was in his choice of whom to record.

The recordings made between 1945 and 1952, originally for 78 rpm issue, were put together to comprise some of the first *Blue Note* 10" LPs in the Modern Jazz Series.

5001
Various Artists – Mellow the Mood
Design: Paul Bacon
(The first Blue Note LP in the Modern Jazz series. A potpourri of groups recorded originally for 78 rpm issue.)

5006
James Moody – James Moody and his Modernists
Design: Julien Alberts
(The saxophonist James Moody recorded in 1948 with one of his early bop groups.)

Recordings leased from Europe
1950 and 1951 saw the first recordings made in Europe by visiting American groups. Some of these, *Blue Note* issued in America under lease or exchange agreements.

5005
James Moody – James Moody with Strings
Design: Paul Bacon
(Leased from Vogue-France. Recorded Paris, July 1951.)

5010
Art Blakey – Art Blakey's Band
Max Roach – Max Roach Quintet
Design: John Hermensader
(The two tracks by Max Roach were leased from Vogue-France. Recorded Paris May 15, 1949. The two tracks by Art Blakey are from a December 1947 session in New York.)

5017
Dizzy Gillespie – Horn of Plenty
Design: Paul Bacon
(Leased from Vogue-France. Recorded Paris, April 1952.)

5061
Fats Sadi – The Swinging Fats Sadi Combo
Design: Reid Miles
(Leased from Vogue-France. Recorded Paris May 8, 1954.)

5052
Mike Nevard's Melody Maker All Stars
The Cool Britons
Design: Arline Oberman
(Leased from Golden Bell records of England. Recorded London—May 13, 1954. A witty cover——caricature of a British Grenadier Guard.)

5031
Wade Legge – Wade Legge Trio
Photo: Herman Leonard
Design: John Hermensader
(Leased from Vogue-France. Recorded Paris Feb 27, 1953. Wade Legge was then the pianist with the touring Dizzy Gillespie Band.)

モダン・ジャズ・シリーズ

1939 年から 44 年にかけて，ブルーノートはアルバート・アモンズやミード・ラックス・ルイス，シドニー・ベシェなどトラディショナル・ジャズのグループの演奏を録音した。次は 1940 年代後期に人気を博すスイングやダンスのグループに目を向けるのが当然の筋道だった。しかし，ブルーノートはスウイング・グループ世代をそっくり飛び越え，いきなりセロニアス・モンク，バド・パウエル，ジェームス・ムーディといったミュージシャンを起用したのである。当時，彼らのサウンドは「モダン」を通り越してあまりに斬新だった。時代の先を行くそのサウンドが初めてブルーノートの 78 回転盤シリーズで発売されたときは，耳の肥えたジャズマニアにさえ受け入れられないことが多かった。だが，やがて歴史が，アルフレッド・ライオンがいかに鋭い目で時代の趨勢を見抜き，ミュージシャンを起用したかを証明することになる。

1945 年から 52 年に録音され発売された 78 回転盤を編集し，「モダン・ジャズ・シリーズ」の最初のブルーノート 10 インチＬＰ盤の何枚かとして発売された。

5001
Various Artists-Mellow the Mood
Design: Paul Bacon

ブルーノートのモダン・ジャズ・シリーズ最初のＬＰ盤。78 回転盤に録音された様々なグループの演奏を集めたもの。

5006
James Moody-James Moody and his Modernists
Design: Julien Alberts
サックス奏者，ジェームス・ムーディ率いる初期のバップ・グループの演奏。1948 年録音。

ヨーロッパよりリースされた録音

1950，51 年，初めてブルーノートによるアメリカのグループが訪問先のヨーロッパでレコーディングした。ブルーノートはこのいくつかをリース，あるいは交換の取り決めでアメリカで発売した。

5005
James Moody-James Moody with Strings
Design: Paul Bacon
ヴォーグ・フランスよりリース。1951 年 7 月，パリにて録音。

5010
Art Blakey-Art Blakey's Band
Max Roach-Max Roach Quintet
Design: John Hermensader
アート・ブレイキーは 1947 年 12 月ニューヨークでの演奏マックス・ローチはヴォーグ・フランスよりリリース。1949 年 5 月 15 日パリにて録音。

5017
Dizzy Gillespie-Horn of Plenty
Design: Paul Bacon
ヴォーグ・フランスよりリース。1952 年 4 月，パリにて録音。

5061
Fats Sadi-The Swinging Fats Sadi Combo
Design: Reid Miles
ヴォーグ・フランスよりリース。1954 年 5 月 8 日，パリにて録音。

5052
Mike Nevard's Melody Maker All Stars-The Cool Britons
Design: Arline Oberman
イギリスのゴールデンベル・レコードよりリース。1954 年 5 月 13 日，ロンドンで録音。イギリスの近衛兵を漫画化した，機知に富んだジャケットである。

5031
Wade Legge-Wade Legge Trio
Photo: Herman Leonard
Design: John Hermensader
ヴォーグ・フランスよりリース。1953 年 1 月 27 日，パリにて録音。このときウェイド・レグはピアニストとして，ツアー中のディジー・ガレスピー・バンドと演奏した。

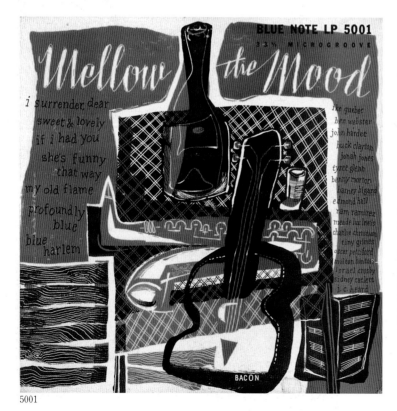

5001

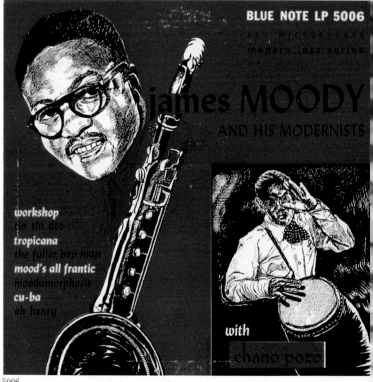

5006

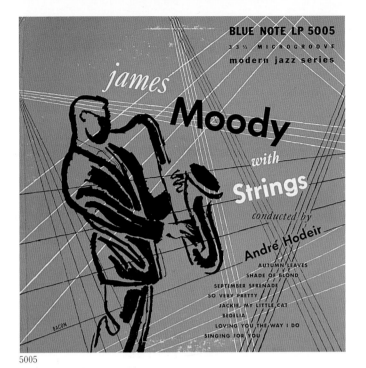

5005

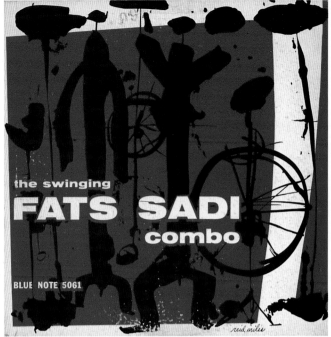

5061

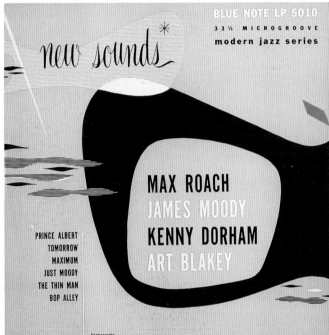

5010

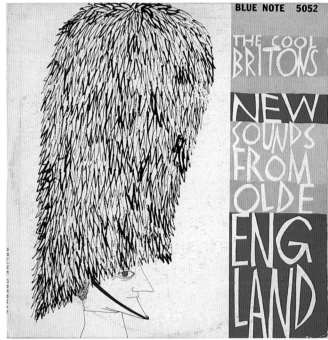

5052

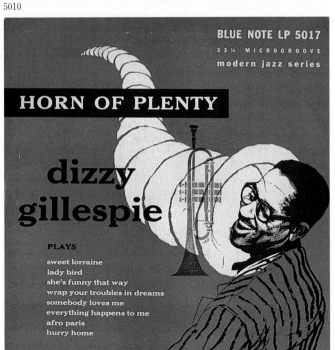

5017

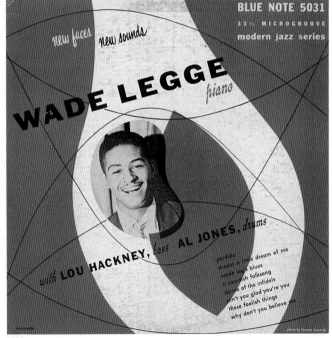

5031

ERROLL GARNER

Baron Timme Rosenkrantz——a Danish nobleman ——supported jazz and its musicians superbly. His New York apartment was equipped as a recording studio for guest musicians to record their improvisations. Erroll Garner was the improviser supreme—— and also a good friend of the Baron. Rosenkrantz recorded Garner many times at his home. And some of these recordings were transferred to **Blue Note** for commercial issue :

5007
Erroll Garner - Overture to Dawn Vol. 1
5008
Erroll Garner - Overture to Dawn Vol. 2
Cover: Paul Bacon

5014
Erroll Garner - Overture to Dawn Vol. 3

5015
Erroll Garner - Overture to Dawn Vol. 4

5016
Erroll Garner - Overture to Dawn Vol. 5
Design: Paul Bacon

エロール・ガーナー

　デンマークの貴族，ティミィ・ローゼンクランツ男爵は，ジャズとジャズ・ミュージシャンを大いに援助した。ニューヨークの彼のアパートは，客のミュージシャンがインプロビゼーション（即興演奏）を録音できるよう，レコーディングスタジオとしての設備が整っていた。エロール・ガーナーは即興演奏にかけては右に出る者がなく，男爵のよき友人でもあった。ローゼンクランツは自宅で何度となくガーナーの録音をし，そのいくつかがブルーノートによって，市販盤として世に送りだされた。

5007
Erroll Garner-Overture to Dawn Vol. 1
5008
Erroll Garner-Overture to Dawn Vol. 2
Cover: Uncredited

5014
Erroll Garner-Overture to Dawn Vol. 3
5015
Erroll Garner-Overture to Dawn Vol. 4
5016
Erroll Garner-Overture to Dawn Vol. 5
Design: Paul Bacon

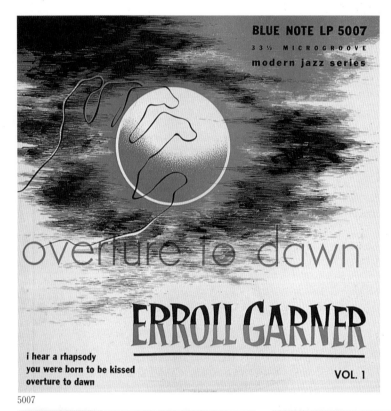

5007

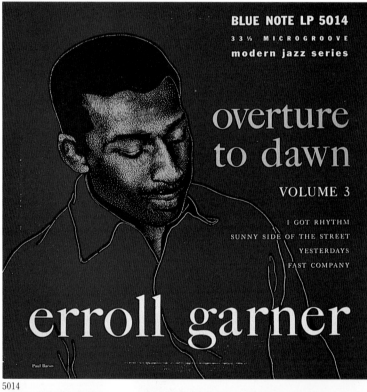

5014

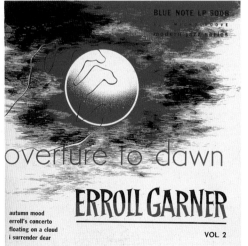

5008

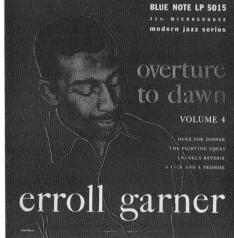

5015

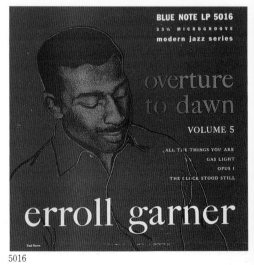

5016

The Early Bop Groups

Blue Note and Alfred Lion have had many achievements. But two are truly great ones. One, they had a penchant to discover great pianists. The other was that they were perhaps the first jazz label to extensively record the first of the 'bop' groups. The 'bop' sound was to become the hall mark of *Blue Note*'s great subsequent records in the 12" 1500 and 4000 series too. But the start was made with these 10" LPs of the Modern Jazz Series.

The alto saxophonist **Lou Donaldson** made his first recordings as a leader for Blue Note both on 78 rpm and LP. Donaldson continued to record extensively for *Blue Note* in the later 12" series. Always producing great music and eminently collectable records his radiant tone, phrasing and style started with these first 10", LPs, now legendary records.

5021
Lou Donaldson – Lou Donaldson Quintet/Quartet
Design: John Hermensader

5030
Lou Donaldson – Lou Donaldson with Clifford Brown and Elmo Hope
Photos: Francis Wolff
Design: John Hermensader

5055
Lou Donaldson – Lou Donaldson Sextet Vol. 2
Photo: Francis Wolff
Design: Reid Miles-John Hermensader

バップ・グループ初期

　ブルーノートとアルフレッド・ライオンは数多くの功績を上げてきたが，なかでも真に偉大な功績といえるのは次の二つである。一つは，名ピアニストの発掘に努めたこと。そしてもう一つは，はしりの「バップ」グループの演奏を大々的にレコード化したおそらく最初のレーベルであるということだ。「バップ」のサウンドは，その後出た12インチ盤の1500，4000シリーズでも折り紙付きのブルーノートの名盤となった。しかし，初めは「モダン・ジャズ・シリーズ」の10インチＬＰ盤であった。

　アルト・サックス奏者，ルー・ドナルドソンは，初のリーダー作品をブルーノートの78回転盤ＳＰとＬＰ盤の両方に吹込んだ。以後，12インチ盤シリーズに至るまで精力的にブルーノートに録音をつづけた。どれもがコレクターに人気の名盤であるが，ドナルドソンの精彩を放つトーンやフレージング，演奏スタイルは，今や伝説と化したこれら最初の10インチＬＰ盤に始まっている。

5021
Lou Donaldson-Lou Donaldson Quintet/Quartet
Design: John Hermensader

5030
Lou Donaldson-Lou Donaldson with Clifford Brown and Elmo Hope
Photo: Francis Wolff
Design: John Hermensader

5055
Lou Donaldson-Lou Donaldson Sextet Vol. 2
Photo: Francis Wolff
Design: Reid Miles-John Hermensader

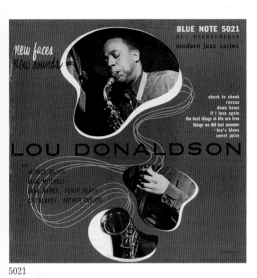

5021

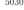

5030

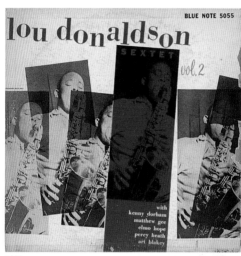

5055

In 1948, Blue Note recorded the **Howard McGhee** group. And also paired the two great bop trumpet players —— **Howard McGhee** and **Fats Navarro** to produce three albums —— essentially from 78 rpm material:

5012
Howard McGhee – Howard McGhee Sextet
Photo: Francis Wolff
Design: Paul Bacon

5024
Howard McGhee – Howard McGhee Sextet Vol. 2
Design: John Hermensader

5004
Fats Navarro – Memorial Album
Design: Paul Bacon
(The brilliance of Navarro's trumpet playing is indisputable. Handicapped by ill health, his recording career barely reached 4 years——mostly as a side man. This album was *Blue Note*'s tribute to him——recordings made in 1947, 1948 and 1949 as a sideman in the groups of Tadd Dameron, Howard McGhee and Bud Powell.)

ハワード・マギーとファッツ・ナバロ

　1948年，ブルーノートはハワード・マギー・グループの演奏を録音。また，ふたりのバップ・トランペットの名手，ハワード・マギーとファッツ・ナバロの顔合わせで，78回転盤から3枚のアルバムを製作した。

5012
Howard McGhee-Howard McGhee Sextet
Photo: Francis Wolff
Design: Paul Bacon

5024
Howard McGhee-Howard McGhee Sextet Vol. 2
Design: John Hermensader

5004
Fats Navarro-Memorial Album
Design: Paul Bacon
ナバロのトランペット演奏のすばらしさは誰もが認めるところだ。彼は病と戦いながらも，かろうじて4年間，大部分はサイドマンとしてレコーディング活動をつづけた。このアルバムはブルーノートがナバロに捧げた追悼盤で，1947，48，49年にタッド・ダメロン・ハワード・マギー，バド・パウエルのグループのサイドマンとして録音したもの。

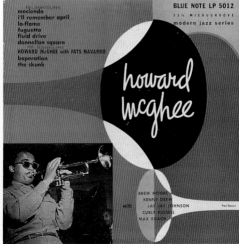

5012

5024

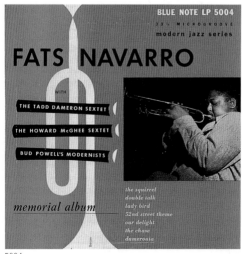

5004

BLUE NOTE——Recordings made directly for LP issue

By 1952 there was no doubt about the permanence of the LP. **Blue Note** were recording almost all sessions at Rudy Van Gelder's studio. The restrictions on recorded time which applied to the previous 78 rpm issue, now no more existed. Extended versions could be recorded for direct issue on LPs of which these records are examples.

5043
Frank Foster - The Frank Foster Quintet
Photo: Francis Wolff
Design: John Hermensader

5045
George Wallington - George Wallington and his Band
Photo: Francis Wolff
Design: John Hermensader
(Playing arrangements by a 21 year old Quincy Jones.)

The trombonist **Jay Jay Johnson** was to make three leader albums:

5028
Jay Jay Johnson - Jay Jay Johnson Sextet
Photo: Francis Wolff
Design: John Hermensader
(Photo shows the front line of the sextet——trumpeter Clifford Brown, tenor saxophonist Jimmy Heath and trombonist Jay Jay Johnson.)

5057
Jay Jay Johnson - The Eminent Jay Jay Johnson Vol. 2
Photo: Francis Wolff
Design: John Hermensader

5070
Jay Jay Johnson
The Eminent Jay Jay Johnson Vol. 3
Photo: Francis Wolff
(A 1955 LP. A dream line up——Jay Jay Johnson, Hank Mobley, Horace Silver, Paul Chambers, Kenny Clarke. All were to become great leaders and go on to record prolifically for later **Blue Note** as well as other labels.)

5066
Hank Mobley - Hank Mobley Quartet
Photo: Francis Wolff
Design: John Hermensader
(Soon after this, his first leader album, tenor saxophonist Hank Mobley was to record often on the **Blue Note** label. This and his subsequent records in the **Blue Note** 1500 series became some of the most collectable and prized of all **Blue Note** issues.)

ＬＰ盤へのレコーディング

1952 年になると，すでにＬＰ盤時代に入ったことは疑う余地がなかった。ブルーノートはほぼすべてのセッションを，ルディ・ヴァン・ゲルダーのスタジオで録音した。以前の 78 回転盤のような録音時間の制限もなくなり，長時間の演奏を直接ＬＰ盤に録音できるようになったのである。以下その例をあげてみよう。

5043
Frank Foster-The Frank Foster Quintet
Photo: Francis Wolff
Design: John Hermensader

5045
George Wallington-George Wallington and his Band
Photo: Francis Wolff
Design: John Hermensader
21 才のクインシー・ジョーンズが演奏のアレンジを担当している。

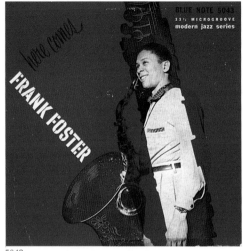

5043

5045

ジェイ・ジェイ・ジョンソン

トロンボーン奏者，ジェイ・ジェイ・ジョンソンは，3 枚のリーダー・アルバムを発表した。

5028
Jay Jay Johnson-Jay Jay Johnson Sextet
Photo: Francis Wolff
Design: John Hermensader
写真はセクステットの前列ートランペットのクリフォード・ブラウン，テナー・サックスのジミー・ヒース，トロンボーンのジェイ・ジェイ・ジョンソン。

5057
Jay Jay Johnson-The Eminent Jay Jay Johnson Vol. 2
Photo: Francis Wolff
Design: John Hermensader

5070
Jay Jay Johnson-The Eminent Jay Jay Johnson Vol. 3
Photo: Francis Wolff
1955 年のＬＰ盤。ＪＪ・ジョンソン，ハンク・モブレー，ホレス・シルヴァー，ポール・チャンバース，ケニー・クラークという夢の共演だ。皆，その後名リーダーとなり，ブルーノートをはじめ他のレーベルからも多くの作品を発表している。

5066
Hank Mobley-Hank Mobley Quartet
Photo: Francis Wolff
Design: John Hermensader

この初リーダー作の発表後ほどなく，テナー・サックス奏者，ハンク・モブレーはブルーノート・レーベルに頻繁に吹込みをするようになった。このアルバムと，つづくブルーノート 1500 シリーズの諸作品は，ブルーノート盤のなかで最も希少で評価の高い名盤に数えられている。

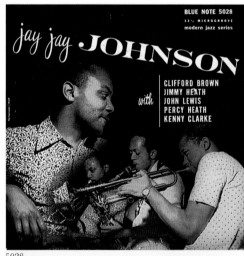

5028

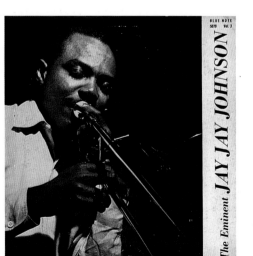

5057

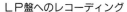

5070

5066

MILES DAVIS

Miles Davis made three excellent quintet recordings featuring J.J. Johnson, Jackie McLean, Horace Silver, Oscar Pettiford, Kenny Clarke, Art Blakey who were already fellow giants of modern jazz. These 1952, 1953 and 1954 recordings have been frequently reissued. But the 10" jacket designs have not been repeated.

5013
Miles Davis – Young Man with a Horn
Design/Photo: Burt Goldblatt

5022
Miles Davis – Young Man with a Horn Vol. 2
Photo: Francis Wolff
Design: John Hermensader

5040
Miles Davis – Miles Davis Quartet Vol. 3
Design/Photo: Uncredited

マイルス・デイヴィス

　マイルス・デイヴィスは，当時すでにモダン・ジャズの大物仲間であったJ．J．ジャクソン，ジャッキー・マクリーン，ホレス・シルヴァー，オスカー・ペティフォード・ケニー・クラーク，アート・ブレイキーを迎え，3枚のクインテットの傑作を発表した。この1952, 53, 54年録音盤は何度も再版を重ねているが，10インチ盤のジャケットのデザインは二度と使われていない。

5013
Miles Davis-Young Man with a Horn
Design/Photo: Burt Goldblatt

5022
Miles Davis-Young Man with a Horn Vol. 2
Photo: Francis Wolff
Design: John Hermennsader

5040
Miles Davis-Miles Davis Quartet Vol. 3
Design/Photo: Uncredited

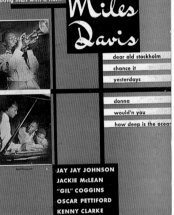

5013

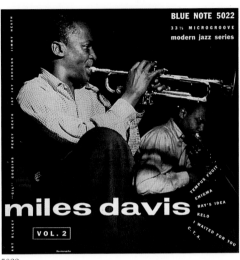

5022

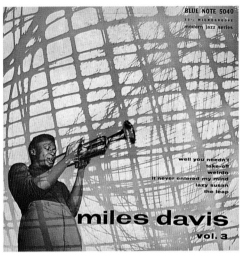

5040

A milestone live recording——the **Art Blakey Quintet at Birdland.** Drummer Art Blakey's Quintet comprised trumpeter Clifford Brown, alto saxophonist Lou Donaldson, pianist Horace Silver and bassist Curly Russell. Recorded live at the 'Birdland' Club, New York, February 21, 1954. This set has become one of the most consistently best selling and reissued jazz records of all time.

5037
Volume 1
5038
Volume 2

5039
Volume 3
The Art Blakey Quintet - A Night at Birdland
Photos: Francis Wolff
Design: John Hermensader

アート・ブレイキー

　記念的なライブレコーディング『バードランド』でのアート・ブレイキー・クインテット。アート・ブレイキー（ドラムス）のクインテットは，トランペットのクリフォード・ブラウン，アルト・サックスのルー・ドナルドソン，ピアノのホレス・シルヴァー，ベースのカーリー・ラッセルという顔触れだ。1954年2月21日，ニューヨークのジャズ・クラブ『バードランド』にてライブ録音。この3枚組は，一貫して最高の売上げと再版を重ねてきたジャズ史上に残る名盤の一つである。

5037-Vol. 1

5038-Vol. 2

5039-Vol. 3
The Art Blakey Quintet - A Night at Birdland
Photos: Francis Wolff
Design: John Hermensader

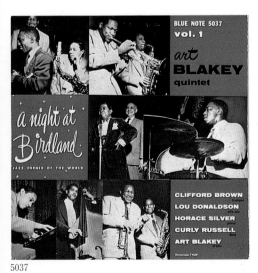

5037

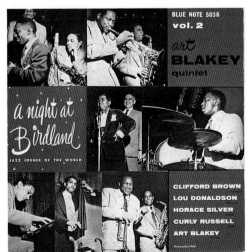

5038

5039

GREAT PIANISTS——their first recordings

Alfred Lion had the outstanding talent to find and recognize great pianists from among the unknown. Even when their music was too ahead of its time to be commercially successful, Blue Note persevered to support them with additional recordings.

In 1952 **Horace Silver** made the first of his countless recordings for *Blue Note*. These three——his first records——also included his own compositions many of which have become jazz standards.

5018
Horace Silver - Introducing the Horace Silver Trio
Design: John Hermensader

5034
Horace Silver Horace Silver Trio - Vol. 2
Photos: Francis Wolff
Design: Jerome Kuhl

5038
Horace Silver - Horace Silver Quintet
Photo: Francis Wolff
Design: John Hermensader

Another of today's great pianists **Kenny Drew** introduced himself in 1953:

5023
Kenny Drew - Introducing the Kenny Drew Trio
Design: John Hermensader

名ピアニストの初レコーディング

アルフレッド・ライオンは無名の新人から名ピアニストを発掘する才能に長けていた。たとえその音楽が時代にしては斬新すぎて商売にならなくても、ブルーノートは次々とレコードを発表して彼らを支援した。

1952年，ホレス・シルヴァーは初めてブルーノートに録音。以後，数え切れないレコーディングをしている。この最初の3作品にはシルヴァー自身の作曲も含まれ，その多くがジャズのスタンダードナンバーとなっている。

5018
Horace Silver-Introducing the Horace Silver Trio
Design: John Hermensader

5034
Horace Silver Horace Silver Trio-Vol. 2
Photos: Francis Wolff
Design: Jerome Kuhl

5038
Horace Silver-Horace Silver Quintet
Photo: Francis Wolff
Design: John Hermensader

1953年，もうひとりの現代の名ピアニスト，ケニー・ドリューがレコード・デビューを飾った。

5023
Kenny Drew-Introducing the Kenny Drew Trio
Design: John Hermensader

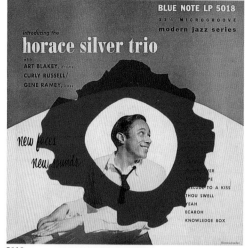

5018

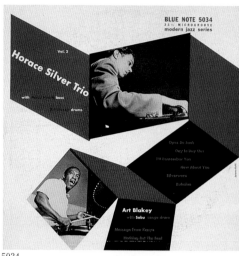

5034

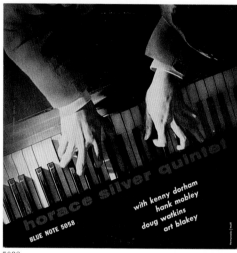

5038

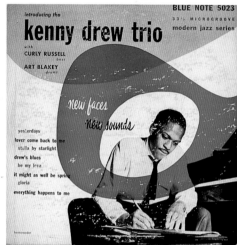

5023

Truly remarkable was *Blue Note*'s confidence in **Thelonious Monk,** whose piano playing and compositions were then considered completely quirky. These two records are transfers to LP of 1947 and 1948 78 rpm material. These records are among the most frequently reissued jazz records. But the original 10" jackets were not reprinted.

5002
Thelonious Monk - Genius of Modern Music
Photo: Francis Wolff
Design: Paul Bacon

5009
Thelonious Monk - Genius of Modern Music Vol. 2
Photo: Francis Wolff
Design: Paul Bacon

ブルーノートがセロニアス・モンクの才能を買っていたのは，実に驚くべきことだ。当時，モンクのピアノ演奏と作曲は完全な邪道とされていたからである。これらの2枚のレコードは，1947，48年の78回転盤録音をLP化したもの。最も再版を重ねているジャズ・レコードの一つだが，10インチ盤のオリジナルのジャケットは用いられていない。

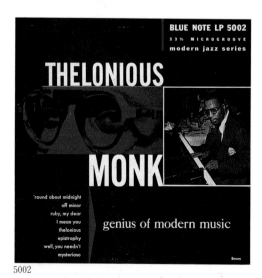

5002
Thelonious Monk-Genius of Modern Music
Photo: Francis Wolff
Design: Paul Bacon

5009
Thelonious Monk-Genius of Modern Music Vol. 2
Photo: Francis Wolff
Design: Paul Bacon

The equally magnificent pianist **Bud Powell** was another Blue Note 'find'. In 1949 he recorded on 78 rpm; in 1953 for LP——and the output was issued on two albums.

5003
Bud Powell - The Amazing Bud Powell
Design: Paul Bacon

5041
Bud Powell - The Amazing Bud Powell Vol. 2
Photo: Francis Wolff
Design: John Hermensader

名ピアニスト，バド・パウエルも，ブルーノートが「発掘」した大器のひとりだ。1949 年に 78 回転盤に録音，1953 年にはＬＰ化され２枚のアルバムとして発売された。

5003
Bud Powell-The Amazing Bud Powell
Design: Paul Bacon

5041
Bud Powell-The Amazing Bud Powell Vol. 2
Photo: Francis Wolff
Design: John Hermensader

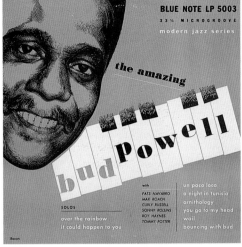

5003

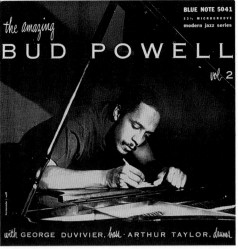

5041

The pianists **Elmo Hope** and **Herbie Nichols** both passed away leaving very few records. **Elmo Hope** was a childhood friend of Bud Powell——his playing was reminiscent of Bud's, but the phrasing was more unusual. **Herbie Nichols** was more in the Thelonious Monk vein. Nichols was suffering from leukemia even when these records were being made and died soon after. These recordings are from 1954 and 1955.

5029
Elmo Hope - Introducing the Elmo Hope Trio
Photo: Francis Wolff
Design: John Hermensader

5044
Elmo Hope - Quintet with Frank Foster and Freeman Lee
Photo: Francis Wolff

5068
Vol. 1
5069
Vol. 2
Herbie Nichols Trio - The Prophetic Herbie Nichols
Design: Martin Craig

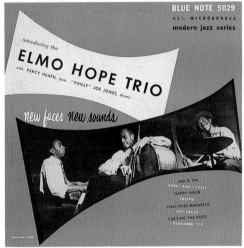

5029

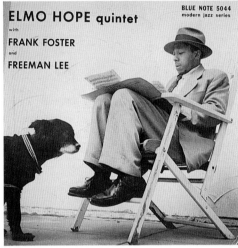

5044

ピアニスト，エルモ・ホープとハービー・ニコルスのふたりは既にこの世になく，ほんのわずかなレコードしか残さなかった。バド・パウエルの幼なじみだったエルモ・ホープの演奏はどこか彼と似ているが，フレージングは異彩を放っていた。ハービー・ニコルスのほうはどちらかというとセレニアス・モンクに近い。ニコルスは白血病と戦いながら，これらのレコードを吹込み，その後まもなく他界した。いずれも 1954 年から 55 年にかけての録音。

5029
Elmo Hope-Introducing the Elmo Hope Trio
Photo: Francis Wolff
Design: John Hermensader

5044
Elmo Hope-Elmo Hope Quintet with Frank Foster and Freeman Lee
Photo: Francis Wolff

5068-Vol. 1
5069-Vol. 2
Herbie Nichols Trio-The Prophetic Herbie Nichols
Design: Martin Craig

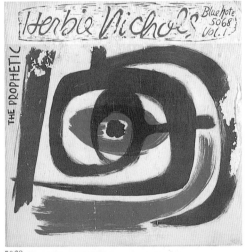

5068

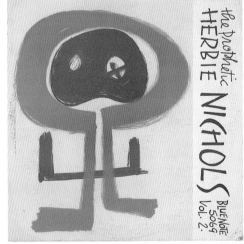

5069

In 1954, the German pianist **Jutta Hipp** was recorded in Frankfurt, Germany for this original *Blue Note* recording. Soon after she came to America. *Blue Note* were to issue later on their 12" 1500 series two of her memorable New York live recordings.

5056
Jutta Hipp - The Jutta Hipp Quintet
Design: Trudi Farmilant

1954 年，ドイツ人女流ピアニスト，ユタ・ヒップが，ドイツのフランクフルトにて，このブルーノートのオリジナル盤の吹込みをした。その後まもなく渡米。後にブルーノートは，12 インチ盤の 1500 シリーズで，ヒップの感動的なニューヨーク公演のライブ録音盤を２枚発売した。

5056
Jutta Hipp-The Jutta Hipp Quintet
Design: Trudi Farmilant

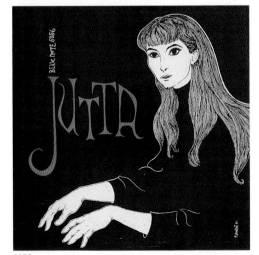

5056

Leonard Feather——an eminent producer, writer and critic among many other talents——started in 1946 a regular series firstly in Metronome magazine and later continued in Down Beat magazine. Called the ' Blindfold Test', musical celebrities were asked to comment on records without any prior information on who was playing. The two **Blue Note** records gave listeners the same opportunity. Vol. 1 was issued without any personnel details——these came with Vol. 2.

5059 Vol. 1
5060 Vol. 2
Various Artists (John Graas, Shorty Rogers etc.) ——

Best from the West
Design: John Hermensader

レナード・フェザーのプロデュース

　著名なプロデューサーにして作家，評論家など多彩な才能を有するレナード・フェザーは，1946 年，『メトロノーム』誌に連載を始め，その後『ダウンビート』誌で執筆をつづけた。「ブラインドフォールド・テスト（目隠しテスト）」といって，演奏者を伏せて音楽通の面々にレコードの批評を依頼するという企画であった。2 枚のブルーノートのレコードが，これと同じことを聴き手に試みた。1 枚目は演奏者などの細かい情報を伏せて発売し，2 枚目で明らかにしたのである。

5059-Vol. 1
5060-Vol. 2
Various Artists (John Graas, Shorty Rogers etc.) -Best from the West
Design: John Hermensader

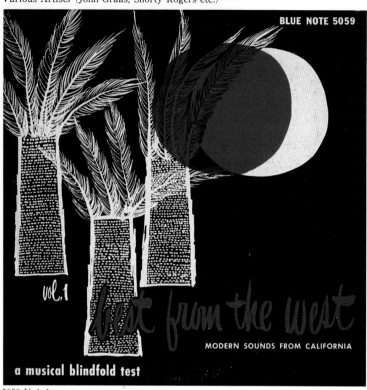

5059 Vol. 1

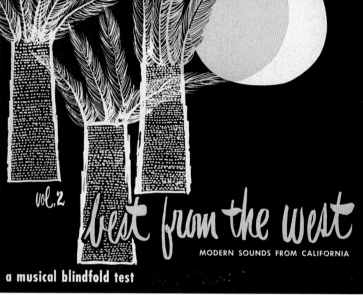

5060 Vol. 2

Blue Note were fascinated by new stars, new instruments. And also oddities.
In 1954 and 1955, the French horn player **Julius Watkins** formed a sextet to make two records :
5053
Julius Watkins - Julius Watkins Sextet
Photo/Design: Bill Hughes
5064
Julius Watkins - Julius Watkins Sextet Vol.Two

Photo: Francis Wolff
Design: Reid Miles

ジュリアス・ワトキンス

　ブルーノートは新しいスター，新しい楽器，そして一風変わった演奏を好んだ。
　1954，55 年，フレンチホルン奏者，ジュリアス・ワトキンスがセクステットを組んで，2 枚のレコードを吹込んだ。

5053
Julius Watkins-Julius Watkins Sextet
Photo/Design: Bill Hughes

5064
Julius Watkins-Julius Watkins Sextet Vol Two
Photo: Francis Wolff
Design: Reid Miles

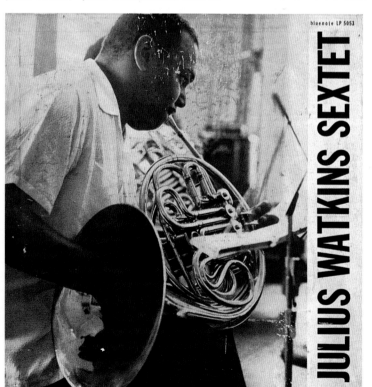

5053

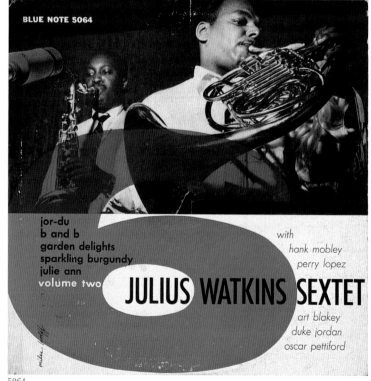

5064

The vibraphone player **Milt Jackson** had an appropriately titled album. Essentially 1952 and 1954 tracks, when he had played with Thelonious Monk.

5011
Milt Jackson - Wizard of the Vibes
Design: Paul Bacon

And finally three guitarists of the day.

5035
Sal Salvador - Sal Salvador Quintet
Photo: Francis Wolff
Design: Jerome Kuhl

5042
Tal Farlow - Tal Farlow Quartet
Photo: Francis Wolff
Design: Bill Hughes

5067
Lou Mecca - Lou Mecca Quartet
Photo: Francis Wolff
Design: John Hermensader

ミルト・ジャクソン

　ビブラフォン奏者，ミルト・ジャクソンは，"ヴァイブの魔法使い" というなんともぴったりのタイトルのついたアルバムを発表した。もともとは 1952，54 年のセロニアス・モンクとの共演の録音。

5011
Milt Jackson-Wizard of the Vibes
Design: Paul Bacon

３人のギタリスト

　最後に，3 人の当時の名ギタリストの作品。

5035
Sal Salvador-Sal Salvador Quintet
Photo: Francis Wolff
Design: Jerome Kuhl

5042
Tal Farlow-Tal Farlow Quartet
Photo: Francis Wolff
Design: Bill Hughes

5067
Lou Mecca-Lou Mecca Quartet
Photo: Francis Wolff
Design: John Hermensader

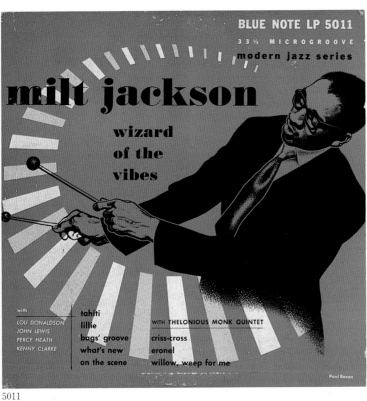

5011

5035

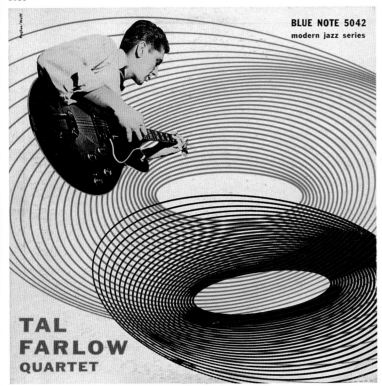

5042

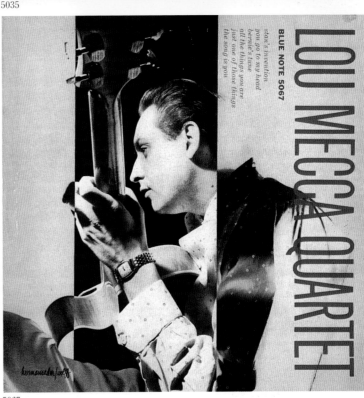

5067

THE 'DEBUT' LABEL

「デビュー」レーベル

1951 was Charles Mingus's 10th year as a professional musician. But disappointment now drove him to abandon music for a job with the post office. It was Charlie Parker who persuaded him to leave the post office and return to music. One of Mingus's frustrations had been the commercial distribution of records. He returned to the scene determined to create and distribute his own label. With drummer Max Roach as associate and fellow Music Director, he founded **Debut** records. Mingus at last had the full freedom to record his own groups and his own compositions to his thoroughly exacting ways.

The dictionary defines 'Debut' to mean ' first appearance in society or on stage as a performer'. An apt definitions of the musicians Mingus and Roach contracted to record for the label: Teo Macero, Paul Bley, Kenny Dorham, Alonzo Levister, Ada Moore, John LaPorta, Sam Most, Thad Jones, John Dennis. **Debut** produced the first albums as leaders. The dominance of Mingus as producer and collaborator was unmistakable――Mingus played on 14 of the first 20 **Debut** records.

Debut issued twelve 78 rpm records and on LP, seventeen 10" and five 12" records. In 1955, the label's third anniversary was celebrated by a special low priced ($1.98) record made up of unissued tracks from earlier sessions. It proved to be **Debut**'s farewell for sadly, it ceased production with this record. Mingus and Roach had differences in musical opinion――divergences never reflected in their joint playing. But their finances were in a ruinous state. In later years Mingus often tried to again control the distribution of his own records.

Fortunately, **Debut** took on a new life with issues now released from Denmark. The American **Debut** recordings had already been partly issued under the Danish **Debut** label (some had also been issued in France by the **Vogue** and **Swing** labels). While it retained the label's name and continued to reissue from the earlier catalogue, **Debut**-Denmark was an independent production. **Debut**-Denmark continued to release records of a consistently high standard, specializing in the music of expatriate Americans who had chosen to live and play in Europe. Europe was a more sympathetic environment to the adventurous musician. To their credit, Danish-**Debut** recorded three of the greatest avant-garde musicians of all time――Albert Ayler, Cecil Taylor and Eric Dolphy. Recordings by resident American legends like Don Byas and Oscar Pettiford were issued during the same period. European musicians, essentially of avant-garde movement were also recorded by then.

Mingus's lofty musical standards were matched by the quality of his taste in record jacket design. **Debut**-Denmark continued these high standards. The **Debut** jackets, are uniformly excellent. While the music itself has been reissued (among others by Fantasy who bought the **Debut** label), many of the original jackets have not. **Debut** was distinguished by its dedication to uncompromising and innovative music. It was truly a musician's label. The covers capture the free spirit and beauty of expression for which **Debut** and Charles Mingus will always be honored.

　1951年，チャールス・ミンガスはプロのミュージシャンになって10年目を迎えた。しかし，失望感に駆られていた彼は，音楽を断念して郵便局に就職する。そんな彼を郵便局を辞めて音楽に戻るよう説得したのは，チャーリー・パーカーだった。ミンガスの不満の一つには，レコードの販売方法にあった。そこで彼は自己のレーベルを設立して売り出すことを決意し，音楽界に復帰。ドラマーのマックス・ローチを共同経営者として音楽監督に迎え，「デビュー」レコードを創設した。ついにミンガスは，自分のグループの演奏や自分の作った曲を，徹底した音作りで録音し発売できる自由を手に入れたのである。

　デビューの第1作目は，ミンガスと，吹込みはめったに聞くことのできないピアニスト，スポールディング・ギヴェンスのデュオだった。つづいて発表した2枚の作品で，デビューは一躍注目を浴びる。「ライブ」録音のこの2枚は，たちまち「画期的」録音としての地位を獲得したのである。『ジャズ・アット・マッセイ・ホール』は，パーカー，ディジー・ガレスピー，バド・パウエル，ローチ，ミンガスから成るクインテットで，『ジャズ・ワークショップ―トロンボーン・ラポート』は，ジャズ界きっての4人の名トロンボーン奏者（J・J・ジャクソン，カイ・ウインディング，ウィリー・デニス，ベニー・グリーン）の演奏であった。

　辞書によれば，「デビュー」とは「パフォーマーとして初めて社会，あるいは舞台に出ること」だと定義されている。その名のとおり，ミュージシャン，ミンガスとローチはこのレーベルから多くのミュージシャンを「デビュー」させた。テオ・マセロ，ポール・ブレイ，ケニー・ドーハム，アロンゾ・レヴィスター，アダ・ムーア，ジョン・ラポータ，サム・モスト，サド・ジョーンズ，ジョン・デニスの初リーダー作である。また，ミンガスがプロデューサー兼共演者として重要な立場にあったことは明らかだ。デビュー盤の最初の20枚のうち14枚で，ミンガスは演奏している。

　デビューは12枚の78回転盤と17枚の10インチLP，5枚の12インチLP盤を発売した。1955年，レーベル設立3周年を記念して，それまでのセッションから未発表のトラックを集めた特別低価格（1ドル98セント）のレコードを売り出

した。だが，それがデビューのさよなら盤となった。残念なことに，このレコードを最後に製作を打ち切ったのである。ミンガスとローチは音楽に対する意見が異なっていた。そうした意見の食い違いは決してふたりの共演には表われなかったが，財政状態は手のつけようのないほど悪化していた。後にミンガスは，何度か再び自分のレコードを自分で発売しようと試みている。

　さいわい，デビューはデンマーク盤としてよみがえった。既にアメリカのデビュー盤の一部は，デンマークのデビューのレーベルで発売されていた（その何枚かは，フランスでもヴォーグとスイングのレーベルで出ている）。デンマーク・デビューは「デビュー」のレーベル名を残し，その初期の作品録から再版をつづけてはいるものの，アメリカのレビューとは別の独立した製作会社だったのである。

　デビュー・デンマークは高い水準を保つレコードを発表しつづけた。その中心はヨーロッパに住み，演奏することを選んだアメリカ人達の音楽であった。進取の気性に富んだミュージシャンにとっては，ヨーロッパのほうが受け入れられやすい環境にあったのだ。さすがにたいしたもので，デンマークのデビューは3人の前衛ジャズの巨匠―アルバート・アイラー，セシル・テイラー，エリック・ドルフィーの作品を売り出している。また同じ頃，ドン・バイアスやオスカー・ペティフォードといったアメリカ在住の伝説のミュージシャンの作品も発表。ヨーロッパの主に前衛的ミュージシャン達の演奏も録音されていた。

　ミンガスはその卓越した音楽水準に劣らず，レコードジャケットのデザインを選ぶ目も鋭かった。そして，デビュー・デンマークもこの高い水準を維持した。デビューのジャケットはどれをとっても珠玉の出来である。それなのに，音楽自体は再版を重ねられながら（デビューを買収したファンタジーなどから），オリジナルのジャケットの多くは用いられていない。デビューの真髄は，音楽への妥協を許さぬ革新的な取り組み方にあった。まさにミュージシャンのためのレーベルだったのである。ジャケットには表現における自由な精神と美とが見事に表われており，デビューとチャールス・ミンガスを永遠にたたえたい。

DEBUT-U.S.A. / DENMARK

The American issues are from 1952 to 1957.
The Danish issues are from 1957 to 1969.

DEBUT-THREE LIVE CONCERTS

'The Quintet'-Jazz at Massey Hall
Toronto-Canada May 15, 1953
The milestone 'live' concert of Charlie Parker, Dizzy
Gillespie, Bud Powell, Charles Mingus, Max Roach——
Massey Hall, Toronto——Canada——May 15, 1953.
Mingus (or the 'New Jazz Society of Toronto') thought-
fully recorded it on one of the primitive recorders of
that time. Parker was then under contract to another
label. So the **Debut** discs list him as 'Charlie Chan'. And
the DEB-124 cover has shown his torso but cuts off his
face. No mistake about the music——the five rarely
played better, ever.

Debut 2-10"
Jazz at Massey Hall Vol. 1

Debut 4-10"
Jazz at Massey Hall Vol. 2
Design: Arnaud Maggs

アメリカ盤とデンマーク盤

アメリカ盤は 1952 年～1957 年　デンマー
ク盤は 1957 年～1969 年

3 枚のライブコンサート

　チャーリー・パーカー，ディジー・ガレスピー，チャー
ルス・ミンガス，マックス・ロートという豪華な顔合わせ
による画期的な「ライブ」コンサートが，1953 年 5 月 15
日，カナダのトロントのマッセー・ホールで行なわれた。
ミンガス（あるいは「ニュー・ジャズ・ソサイティ・オブ・
トロント」）は，賢明にも当時使われていた旧式の録音機
で，その模様を録音した。このときパーカーは別のレーベ
ルと契約していたため，デビュー盤のリストには「チャー
リー・チャン」の名で載っている。DBE-142 のジャケット
にはパーカーの胴体だけが写っていて，顔の部分は切り取
られている。演奏のすばらしさは太鼓判を押していい。5 人
のこれほどの演奏はめったに聴かれない。

Debut 2-10"
Jazz at Massey Hall Vol. 1
Debut 4-10"
Jazz at Massey Hall Vol. 2
Design: Arnaud Maggs

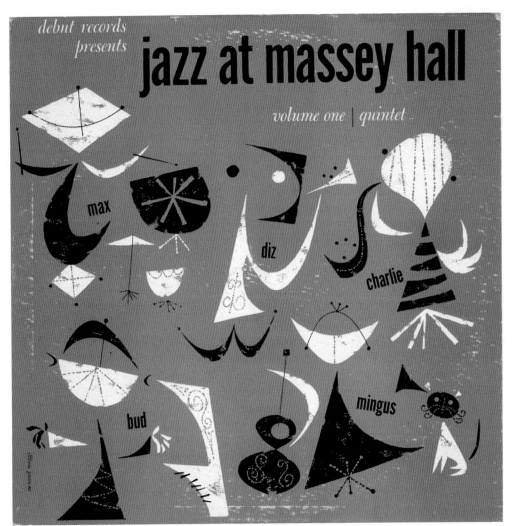

Debut 2-10"

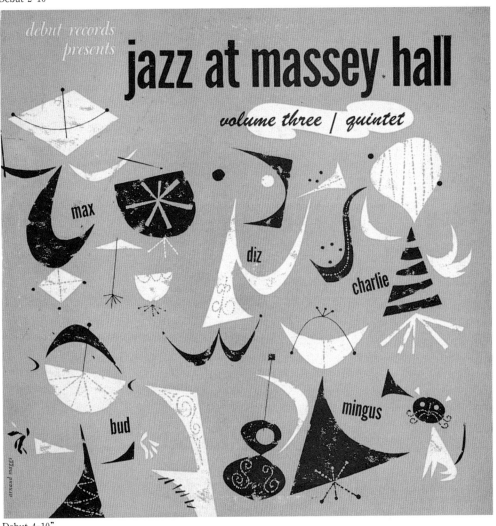

Debut 4-10"

Debut 3-10"
Bud Powell - Jazz at Massey Hall Vol. 2
Photo: Herman Leonard
(The photo is not from the Massey Hall concert. It is
Herman Leonard's classic Bud Powell——shot in
Birdland 1949.)

Debut 124 (American issue)
The Quintet - Jazz at Massey Hall
Photo: Bob Parent
(Charlie 'Chan' Parker with face cut off.)

Debut 124 (Danish issue)
Jazz at Massey Hall
Design: Jens Nordsø
(The Danish cover included to show an American and
Danish cover side by side)

Debut 3-10"
Bud Powell-Jazz at Massey Hall Vol. 2
Photo: Herman Leonard
マッセー・ホールのコンサートの写真ではない。1949年『バ
ードランド』にてハーマン・レナードの撮影したバド・パ
ウエルの傑作。

Debut 124 （アメリカ盤）
The Quintet - Jazz at Massey Hall
Photo: Bob Parent
顔を切り取られた「チャーリー・チャン」

Debut 124 （デンマーク盤）
Jazz at Massey Hall
Design: Jens NordsΦ
デンマーク盤のジャケットは，アメリカとデンマークのジ
ャケットを並べたデザインになっている。

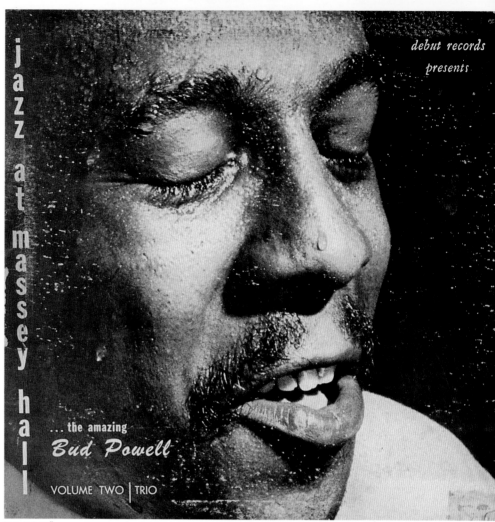

Debut 3-10"

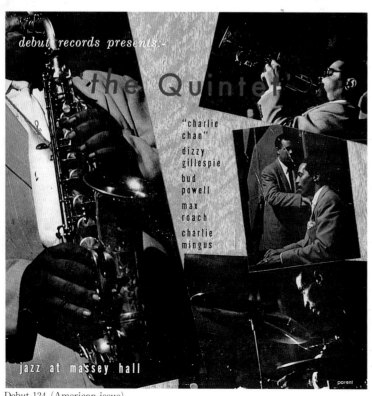

Debut 124 (American issue)

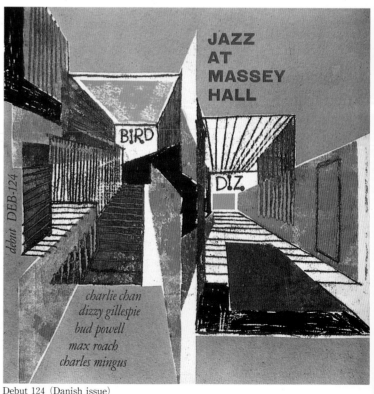

Debut 124 (Danish issue)

DEBUT——'TROMBONE WORKSHOP'
'MINGUS AT BOHEMIA'
 'Trombone Workshop'
Putnam Central Club, New York City-September 18,
1953
The 4 great trombonists of the day——J. J. Johnson,
Kai Winding, Benny Green, Willie Dennis in concert.
DLP 5-10"
Jazz Workshop - Trombone Rapport Vol. 1
DLP 14-10"
Jazz Workshop - Trombone Rapport Vol. 2
Photos: Herman Leonard
 CHARLES MINGUS QUINTET
Cafe Bohemia, New York City,——December 23rd,
1955
DEB 123
Charles Mingus - Mingus at the Bohemia
Photo: Bob Parent
(The Mingus Quintet with special guest Max Roach.)

「トロンボーン・ワークショップ」と「ミンガス・
アット・ザ・ボヘミア」

DLP 5-10"
Jazz Workshop-Trombone Rapport-Vol. 1
DLP 14-10"
Jazz Workshop-Trombone Rapport-Vol. 2
Photos: Herman Leonard
当時の4人の名トロンボーン奏者ーJ．J．ジャクソン，
カイ・ウインディング，ベニー・グリーン，ウィリー・デ
ニスによる，1953年9月18日ニューヨークのプットナム・
セントラル・クラブでのコンサート。

DEB 123
Charles Mingus-Mingus at the Bohemia
Photo: Bob Parent
ミンガス・クインテットと特別ゲストのマックス・ローチ
による，1955年12月23日ニューヨークのカフェ・ボヘミ
アでの演奏。

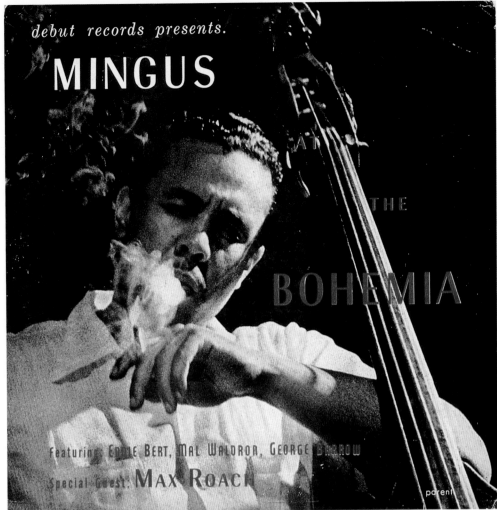

DEB 123

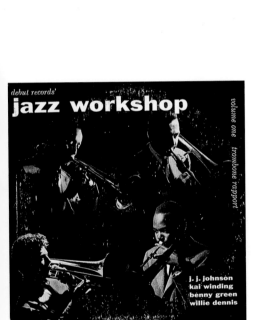

DLP 14-10"

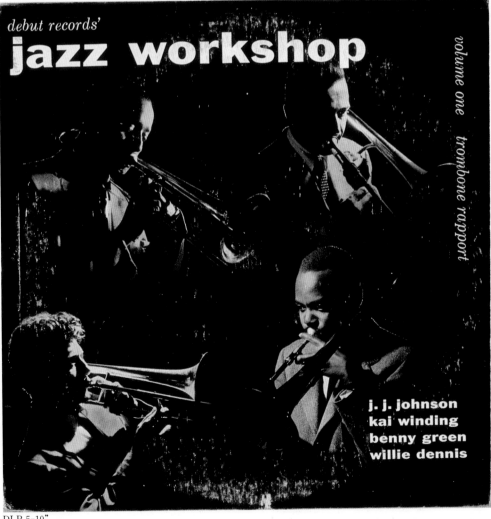

DLP 5-10"

DEBUT——THE 'FIRST APPEARANCE'
DEBUT-ALBUMS

Debut's first album was:
Debut 1-10"
Charles Mingus - Strings and Keys
Design: 'bm'
(The first Debut LP. A duo of Mingus on Bass with the rarely recorded pianist Spaulding Givens.)

Debut was indeed the leader 'debut' (first appearance) on records for :
Debut 7-10"
Paul Bley - Introducing Paul Bley
Design: Bill Spilka

Debut 6-10"
Teo Macero - Explorations
Design: Gene Bilbrew

Debut 10-10"
John La Porta - John La Porta Quintet
Design: Bill Spilka

Debut 9-10"
Kenny Dorham - Kenny Dorham Quintet
Photo: Bob Parent

Debut 11-10"
Sam Most - Sam Most Quartet Plus Two
Photo: Bob Parent

Debut 12-10"
Thad Jones - The Fabulous Thad Jones
Photo: Hugh Bell
Design: Bill Spilka

Debut 15-10"
Ada Moore - Jazz Workshop
Photo: Hugh Bell

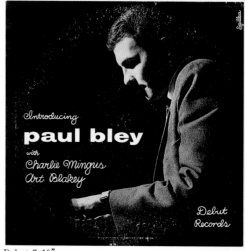

Debut 7-10"

Debut 1-10"

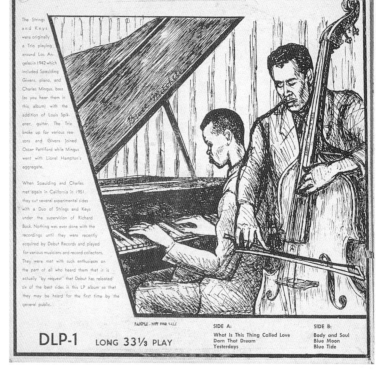

Debut 6-10"

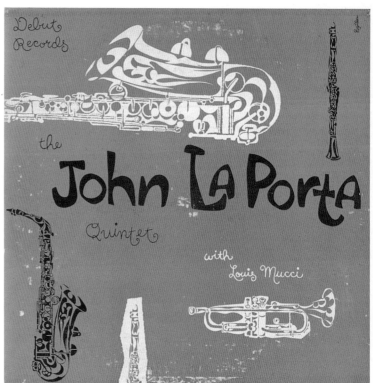

Debut 10-10"

デビュー・レーベルはその名のごとく，初リーダー
作を「デビュー」（初お目見え）させた。

Debut 1-10"
Charles Mingus-Strings and Keys
Design: 'bm'
デビューが最初に発表したＬＰ。ベースのミンガスと，貴
重なピアニストのスポールディング・ギヴェンスとのデュ
オ。

Debut 7-10"
Paul Bley-Introducing Paul Bley
Design: Bill Spilka

Debut 6-10"
Teo Macero-Explorations
Design: Gene Bilbrew

Debut 10-10"
John La Porta-John La Porta Quintet
Design: Bill Spilka

Debut 9-10"
Kenny Dorham-Kenny Dorham Quintet
Photo: Bob Parent

Debut 11-10"
Sam Most-Sam Most Quartet puls Two
Photo: Bob Parent

Debut 12-10"
Thad Jones-The Fabulous Thad Jones
Photo: Hugh Bell
Design: Bill Spilka

Debut 15-10"
Ada Moore-Jazz Workshop
Photo: Hugh Bell

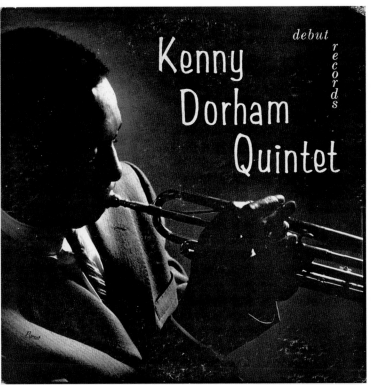

Debut 9-10"

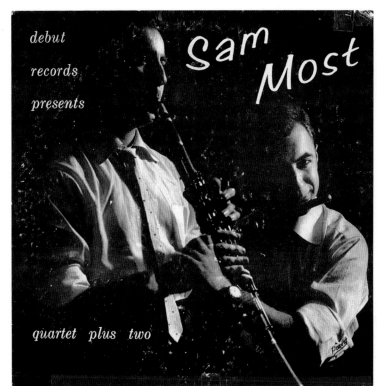

Debut 11-10"

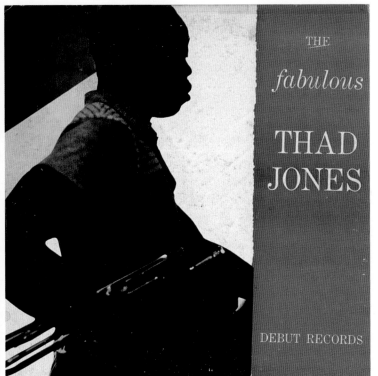

Debut 12-10"

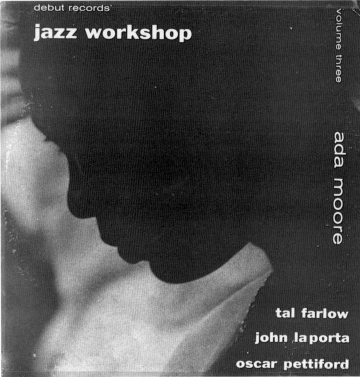

Debut 15-10"

127

Debut 121
John Dennis - New Piano Expressions
Design: Uncredited

Debut 125
Alonzo Levister - Manhattan Monodrama
Design: Uncredited

Debut 127
Thad Jones - Thad Jones
Design: Uncredited

Debut 121
John Dennis-New Piano Expressions
Design: Uncredited

Debut 125
Alonzo Levister-Manhattan Monodrama
Design: Uncredited

Debut 127
Thad Jones-Thad Jones
Design: Uncredited

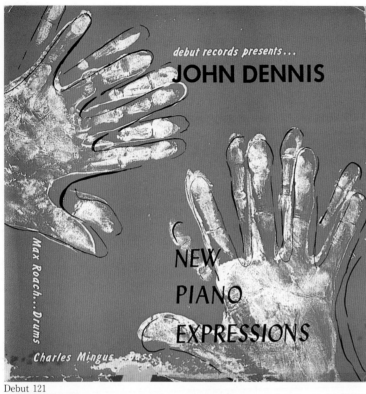

Debut 121

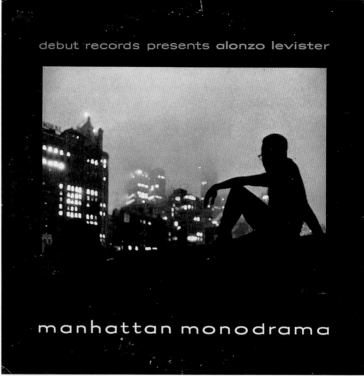

Debut 125

Debut 127

DEBUT—OTHER ALBUMS FROM DEBUT-AMERICA

The rest of the rare and beautiful covers from *Debut*-America:

Debut 16-10"
Hazel Scott - Relaxed Piano Moods
Design: Uncredited

Debut 13-10"
Max Roach - Max Roach Quartet
Design: Uncredited

Debut 8-10"
Oscar Pettiford - The New Oscar Pettiford Sextet
Photo: Herman Leonard
Design: Bill Spilka
(The great bassists Pettiford and Mingus play together. Pettiford switches to the Cello and leaves the Bass to Mingus.)

Debut 17-10"
Charles Mingus/Thad Jones - Jazz Collaborations
Photo: Cork
Design: Uncredited

Debut 120 (American issue)
Miles Davis - Blue Moods
Design: Bob Parent
Debut 120 (Danish issue)
Design: Jens Nords∅
(Coincidentally, Miles Davis and Charles Mingus independently considered Britt Woodman a special influence on their own early careers. A rare recording of the three of them together with Teddy Charles and Elvin Jones to round off the quintet. Both the American and Danish jackets are shown.)

Debut 122
John LaPorta - Three Moods
Design: Kiriki

Debut 198
Various Artists - Autobiography in Jazz
Design: Kiriki
(The low priced record to celebrate the label's 3rd (or 4th!) anniversary which turned out to be *Debut*'s swansong.)

その他のアメリカ盤

Debut 16-10"
Hazel Scott - Relaxed Piano Moods
Design: Uncredited

Debut 13-10"
Max Roach-Max Roach Quartet
Design: Uncredited

Debut 8-10"
Oscar Pettiford-The New Oscar Pettiford Sextet
Photo: Herman Leonard
Design: Bill Spilka
偉大なベース奏者，ペティフォードとミンガスのふたりが共演。ペティフォードはチェロに転じ，ミンガスにベースを譲っている。

Debut 17-10"
Charles Mingus/Thad Jones-Jazz Collaborations
Photo: Cork
Design: Uncredited

Debut 120 （アメリカ盤）
Miles Davis - Blue Moods
Design: Bob Parent
Debut 120 （デンマーク盤）
Design: Jens NordsΦ
偶然，マイルス・デイヴィスとチャールス・ミンガスはふたりとも，ブリット・ウッドマンこそ自分の初期の演奏に大きな影響を与えた人物だとしていた。この3人にテディ・チャールスとエルヴィン・ジョーンズを加えたクインテットによる珍しい録音。アメリカ盤とデンマーク盤のジャケットを紹介。

Debut 122
John LaPorta-Three Moods
Design: Kiriki

Debut 198
Various Artists-Autobiography in Jazz
Design: Kiriki
レーベル設立3周年（あるいは4周年）を記念して発売された低価格のレコード。これがデビューの最後の作品となった。

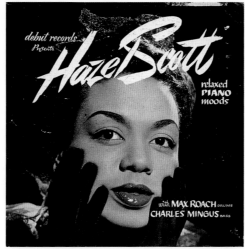

Debut 16-10"

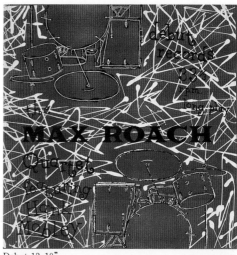

Debut 13-10"

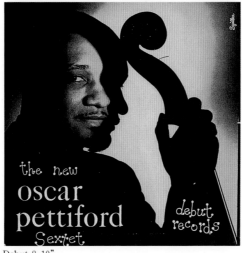

Debut 8-10"

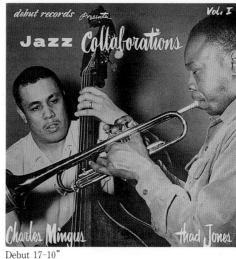

Debut 17-10"

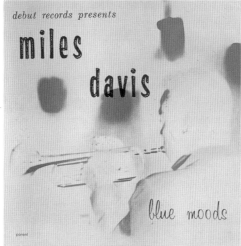

Debut 120 (American issue)

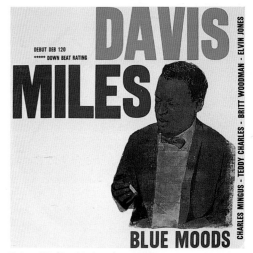

Debut 120 (Danish issue)

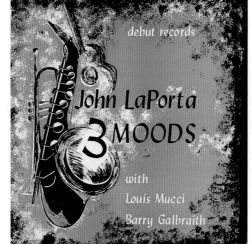

Debut 122

Debut 198

DEBUT-DENMARK——ALBUMS FEATURING AMERICAN MUSICIANS

Debut-Denmark issued three 7" LPs. The 7" EP (45 rpm) had been more popular in Europe than in America. But a 7" LP (33 rpm) was a universal curiosity. Fittingly, these three *Debut*-Denmark 7" LPs are among the rarest of all jazz LPs. Their existence was never in doubt, but few collectors have ever seen them. The sessions had been recorded by *Debut*-America before its demise:

Debut 101-7"
Jimmy Knepper - Jimmy Knepper Quintet
Design: Diane Dorr-Dorynek

Debut 102-7"
Oscar Pettiford - The New Oscar Pettiford Sextet
Photo: Herman Leonard
Design: Bill Spilka
(This is the same cover as *Debut* 8 (10") which is shown separately. But it is now reduced in size to 7". Shown again here for the sake of completeness and for its rarity.)

Debut 103-7"
Max Roach - Max Roach Quartet
Design: Diane Dorr - Dorynek

デンマーク盤
アメリカ人ミュージシャンをフィーチャーしたアルバム

　デビュー・デンマークは3枚の7インチLP盤を発売した。7インチEP（45回転）盤はアメリカに比べてヨーロッパでは普及していたが，7インチLP（33回転）盤は世界でもたいへん珍しかった。したがって，この3枚のデビュー・デンマークの7インチLP盤は，ジャズLPのなかでもきわめつけの珍盤である。存在することは確かなのだが，実際にお目にかかったコレクターはほとんどいない。デビュー・アメリカがなくなる前に録音したセッションである。

Debut 101-7"
Jimmy Knepper-Jimmy Knepper Quintet
Design: Diane Dorr-Dorynek

Debut 102-7"
Oscar Pettiford-The New Oscar Pettiford Sextet
Photo: Herman Leonard
Design: Bill Spilka

別に紹介したDebut-8（10インチ盤）と同じジャケットだが，7インチ盤のサイズに縮小されている。念のため，希少なものでもあるのでここで改めてとりあげた。

Debut 103-7"
Max Roach-Max Roach Quartet
Design: Diane Dorr-Dorynek

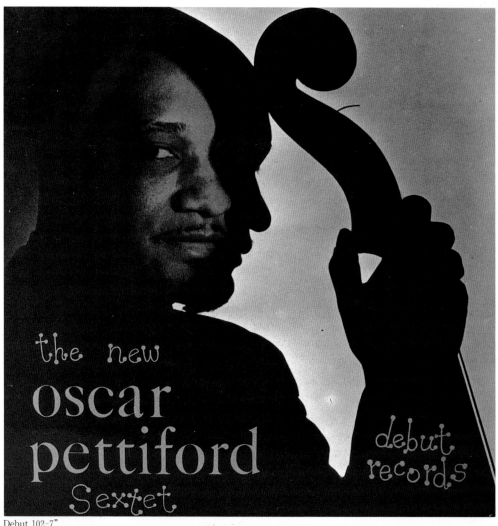

Debut 102-7"

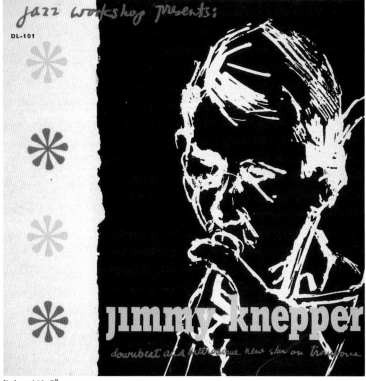

Debut 101-7"

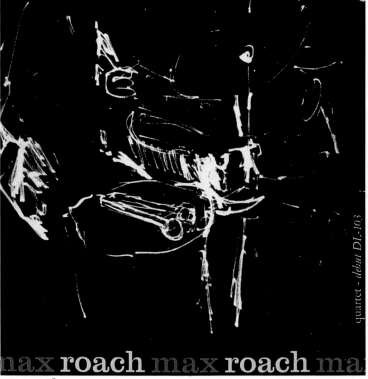

Debut 103-7"

Debut-Denmark did Jazz a great service to record American musicians then considered by other labels to be too avant-garde to be successful. As also American musicians who were more mainstream in their playing and had made Europe their home.

Debut 131
Coleman Hawkins/Bud Powell/Oscar Pettiford/Kenny Clarke
The Essen Jazz Festival All Stars
Photo: Jazzlive-Germany

Debut 132
Oscar Pettiford - My Little Cello
Photo: Lennart Steen
Art Direction: Anders Dryup

Debut 136
Eric Dolphy - In Europe
Photo: Debut Records

Debut 137
Brew Moore - Swinget 14
Photo: Jack Lind

Debut 138
Cecil Taylor - Live at the Cafe Montmartre
Photo: Lennart Steen
Design: Nina Aae

Debut 140
Albert Ayler - My Name is Albert Ayler
Design: Nina Aae

デビュー・デンマークは，当時他のレーベルから前衛的すぎると敬遠されていたアメリカのミュージシャンや，そこまで斬新ではないヨーロッパを拠点にしたアメリカのミュージシャンのレコードを製作し，ジャズ界に大きく貢献した。

Debut 131
Coleman Hawkins/Bud Powell/Oscar Pettifoed/Kenny Clarke
-The Essen Jazz Festival All Stars
Photo: Jazzlive-Germany

Debut 132
Oscar Pettiford-My Little Cello
Photo: Lennart Steen
Art Direction: Anders Dryup

Debut 136
Eric Dolphy-In Europe
Photo: Debut Records

Debut 137
Brew Moore-Swinget 14
Photo: Jack Lind

Debut 138
Cecil Taylor-Live at the Cafe Montmartre
Photo: Lennart Steen
Design: Nina Aae

Debut 140
Albert Ayler-My Name is Albert Ayler
Design: Nina Aae

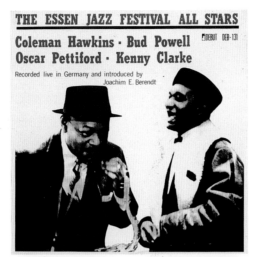

Debut 131

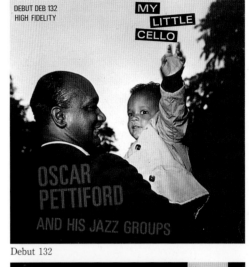

Debut 132

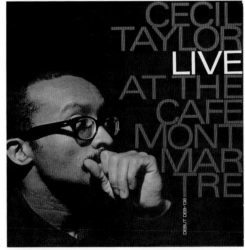

Debut 138

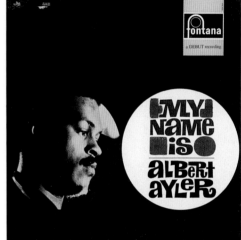

Debut 140

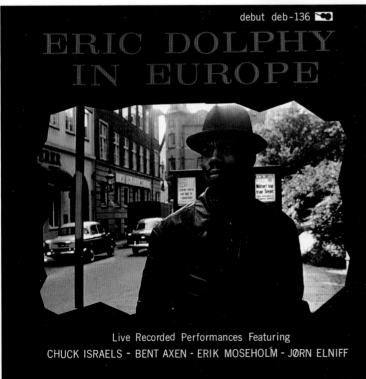

Debut 136

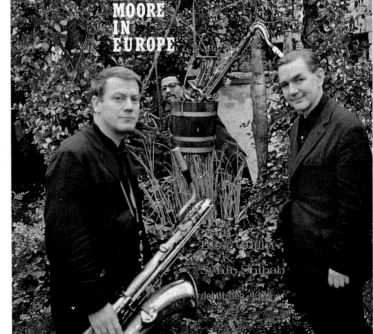

Debut 137

131

Debut 141
Sahib Shihab - Sahib's Jazz Party
Photo: Jan Persson
Design: Nina Aae

Debut 142
Don Byas - 30th Anniversary Album
Design: Nina Aae

Debut 143
Sonny Murray - Action
Design: Boris Rabinowitsch

Debut 144
Albert Ayler - Ghosts
Design: Nina Aae

Debut 146
Albert Ayler - Spirits
Design : Nina Aae

Debut 148
Cecil Taylor - Nefertiti
Design: Marte Roling

Debut 141
Sahib Shihab-Sahib's Jazz Party
Photo: Jan Persson
Design: Nina Aae

Debut 142
Don Byas-30th Anniversary Album
Design: Nina Aae

Debut 143
Sonny Murray-Action
Design: Boris Rabinowitsch

Debut 144
Albert Ayler-Ghosts
Design: Nina Aae

Debut 146
Albert Ayler-Spirits
Design: Nina Aae

Debut 148
Cecil Taylor-Nefertiti
Design: Marte Roling

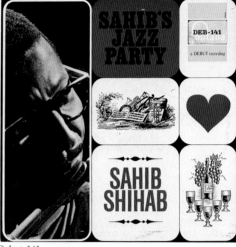
Debut 141

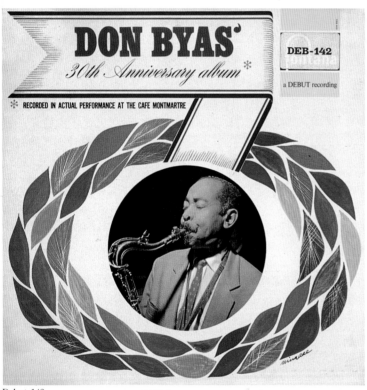
Debut 142

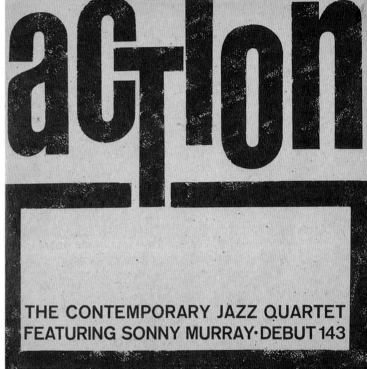
Debut 143

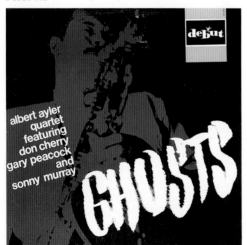
Debut 144

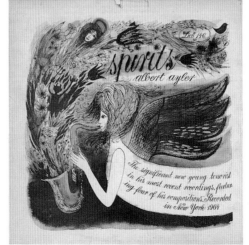
Debut 146

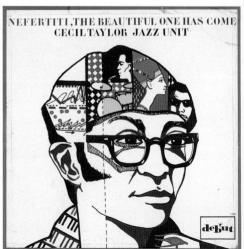
Debut 148

DEBUT-DENMARK——JAZZ FROM EUROPE

Scandinavian audiences and record buyers were more receptive to the sounds of 'free jazz' or just 'imaginative sounds'. **Debut**-Denmark produced some exceptional records which gave 'new music' players their shot at the rare and the beautiful.

Debut 133
The Axen - Jaedig Jazz Groups
Let's Keep the Message
Photo: Lennart Steen

Debut 134
Jorn Elniff Trio & Quartet
Music for Mice and Men
Photo: Lennart Steen

Debut 135
Louis Hjulmand & Allan Botschinsky
Blue Bros
Photo: Vibeke Winding

Debut 150
Palle Mikkelborg - The Mysterious Corona
Photo: Jan Persson

ヨーロッパのジャズ

　北欧のジャズファンやレコードファンは、「フリージャズ」すなわち「想像的なサウンド」を歓迎した。デビュー・デンマークは何枚かの異例な作品を発表し、「ニューミュージック」奏者の希少な美しい瞬間をとらえた。

Debut 133
The Axen-Jaedig Jazz Groups
Let's Keep the Message
Photo: Lennart Steen

Debut 134
Jorn Elniff Trio &Quartet
Music for Mice and Men
Photo: Lennart Steen

Debut 135
Louis Hjulmand & Allan Botschinsky
Blue Bros
Photo: Vibeke Winding

Debut 150
Palle Mikkelborg-The Mysterious Corona
Photo: Jan Persson

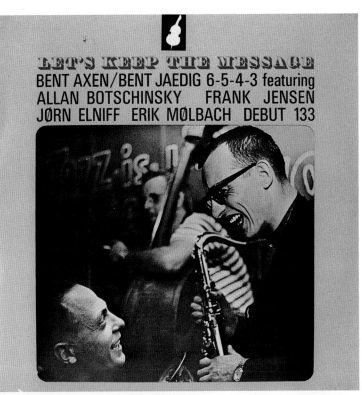

Debut 133

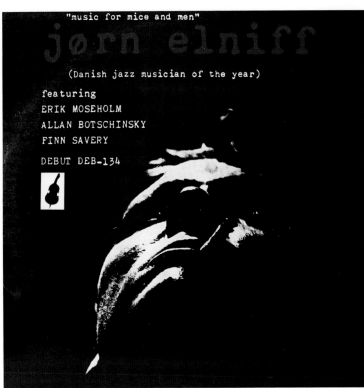

Debut 134

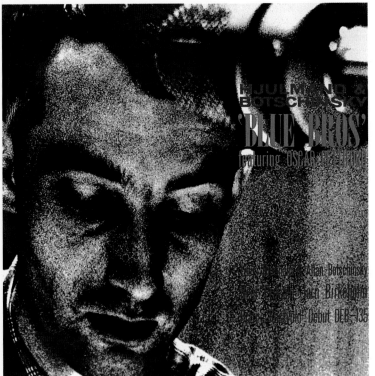

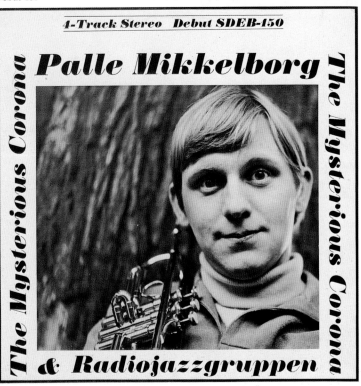

Debut 150

THE 'SOUTHLAND' LABEL

「サウスランド」レーベル

You cannot separate jazz and New Orleans. Leaving aside the myths and the folklore, let us get down to facts.

New Orleans was the port of entry for the West African slave trade. The slaves brought their own music, which the slave traders actually encouraged to placate their fears for the future. New Orleans produced the first acknowledged jazz musician——the trumpet player Buddy Bolden and the first jazz band——the Original Dixieland Jazz Band. Buddy Bolden, King Oliver, Jelly Roll Morton, Louis Armstrong, Sidney Bechet, Johnny Dodds, Kid Ory, Mahalia Jackson, Bunk Johnson, Al Hirt, Pete Fountain are some of the musicians born in New Orleans.

New Orleans or Dixieland music (only extreme purists separate these) is never a challenge to enjoy, follow or even remember. If anything, it is more of a challenge to avoid playing the same familiar tunes. The music itself is preserved through the countless tourists from all over the world on their pilgrimage to New Orleans. To the city streets and areas immortalized in music: Basin Street, Beale Street, St. Louis Street, Rampart Street, Mahogany Hall, Perdido, Canal Street, Storyville. The music is kept alive through devoted followers, festivals and records.

New Orleans produced an inexhaustible supply of musicians. Curiously, many preferred to live in New Orleans. Often with regular day-time jobs, many only worked as musicians at night. Such as the Mares brothers. The elder, Paul played trumpet and led the New Orleans Rhythm Kings. The younger, Joe was a part time musician, who soon shifted to band management. Joe Mares recorded New Orleans groups for release on the *Circle* label. But he aimed for a lot of releases——so his own label became essential. *Southland* was started in 1950.

Southland issued 40 albums. The *Southland* label remained a small one, restricted essentially to sales in New Orleans and without national distribution. In 1960 the label was sold to George Buck whose GHB Records, fortunately for both the collector and listener, provided both national and international marketing outlets.

Many years later——in July 1984——Joe Mares reminisced about *Southland* records in the magazine 'Mississippi Rag':

"I had anybody who was who in New Orleans. All leaders themselves——I put together. In my lifetime I think of fellas like Santo Pecora, and Harry Shields, Monk Hazel and Armand Hug as great men in my book but they didn't have exposure. I got everybody who's who on the records, so I accomplished what I wanted. I thought may be this was it. No more bands unless I put the, same bands back together. I did such a good job, I thought 'Lets let it stay at that'.

I am really proud of my association with *Southland* records. I accomplished what I wanted to——that is to give some New Orleans jazz greats a chance to be heard outside of New Orleans and around the world and to get the recognition they deserved."

ジャズとニューオリンズとは切っても切れない関係にある。神話や民間伝承はさておき、事実をたどっていくとしよう。

ニューオリンズは西アフリカからの奴隷貿易の通関港であった。奴隷達は自分達の音楽を持ちこみ、奴隷商人も前途を不安がる奴隷達を慰めるためにそれを奨励した。そうして後に、ニューオリンズは世に認められる最初のジャズ・ミュージシャン、トランペット奏者のバディ・ボールデンと、最初のジャズ・バンド、オリジナル・ディキシーランド・ジャズ・バンドを生み、バディ・ボールデン、キング・オリヴァー、ジェリー・ロール・モートン、ルイ・アームストロング、シドニー・ベシェ、ジョニー・ドッズ、キッド・オリー、マヘリア・ジャクソン、バンク・ジョンソン、アル・ハート、ピート・ファウンテンなど多くのミュージシャンを輩出することになった。

ニューオリンズ・ジャズまたはディキシーランド・ジャズ（よほどの純粋主義者でなければこれを区別しない）は、楽しむことや倣うことはもちろん、覚えることさえ強要する音楽ではない。しいて言えば、馴染みの旋律を繰り返して演奏するのは避けるということぐらいだ。その音楽自体は、世界中からジャズの聖地ニューオリンズを訪れる無数の人々によって受け継がれ、ベイズン・ストリート、ビール・ストリート、セントルイス・ストリート、ランパート・ストリート、マホガニー・ホール、パーディド、カナル・ストリート、ストーリーヴィルなど、町の通りや場所は曲の中に永遠に名を刻まれている。熱心な信奉者やジャズ祭やレコードを通して、ニューオリンズ・ジャズは生きつづけているのである。

ニューオリンズは次々とミュージシャンを生んだ。そしておもしろいことに、その多くはニューオリンズで暮らすことを選んだ。たいてい昼間は定職に就くかして、夜だけミュージシャンとして活動した。メアース兄弟もそうだった。兄のポールはトランペット奏者で、ニューオリンズ・リズム・キングスのリーダーだった。弟のジョーはぽちぽち演奏をしてはいたが、まもなくバンドのマネージャーの仕事に移った。ジョー・メアースはニューオリンズのグループの演奏を録音しては、サークル・レーベルに発売をもちかけたが、多くのレコード発売を目指す彼には、自己のレーベルが不可欠だった。こうして1950年、サウスランド・レーベルが創設されたのである。

サウスランドは40枚のアルバムを発表したが、ニューオリンズでのみ売られているような状態で、全国的に出回ることもなく、小規模レーベルのままであった。1960年、ＧＨＢレコードのジョージ・バックがサウスランドを買収。コレクターにとっても聴き手にとっても幸いなことに、全国、そして世界へと販路が拡大された。

それから20年あまりたった1984年7月、ジョー・メアースは『ミシシッピーラグ』誌でサウスランドの思い出をこう語っている。

「ニューオリンズ中の一流ミュージシャンがそろっていた。リーダーになれる器ばかりを集めたんだ。サント・ペコラやハリー・シールズ、モンク・ヘイゼル、アーマンド・ハグといった連中は、世の注目こそ浴びなかったけれど、私には一生忘れられないジャズの名手だった。私は一流ミュージシャンの演奏はみんなレコードにおさめた。だから、望みは達成したんだ。たぶんこれが自分が求めていたことなんだと思った。後にも先にももうこんなすごいバンドはできない。おれはすごいことをしたんだ。『さあ、この調子だぞ』ってね。

サウスランドを設立してレコードを出せたことを、私は心から誇りに思ってい

Mares made some impressive records for *Southland.* The legendary trumpet player Nick LaRocca had stopped playing 25 years earlier. LaRocca was 71 and had been retired for over 25 years when he came out of retirement to make one *Southland* record. Johnny St.Cyr was best known as the guitar player in Louis Armstrong's original Hot Five. Within the same Hot Five format, he now made his first leader album ever. 'Papa' Celestin celebrated his 50th year as leader of his New Orleans Band by making two *Southland* records. Al Hirt and Pete Fountain made their first recordings again on the *Southland* label. In sum, *Southland* left us the best legacy possible of recently recorded New Orleans music.

New Orleans honored Joe Mares with the Key to the City (twice) along with Citations from the Mayor. But his greatest pride was Doc Souchon's——an eminent surgeon by day, a great guitar player by night——sending a photograph with the inscription **"To the man who has done more for New Orleans musicians than anyone I've known."**

A few *Southland* records were recorded at Festivals outside of New Orleans. But the bulk were recorded in New Orleans itself. To match the music, all of its jackets feature drawings or photographs of New Orleans.

Joe Mares passed away in 1991. It is my personal loss not to have talked or written to him about this book, in his lifetime.

る。夢がかなったんだ。ニューオリンズの大物ジャズメンの演奏をニューオリンズの外，そして世界中に紹介して，そのすばらしさを認めてもらうっていう夢がね」

　メアースはサウスランド・レーベルで何枚か印象的なレコードを作っている。伝説のトランペット奏者，ニック・ラロッカは 25 年前に引退していた。すでに 71 才を迎え，25 年以上も現役を退いていた彼が，復帰して 1 枚のサウスランドのレコードを吹込んだ。ジョニー・センシアはルイ・アームストロングの最初のホット・ファイヴのギター奏者として有名だったが，同じホット・ファイヴのフォーマットで初リーダー・アルバムを吹込んだ。また，'パパ'・セレスティンはニューオリンズ・バンドのリーダーとして 50 年目を祝って，2 枚のレコードを発表。アル・ハートとピート・ファウンテンも最初の吹込みをしている。つまり，サウスランドは私達に，近年録音されたニューオリンズ・ジャズというとびきりの遺産を残してくれたのである。

　ジョー・メアースはニューオリンズの市民栄誉賞を 2 回と，さらに市長表彰も受ける名誉にあずかった。しかし，彼の最大の誇りは，昼は名外科医，夜は名ギター奏者であったドク・スーション から，「私の知るだれよりもニューオリンズのミュージシャンの力になった男へ」と書かれた写真を送られたことだった。

　サウスランドのレコードは，ニューオリンズ以外のジャズ祭で録音されたものも少しはあるが，大半は地元ニューオリンズで録音されている。中身の音楽に合わせ，ジャケットにはいずれもニューオリンズの絵や写真が用いられている。

　1991 年，ジョー・メアースは他界した。生前に，本書のことを彼に話すか手紙を書くかしなかったことが悔やまれてならない。

212
Johnny St Cyr and his Hot Five-Paul Barbarin and his Jazz Band
Design: Johnny Donnels
ジョニー・センシアがキング・オリヴァー，ジェリー・ロール・モートン，バンク・ジョンソンとリズム・ギターを演奏。彼は 1930 年代初めのルイ・アームストロングのホット・ファイヴのメンバーとしてが最も有名だが，これは初リーダー作品である。

220
Dixieland Down South
Idea: Down South Magazine
Design: Fred Sparnell

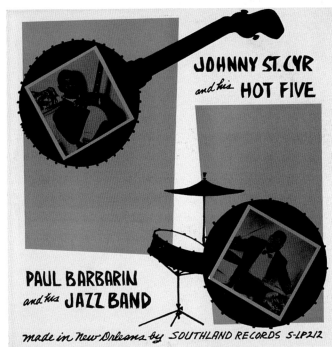

212

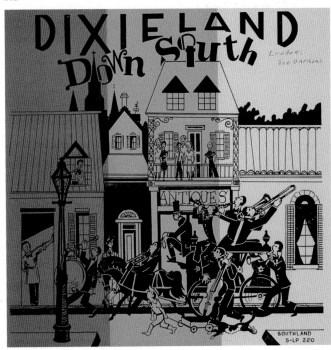

220

210 Tracks by George Brunis and his All Stars; Octave Crosby's Ragtime Band; Leon Prima and his New Orleans Jazz Band
New Orleans Jazz
Photo: John Kuhlman
Design: Johnny Donnels

231 Doc Souchon and his Milneburg Boys
Photo: John Kuhlman
Design: Dessie Lee
(Doctor Edmond Souchon——an eminent surgeon by profession; a fine guitarist by vocation and also a distinguished historian on New Orleans.)

217x New Orleans Jazz
Featuring Al Hirt–Pete Fountain
Photo: Cole Coleman
Design : Dessie Lee
(The disc debut of Al Hirt. Recorded – 1957 – at the annual Dixieland Jubilee in Los Angeles.)

222 Sharkey and his Kings of Dixieland
Design: Johnny Donnels

210
George Brunis and his All Stars/Octave Crosby's Rag-time Band/
Leon Prima and his New Orleans Jazz Band-New Orleans Jazz
Photo: John Kuhlman
Design: Johnny Donnels

231
Doc Souchon and his Milneburg Boys
Photo: John Kuhlman
Design: Dessie Lee
ドク・エドモンド・スーションは著名な外科医であり，ギターの名手であり，そしてまた優秀なニューオリンズの歴史家でもあった。

217x
Featuring Al Hirt・Pete Fountain-New Orleans Jazz
Photo: Cole Coleman
Design: Dessie Lee
アル・ヒートのデビュー作。1957年，ロサンゼルス，毎年

恒例のデイキシーランド・ジュビリーにて録音。

222
Sharkey and his Kings of Dixieland
Design: Johnny Donnels

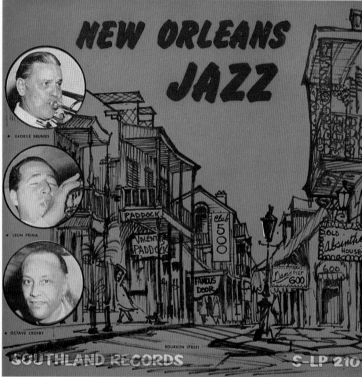

210

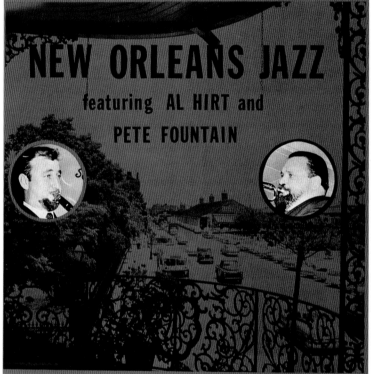

217x

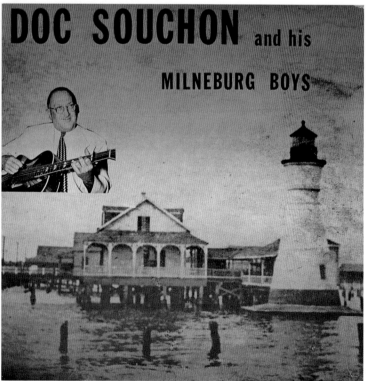

231

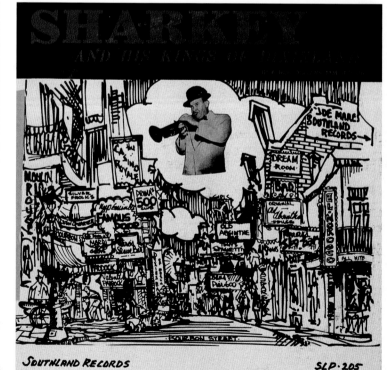

222

230 Nick LaRocca and his Dixieland Jazz Band
Photo: Charles Vagabond
Design: Johnny Donnels
(In 1917 Nick LaRocca formed and led the Original Dixieland Jazz Band. The ODJB quickly became the highest paid, most popular band in the world——with discs selling in record numbers. LaRocca was 71 and had been retired 25+ years. He came out of retirement to make just this Southland record. He did so——and talked on it-Joe Mares's persuasion: **"otherwise a lot of people don't think you are living."** The cover shows LaRocca seated, surrounded by the other great musicians of New Orleans.)

229 Thomas Jefferson - New Orleans at Midnight
Photo: Cole Coleman
Design: Dessie Foreman

233 New Orleans Dixieland Express
Tracks by Emile Christian Band, Joe Capraro All Stars, Tony Almerico All Stars)
Design: Dessie Lee

235 Papa Laine's Jazz Band
Photo: John Kuhlman
(Drummer Papa Laine was 89 and did not play on this record when it was made, but led the group. It was an affectionate tribute to the music he first played from 1890 to 1910——referred to as 'the Jack Laine era'. He led the Reliance Brass Band which preceded Nick LaRocca's ODJB.)

230
Nick LaRocca and his Dixieland Jazz Band
Photo: Charles Vagabond
Design: Johnny Donnels
1917 年，ニック・ラロッカはオリジナル・ディキシーランド・ジャズ・バンド（ODJB）を結成し，リーダーを務めた。ODJBはたちまち世界で最高の収入と人気を誇るバンドとなり，最高のレコード売上枚数を記録した。71 才のラロッカは，25 年以上も現役を退いていたが，この１枚のサウスランドのレコードを吹込むためだけに復帰した。ジョー・メアースに「でないと，たくさんの人々に死んだと思われてしまいますよ」と説得されたからだという。ジャ

ケットの写真は，ラロッカがニューオリンズの他の大物ミュージシャンたちに囲まれて座っているところ。

229
Thomas Jefferson-New Orleans at Midnight
Photo: Cole Coleman
Design: Dessie Foreman

233
Emile Christian Band/Joe Capraro All Stars/Tony Almerio All Stars-New Orleans Dixieland Express
Design: Dessie Lee

235
Papa Laine's Jazz Band
Photo: John Kuhlman
これを録音したとき，ドラマー，パパ・レインは 89 才で，演奏には参加せずグループを指揮した。「ジャック・レイン時代」といわれた 1890 年から 1910 年，彼が初めて演奏した音楽への愛情を表わした作品。レインの率いたリライアンス・ブラス・バンドは，ニック・ラロッカのODJBの前身であった。

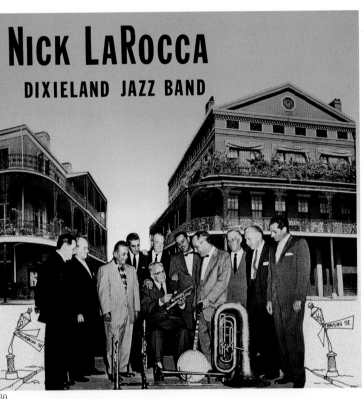

230

233

229

235

206 Oscar 'Papa' Celestin's Golden Wedding

225 Oscar 'Papa' Celestin and his New Orleans Ragtime Band
Photo: John Kuhlman
Cover: Johnny Donnels
(Papa Celestin was the most popular of New Orleans's resident musicians. He lived and played in New Orleans for 50 years——hence the title Golden Wedding. These Papa Celestin records were the best selling of all **Southland** records.)

205 Sharkey and his Kings of Dixieland
Design: Johnny Donnels

200 Johnny Wiggs' New Orleans Jazz
Photo: John Kuhlman
Design: Johnny Donnels

208 George Lewis Ragtime Jazz Band
Photos: John Kuhlman and Roy Heinecke
Design: Johnny Donnels

221 Armand Hug and his New Orleans Dixielanders
Eddie Miller and his New Orleans Rhythm Pals
Photos: John Kuhlman
Design: Johnny Donnels

224 Armand Hug Band - Dixieland from New Orleans
Photos: Charles Vagabond
Design: Johnny Donnells

234 Thomas Jefferson - New Orleans Creole Jazz Band
Painting: Robert Riggs
Design: John Larkins

206

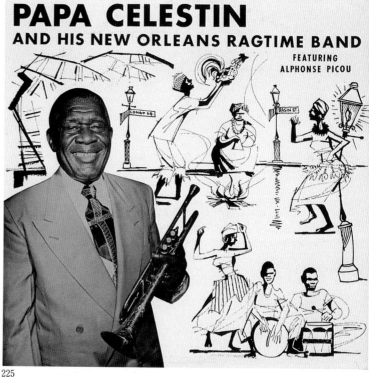

225

200

208

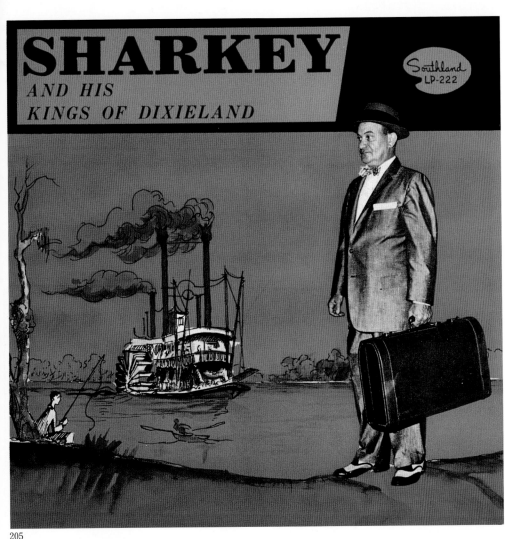

205

206
Oscar 'Papa' Celestin's Golden Wedding
225
Oscar 'Papa' Celestin and his New Orleans Ragtime Band
Photo: John Kuhlman
Cover: Johnny Donnels

'パパ'・セレスティンはニューオリンズ在住のミュージシャンのなかでも抜群の人気があった。50年間, ニューオリンズに居を構えて演奏活動をつづけ, そこから『ゴールデン・ウェディング（金婚式）』というタイトルがついた。この'パパ'・セレスティンの2枚は, サウスランドのレコードのなかでも最高の売上げを誇る。

205
Sharkey and his Kings of Dixieland
Design: Johnny Donnels

200
Johnny Wiggs' New Orleans Jazz
Photo: John Kuhlman
Design: Johnny Donnels

208
George Lewis Ragtime Jazz Band
Photos: John Kuhlman and Roy Heinecke
Design: Johnny Donnels

221
Armand Hug and his New Orleans Dixielanders/Eddie Miller and his New Orleans Rhythm Pals
Photos: John Kuhlman
Design: Johnny Donnels

224
Armand Hug Band-Dixieland from New Orleans
Photos: Charles Vagabond
Design: Johnny Donnels

234
Thomas Jefferson-New Orleans Creole Jazz Band
Painting: Robert Riggs
Design: John Larkins

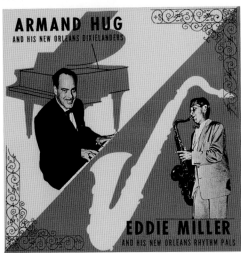

221

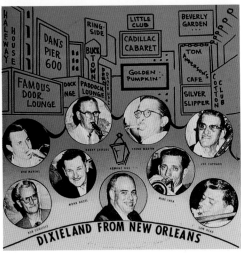

224

234

239　Tracks by Don Albert and Band; Kid Howard and Band
Echoes of News Orleans
Photo: Allan Jaffer
Design: John Larkins

227　Irvine 'Pinkie' Vidacovich and Band/Raymond Burke and Band
Clarinet New Orleans Style
Photo: Cole Coleman
Design: Dessie Foreman

240　Louis Cottrell and Band – Shades of New Orleans
Photo: Dessie Lee

237　Paul Barbarin's Bourbon Street Beat
Design: John Larkins
(Bourbon Street——Home of the Barbarin Band)

238　Thomas Jefferson
Dreaming Down the River to New Orleans
Design: John Larkins

217　Monk Hazel and his New Orleans Jazz Kings
Photo: John Kuhlman
Design: Johnny Donnels

218　Tracks by Bands of Johnny Wiggs; Armand Hug; Edmond Souchon – Crescent City Music
Photos: John Kuhlman
Design: Johnny Donnels

209　Raymond Burke and his New Orleans Jazz Band
Design: Andrew Land

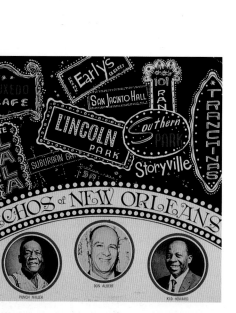

239

237

227

240

239
Don Albert and Band/Kid Howard and Band-Echoes of
New Orleans
Photo: Allan Jaffer
Design: John Larkins

227
Irvine 'Pinkie' Vidacovich and Band/Raymond Burke
and Band-Clarinet New Orleans Style
Photo: Cole Coleman
Design: Dessie Foreman

240
Louis Cottrell and Band-Shades of New Orleans
Photo: Dessie Lee

237
Paul Barbarin's Bourbon Street Beat
Design: John Larkins
バーボン・ストリートはバーバリン・バンドの本拠地。

238
Thomas Jefferson-Dreaming Down the River New
Orleans
Design: John Larkins

217
Monk Hazel and his New Orleans Jazz Kings
Photo: John Kuhlman
Design: Johnny Donnels

218
Bands of Johnny Wiggs
Armand Hug/Edmond Souchon
Crescent City Music
Photos: John Kuhlman
Design Johnny Donnels

209
Raymond Burke and his New Orleans Jazz Band
Design: Andrew Land

238

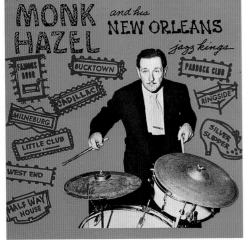

217

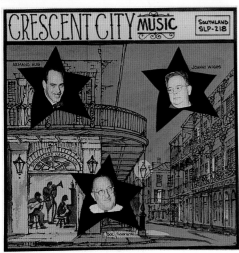

218

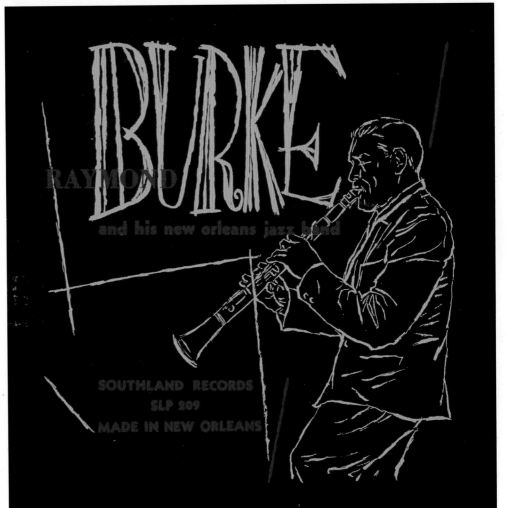

209

POSTSCRIPT

Three years have passed since the first pages for this book were drafted. The LP has completed its thirty-year life span. The CD has already reached, perhaps even passed, the prime of its own life span as a new generation of recorded media have begun to succeed it in the form of the Mini Compact Disc, the recordable Compact Disc, Digital Audio Tape and Digital Compact Cassettes. In the wings, the industry prepares to exploit the multi-media revolution with its promise of practical 'interactive' systems. All are innovations to be welcomed; whatever makes music more accessible cannot be faulted. Music and audio must be considered among the basic needs for the growing young. Music and audio/video have become synonymous with vigorous marketing practices and constant development of new reproduction systems.

Each new development emphasizes smaller formats, greater storage capacity and increased ease of operations. In humble contrast, the LP is a headache and in more ways than one. For starters, it demands a correctly balanced tone arm and a well maintained stylus. There is also the inherent fragility of the LP's vinyl surface to be reckoned with not to mention the perpetual need for clean playing surfaces. And yet the LP manages to survive despite the obvious advantages enjoyed by the competition, despite its modest playing time, despite the time consuming mechanical rituals and other impracticalities associated with it.

Modern sound engineering makes it possible for recordings made in the reign of the LP to be reissued under new compact forms in greater profusion then anyone has a right to expect. There are an endless number of new issues too for Jazz is an art that relentlessly pursues its own future through a flow of gifted musicians. Happily accepting that some reissues will continue in the new formats where does all this excitement leave the art of the jacket designer? Few will argue against the view that we live in an age dominated by the image. But whose image is it? And in whose control is it now placed? For the death knell of the art of the jazz cover design has sounded. Ignored by museums, still 'unarchived', the art LP cover design is without question an art, a great art, an art which once flourished in its own eloquent even swaggering language. A treasure which now more than ever cries out for proper recognition and for archival classification and protection.

あとがき

　本書の編纂にとりかかって3年がたつ。今や、30年間にわたるLP盤の時代は完全に終わりを告げ、CDが全盛期を迎えた。いや、それすらもすでに過ぎてしまったといっていいかもしれない。CDに続いて、ミニ・コンパクトディスクや録音可能なコンパクトディスク、デジタル・オーディオテープ、デジタル・コンパクトカセットといった次世代の記録媒体が、続々と登場しはじめている。こうした舞台裏には、将来、異なるメディア間の「相互作用」システムの時代が来ることを見込んで、マルチメディア改革に乗じようするオーディオ産業の動きがあるが、どれも歓迎すべきものである。音楽をより身近にしてくれるのだから、なにをとがめる理由があろう。音楽とオーディオは、若者にとって必需品の一つといってよい。音楽とオーディオ、ビデオは、熾烈な市場競争と、たゆまぬ再生システムの開発の代名詞となったのである。

　開発が進むにつれて、レコードはますます小型化して記憶容量が大きくなり、ますます操作が簡単になっていく。それにひきかえ、こういってはなんだが、LP盤はなにかと面倒なことが多い。まず、プレーヤーのトーンアームのバランスを正しく調節しなければならないし、レコード針の手入れも忘れない。しかも、もともとビニル製のLP盤の表面は傷つきやすいときているので、当然、常にレコード面を清潔に保つことが必要である。それでも、LP盤はほそぼそと生きながらえている。ライバルたちに大きく差をつけられても、演奏時間が短めでも、プレイヤーの操作や手入れなどやたらと時間がかかっても、姿を消すことはない。

　現代の音響技術によって、LP盤の全盛期の録音を、小型化した新しい形態で再発することが可能となり、驚くほどたくさんの作品が復活した。その一方で、数えきれないほどの新しい作品も発表され、ジャズは次々と登場する才能豊かなミュージシャンによって、芸術としての道を模索しひたすら前進を続けている。さいわい、LP盤の一部は今後も形を変えながら再発を繰り返すことになりそうだが、喜ぶあまり、ジャケット・デザイナーの作品をどこかに置き忘れてしまっているのではないだろうか？　私たちがイメージに支配される時代に生きていることに、異論を唱える者はほとんどいないだろう。しかし、それはだれのイメージなのか？　だれに管理されているのか？　ジャズ・アルバムのカバー・デザインという芸術の死を告げる鐘は鳴った。美術館に所蔵されているわけでも、「保管所」に納められているわけでもないが、LP盤のジャケットのデザインがれっきとした芸術であることはまちがいない。かつて、絵や写真という独自の言葉で雄弁に、ときには誇張ぎみにジャズを語り、隆盛を極めたすぐれた芸術。その貴重な財産を正しく評価し、きちんと分類して保管し保護することが、今、これまでになく切実に求められている。

The David Stone Martin jacket designs-which literally burst the confines of their original square format-will never fit any of the new compact formats. Even the magnificent 10" Blue Note and Pierre Merlin jackets, to mention only these, have faded into obscurity with the appearance of 12" jackets. It saddens me, as it must sadden the reader, to see record companies now truncate and otherwise mistreat designs intended for the LP. Adding insult to injury, too many companies think nothing of omitting the names of designers and photographers entirely, as if it were a matter of little importance. But matter it does and matter it will. The jacket designer was an integral part of the overall production of the record. True, we bought the record for the music. But the essential point is that the music, the musician, the liner notes and the jacket created a seamless whole for the music itself. And the jacket promised what it delivered; often enough the jacket would resonate with a kind of superior knowledge. Drawing upon all his resources, his wit, his imagination, his finesse and circumstances far form ideal, the record designer created the ambience and the intimacy for which the music itself seemed to be designed.

All of us involved with jazz or with graphics need to do what we can to record the history of the pictorial and photographic art of the jazz album cover. We do not have much time left for many of its great practitioners are no more with us or have just dropped out of sight. This is a legacy to us of great understanding of a marvelous music listened to and played with appreciation throughout the world.

Tokyo January 10, 1994

　デヴィッド・ストーン・マーチンの手がけたジャケットのデザイン
は，オリジナル盤の正方形でも狭すぎるくらいだったから，小型化し
た新しい形の記録媒体には適するはずがない。格調高いブルーノート
の10インチ盤やピエール・メルランのジャケットに限って言えば，同
じ作品が12インチ盤のジャケットでは鮮明な印象を失ってしまうこ
とになった。端をカットするなど，レコード会社がLP盤のデザイン
をひどく無神経に扱っているのを見ると，私は心が痛む。きっと読者
の皆さんも同じ気持ちにちがいない。さらに屈辱的なことに，デザイ
ナーや写真家の名前を平気で削ってしまう会社が多すぎる。どうでも
いいことだと言わんばかりだが，デザインを手がけた人物を表示する
のは大切なことであり，その重要性は今後も変わらない。かつてジャ
ケット・デザイナーは，レコード製作に欠かせない存在だった。確か
に，レコードを買うのは演奏を聴くためだった。しかし，肝心なのは，
曲とミュージシャンとライナーノーツとジャケットとが調和し，一体
となって音楽そのものを作り上げていたという点である。ジャケット
はレコードの中身を保証するものであり，ジャケットが一種のすぐれ
た情報を提供してくれることも少なくなかった。ジャケット・デザイ
ナーは，自分の才能や機知，想像力，技巧，理想とはほど遠い境遇な
どすべてを結集して，音楽が伝えようとしていると思われる雰囲気や
親近感を表現したのである。

　私たちジャズやそのグラフィックを愛する者は皆，絵や写真による
ジャズ・アルバムのカバー・アートの歴史を記録に残すために，でき
る限りのことをしなくてはならない。残された時間はあまりない。偉
大なデザイナーの多くは，すでにこの世になかったり，消息がわから
なくなったりしているからだ。ジャズ・アルバムのジャケットという
芸術は，世界中で認められ聴かれ演奏されているこのすばらしい音楽
を，こよなく愛し理解する私たちに残されたかけがえのない遺産である。

東京にて　　1994年1月10日

ジャズアルバムカバーズ

1994 年 3 月 25 日　初版第 1 刷発行

著者　　マネック・デーバー©

発行者　久世利郎

印刷　　錦明印刷株式会社

製本　　大口製本株式会社

写植　　三和写真工芸株式会社

発行所　株式会社グラフィック社

　　　　〒 102 東京都千代田区九段北 1-9-12

　　　　Tel.03 (3263) 4318 Fax.03 (3263) 5297

ISBN4-7661-0726-8